Four Centuries of Decorative Arts
from Burghley House

Four Centuries of Decorative Arts from Burghley House

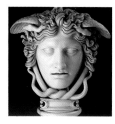

OLIVER IMPEY

Essay by Christina H. Nelson

with a foreword by Lady Victoria Leatham

Art Services International

Alexandria, Virginia, 1998

This exhibition is organized and circulated by Art Services International, Alexandria, Virginia. Copyright © 1998 by Art Services International and Burghley House. All rights reserved.

Support has been provided by an indemnity from the Federal Council on the Arts and the Humanities.

PARTICIPATING MUSEUMS

Cincinnati Art Museum
Cincinnati, Ohio

Society of the Four Arts
Palm Beach, Florida

New Orleans Museum of Art
New Orleans, Louisiana

Santa Barbara Museum of Art
Santa Barbara, California

Columbia Museum of Art
Columbia, South Carolina

LIBRARY OF CONGRESS CATALOGING-IN-PUBLICATION DATA
Impey, O. R. (Oliver R.)
 The Cecil family collects : four centuries of decorative arts from Burghley House / Oliver Impey : essay by Christina H. Nelson with a foreword by Lady Victoria Leatham.
 p. cm.
 This exhibition is organized and circulated by Art Services International, Alexandria, Va.
 Includes bibliographical references.
 ISBN 0-88397-130-5
 1. Decorative arts—Exhibitions. 2. Cecil family—Art collections—Exhibitions. 3. Decorative arts—Private collections—England—Stamford—Exhibitions. 4. Decorative arts—England—Stamford—Exhibitions. 5. Burghley House (Stamford, England)—Exhibitions. 6. Burghley House (Stamford, England) I. Nelson, Christina H. II. Art Services International. III. Title.
 NK550.G72C435 1998
 745'.074'42538—DC21 98-8036
 CIP

EDITOR Ellen Hirzy

DESIGNER The Watermark Design Office

PRINTER Craft Print PTE, Ltd.

Printed and bound in Singapore.

Cover: Cabinet, Florence, ca. 1680, ebony with bone and mother-of-pearl marquetry, marble, gilt-bronze, on English gilt-wood stand (cat. no. 93)

Inside front cover: Detail, Mortlake, after Giulio Romano, The Grape Harvest, *wool tapestry, possibly before 1678 (cat. no. 100)*

Frontispiece: Details, cat. nos. 16, 37, 58, 85A. Background, Burghley House, North Front, with alterations proposed by Lancelot "Capability" Brown, ca. 1756 (cat. no. 8)

Table of contents: Arita figure of an Immortal on a tortoise, Japan, ca. 1660–1680, enameled porcelain (cat. no. 74)

Table of Contents

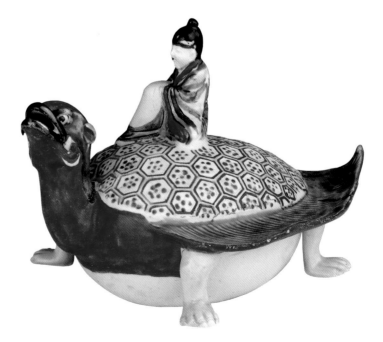

Acknowledgments

Burghley House, near Stamford in Lincolnshire, contains one of the oldest and most influential private collections in Great Britain. Home of the Cecil family since 1577, Burghley is the grandest Elizabethan house in England still inhabited by main-line descendants. It was built in an era when formal state rooms were in demand, intended for possible visits from the Sovereign whose subjects were eager to receive the royal entourage. Over four centuries, and particularly as the result of purchases made on Grand Tours—an obligatory aspect of the education of every aristocratic young Englishman—these rooms became filled with extraordinary furniture, tapestries, frescoes, and art objects. With ownership passing in unbroken succession from father to son well into the twentieth century, the collections at Burghley have been superbly preserved, and the house is a treasure trove of diverse riches.

Art Services International is honored to bring to American audiences this unique presentation of the superb decorative arts housed at Burghley, following as it does the important exhibition, *Italian Paintings from Burghley House*, which Art Services International organized and toured throughout the United States in 1995–1996. To Lady Victoria Leatham, seventeenth-generation descendant of the Cecil line and present resident of Burghley House, we owe our sincere gratitude for her generous permission to exhibit this selection of priceless objects in America. Both Lady Victoria and her husband, Simon Leatham, are actively committed to upholding her family's tradition of stewardship for the treasures at Burghley, and we applaud their achievement. Through their unceasing efforts, the house and its gardens prevail as magnificent and vibrant examples of England's history.

Dr. Oliver Impey, guest curator of the exhibition and senior assistant keeper in the Department of Eastern Art at the Ashmolean Museum, Oxford, brings an impressive breadth of knowledge to his exploration of the house, its collections, and the history of the Cecil family. Both his expertise and his affection for this subject are evident as he chronicles the furnishing of Burghley and describes the objects selected for the exhibition. We are delighted and fortunate that he agreed to share his vast knowledge with us.

Christina Nelson, curator of decorative arts at the Nelson-Atkins Museum of Art, Kansas City, Missouri, and contributing author, has written a fascinating introduction to the British country house tradition, placing the collections of Burghley in historical context. We are pleased to have received her valued and enthusiastic collaboration.

At Burghley House, we are most grateful for the expert assistance of Jon Culverhouse, house manager, whose cooperative spirit and careful attention to detail at every stage of this project were critical to its successful realization. His assistant, Charlotte Rawlinson, was also helpful at the earliest stages with the myriad tasks that are inevitable in such a

project. Our colleagues at the house have made this exhibition a joy to develop.

We are indebted to the Federal Council on the Arts and the Humanities, and especially to Alice Whelihan, for supporting this tour with an indemnity. We respectfully acknowledge His Excellency Sir Christopher Meyer, KCMG, Ambassador from the United Kingdom, Great Britain, and Northern Ireland, Honorary Patron of this exhibition, for his interest in presenting the rich history of Burghley and its collections to the American audience. We also extend our thanks to David Evans, cultural counsellor at the British Embassy, for once again providing his kind assistance.

With our sincerest gratitude for their partnership, we recognize our colleagues in museums throughout the nation who are so enthusiastically hosting *The Cecil Family Collects: Four Centuries of Decorative Arts from Burghley House:* Barbara Gibbs, director, and Anita Ellis, chief curator and curator of decorative arts, at the Cincinnati Art Museum, Cincinnati, Ohio; Robert Safrin, director, and Nancy Mato, deputy director, at the Society of the Four Arts, Palm Beach, Florida; E. John Bullard, director, and William A. Fagaly, assistant director of art, at the New Orleans Museum of Art, New Orleans, Louisiana; Robert Frankel, director, and Robert Henning Jr., assistant director for curatorial services, at the Santa Barbara Museum of Art, Santa Barbara, California; John B. Clark, executive director, and Kristan McKinsey, director of art programs and collections, at the Lakeview Museum of Arts and Sciences, Peoria, Illinois; and Salvatore G. Cilella Jr., director, and William Bodine Jr., chief curator, at the Columbia Museum of Art, Columbia, South Carolina.

We are pleased to acknowledge the cooperation of Duilio d'Onofrio of Gruppo Rinascente, Milan, as well as Roberto Valeriani, who researched the collection and shared his scholarship. We also wish to recognize Roger M. Berkowitz, deputy director of the Toledo Museum of Art, who provided much valued assistance.

This catalogue will extend the educational value of the exhibition far beyond the course of the tour. It reflects the creative expertise of editor Ellen Hirzy and The Watermark Design Office. The extensive bibliography that supplements the text was prepared by Nancy Miller-Franitza of the Nelson-Atkins Museum of Art. William Skinner provided expert translations. We also recognize Craft Print PTE, Ltd., which produced this handsomely printed volume.

As always, it is our pleasure to commend the dedicated staff of Art Services International: Douglas Shawn, Donna Elliott, Sheryl Kreischer, Linda Vitello, Kerri Spitler, Catherine Bade, and Sally Thomas in our United States office, and Marcia Brocklebank, our representative in the United Kingdom. Their effective contributions to this project have been critical to its success.

LYNN K. ROGERSON JOSEPH W. SAUNDERS
Director *Chief Executive Officer*
ART SERVICES INTERNATIONAL

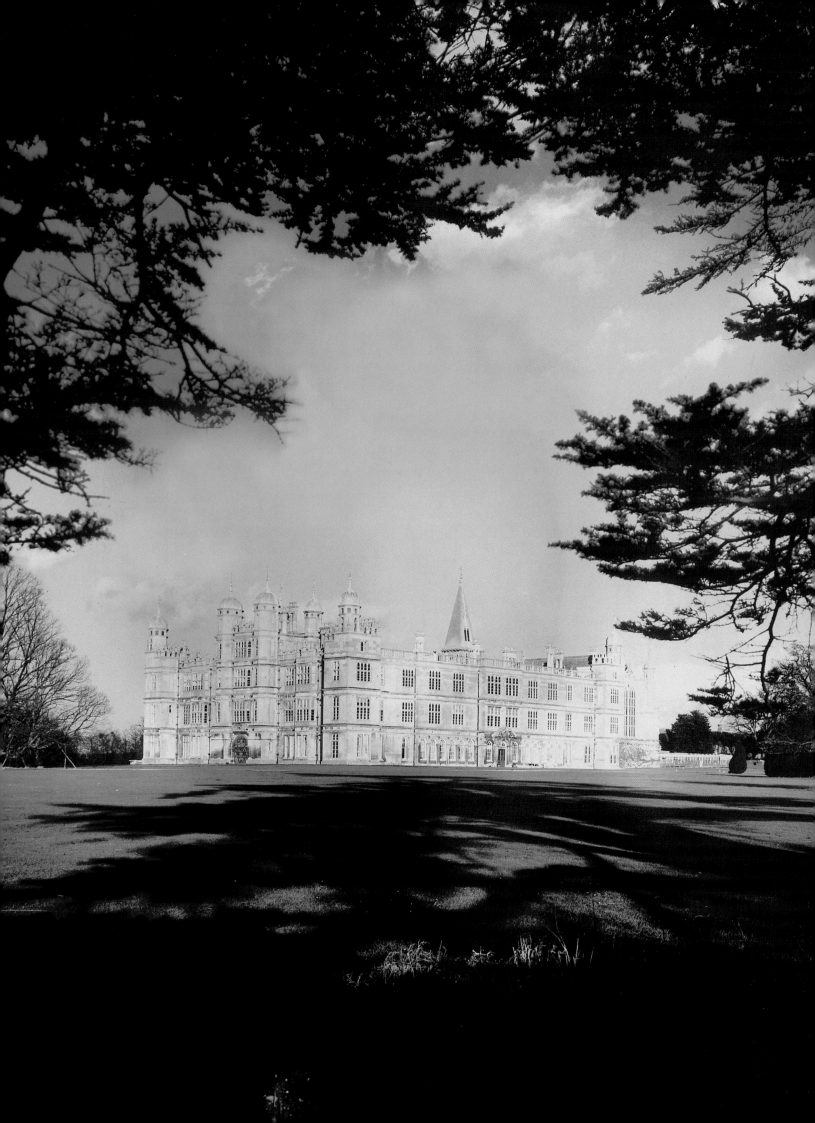

Foreword

LADY VICTORIA LEATHAM

It is debatable whether the Fifth and Ninth Earls of Exeter paid any heed to the future of the treasures that they had bought for Burghley when they were drawing into their twilight years. They were probably more concerned with handing on the family home and agricultural estates to the next generation unencumbered by taxes or debts. This was an ideal scenario of forward planning that, unfortunately, was not always achieved.

Both men were compulsive shoppers for every discipline and work of art that they could lay their hands on, although they lived about one hundred years apart. The one exception to their collecting mania was old master drawings, which obviously neither cared for, as there are none at Burghley. The seventeenth century was a time of experimentation and discovery for those with sufficient funds to travel, and the Fifth Earl and his family were pioneers both in the field of continental buying of art and in the new and revolutionary perception of the Italian palazzo look in interior design. They traveled to Italy via France with many members of the household, and virtually at once the purchases began to arrive back at the house for dispersal through the rooms. Burghley House was undergoing radical rebuilding, and its Tudor inside was being lost forever.

The Fifth Earl died abroad unexpectedly in 1700. In all, he and his wife had made four trips to Italy and had bought phenomenal numbers of things—including more than four hundred paintings, almost all of which were contemporary. The Fifth Earl's paintings and other works of art had not yet all arrived at Burghley when he died, so his widow was left with the task of finishing the interior refurbishment and overseeing the installation of their magnificent joint tomb in St. Martin's Church,

Left: Burghley House from the southwest

Stamford. She died in 1703, before the apartments on the south side of the house were completed. Many of the paintings probably destined for the walls in these areas were in storage elsewhere in the building, awaiting the floors and paneling.

At this juncture, the estate was so bankrupt due to the purchases of delectable paintings, porcelain, and statuary that all the agricultural land, together with the house and its contents, was nearly forfeited to the government. So much for forward planning! This determination to outwit the tax collector and avoid financial embarrassment has been a family trait, with one or two exceptions. The first Lord Burghley, right-hand minister to Queen Elizabeth I, advised his son on attaining his majority to "set aside one third of your income for unexpected expenditure and do not marry a poor woman or her family will always be at your gate." With advice like this, who could fail to prosper?

My grandfather, the Fifth Marquess of Exeter, died in 1956, leaving an agricultural estate of several thousand acres, much of it unprofitably farmed. The farmworkers' cottages lacked basic amenities such as electricity and indoor plumbing. Burghley was by this time a decaying mansion with a lead roof resembling a sieve. There was no electricity, and it was full of woodwormed furniture and blackened pictures. There were ragged carpets and textiles as far as the eye could see. In addition, an enormous bill for death duties was levied at 80 percent of all assets. As a result, my father had to dispose of works of art, land, and town properties; it took him about ten years to pay off the debt.

Unwilling to subject Burghley to such a ruinous situation again, my father set up a foundation to take care of the house. This means, naturally, that no family member can ever be the sole owner of the

house or its contents, something for which we are truly thankful. It seems a small price to pay for peace of mind about the future of the beautiful treasure that we are fortunate to have in our care.

Great families have had to adapt very rapidly to changes in the social structure of country house life since the two world wars. Once it was accepted that the wives of agricultural and estate workers would be available for domestic work in the big house. The many jobs ranged from the skilled, such as ladies' maid and housekeeper, to scullery maid, nursery maid, and kitchen skivvy. The house absorbed enormous numbers of people, some of whom did not work for the family at all but waited on one another. The butler had his own "household," those people who were responsible for his clothes, his food, and the fire in his rooms. He had privileged access to his Lordship's cellar and drank fine claret, port, and hock, while lesser mortals were given daily quantities of beer, which was far safer than the local water supply. The housekeeper was in a similar situation. She and the butler would preside over the staff hall, where as many as forty people would be served three meals a day. She had her own suite of rooms and a personal maid to care for her wardrobe.

A cousin of mine has vivid memories of an experience during the dark days of World War II that illustrates the changing conditions at great houses such as Burghley. Having been invited to dine with my grandparents, he and his father left their home about thirty miles from Burghley in their car, which was running very economically on fuel purchased with borrowed and saved coupons. They drove slowly, partly to save gas and partly because they were using black-out lights, tiny pinholes of illumination from each headlight. Eventually, thoroughly chilled and rather hungry, they turned in through the park gates and approached the huge house. It was in total darkness. An elderly security guard informed them that their hosts were awaiting them in the housekeeper's room, as it was warmer than the rest of the house. All of the workers who would have cut logs to burn in the fireplaces had gone to war, and in any case there was no one to clean out the grates. They followed the security guard down endless corri-

dors lit only with a few candles. All the furniture was covered in white dustcovers, and there were no paintings on the walls because they had been removed to the cellar for safety; it was freezing cold. Finally, they climbed a dusty staircase and found my grandparents crouched over a tiny fire, wearing many layers of ill-assorted clothing. There were tiny glasses of sherry for the visitors, and then dinner was served by the ancient and creaking butler—off the finest eighteenth-century gold plate. It held the heat better than china, and the butler couldn't break it.

When World War I ended in 1918, women decided that there was more to life than waiting at table, and there was better money to be earned as an office clerk than the rather stingy wages paid to domestic workers. The advantages of working for a family estate were not so easily quantified—free housing and coal, and work within the "estate family" for almost anyone who desired employment. A network of friends and some estate families had worked the land for generations.

Titled families thus had to get used to the idea of reduced staffs in their enormous dwellings. People became more efficient, and labor-saving devices such as vacuum cleaners and refrigerators made an impact—except at Burghley, where there was no power. Until 1956, ice was still cut from the lake in winter and stored underground in the ice house for use in the warm months. All lighting and heat had come from gas made on the estate from coal. Later, town gas was piped through lead pipes from Stamford; it leaked so copiously that we gassed our own rabbits.

Family lifestyles, however, still changed slowly. Between the world wars and until the 1950s, it was considered fairly normal for young men back from war to drift into life on their inherited estates without another exterior means of earning a living. Some did take up commerce and banking; the profession of stockbroker and board room positions in industry were considered respectable. Well-brought-up and titled women did not, as a rule, work outside the home.

My father and his eldest sister were most unusual in having careers. My aunt was an opera singer on the Continent. She traveled, without a ladies' maid, with

a troupe of artists and was mainly employed at the Carla Rosa Opera House in Milan. My father was a superb hurdler and won a gold medal in the 1928 Olympic Games in Amsterdam. In the movie *Chariots of Fire*, the character of Lord Lindsay was loosely based on him. He began his athletic career as a young schoolboy and continued it until he was an undergraduate at Cambridge. Nowhere in the family, before or since, have there been two such diverse and exotic talents.

Following the death of his father, and faced with the huge challenges of the house, my father carried on the interest in and work on the collections of art begun by his mother, who was deeply fascinated by the paintings at Burghley. He was bored by ceramics and furniture, and textiles were not even a vague interest. Research and historical investigations were only noteworthy if they referred to paintings. It was perhaps for this reason that the inventories and deeds of gift at Burghley had never been highly regarded; certainly, when my family came to the house in 1982, no research had been done to speak of except by our invaluable friend, art historian, and mentor Dr. Eric Till, a local physician who looked after us all and in his spare time did great work on the whole estate, the house, and its contents.

After my parents died, the trustees of the Burghley House Foundation asked my husband and me, with our two children, to come to the house and run it. This meant managing the staff, sorting out the priorities for repairs and restorations, investigating the inventories and collections, giving lectures and talks, and facilitating the approaches of all the various art historians and experts from throughout the world who were desperate to come to this lovely sleeping beauty of a place and see what was here.

Since we arrived we have been on a huge learning curve, and I have acquired many new skills and interests. The fact that I had been working for Sotheby's for about six years was a huge help, as a whole network of experts were anxious to help.

The world of art conservation is a financial minefield, and for us funding was limited. We were enormously fortunate to find some superb inter-national sponsors to help us conserve and repair artifacts. The French company Remy Martin restored a four-poster bed. American Express funded our book repair program. A skilled woodworker did not charge us for working on some chairs, and a local businessman enabled yet another great bedroom suite to face the future with dazzling new fabrics and fringes.

In 1985 and 1986, we were involved in the first of our international traveling exhibitions. We were proud to be part of the great exhibition, *Treasure Houses of Britain*, to which Burghley lent more objects than any other house in Britain. Then *The Burghley Porcelains* captured the imagination of visitors in New York and Atlanta who were attracted to the romance of this previously unknown and hidden collection of early Japanese porcelain.

Gradually, this splendid house began to recover its self-respect and dazzle visitors with the breadth and variety of its collections. We rehung the paintings, recarpeted the State Rooms, and repainted the west-facing rooms in the original faux marble finishes. The eclectic mixture of objects, differing widely in date but all settled into a harmonious whole, is very beguiling. One is constantly reminded that this is a family house, filled with things chosen for their beauty, not their value, by generations of occupants. These bygone ancestors have loved them, cared for them, and in the main kept them through wars and financial hardship. It would be a denial of our history in this place if we were to fail to protect them for the future.

As part of this strategy, we are hugely grateful to Art Services International, which has made this exhibition possible. They have been our friends and supporters for many years, and Burghley is fortunate to have their help. Dr. Oliver Impey is probably the greatest enthusiast we will ever have the pleasure of meeting. He came to Burghley for the first time in the dark early days when the discoveries were just beginning. His interest, friendship, and kindness to us, and his irrepressible sense of humor, have been a vital part of our journey through the past fifteen years. We are honored and delighted that he agreed to write this catalogue for us.

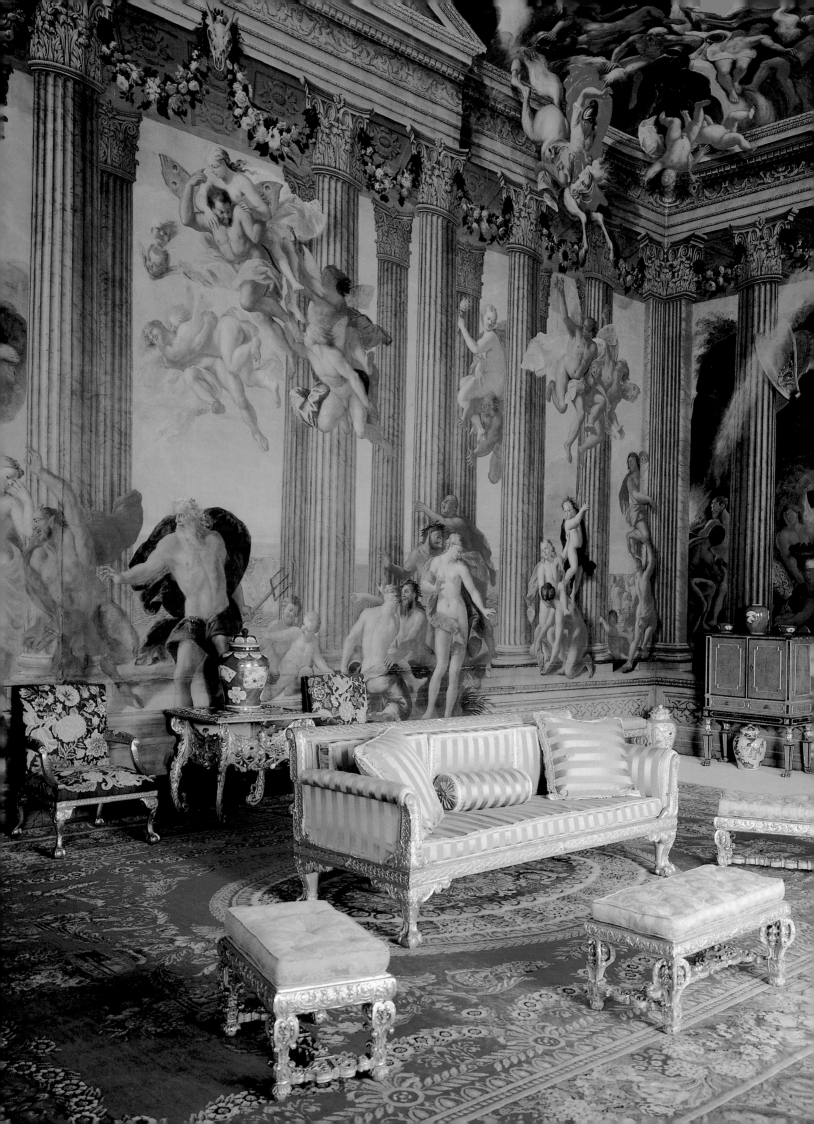

The British Country House Tradition

CHRISTINA H. NELSON

Travelers in Britain today cannot help but notice great estates—or the remnants of them—scattered around the countryside. Maps indicate their presence and road signs point the way, for many of these great country houses and their surrounding parks are open to the public. Often motivated by little more than curiosity and the desire for a pleasant day in the country, twentieth-century visitors marvel at the grand house, extensive collections, and beautiful gardens, but to visitors in previous centuries, these things were layered with additional meaning. Many country houses have been open to visitors since they were first built. In the eighteenth century, nearly anyone of respectable appearance arriving on horseback or in a carriage could apply to the housekeeper and be shown around the house; in the nineteenth century, some owners admitted anyone who asked.[1] Visitors in earlier centuries viewed the estates not only with curiosity but with a sense of rivalry, however, for building, furnishing, and collecting were competitive as well as aesthetic undertakings.

Historically, English country houses were much more than imposing structures in bucolic settings. They were centers of business, and as such reflected the owners' wealth and influence. Aptly called "power houses" by architectural historian Mark Girouard, they were essential elements in a complex economic, political, and social structure. Based on land ownership, this structure took form in Britain in the sixteenth century and remained essentially intact until agricultural depression set in at the end of the nineteenth century. Social, economic, and political conditions following World War I led to further decline, but vestiges of this unique social structure have survived to the present.[2]

Taxation and changing land use in the late nineteenth and twentieth centuries have effected the disappearance of many country houses and the dispersal of the treasures they contained, but Britain still retains a remarkable number of these properties. In their sheer number and in the richness of their collections, these houses are unique in Europe. Although great houses still stand on the Continent, only Britain can boast such a high concentration of houses with their original contents, often accompanied by documentation in the family archives.

This survival is due in part to geography and in part to the British character. No army has successfully invaded Britain since 1066; wars were fought on foreign soil. The British lived on the land they owned, participated in local affairs, and from the end of the seventeenth century, have enjoyed a certain immunity to the bitter civil strife and violent revolutions that plagued some of their counterparts on the Continent.[3] In other European countries, landowning families often have fared badly. Great houses were sacked in times of war, and personal property was destroyed or confiscated and systematically dispersed in times of revolution or conquest. As the "collections"—essentially the personal belongings of a succession of owners—are an integral part of the history of a house, the great houses of England take on added importance for the objects they contain.

The collections of Burghley House are particularly significant because they are very extensive. They were begun nearly four and a half centuries ago, and are extremely well documented.

The Heaven Room, with ceilings painted by Antonio Verrio in the late seventeenth century. (Burghley House)

A series of household inventories dating from 1688 to 1992 allows us to see how the collection grew and how objects took their places in the interior scheme of the house over time (fig. 1).[4] Burghley houses significant collections within the collection—important Japanese porcelain, silver by Pierre Harache II, furniture by Mayhew & Ince—that have captured the interest of art historians and specialist scholars studying the history of commerce or seeking to document the work of individual craftsmen.[5]

All of these aspects of study illuminate the cultural environment in which generations of the Cecil family lived during their many years in the house. The house and collections teach us about building and patronage, connoisseurship and style, commerce and trade, social customs and daily life. This knowledge allows us to pass through time and glimpse, for a moment, the existence of people who lived in a different time and place, but whose goals, interests, and outlook were fundamentally not so very different from our own. Beautiful, interesting, rare, or mundane, these objects are documents. Carefully read and thoughtfully interpreted, they illuminate the past and enrich our understanding of history in ways the printed word cannot hope to achieve.

LAND AND POWER

Until the nineteenth century, land was the primary source of wealth and the securest form of investment in Britain. Alternatives were risky. In the course of the eighteenth century, government bonds and shares in the East India Company or canal ventures became available, but there were few other investments, aside from land, yielding a steady income.[6] The London stock exchange was not formally organized until the late eighteenth century, and it did not trade shares in private companies until the middle of the nineteenth century.[7]

The owner of a large estate did not actually work the land himself. Although he might maintain a farm to grow food for his household, he did not farm for profit. He leased most of his land to tenants, as had been the custom since the Middle Ages. The rents he collected provided the income on which he lived. A minimum of about 1,000 acres was required to generate sufficient income to support the average estate and allow the owner to live as a gentleman.[8] The Cecil holdings in the seventeenth and eighteenth centuries are difficult to calculate, but today the estate totals about 12,000 acres.[9]

Living as a gentleman was a costly undertaking. A man was expected to maintain a house, garden, and surrounding park of a size and appearance appropriate to his income and reflective of his position—either real or desired—in society. He required horses and carriages, and he pursued pastimes, such as hunting, in which others of his class engaged. Most gentlemen also sought to maintain or advance their own positions and those of their families through education, travel, judicious entertaining, and marrying their offspring into families of wealth and social standing.[10] This, too, required money and influence.

Those who did not have the good fortune to inherit land often sought to buy it. Men made newly

rich by government service, the East India trade, commerce, or the factories of the Industrial Revolution often attempted to secure a country estate either by purchase or marriage. It provided an agreeable way of life, the appearance of established respectability, and a way of exerting or extending one's influence. Owning a suitably imposing country house represented a significant step up the social ladder.

As estates of a certain size were required to generate sufficient income to support a gentleman, land was concentrated in the hands of relatively few individuals or families. As late as 1873, fewer than 7,000 people owned four-fifths of the land in Britain.[11] It passed from father to eldest son according to the strictly observed rules of primogeniture and the tradition of entailment; owners of country houses generally inherited them. Daughters could not inherit land, and younger sons often purchased a commission in the army or entered the service of the church.

Most landowners simply collected their rents, but many of them took a lively interest in running their estates. They also frequently participated in local and national government, for land ownership conferred political power, both on the local, or county, level and in national affairs.

From the sixteenth century onward, a Lord Lieutenant represented the Crown in each county. Usually a titled landowner, the Lord Lieutenant enjoyed the right to appoint the Justices of the Peace who ran the local government and presided over the county court. Inevitably, the Justices of the Peace were also landholders or well-connected clergymen enmeshed in local society.[12]

In the national political arena, until the nineteenth century, the vast majority of members of both houses of Parliament were the owners of large estates. The House of Lords was composed of peers (dukes, marquesses, earls, viscounts, and barons) who inherited their titles and lands, together with archbishops and bishops of the Church of England. Although the members of the House of Commons were elected by popular vote, historically, relatively few men were permitted to cast ballots. Until the Reform Acts of 1832 and subsequent legislation gradually extended voting rights to residents of newly rich urban industrial areas, landowners controlled the government on every level. Even though more men gained the right to vote, there was no secret ballot until 1872, and it was expected that an estate owner's tenants would vote as he wished.[13] Universal male suffrage did not become a reality until the twentieth century, and women had no voice until 1918.

THE DAWN OF THE RENAISSANCE: A NEW STYLE OF ARCHITECTURE

In medieval Britain, land belonged predominantly to the Sovereign, powerful barons, and monastic orders of the Roman Catholic Church. Political and economic power was less centralized than it is today, and civil strife was commonplace. Architecture reflected the social climate; turbulent times required building for defense. Castles and other fortified structures afforded the best protection, and they provided a center from which local barons fought to extend their political and economic power. Tenants farmed the baron's land, relied on him for protection, and were called upon to fight for him in times of war.[14]

By the sixteenth century, power increasingly was centralized in the Crown, and the once-powerful local barons came to depend on the favor of the Sovereign for political power and economic advancement. Soldiers evolved into courtiers as armed conflict gave way to more peaceful methods of securing wealth and power. Fortified living spaces were no longer required, and castles became obsolete.[15]

Great tracts of land and former ecclesiastical structures became available for secular use when Henry VIII dissolved the monasteries in the 1530s and seized Church property in a dispute with the Pope over his desire to end his marriage to Catherine of Aragon. The primary beneficiaries of the Church's misfortunes were the King's loyal retainers, his courtiers, diplomats at work on the

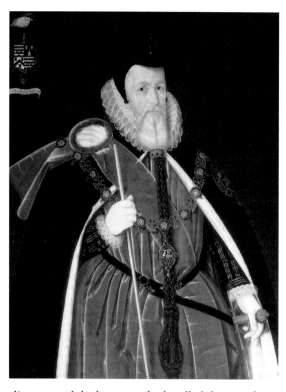

Figure 2. William Cecil, Lord Burghley, attributed to Marcus Gheeraerts the Younger, ca. 1585, oil on canvas, Leatham Collection (cat. no. 1). William Cecil (1520–1598), Lord Treasurer of England and builder of Burghley House, was a trusted advisor to Queen Elizabeth I and the most powerful English statesman of his time.

divorce, and the lawyers who handled the transfer of Church land to the Crown. These favored supporters were given or sold confiscated property and vast tracts of land, and by the mid-sixteenth century, new types of domestic architecture evolved. Better suited to the calmer social climate, these new structures were more open in plan, comfortable in arrangement, and designed for pleasure and quiet living rather than defense.[16]

The final years of the reign of Henry VIII saw a flourish of construction activity as monastic buildings were plundered for their stone and other materials and the resulting ruins were converted to domestic use. Imposing houses on large estates became centers of lay power and visual affirmation of a courtier's wealth and importance. With the growing interest in construction came the first lasting evidence of a new, classical style.

Although classical designs of the Renaissance were brought to England by Italian craftsmen early in the reign of Henry VIII, these early influences did not last. The classical taste reappeared in the 1540s, as the reign of Henry VIII drew to a close. For nearly forty years thereafter, the classical influences or "antique" style of the Renaissance came not from Italy, but from France and later

from Flanders, and was first expressed in newly important decorative detail.

The classical style gained a firmer foothold in Britain in the 1550s, propagated by a circle of men at Court who were greatly influenced by the highly important and innovative construction of old Somerset House.[17] Completed in 1552, Somerset House featured an entire front designed in the new classical taste, arguably the first fully developed statement of the English Renaissance.[18]

The new style did not blossom in Britain until the 1560s when Elizabeth I was on the throne. Britons explored the Continent in greater numbers, and books and engravings of classical architecture and ornament appeared on the London market, principally from the Low Countries. Designs from Antwerp, especially those of Hans Vredeman de Vries, were particularly influential, and Flemish Protestant craftsmen fleeing religious persecution in the mid-1560s reinforced the impact of the new style. Although rooted in Italian mannerism, the designs from the Low Countries were uniquely northern European, and their strapwork and fanciful "grotesques" inspired by ancient Roman decoration found a receptive market in Britain.[19]

In architecture, the works of north Italian architect Sebastiano Serlio (1475–1553/1555) had the most lasting impact on English building of the period. His six books on architecture published between 1537 and 1551, and a seventh volume published after his death, directly influenced the design and construction of Longleat House, Wollaton Hall, and Hardwick Hall, and details are seen at Burghley.[20]

The construction of Somerset House and the new fashion for classicism undoubtedly influenced the young William Cecil, future Lord Burghley (fig. 2). Engaged as the Duke of Somerset's private secretary at the time old Somerset House was built, he clearly knew the style.[21] He had access to design and building sources, for he was a learned and cosmopolitan man with a large library.[22] When he inherited Burghley House in 1552, Sir William Cecil embarked on a building campaign that embodied many of these new influences.

EARLY BUILDING AT BURGHLEY

David Cecil bought the manor of Little Burghley in 1527.[23] He and his son Richard held advantageous appointments at the Court of Henry VII and Henry VIII, respectively, and were able to accumulate extensive land by royal grant, judicious marriage, and outright purchase.[24]

A house already stood at Burghley when Richard Cecil died in 1552, and his elder son Sir William Cecil (1520–1598) inherited. Knighted the previous year, he was then surveyor of Princess Elizabeth's estates.[25] Although Burghley was still occupied by Sir William's widowed mother, he began to rebuild the existing structure, adding substantially to its size. It is now thought there are virtually no visible remains of the building project of the 1550s and 1560s.[26]

The oldest parts of the house seen today show a marked classical influence and may date from the 1570s and 1580s when a richer and more powerful Sir William Cecil, by then Lord Burghley, embarked on an ambitious building scheme that transformed the house into one of the greatest monuments of the English Renaissance.[27] This date is absolutely consistent with the strength of classicism in British art and architecture during the period 1570 to 1580.

At Burghley, this influence is apparent in the classical arches and obelisks at the roofline, the interior details of lions' heads, and the moldings that are clearly classical in cross-section (fig. 3).

Figure 3. The arches and obelisks at the roofline of Burghley reflect the classical influences prevalent in English architecture of the 1570s.

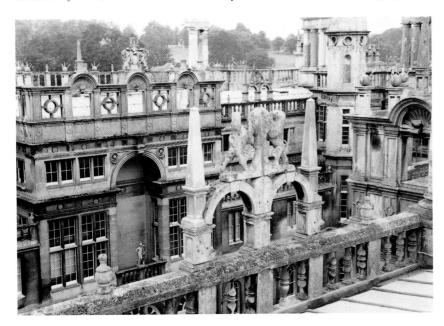

In the courtyard, the design of the tower derives from the classical gateway at old Somerset House, and further references to antiquity appear in the portrait roundels of Greek and Trojan gods and notables and in the low relief figures of Hermes and Minerva, now gone. The design of the chimneypiece in the hall and other interior decorative details were taken directly from Serlio. The classical influences visible in the stone north staircase (the Roman Staircase) possibly reflect a French interpretation. There is also evidence that Flemish architect Hans Hendrik was sending arcade designs and building material from Antwerp in the 1560s, although his work probably disappeared in later construction.[28]

Cecil had an interest in the new classical style, but from correspondence it is obvious that he also had extensive knowledge of construction. As was the custom, Cecil actively participated in designing his own house. In virtually all building of the time, details of design and construction were decided upon by the owner in consultation with his workmen, usually supervised by a master mason or master carpenter. The profession of architect did not exist. Indeed, the term "architect" was little used in the sixteenth century, and only to denote a craftsman who specialized in ornament and was adept at executing the decorative vocabulary of the new classical style.[29]

Although Cecil was sensitive to the classical influences that pervaded British art from the 1560s onward, his building program was shaped by an equally strong influence in the personality of Elizabeth I, the Queen he served. She came to the throne in 1558, and during her reign of forty-five years built nothing of great importance. Elizabeth I is remembered principally for the construction she inspired. Each summer the Queen and her Court descended upon an influential subject for an extended visit that would often require the host to add substantially to the size of his house.

Rooted in medieval custom, the Queen's Royal Progresses were in part an economy measure, for Henry VIII had incurred vast expenses keeping the Court at the royal palaces in and around London.

By visiting various courtiers, Elizabeth was able to minimize the expenses of her own court, reduce the debt left by her predecessors, and exert a certain political authority by forcing a subject of questionable loyalty to incur ruinous expense. Once threatened with a royal visit, a courtier spared no expense in trying to assure a successful stay, for receiving and entertaining the Queen and her Court were an affirmation of loyalty and possibly the road to political, social, and economic advancement. Courtiers openly vied with each other to provide the most lavish entertainment and accommodation.

The Queen traveled with a large party; her entourage is thought to have numbered about 150 on one of her later visits to Lord Burghley at Theobalds, the house he began closer to London in the mid-1560s.[30] The sheer number of guests on any Progress often created logistical problems of accommodation that only a building program could solve. Houses were remodeled, wings were added, and some loyal subjects built entirely new structures expressly for the purpose of receiving and entertaining the Queen. These so-called "prodigy houses" were extraordinary in their visual effect and clearly meant to inspire awe, wonder, and delight. Careful study shows that "each [house]. . .is unique, a prodigy, an attempt to make and display, at one blow, a completely integrated style."[31] Strictly speaking, Burghley is part of this group, although Theobalds, the house Sir William Cecil built for his

second son, was a more extravagant example. As the Queen's advisor and confidant, Sir William Cecil entertained the Sovereign regularly. She visited him thirteen times at Theobalds, which was expanded to such an extent that it became the largest house in England.[32] Ironically, the Queen did not visit Cecil at Burghley House. She planned to visit in 1565, but there was an outbreak of smallpox in the Cecil household, so she stayed at a nearby priory.[33]

The most distinctive feature of a "prodigy house" such as Burghley or Theobalds lay in the number of "lodgings," or suites of private rooms used as living quarters by persons of high rank. Each suite consisted of between two and five rooms, depending on the importance of the occupant; the Queen herself required a series of rooms, both for ceremonial use and private residence.[34]

Another distinctive feature of the "prodigy house" was the long gallery, a room with early Tudor origins. Usually placed on the first floor of a house, the long gallery was, as the name suggests, a long expanse of enclosed space. In bad weather, it was a place in which to exercise, and it became a place in which to hang portraits of family members and important people of the day. Hardwick Hall (built 1591–1597) retains a superb late-sixteenth-century long gallery, still hung with the original tapestries and portraits (fig. 4). The long galleries at Burghley disappeared in a building campaign launched by the Fifth Earl at the end of the seventeenth century.

The 1690s marked a period of enormous expenditure on interior decoration in many great houses in Britain. William and Mary came to the throne in 1689 and immediately launched a building program to increase the size of Hampton Court Palace and redecorate its rooms. Owing much to French taste, these opulent interiors influenced the British aristocracy to initiate decorating schemes of their own. At Burghley, the Fifth Earl, knowledgeable in the arts and a collector of pictures, very likely engaged the architect William Talman to make extensive changes to the house. When Talman visited the house in 1688, work was

Figure 4. Many Elizabethan and Jacobean houses had a long gallery, a place in which to exercise and display paintings. The long gallery at Hardwick Hall (built 1591–1597) is still hung with the original tapestries and portraits. (National Trust Photographic Library)

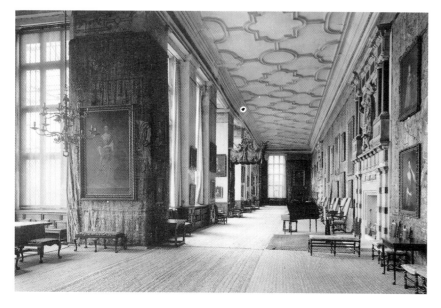

clearly under way already, for bills survive from the plasterer, Edward Martin, and several woodcarvers, including the famous Grinling Gibbons (fig. 5).[35]

This period of construction at Burghley included various structural changes and the

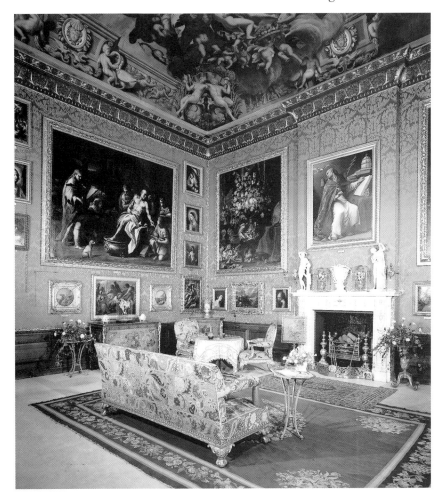

Figure 6 (above). The Third George Room has a ceiling painted by Antonio Verrio depicting Cupid and Psyche. The paintings on the walls include Giuseppe Recco flower pictures and The Death of Seneca, *by Luca Giordano, bought by the Fifth Earl. (English Life Ltd.)*

Figure 5 (right). This exceptional overmantel carving in the Black and Yellow Bedroom is by Jonathan Mayne, one of the talented woodcarvers to work at Burghley around 1690. The painting is Magdalen, *by Lorenzo Pasinelli. (Burghley House)*

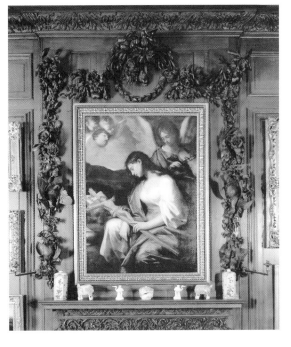

addition of interior detail. The great painted ceilings by Antonio Verrio belong to this period. Working on the ceiling of the Dressing Room or First George Room about 1690, Verrio executed a fresco of *Morning Chasing away Night*. Over the next six years he painted other ceilings in the house, including the Bedchamber (Second George Room), the Drawing Room (Third George Room) (fig. 6), the Dining Room (Fourth George Room), the Great Staircase, which received a painting of Hell, and the Saloon (Fifth George Room), called the "Heaven Room."[36] These ceilings are among the great glories of the house and would have provided the perfect baroque setting for the Fifth Earl's paintings and decorative arts, but unfortunately, the rooms were left unfinished.

COUNTRY HOUSE CONTENTS AND
COLLECTIONS: BURGHLEY IN CONTEXT
As houses were enlarged or altered under a succession of owners, the interior furnishings and decorative objects moved around the house according to the interests of the owner and in keeping with changes in social custom and fashion. On the most basic level, these were the owner's personal possessions, his household furnishings. Bequeathed with the house from generation to generation, frequently country house "collections" are the accumulation of centuries, augmented by gift, marriage, and purchase. The objects and "collections" in great houses were essential in creating a pleasant living environment for the owners, but they were as important as the building itself in conveying the image of wealth and influence.

From the sixteenth century onward, houses and their contents became increasingly oriented toward comfort and attractive appearance, and the arrangement of rooms became more symmetrical on the designer's ground plan.[37] Room use became more specialized, and for privacy, the family quarters were separated from the State Rooms, the formal and more public areas of the house.

Visitors to a grand late-sixteenth- or early-seventeenth-century house often first entered into

the hall, at this period a large room that also served as the area in which servants ate and congregated. A centrally located "great chamber" on the floor above was the most important reception space for dining, dancing, and other entertainments of the gentry. An adjacent withdrawing or drawing chamber with an important bedchamber next to it evolved from a sleeping area for a servant to become a more significant room for private dining and entertaining. Great houses of this period also had a long gallery for exercise and the display of paintings. Parlors, often on the ground floor, were rooms for informal family dining and relaxation, and they gradually became important for the reception of guests. Some houses had different parlors for summer and winter, and by the early seventeenth century, they were nearly as elaborately decorated as great chambers.[38] Libraries evolved gradually as the interest in knowledge and learning increased in genteel society. By the mid-seventeenth century, libraries were not uncommon in country houses; by the eighteenth century, they were a standard feature.

The upheaval of the Civil War in the mid-seventeenth century caused many aristocrats to flee to the Continent, and when they returned at the restoration of the monarchy in 1660, they brought continental influences that led to a more formal arrangement of rooms within the house. The uses of those rooms were modified, and they acquired new names. The central "great chamber," for example, became the *salon*, *salone*, or saloon, and the *antechambre* began to appear, sometimes replacing the withdrawing room.[39] Bedrooms and withdrawing rooms became more public, and the suite of rooms known as "lodgings" in the sixteenth century evolved into the French influenced "apartments" of the seventeenth century.

The apartments were often symmetrically arranged around a saloon, which took over the ceremonial functions of the great chamber and became the main dining area for the entertainment of guests. Small, intimate, often elaborately decorated rooms called "cabinets" or "closets" increased in popularity. They frequently contained favorite or valuable personal possessions, as we see at Burghley where jewels, semiprecious stones, and other prized possessions appear in the household inventories (see cat. nos. 19, 54B, 55, 85A&B, 93A&B, 105A&B). Dressing rooms, a particularly English phenomenon, were in place by the mid-seventeenth century. With one for the husband and one for the wife, they were placed near bedchambers for easy access.[40] The placement and naming of rooms on ground plans varied from house to house, for each builder arrived at his own solution for a more formal, symmetrical arrangement of space; owners of existing houses such as Burghley remodeled to adapt to changing fashions.

At the beginning of the eighteenth century, Palladianism took firm hold in Britain, increasing the importance of the *piano nobile* (British first floor, American second floor), but the arrangement of the rooms on the ground plan remained essentially the same until the 1730s. At that time, rooms specifically for dining came into more general use, and the importance of the saloon began to decrease. Eventually, the saloon became a vestibule or the name was transferred to a large, less centrally located room for balls, entertainment, and the display of paintings. Suites of connected rooms became necessary for entertaining, and state apartments were put into more general use.[41]

By the mid-eighteenth century, dining rooms replaced the saloon as the place where meals were served to the gentry, and drawing rooms became important public spaces. The main reception rooms of the house began to shift to the ground floor, replacing informal family apartments and service areas in that location, for the setting afforded guests a closer view of the gardens. The private apartments decreased in importance as more space was used for social functions. In the last half of the eighteenth century, the symmetrical ground plan began to weaken.[42]

No matter where they were located, the public rooms of a house always were expected to conform to certain standards of luxury and elegance. From the Middle Ages through the seventeenth century, textiles in particular played a significant role in creating that image. They constituted the most

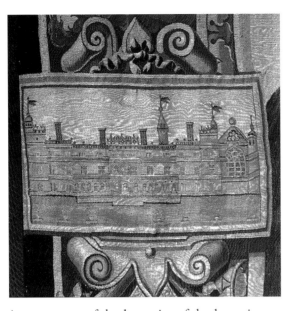

important part of the decoration of the domestic interior and represented the greatest expense. Tapestries hung on dank walls served a practical purpose in reducing drafts, but their opulent appearance also enhanced the owner's image of wealth and power. The role of the upholsterer became paramount. He furnished wall hangings, carpets (used on tables in the seventeenth century), window hangings, and furniture covered with textiles either as cushions or as upholstery permanently attached to the frame. Rooms were dressed with different sets of textiles in summer and winter, creating a dramatically different appearance

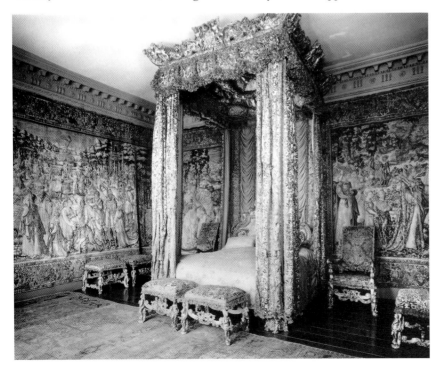

according to the season. By the beginning of the seventeenth century, the upholsterer was also responsible for supplying new furniture as well as remodeling the old, for the wood was of secondary importance to the textile elements.

At Burghley, payments are recorded in the late seventeenth century to the important London upholsterer, Francis La Pierre, and to suppliers of specialty textile accessories such as fringe. There are also bills for hangings and payments for silk made to tapestry weaver John Vanderbank of the Great Wardrobe looms in Soho. Many tapestries from his shop still survive at Burghley (fig. 7), and he may have supervised others supplying textiles to the Cecils.[43]

Perhaps the greatest achievements of the upholsterer's art were the great beds of the period. Often the most important and expensive pieces of furniture in the house, beds were frequently made *en suite* with window hangings and the upholstery on seating furniture in the room to create a unified appearance. The upholsterer often used rich wool or silk damasks and velvets, usually imported from Genoa or Lyons, and embellished them with *passementerie* (decorative cords, tassels, and fringe) to create the stunning appearance of luxury and wealth.[44]

At Burghley, the intrepid traveler and famous diarist, Celia Fiennes, recorded a number of beds at the time of her visit in 1697. Lord Exeter's apartments contained "a blew velvet bed with gold fringe and very richly embroidered all the inside with ovals on the head piece and tester where the figures are so finely wrought in satten stitch it looks like painting. . . ."[45] In the winter, the lady of the house slept in "a green velvet bed and the hangings are all Embroydery of her Mothers work, very fine, the silk looks very fresh and figures look naturall."[46]

None of the great beds at Burghley have survived completely intact, but an extraordinary example at Knole, probably made for King James II in 1688, dramatically illustrates the opulent appearance of this furniture form (fig. 8). Elaborately carved by Thomas Roberts and then gilded, the King's Be hung with blue-green Genoa velvet with arm and stools upholstered to match. The identit

upholsterer is not documented, but the most likely candidate is a French Huguenot, Jean Poitevin. Like many of the French Protestant craftsmen working in England at this period, he was highly skilled, had a thorough knowledge of design, and enjoyed aristocratic patronage.

The Huguenots proved to be extremely influential in English design of the late seventeenth and eighteenth centuries; their considerable talents and knowledge of French style altered the appearance of the English interior. Although they excelled in the textile trades, they were especially talented as goldsmiths. Their technical skills were second to none, and they introduced sophisticated new forms and stylish decoration that found enthusiastic patronage in England. One of the most talented goldsmiths of the late seventeenth and early eighteenth centuries was Pierre Harache II, who made the toilet service at Burghley (cat. nos. 106A–F).

Historically, silver was a tangible form of wealth and a source of ready cash. As an indication of the family's fortune and social standing, some of it was openly displayed as part of the interior decoration. Lighting devices such as sconces (cat. nos. 103A&B) and candlesticks (cat. nos. 35A&B), hearth sets, and a wide variety of other household objects were available in silver for those who could afford them. In the rooms for dining, silver was displayed on important occasions, a custom that has survived to the present. An engraving after a drawing by Lady Sophia Cecil shows the family's plate arranged on the sideboard in the Dining Room at Burghley in 1818 (fig. 9). The George II wine cistern and fountain (cat. nos. 110A&B) are clearly recognizable. The great silver toilet services were confined to slightly more private areas of the house, but as certain guests were received there, these objects of personal luxury also served as important statements of the owner's wealth and position.

Throughout the seventeenth century, imported goods took on greater importance, especially those from the Far East. Tea drinking became fashionable, and porcelain, textiles, and lacquer took their place as part of the interior decorative

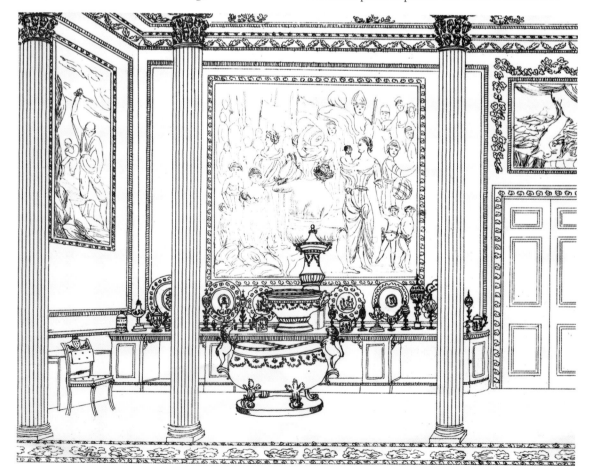

Figure 9. This engraving after a drawing by Lady Sophia Cecil shows silver in the Dining Room at Burghley in 1818, with the George II wine cistern and fountain by Thomas Farren (cat. nos. 110A&B) on the sideboard. (Burghley House)

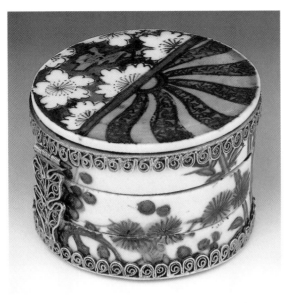

scheme. In the second half of the seventeenth century, collecting porcelain became an aristocratic passion; it was arranged either in "porcelain rooms" dedicated to its display or massed on top of cabinets or around chimneypieces (cat. nos. 75A&B). The Japanese porcelain at Burghley comprises one of the most important Asian export collections in Europe. Primarily Japanese in origin rather than Chinese, it is early, extensive, and very well documented (fig. 10).

Goods from Asia continued in fashion throughout the eighteenth century, when Britain dominated trade in the region. Europeans were fascinated by that part of the world. Tea and porcelain imports increased, and textiles from the Far East were used both for upholstery and for dress. Writing somewhat sarcastically in 1708, Daniel Defoe noted that the printed cotton chintzes from India "crept into our houses, our closets and bed chambers, curtains, cushions, chairs, and at last beds themselves. . .in short everything that used to be made of wool or silk, relating to the dress of the women or the furniture of our house, was supplied by the Indian trade."[47] Screens, lacquer furniture, and a large variety of other objects were also imported, but not in the same quantities as tea, porcelain, and textiles.

At home, English craftsmen created new forms to meet changing social customs and fashions. In the early eighteenth century, cabinetmakers introduced new or refined furniture forms that often reflected a

French influence. Elaborate chests of drawers, looking glasses of large size, and writing desks made their appearance, followed later in the century by additional specialized forms such as ladies' work tables and new types of seating furniture. An increased supply of imported exotic woods, including mahogany, encouraged chairmakers and cabinetmakers to exploit the beauty of their raw materials rather than covering the wood components with textiles. Carved and veneered furniture became increasingly important in the appearance of rooms, and by the middle of the eighteenth century, textiles no longer dominated the domestic interior. The upholsterer had become an interior decorator, "a connoisseur in every article that belongs to a house."[48]

In selecting new furnishings, the country house owner often sought the fashionable craftsmen of the day and, if the collaboration proved successful, patronized them on subsequent occasions. Evidently, the Cecil family followed this custom, for they repeatedly engaged the versatile cabinetmaking firm of Mayhew & Ince. In the 1760s and 1770s, Mayhew & Ince created elaborate pieces of furniture for the Cecils, both in old styles (see cat. no. 95) and in the neoclassical style popularized in part by the great architect Robert Adam (cat. no. 98). For one commission, a pair of commodes and corner cupboards not shown here, they used old panels of inlay in new furniture, as was the French custom. Beautiful and well made, all of these objects were probably intended only to enhance the appearance of a room. They took their place in a general decorative scheme.

Connoisseurship, or the discriminating selection of individual objects based on knowledge or aesthetic merit, was altogether different and not a significant factor in the formation of country house collections until the eighteenth century. Occasionally, a piece of furniture or sculpture had been commissioned to fill a specific space in order to create a more pleasing overall decorative effect, but until the eighteenth century, it was rare to place primary importance on specific art objects. In a country house interior, it was equally rare

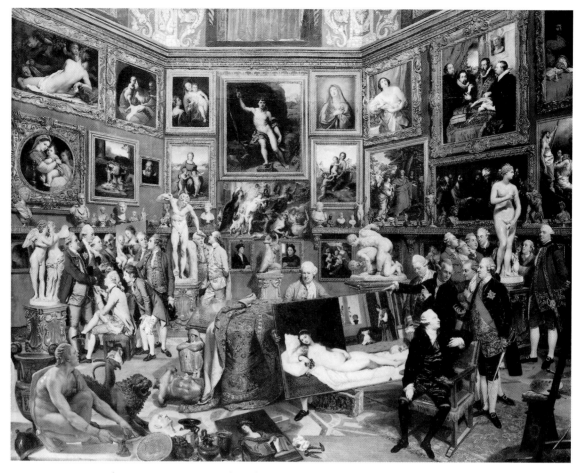

Figure 11. The Tribuna of the Uffizi, *1772–1778, by Johan Zoffany. This painting depicts the British Resident in Florence, Sir Horace Mann, and others discussing some of the artworks studied by young Englishmen on the Grand Tour at the period. (The Royal Collection—Her Majesty Queen Elizabeth II)*

to construct particular spaces to accommodate their display. Perhaps the earliest notable example of this phenomenon occurs at Hardwick Hall at the end of the sixteenth century where the long gallery (fig. 4) and "high great chamber" were constructed to accommodate the owner's two sets of Flemish tapestries.[49]

In the seventeenth century, Charles I (r. 1625–1649) was an avid collector of old master paintings, and the Earl of Arundel amassed an important collection of works of art of all kinds, but this early interest in collecting art was dealt a severe blow by the Civil War and Interregnum (1649–1660). Collecting art as a pastime or educational exercise was discouraged during the Puritan era. After the restoration of the monarchy, the collecting interests of the aristocracy shifted in favor of scientific specimens for the remainder of the seventeenth century. The paintings collected by the Fifth Earl of Exeter in the 1680s and 1690s were an exception to this trend.

Collecting for aesthetic reasons increased dramatically in the early eighteenth century when Lord Burlington and his circle revived the interest in old master paintings. Objects were selected for their own merit and for their relationship to other objects in a collection. Specialized areas such as picture galleries were created for their display.

In the eighteenth century, connoisseurship became an intellectual exercise of "taste." An abstract idea with distinct moral overtones, taste was linked to virtue. Based on knowledge and learning, possessing taste was evidence not only of good education but of good breeding. It indicated one's position in society. According to the influential writings of Anthony Ashley Cooper, Third Earl of Shaftesbury, "The Accomplishment of Breeding is, To learn whatever is *decent* in Company, or *beautiful* in Arts: and the Sum of Philosophy is, To learn what is *just* in Society, and *beautiful* in Nature, and the Order of the World."[50] Clearly, a gentleman possessed taste. It was the mark of a noble spirit and, therefore, of a superior person.

This philosophy was in large part responsible for establishing the Grand Tour as an essential element

of a young gentleman's education. An accepted activity by the end of the seventeenth century, the Grand Tour increased in importance as the eighteenth century progressed, reaching the height of its popularity in the period from 1750 to 1800. This extended trip to the Continent varied from months to several years. It might include Flanders, Germany, and Holland, depending on the money and time at a gentleman's disposal, but a pilgrimage to Italy and France was essential.

It was believed that only study in Italy would lead to the acquisition of taste. Grand Tourists generally visited Florence, Rome, Naples, and Venice, and if they were not traveling with a knowledgeable tutor, they hired a *cicerone*, or antiquarian, in each city to show them the ancient ruins, palaces, and local points of interest.[51] Certain major works of art and architecture were required viewing, and a student or connoisseur was expected to respond to them rather than engage in mere passive examination.

The spirit of this obligatory discussion of art is captured in the famous painting *The Tribuna of the Uffizi* (fig. 11), by Johan Zoffany. It shows Sir Horace Mann, the British Resident, or senior British diplomat, in Florence surrounded by young Englishmen and other famous personalities of the Grand Tour of the mid-1770s. The painting also records a number of the famous works of art to be seen at the time. The group of admiring figures on the right is clustered around the Medici Venus, one of the most celebrated antiquities seen on the Grand Tour.

Aside from studying works of art and seeing the sights, it was thought important to be present at certain events of cultural interest. The carnival in a major city just before Lent, Holy Week in Rome, and Ascension Day in Venice were the most popular activities, and travel schedules were often planned to assure attendance. In reality, some young Englishmen considered the Grand Tour an unparalleled opportunity for amusement and self-indulgence; drinking and womanizing were commonplace.

Grand Tourists had ample time to shop, and most English country houses are richer for it. The Cecils were early and enthusiastic travelers, and each generation added to the family collection. The Fifth Earl traveled extensively on the Continent with his countess at the end of the seventeenth century, acquiring art objects that are still part of the collections at Burghley. They sat for their portraits in Italy, as many travelers did (cat. no. 4), and they purchased works of art, including small sculptures (cat. nos. 54A–D, 55, 56). Perhaps their greatest acquisition was the ebony and marquetry cabinet with *pietra dure* panels, a gift from Archduke Cosimo III of Tuscany (cat. no. 93). According to the inventory of 1688, several of the small sculptures, including the *Apollo and Daphne* (cat. no. 55) and two of the boxwood figures (see cat. nos. 54A–D), were displayed in the Countess's closet, the room where prized personal possessions and works of art were often found in the late seventeenth century. In the 1738 inventory, the marquetry cabinet appeared in a closet off the North Dressing Room.

The Ninth Earl traveled to the Continent in the 1760s and 1770s at the height of the Grand Tour's popularity. Among other things, he bought majolica (cat. no. 59), a sculpture by Joseph Nollekens (cat. no. 58), and a pair of Roman mosaic pictures (cat. nos. 45A&B). The last item was purchased through the famous antiquarian Thomas Jenkins, agent to a number of Grand Tourists. All of these objects took their place in the family collection at Burghley, a lasting record of the Ninth Earl's taste and interests.

For nearly four hundred fifty years, Burghley has housed succeeding generations of Cecils and the objects they chose to have around them. The resulting collection is rich, varied, and highly personal. Over the centuries, the objects have moved silently around the house, shifting according to changing fashions, social customs, and family interest. In the final analysis, it is the objects themselves and the documents so carefully recording their long history that make this collection so compelling to the modern viewer. Thoughtfully studied, these objects teach us about the past and present history in microcosm.

NOTES

1. In the mid-nineteenth century, the Sixth Duke of Devonshire supposedly allowed "all persons whatsoever" to see Chatsworth. See Gervase Jackson-Stops, "Temples of the Arts," in *The Treasure Houses of Britain: Five Hundred Years of Private Patronage and Art Collecting*, ed. Gervase Jackson-Stops, exh. cat., National Gallery of Art (Washington, D.C., 1985), 15.

2. Mark Girouard, "The Power House," in Jackson-Stops, ed., *Treasure Houses of Britain*, 22–27.

3. The forces of Oliver Cromwell occupied Burghley during the Civil War.

4. The author is grateful to Jon Culverhouse, house manager at Burghley, for supplying this information.

5. For the purposes of this study, the partnership of John Mayhew and William Ince will be called "Mayhew & Ince," rather than the more common "Ince & Mayhew." The existing bills from the firm preserved in the Burghley archives clearly indicate the firm was called "Mayhew & Ince" at the time its principals worked for the Cecils. The two men were partners from 1758/59 to 1804. Mayhew was the partner responsible for managerial and business affairs. A trained cabinetmaker, William Ince was the designer and draftsman. As such, he contributed the majority of the plates in *The Universal System of Household Furniture*, which was issued in parts between 1759 and 1760 and then published in its entirety in 1762.

6. Girouard, "Power House," 23–24.

7. Daniel Pool, *What Jane Austen Ate and Charles Dickens Knew: From Fox Hunting to Whist—The Facts of Daily Life in Nineteenth-Century England* (New York, 1993), 86.

8. Girouard, "Power House," 23.

9. See Eric C. Till, *A Family Affair: Stamford and the Cecils, 1650–1900* (Rugby, Warwickshire, 1990), 1–20 for a detailed discussion of the Cecil finances. Their land holdings were extensive, but in the family papers, only the income from the land is recorded. Exact acreage is more difficult to determine, especially in the early years. Statistics on the current acreage were kindly provided by Jon Culverhouse, house manager at Burghley.

10. Girouard, "Power House," 23–24.

11. *Ibid.*, 22.

12. *Ibid.*, 22–23.

13. *Ibid.*, 22–24.

14. *Ibid.*, 24.

15. John Harris, *The Architect and the British Country House 1620–1920* (Washington, D. C., 1985), 9.

16. *Ibid.*, 9.

17. When Henry VIII died in 1547, his heir Edward VI (r. 1547–1553), was a child of nine. The boy's uncle, Edward Seymour, Earl of Hertford, secured appointment as Lord Protector, effectively controlling the council of regency appointed to conduct affairs of state during the royal minority. In 1547, he was created Duke of Somerset and began construction of a grand residence suitable to his new position.

18. John Summerson, *Architecture in Britain from 1530–1830* (Baltimore, 1970), 45–48.

19. *Ibid.*, 53.

20. The 1566 Venetian edition of Serlio's books 1–6 and the Frankfurt edition published with the posthumous material in 1575 were the most influential editions of Serlio's works used in Britain. See *ibid.*, 54–5. Serlio was also a primary source for John Shute's *The First and Chief Groundes of Architecture* (1563), and his influence also came to England in Flemish works. Reprinted numerous times, Serlio's works were disseminated under a number of different titles.

21. John Thynne, the Lord Protector's Steward, supervised the building of old Somerset House and was an active builder for himself. It is hypothesized that he incorporated classical elements at his first house at Longleat, but the extent of their use is unknown as the building burned in 1567. The new construction at Longleat also exhibited the influence of old Somerset House. See Summerson, *Architecture in Britain*, 45–47 and 62–66.

22. William Cecil owned one of the largest libraries in Renaissance England. According to Girouard, *Life in the English Country House: A Social and Architectural History* (New Haven, 1978), 165, Cecil owned more than one thousand books. According to Jon Culverhouse, house manager at Burghley House, part of his library went to his son Robert, who became Earl of Salisbury. Some of those books remain at Hatfield House. Cecil's manuscript collection went to his other son, Thomas, who became the First Earl of Exeter. This part of the collection was eventually dispersed at auction by a later heir at the end of the seventeenth century. In *The Tudor & Jacobean Country House: A Building History* (Stroud, Gloucestershire, 1995), 37, Malcolm Airs notes Lord Burghley's request for de l'Orme's *Nouvelles Inventions*. It is, therefore, highly likely that Lord Burghley also owned other books on architecture. According to Airs, Lord Burghley and his son Robert also owned a large collection of original designs and ground plans, further confirming the Cecil knowledge of architecture.

23. Eric Till, "Some Cecils of Burghley," in *The Burghley Porcelains: An Exhibition from the Burghley House Collection and based on the 1688 Inventory and 1690 Devonshire Schedule*, exh. cat., Japan Society (New York, 1986), 26.

24. Mark Girouard, "Burghley House, Lincolnshire," part 1, *Country Life* 186, no. 17 (April 23, 1992), 58.

25. Till, "Some Cecils of Burghley," 26.

26. Mark Girouard, "Burghley House, Lincolnshire," part 2, *Country Life* 186, no. 18 (April 30, 1992), 58.

27. Sir William Cecil was appointed as master of the Court of Wards, an extremely lucrative position, in 1561. He was made a peer in 1571, a Knight of the Garter in 1572, and Lord Treasurer in 1572. See Till, "Some Cecils of Burghley," 26, for further family history.

28. Mark Girouard has suggested the classical figures may allude to the Cecils' Welsh ancestry. See "Burghley House, Lincolnshire," part 2, 58–61.

29. Summerson, *Architecture in Britain*, 56.

30. Girouard, *Life in the English Country House*, 111.

31. Summerson, *Architecture in Britain*, 51.

32. Girouard, *Life in the English Country House*, 112.

33. The author is grateful to Jon Culverhouse for supplying this information.

34. Girouard, *Life in the English Country House*, 110.

35. Geoffrey Beard, *Craftsmen and Interior Decoration in England 1660–1820* (London, 1981), 133–34.

36. *Ibid.*, 133–36.

37. Girouard, *Life in the English Country House*, 120.

38. *Ibid.*, 104.

39. *Ibid.*, 129.

40. *Ibid.*, 129–35, 150, 173–74.

41. *Ibid.*, 162, 201.

42. *Ibid.*, 203–20.

43. Beard, *Craftsmen and Interior Decoration*, 134.

44. Peter Thornton, *Seventeenth-Century Interior Decoration in England, France and Holland* (New Haven, 1978), 115, 127–28.

45. Christopher Morris, ed., *The Illustrated Journeys of Celia Fiennes 1685–c. 1712* (Stroud, Gloucestershire, 1995), 83.

46. *Ibid.*, 83–84.

47. Quoted by Charles Saumarez Smith in *Eighteenth-Century Decoration: Design and the Domestic Interior in England* (London, 1993), 48.

48. Quoted by Peter Thornton in *Seventeenth-Century Interior Decoration*, 99.

49. Gervase Jackson-Stops, "Temples of the Arts," in Jackson-Stops, ed., *Treasure Houses of Britain*, 17.

50. Quoted by Smith in *Eighteenth-Century Decoration*, 50.

51. Brinsley Ford, "The Englishman in Italy," in Jackson-Stops, ed., *Treasure Houses of Britain*, 41.

The Furnishing of Burghley

OLIVER IMPEY

Figure 1. Burghley House from the northwest. This view of the North Range would not have been possible until the removal of the Library Wing by Capability Brown for the Ninth Earl in the 1770s. (RCHME, © Crown Copyright)

The approach to Burghley House from the north, the private drive, leads one through the great deer park. Cresting a rise, one sees the fantastic roofline, with its towers, turrets, chimneys, and balustrades, in the far distance. Into a dip and up again and the whole north front, with the west front at an angle, built in honey-colored stone, is now visible. At last Burghley House reveals its huge size and imposing presence. It sits comfortably and solidly in place, as if it had always been there, just as it is (fig. 1).

This air of immutability, of unchanging and unchangeable permanence, is, of course, misleading. Burghley has gone through great changes, both without and within, over the centuries under its different Cecil masters, with their differing requirements and tastes. It is these changes to the structure of the house, to the arrangement of its rooms, to its furnishing, and to its decoration that can tell us much about how the house was actually used by successive generations over 450 years.

Our intention is to relate the objects in this exhibition to the house. With the use of the remarkably complete documentation available to us, we shall try to see which of the Cecils bought each object, how it was used by the purchaser, and how it was used by his successors. We shall follow certain objects in their removal from room to room, as they waxed or

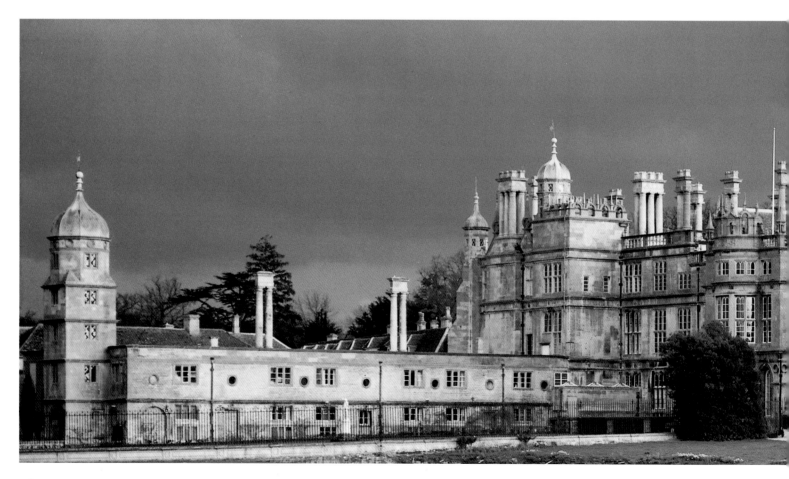

waned in fashionable esteem. We should be able to see just how the house was used at certain times. We shall choose two periods when the family was both prosperous and acquisitive, and when the records help us most: the last quarter of the seventeenth century and the second half of the eighteenth century. We shall concentrate first on John Cecil, Fifth Earl of Exeter (1648–1700), who inherited in 1678, and on his energetic and strong-willed Countess. Together they radically changed the interior of the house and filled it with splendid works of art, many of which they gathered on their four journeys to France and Italy—their Grand Tours. Their purchases were remarkable, and fortunately many remain in the house, but they were extravagant. After

their deaths, the estate was grossly encumbered by a huge debt until the Eighth Earl wisely married an heiress, allowing his son Brownlow, the Ninth Earl (1725–1793), who succeeded in 1754, to follow in his great-grandfather's footsteps, sometimes literally, for he, too, traveled to Italy. The Ninth Earl's life is the second period of interest.

Many of the purchases made by the Fifth and Ninth Earls were paintings. The house has a large collection of, particularly, Italian pictures of the seventeenth and eighteenth centuries. Both Earls were buying as Grand Tourists usually did, according to the tastes of the time; it should be remembered that the Fifth Earl was a relatively early Grand Tourist, while the Ninth Earl traveled

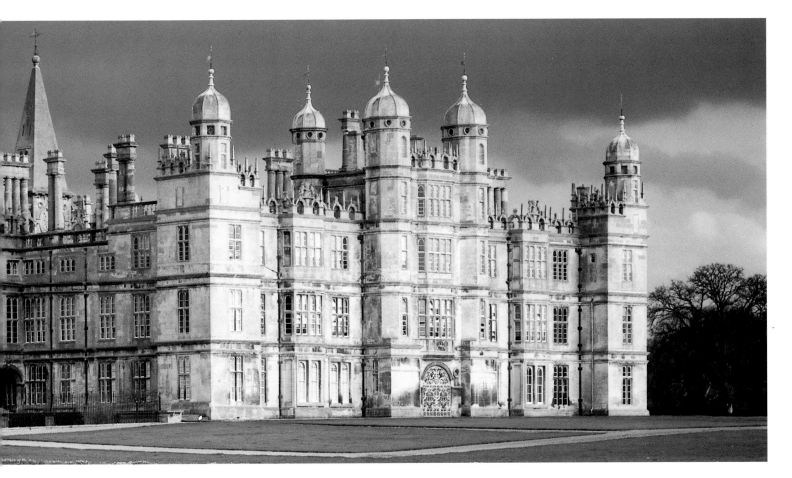

Figure 2. The interior of the
Great Hall with its double
hammer-beam roof. At the
center stands the huge wine
cooler by Phillip Rollos (not
exhibited), bought by the
Eighth Earl. (English Life
Ltd.)

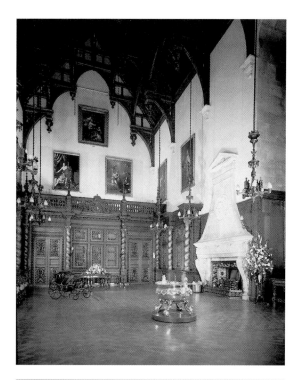

Figure 3. The Inner Court
looking northeast. The East
Range was the first to be built,
finished in 1564. The obelisk
was added in 1585 to emphasize
the placing of the main door to
the house. The corridors
flanking the central feature of
the North Range were added in
1828. (English Life Ltd.)

century Italians, so that the best of the pictures
(mostly bought by the Fifth Earl) were spared,
while the duds were still thought to be genuine. By
no means all the Ninth Earl's purchases were duds;
to give him his due, he bought good paintings by
Bassano and Veronese, among others. Surprisingly,
in an age when the antiquities of Rome were still
much sought after, there are few antiquities, though
we know the Ninth Earl was a client of Thomas
Jenkins in Rome.[1]

This exhibition and catalogue do not concern
themselves with pictures,[2] but with works of the
applied or decorative arts. Many of these objects
were purchased, ordered, or acquired as gifts while
either of the Earls was on the Grand Tour, but others
were ordered or acquired in England. Of particular
interest are the pieces that arrived from Chatsworth
under the deed of inheritance of the Countess of the
Fifth Earl from her mother, of 1690.[3]

The first Lord Burghley, Sir William Cecil
(1520–1598), was Lord Treasurer and Chief
Minister to Queen Elizabeth I (r. 1558–1603), whom
he served for some forty years. A powerful,
energetic, and immensely successful statesman, he
was intensely loyal to the Queen—not an easy
personality—and was absolutely in her confidence.[4]
He was created a Knight of the Garter in 1572. His
main residence was Theobalds, near London and
the Court, but his widowed mother lived at
Burghley in a house of apparently no great size,
close to the remains of St. Michael's Priory.
Theobalds would become a house of vast size, a
"prodigy" house, comparable to the future
Burghley, or Longleat, or Wollaton, and it is not
certain why the Lord Treasurer undertook the
building of his second great house, Burghley.
Burghley stands just outside the town of Stamford,
in Lincolnshire; it is ninety miles north of London
and about forty miles from Cambridge.

Building began in 1555, on the East Range;[5] this
part of the house has been much altered over the
years, and it is by no means clear in what sequence
the various parts of it that remain today were built,
nor how much was preserved of the previous house.

when the Grand Tour was at its height of fashion.
The Fifth Earl bought mostly paintings by recently
deceased masters or masters of the day. It was the
Ninth Earl who indulged rather too assiduously in
the search for the works of the great masters of the
past, so there would have been quite a few
downgraded "Raphaels" or "Michelangelos" hung
today in the attic bedrooms had they not mostly
been sold to pay the Third Marquess's debts in 1888.
Fortunately, taste then still ignored the seventeenth-

Figure 4. The Roman Staircase. Another staircase, at the meeting of the East and South Ranges, was intended to be the Great Staircase, but it must have been virtually unusable, in spite of its rebuilding to designs by Adam, until the completion of the George Rooms in 1797. (RCHME, © Crown Copyright)

Certainly, the great kitchen must date from the mid-sixteenth century, while the Great Hall has been rebuilt, and though the double hammer-beam roof (fig. 2) is sixteenth-century, some of the windows have been blocked in, giving a changed impression. The East Range was not to be seen from the outside; beyond it were offices, stables, servants' quarters, and the like. The other three ranges were intended more for show and were conceived symmetrically. The house is basically a rectangle around a central courtyard, with (originally) two low wings projecting northward from the extremities of the North Range. In the Inner Court, the symmetrical facade of the East Range is centered by a three-story porch that was completed by 1564 (the tall pyramidal obelisk was added later); this was, at first, the main entrance. With the addition of the South Range, with its open arcade (probably finished in 1564), and of the West Range (and the planned North Range), this porch now faced onto an Inner Court. The West Range therefore was centered by the great tower, flanked by four turrets, to act as the gatehouse, the main entrance to the courtyard, through which entry to the house would be gained through the porch in the east facade; it was finished in 1577. The West Range had small projecting rectangular turrets at each end,

which enclosed the closets on each floor. No doubt to balance the West Tower-Gatehouse, the obelisk was built above the main doorway in the east facade facing onto the courtyard (fig. 3) in 1585.

The North Range was finished in 1587. Centered by a large hall, it had a north-projecting wing at each end. The North Range must almost immediately have become the entrance front, perhaps because more outbuildings were built immediately west of its western north-projecting wing. According to the contemporary traveler and diarist Celia Fiennes, when she visited Burghley in 1697, the courtyard thus made was enclosed to the north by a low wall and railings.[6] (Both the northwestern wing and the outbuildings to the west were removed by 1770 by the Ninth Earl.)

Two sets of plans drawn up in 1623 (plan 1, p. 68)[7] show that the West Range was not divided into rooms on the first floor (we learn from the 1688 inventory that the second floor was also undivided)[8] and that most of the first floor of the South Range was similarly undivided. Thus there were three long gallery rooms; most houses of the period had but one. Each gallery in the West Range probably had two fireplaces only, while the South Range may have had only one. Two main staircases served the first floor, the Roman Staircase at the junction of the East and North Ranges and another at the junction of the South and West Ranges (there were subsidiary ones, probably for servants). The Roman Staircase (fig. 4), which still stands, is barrel vaulted and decorated with classical reliefs; it may derive from French precedents.[9] The form of the other staircase is unknown, as it has been entirely rebuilt.

The family lived on the ground floor and on the second floor; the first floor (plan 2, p. 69) was for the State Rooms, which were used only on ceremonial occasions or for visits of the Queen or other great personages. As the First Lord Burghley hardly ever visited the house, it may have been a relatively modest household that his mother kept. It is not known how it was furnished. Burghley's failure to visit the house was no doubt due to the pressure of Court life and the need to be always present there.

Figure 5. Roofscape, Burghley House. The paired (or triple) chimneys were added by the Fifth Earl, in classical style. (Burghley House)

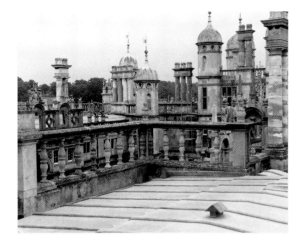

Yet he was clearly the guiding hand in the actual design of the house, seeking help in the details only; it is known that he took an interest in the building of Longleat, a house of comparable size and style, by the Thynne family. Some of the design details must have come from France, where such great houses as Chambord had a similar profusion of turrets; as at Burghley and Longleat, these could be and were used as private rooms. The roofs themselves could be used for promenade, and they present a dramatic picture with their turrets and chimneys (fig. 5). In fact, the Doric column–shaped chimneys must have been added by the Fifth Earl, whose renovations and modernizations to the house included the addition of between fifty and sixty fireplaces.[10]

When the Fifth Earl inherited in 1678, he determined to bring the house up to date, and his works comprise the major changes to the house since its completion. The Lord Treasurer had had two sons by his successive wives: the elder, Thomas, who became the first Earl of Exeter and who inherited Burghley, and Robert, who became the first Earl of Salisbury and who inherited Theobalds, which he exchanged with King James I for Hatfield House. Thomas, though a distinguished soldier, was not in favor with his father and received the smaller portion. We know very little of the house during his time and that of the Second, Third, and Fourth Earls, but two incidents stand out. In 1603, King James I stayed in the house on his way south from Scotland to take the English throne, and on July 24, 1643, during the minority of the Fourth Earl, Oliver Cromwell bombarded the South Range of the

house, which a troop of Royalists had occupied. Sensibly, the Royalists surrendered, but a contemporary account by one of the Parliamentarian officers describes how after the surrender, "such was the madnes of our soldiers for pilladge that they brake in uppon them and fell a plunderinge."[11] In all probability the damage to the house itself was not great,[12] but it may have been a stimulus to the alterations set in hand by the Fifth Earl after 1678, when the open arcade of the South Range was filled and the small arches visible today were inserted (see cat. no. 6). He also had the windows altered; Daniel Defoe wrote in 1724 that the Fifth Earl "turn'd the old *Gothic* Windows into those spacious Sashes which are now seen there."[13]

THE HOUSE IN THE SEVENTEENTH CENTURY
The Family Apartments

John Cecil, the Fifth Earl (1648–1700) (see cat. no. 3A), made an excellent marriage when he married Lady Anne Cavendish (see cat. no. 3B), daughter of the Third Earl of Devonshire and widow of Lord Rich. The Devonshires were exceedingly wealthy, and they gave great assistance to and were firm friends with the Exeters. Lady Anne inherited a fortune in her own right, and there were other family inheritances that occurred then, too. The Fifth Earl was, then, well enough off to set about the modernization of his great house.

The initial work was the division of the two galleries of the first and second floors of the West Range into smaller rooms. The second floor was divided into seven family rooms. The first floor was divided into State Rooms. The ground floor became the Earl's and the Countess's apartments; such separate apartments were the normal arrangement in the seventeenth century. With a room at the center of the front as a Saloon (the small Gothic Hall at Burghley was unsuitable for this—too low and too small—though it was painted later), the Countess's apartment extended southward and the Earl's to the north. Each began with an anteroom, followed by a bedroom, then a dressing room, and finally a closet—a very small room—in the small corner

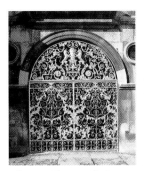

Figure 6. The wrought-iron gates in the center of the West Range, made by Jean Tijou and gilded by René Cousin in the early 1680s. Celia Fiennes in 1697 described these as "of iron carv'd the finest I ever saw." (English Life Ltd.)

tower.[14] The degree of intimacy in which the Earl or Countess held a person governed how far that person would reach in this progression of rooms; only the closest friends reached the closet. And it was the closet that was usually the most finely decorated; the Countess insisted that her apartment was to be finished first. This division into small rooms provoked the creation of so many fireplaces, one for each room, and their chimney stacks (see fig. 5). The rooms all ran into each other, with no corridors, in a defile. Thus the apartment system dictated this progression of intimacy as one passed (or failed to pass) from one room into the next. Only in the eighteenth century was this system generally abandoned. At Burghley, it was only possible totally to abandon it after the erection in 1828 of corridors around the inner court at ground-floor and first-floor levels.

We are able to see what each room contained because in 1688—when building work was in progress and there were presumably a large number of extraneous people milling around the house—the steward of the household, Culpepper Tanner, drew up *An Inventory of the Goods in Burghley House belonging to the Right Hon*ble *John Earl of Exeter and Ann Countesse of Exeter Taken August 21th 1688*, which describes the contents of each room.[15] This

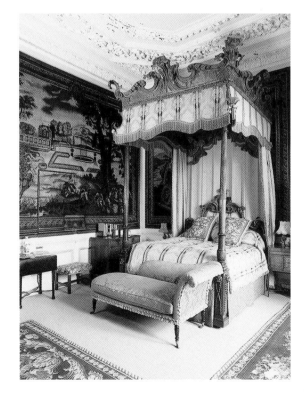

Figure 7. The Blue and Silver Room. The tapestries were present in 1688 when this room was Lord Exeter's Bedd Chamber, and they have been there ever since. The bed was made and installed by Mayhew & Ince in antique style in 1768. The carved ceiling by Edward Martin is just visible. (Burghley House, Bob Laughton)

inventory is famous for its descriptions of the earliest recorded Japanese porcelains in Europe that can today be identified, but it is also an invaluable record of this great house. It is worth remembering that this inventory was taken after two of the Exeters' Grand Tours (those of 1679–1681 and of 1683–1684) and before those of 1693 and 1699–1700, and that it was taken before the death of the Countess's mother and therefore before the arrival of the myriad items listed in the Devonshire Schedule.

Most of the furniture in all these rooms would have been ranged around the walls, with very few pieces (and no chairs) placed in the center. Chairs had their backs to the walls, and one of the purposes of the carved dado rails was to prevent damage to the walls by the backs of the chairs. In contemporary paintings one sees chairs pulled away from walls only in scenes that were meant to be informal; no doubt this reflected actual practice. All the rooms in any apartment would have had a number of chairs, and in effect each room, even the bedroom, was used as a sitting room. The closet often had but two chairs, indicating its position as a truly private room. The State Rooms reflected the same pattern of layout as the private apartments; progressively, the rooms got smaller and more intimate.

Let us examine the Exeters' living accommodations in the West Range first (plan 3, p. 70). Tanner does not mention the Gothic Hall, the center of the West Range, in the 1688 inventory, so presumably it was empty. The great wrought-iron gates to the exterior (fig. 6) had just been made by Jean Tijou[16] and gilded by René Cousin.[17] The walls of the hall were later painted, though no trace of this remains today. Immediately to the north, Lord Exeter's *Anty Room* (anteroom)[18] contained a couch and six chairs covered in *Greene figurd velvett* and with *Right Japann fframes*,[19] a *Black Japannd Table*, and the accompanying pair of stands for candles, though apparently no mirror. The curtains were *white Damask*, but no decorative hangings are mentioned. There were seven pictures, and *over ye Chimney* were thirteen pieces of Chinese and Japanese porcelain. His *Bedd Chamber* next door was hung

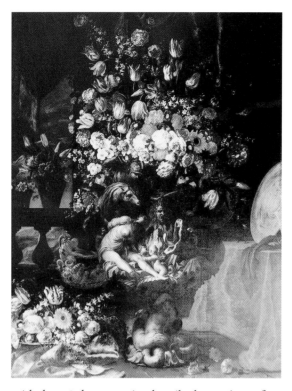

with three Soho tapestries described as *3 pieces of
Blue and Gold hangings by Vanderbanc*.[20] These are
still in the room, though the gilding of the silver
thread has worn (or been cleaned) away; they now
look blue and silver, hence the present name for the
room, the Blue and Silver Room (fig. 7). The
tapestries depict Venus and Cupid, the Judgment of
Paris, and a Garden. There is some evidence that
they may be related to the great bed now in Queen
Elizabeth's Bedroom (see fig. 13), which may be
Lord Exeter's bed, then described as *1 Large
Imperial Bedstead*.[21] The present bed is hung with
blue and gold and was supplied in 1768 by Mayhew
& Ince.[22] Besides the tapestries there were three
pictures, the subjects indicating a male bedroom:
Susanna, *Lott and his 2 Daughters*, and *Joseph and
Pottipher's wife*. Celia Fiennes was shocked by these;
"fine paint in pictures, but they were all without
Garments or very little, that was the only fault, the
immodesty of the Pictures, especially in my Lords
appartment." Over the chimney were seventeen
pieces of Chinese and Japanese porcelain, including
2 large Ellephants, one of which is included in this
exhibition (cat. no. 76). The *Dressing Roome* was
covered in *Aurora* (pale blue?) *Damask*, with four
chairs covered to match. There was *1 writing Desk

Table, & Drawer Inlaid with metall white, which is
the fine side table by Gerreit Jensen in this exhibi-
tion (cat. no. 91).[23] The pictures were extraordinary
for such a small room (it measures 18 by 14 feet),
for not only did it contain a portrait of the Lord
Treasurer but also the two vast flower paintings
by Giuseppe Recco (fig. 8) that the Fifth Earl had
commissioned in Naples in 1684, which must have
seemed the size of tapestries;[24] they are still in the
house. Over the chimney were eleven pieces of
Chinese and Japanese porcelain, several of which
can be identified today. The *Clossett* measures nine
feet square; it was hung with *Indian Crimson and
Gold stuff*, and it contained two *Armd Chairs* and two
Stooles to match, and a desk and its candlestands. It
was hung with thirty-eight pictures, mostly
miniatures. This room led into the northern wing
extension (now pulled down), which then contained
the Library and some offices. Listed as part of *My
Lords Appartments* is the westernmost room in the
North Range, the *Tile Roome*, which will be
discussed below.

Lady Exeter's *Anty Roome*, as her husband's,
apparently had no hangings. It had four *Armd
Chaires*; two *walnutt Tree chest of Drawers* (still
unusual pieces of furniture at that time), one with
candlestands; a walnut *Scritto* (desk); and some other
pieces of furniture. The curtains were white damask,
and there were thirteen pictures. Over the chimney
was a picture (of Apollo and Daphne), and on the
chimneypiece were *A Virgin Mary with our Saviour
in armes in Allablaster*, which may be the figure
exhibited here (cat. no. 56), and seven porcelains.
Lady Exeter's *Bed Chamber* was hung with five
Gobelins tapestries depicting the fables of la
Fontaine, by Jan Jans,[25] ordered on the Exeters' first
trip to Paris in 1679. Three of them are still in the
house. In her *Bed Chamber*, the *Imperial* bedstead
had blue hangings of some complexity, and there
were eight chairs to match. The *Right Jappan Table
& Stands* was probably a dressing table and its
candlestands, though no mirror is mentioned; nor is
one mentioned in her *Dressing Roome*. Presumably,
any mirrors would have been of silver, part of a

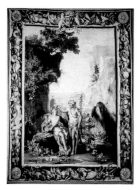

Figure 9 (above). Mortlake tapestry of Ovid's Metamorphoses, *bought by the Fifth Earl, in Queen Elizabeth's Bedroom. The shell border (see fig. 19) is particularly fine. (English Life Ltd.)*

Figure 10 (right). The Right Jappan Cabinett inlaid with mother of perle on a carv'd guilt fframe *of 1688; it then stood in the* Best Bedd Chamber. *It is a Japanese export lacquer cabinet of the mid- to late seventeenth century with an unusual pearl-shell inlaid decoration on an English gilt-wood stand. (Burghley House, Bob Laughton)*

toilet service (such as cat. no. 106), and therefore listed in a separate inventory of the plate, which does not survive. There were seventeen pieces of china, including a garniture of three pieces, not all over the chimney. There were only three pictures.

My Ladyes Dressing Roome was hung with crimson damask and *Indian* flowered silk and had eight chairs and a couch to match; there was also a *right Jappan or Indian painted Tea Table*, which may have been of lacquer. There were seven pictures. Over the chimney were *2 Cocus Nutt Shells*, typical *Wunderkammer* objects,[26] nine pieces of porcelain, and *2 Figures Carv'd in box being a Cleopatra & a Pallace* (Pallas Athene or Minerva). These Italian figures are part of a "set" of eight acquired in Italy by the Exeters, probably in 1680 (see cat. nos. 54A–D). Two further figures were next door in the Closet; all the figures in these two rooms represent women; the other four, of men, were then in *The Best Bedd Chamber*. The *Clossett* was hung with *Green figur'd Velvett & silk fringe*, and there were *1 Easie Chaire*, two stools, and two footstools. The *Inlaid walnut Tree writing Table* had a *silver sand-box & Standish in itt*, and the inlay of the desk matched that on the floor; this is the only mention in the 1688 inventory of a marquetry floor (see fig. 18). It is not known whether other rooms in the West Range had marquetry floors. Note that no mention has been made of any floor carpets in these rooms. There were more than forty pictures in this tiny room, most of them miniatures. Over the chimney were two of the Italian carved wooden figures, representing Venus (cat. no. 54B) and Lucretia; an Apollo and Daphne in ivory that had been bought in 1683 or 1684 (cat. no. 55); two silver sprigs of flowers from Milan (possibly but not certainly nos. 105A&B); and seventeen pieces of porcelain.

Among the great glories of Burghley are the superb plaster ceilings in the rooms on the ground floor of the West Range, most of those on the first floor of the West Range, and those on the ground floor of the South Range (see figs. 7, 11). They are modeled with high-relief wreaths and swags of flowers and fruit, made by Edward Martin.[27] Most of the walls were intended for tapestry and were not

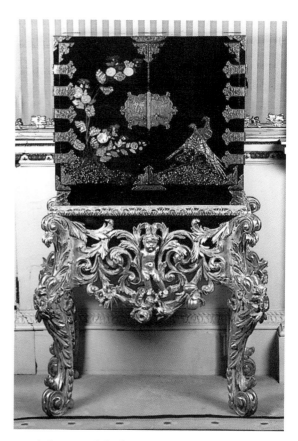

paneled. Most of the later rooms to be refurbished— the Marble Hall of 1682 and three of the George Rooms[28] on the first floor of the South Range (which were not completed at the time of the Fifth Earl's death in 1700)—were to be paneled in oak with finely carved moldings. Some of the moldings were made by Grinling Gibbons, but most were made by his contemporaries, including Thomas Young and Jonathan Mayne.[29] Roger Davis, a wainscot-joiner, was employed over many years from 1678 as a furniture maker as well as a carver; he seems to have specialized in moldings.[30]

Next door to Lady Exeter's *Dressing Roome*, still on the ground floor, was the *Best Bedd Chamber*, in effect the second room of the South Range (if we count the dressing room as the first). This room was presumably kept mainly for Lady Exeter's parents, the Earl and Countess of Devonshire, who were frequent visitors, passing between Chatsworth in Derbyshire and their house in London. This chamber was hung with four Gobelins tapestries woven by Jan Jans to the same order as that for the *fables*, of *Storyes out of Ovids Mettamorphoses* (fig. 9). The *Imperial Bedstead* was hung with crimson

velvet curtains with elaborate fittings and had eight chairs with gilded frames upholstered to match. The *Right Japan Cabinett inlaid with mother of perle* (fig. 10) on a *Carv'd guilt fframe* (stand) is still in the house; on it stood Chinese or Japanese porcelain. There were twenty-one pieces of china in the room, some over the chimney with the four boxwood figures (Alexander, Mars, Cicero, and Catalina) and *2 wrought Indian Silver Coffe Cupps & Dishes to them.*

Beyond this room was the *Drawing Roome*, an important public room. It was hung with blue velvet and had sixteen *Armd Chairs* upholstered to match, with japanned frames. There were also two japanned triads, each consisting of table, mirror, and pair of candlestands; they probably stood between the windows. Most important, in this room there also stood the magnificent Florentine ebony, marquetry, and *pietra dure* cabinet that had been given to the Earl by the Archduke Cosimo III only a few years earlier (cat. no. 93).[31] It stood then on an English carved and gilt stand, which was discarded temporarily in the very early eighteenth century, for in 1738 the cabinet stood *upon 6 Marble Statues* in the northwest closet on the first floor. Among the *4 very large pictures in Guilt fframes* in the *Drawing Roome* were the two pictures by Luca Giordano[32] bought for the Fifth Earl in 1683 in Genoa by the agent Giles Balle.[33] A miniature self-portrait by

Giordano is included in this exhibition (cat. no. 18).

The central room of the South Range was the *Marble Salloon Roome*, now the Marble Hall (fig. 11), so called because of the marble statues shown there. This room has a particularly fine ceiling by Edward Martin and elaborate carving in oak around the frame of the picture over the fireplace. The upper register of paneling served as frames for pictures, mostly portraits. A few generations ago, the moldings of the paneling around the pictures were adapted so that they could be removed from the wall to act as ordinary picture frames. Such are the frames to the portraits of the Fifth Earl and his Countess by Sir Peter Lely (Tanner calls him *Lilly*) in this exhibition (cat. nos. 3A&B).[34]

Beyond this central room was the *Dining Roome*, hung with crimson-figured velvet, with sixteen walnut chairs upholstered to match. No tables are listed; Roger Davis, the carver, had been employed in the house since 1678 making, among other things, *Spanish tables*, which could be folded to be put away outside the room when not required. There must also have been tables with additional leaves, for some leaves are listed *under ye Great Staires*. There were four large pictures, including two by Johann Carl Loth,[35] bought by the Fifth Earl in 1684 in Venice, and three others (over the chimney and the doors). There were thirteen pieces of Chinese or Japanese porcelain and *2 Brasse horses on ebony pedistalls* (see cat nos. 50, 51) over the chimney. Beyond this room again was the *Tea Roome*, later to be thrown into one with the *Dining Roome*, in which were seven chairs (again, no tables), fifteen paintings, and eleven pieces of porcelain over the chimney.

Beyond lay the staircase, the configuration of which is unknown, though it was probably free-standing, as it was altered in shape in the eighteenth century. Other steps lead up to the *Great Hall* (see fig. 2), part of the East Range. By this time, great halls were out of fashion, and in 1688 the hall at Burghley was used as a storeroom for odds and ends, including the fire engine (an essential piece of equipment for all great houses). In the East Range were also the great Kitchen, possibly the oldest part

of the house, and many other rooms of domestic necessity, including *Mr Tanner's roome*, which contained bedroom furniture and a *Turkey Carpett*.

Two other rooms on the ground floor were used by the family, or at least the male members of the family: *The Guilt Leather Dining Roome* and a *Smoaking Roome*. The *Dining Roome*—hung with gilt and blue "Spanish" leather[36] with *18 New Guilt and blue Leather Chaires* and *2 Spannish Sideboard Tables*—was presumably used by the Earl for meetings of the *Honourable Order of Little Bedlam*,[37] his private drinking club. The *Smoaking Roome* contained thirteen chairs and two tables. Note that these very masculine rooms were far from the living quarters. The central room of the internal East Facade, which had been the old entrance hall, was later to be painted by Antonio Verrio,[38] who worked at Burghley from 1686 to 1697; he had just begun work on the George Rooms when the 1688 inventory was taken.

Lord Exeter also kept another *Closett* on the first floor (see plan 4, p. 71), near the Roman staircase and the Chapel. Presumably this was a private office away from all the noise and mess caused by the almost permanent building and decorating program, for it contained a desk, some bookcases, a table and candlestand, two *Easie* chairs and two stools, and a close stool. There were many pictures, but no mention is made of hangings. This room had a door opening onto the roof leads of the northeast-projecting wing (the one that still stands); such private roof walks were much prized. In the Chapel Chamber next door was a *walnutt Tree Cabinett or Scritto*, which may have been the fall-front *secretaire* cabinet cannibalized by James Newton for the interior of two cabinets made for the First Marquess before 1804, now in a corridor.[39]

Culpepper Tanner does not describe the three main rooms on the ground floor of the North Range; presumably they were in course of decoration in August 1688. (The same is true for the George Rooms on the first floor of the South Range). The only room he does describe is the *Tile Roome*, so called, presumably, because tiles were used somewhere in the decoration. The presump-

tion is that the floor was tiled, made more likely by a recent find in an outhouse of a large stack of late-seventeenth-century Neapolitan glazed tiles. Perhaps the Earl dreamed of an Italian palazzo in Lincolnshire; grim necessity must have later dictated the removal of the cold floor and its replacement in wood, for no tile floor is mentioned in the 1738 inventory, which meticulously records the fittings (Tanner does not). In 1688 the *Tile Roome* was an extra dressing room for Lord Exeter, for it is placed at the west end of the North Range, adjacent to his *Dressing Roome*. It contained a *field bedstead* with olive-colored curtains, the valance and base in gold with colored flowers, with crimson fringes. The interior curtains were straw-colored Indian satin worked with flowers. The *Indian quilt wrought in Coullers* may have been a palampore. There were eight japanned armchairs covered in cloth of gold, two tables (one of *Jamaica* wood),[40] an elaborate carved and gilt mirror (now in Queen Elizabeth's Bedroom), and a close stool. It will come as no surprise that there was also a Turkey-work foot-carpet,[41] one of the few described in the house. There were fourteen pictures, but no hangings are described.

It was in the rooms we have described that Lord and Lady Exeter lived. The rooms on the first floor, not all of which were finished in the seventeenth century, were the State Rooms, while those on the second floor were for other members of the family.

On the second floor, Tanner describes only the West Range and the westernmost three rooms of the North Range. The West Range contained seven bedrooms, created when the long upper gallery room was divided up between 1678 and 1682. Each room was modestly furnished, though most were hung with old or old-fashioned tapestries described as *Landskip* or *Old*. No chests of drawers were present, and no mirrors; these were both expensive items. The carpets described were all table-carpets. In the North Range were the rooms of Lord Burghley, the Earl's eldest son (see fig. 11), who was fourteen years old in 1688, and of his tutor. Lord Burghley had seven chairs, a *wallnut Tree Chest of Drawers*, and a *wallnut*

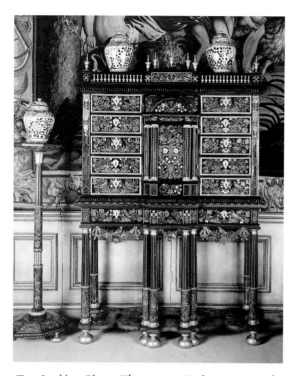

Figure 12. The marquetry cabinet and one of the two candlestands made by Pierre Gole at the Gobelins Manufactury and bought by the Fifth Earl on his Grand Tour, probably in 1683. Behind them hangs the Mortlake tapestry of the Triumph of Bacchus. The porcelain is Japanese Imari. (Burghley House)

Tree Looking Glasse. There was a Turkey carpet and a spinet, so his room was well appointed; the tutor's was definitely Spartan. On the eastern side of the house were servants' rooms and some storage rooms.

The State Rooms

The 1688 inventory of the first floor, of those State Rooms that were completed by then, covers the West and North Ranges. The East Range contained the Chapel, various offices and housekeepers' rooms, and, of course, the open spaces of the upper parts of the Kitchen and Great Hall. The South Range was in the process of division and decoration, so Tanner does not describe any of the rooms. Lack of passage through the South Range made the circuit of the house incomplete, for there was no convenient access to the large staircase at the east end of the South Range.

Tanner begins with the *2nd Roome next the South* in the West Range, omitting the corner room that was to become the First George Room. We shall not follow his route, but describe the rooms in sequence as they would have appeared to a visitor who had reached the first floor by the Roman Staircase at the corner of the North and East Ranges. The first room in the North Range, the first room off the Roman Staircase, and therefore the first of the State Rooms

at this date was called the *Plaster Dining Roome*. The reasons for this name are unclear, though it may have had a plaster frieze (the ceiling was altered in the eighteenth century). In this room were two tables, two armchairs, and twenty-eight gilt leather chairs. There were thirty-six pictures. The central room, which was deep and consequently dark, was then the *North Dining Roome*. It is the fourth dining room we have described, a comment on the various levels of entertaining the Exeters were obliged to hold. This room was to be painted by Louis Laguerre with scenes from Roman history; we do not know how it was decorated before 1697.[42] It contained two Spanish tables and their Turkey-work table-carpets, thirty-six Turkey-work chairs, an armchair (*of my Ladyes work*),[43] and an easy chair. There were twenty pictures hanging in the room, not all of them framed, which seems odd for a State Room.

The *North Drawing Roome*, beyond the *North Dining Roome*, was hung with three tapestries of the story of Psyche; a fourth in the series was in the *wardrobe*,[44] classified as Mortlake, but none can be traced today. There was a *Large Turky work foot Carpett*[45] and thirteen walnut chairs upholstered in crimson velvet. Most importantly in this room were the *Inlaid large french Cabinett, Guerridons Table & stand to itt* (fig. 12), fine examples of the work of the celebrated cabinetmaker Pierre Gole[46] that are now in the Blue Silk Bedroom. Clearly there was no mirror *en suite*, and in the room there was also a *Large Looking Glasse, with quivre d'or & Glasse frame*, probably the one in the Black and Yellow Bedroom today. In the two closets were twelve flowered silk *old chaires*. It is clear from these contents that this was a very grand room indeed.

The last room on the North Range was actually not the corner room, but the room next to it, which looked only north. Tanner describes this room as *The Bedd Chamber next ye Gallery Roomes*, referring to the recent conversion of the West Long Gallery into the small rooms described below. This room was hung with three Mortlake tapestries from the *Bacchanals* or *Naked Boyes* series, attributable to Francis Poyntz;[47] these and the fourth in the series,

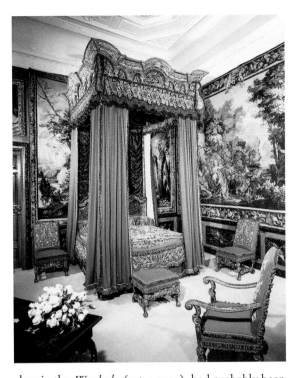
then in the *Wardrobe* (cat. no. 99), had probably been ordered by the Fifth Earl in 1679 or 1680. The *New Imperial Bedstead* had hangings of *haire* color, and there were eight armchairs to match, with gilt and painted frames. This set may be represented by the armchair and three chairs and a stool (formerly a chair) now in Queen Elizabeth's Bedroom (fig. 13). They were probably supplied by Daniel Cookman between 1678 and 1683.[48] Also in the room were a large mirror and the *Ebbony Cabinet Inlaid with Stone and guilt frame*, the Florentine cabinet now in the Heaven Room, surely acquired on the Exeters' first or second Grand Tour. It should not be confused with the grander Florentine cabinet (cat. no. 93).

The first floor of the West Range was laid out as two apartments running north and south from the central room, now the Pagoda Room, called by Tanner the *Midle or 4th Roome*. Access to this room without passing through the sequence of rooms in the West Range was by a passage along the courtyard side of the West Range. These were the only rooms accessible by a passage other than through the enfilade, for the north and south corridors were not built until the nineteenth century. The central room seems to have been remarkably bare and must have acted as a Saloon. It was hung with large pictures, including two of the seven paintings by David de

Koninck bought by the Fifth Earl in Rome in 1684,[49] and contained merely two tables, eight cane chairs, and an *old* stool. The gilt leather close stool was probably in one of the two adjacent closets formed out of the two turrets of the West Tower. The bedroom next door to the south was hung with four tapestries depicting the story of Moses. These tapestries are no longer in the house, for they were sent to Snape Castle in Yorkshire, a subsidiary Cecil house, in 1689 or 1690. The subject was a popular one, and many different versions exist; we have no further clues to their appearance. The *Large Imperial Bedstead* had green and white hangings *Cantoone ffashion*.[50] There were eight *wrought Chaires, & Jappand fframes* with green covers, and a white japan table, candlestands, and mirror. Over the chimney was the portrait of William Cecil by William Wissing that is now in the Marble Hall (see fig. 11).[51]

The next room, called by Tanner the *2nd Roome next the South*, was the last in the south sequence of the West Range, for the First George Room, then unfinished and unfurnished, was the corner room. The *2nd Roome* was obviously the dressing room for the previous bedroom. It was hung with *Aurora Damask*; it had no bed, but had seven walnut chairs upholstered to match the walls. There was an *Inlaid black Ebony Table* and two stands, but no mention is made of a mirror. There were two overdoor pictures and three others, along with five busts (*4 pollisht Caesars heads, & 1 larger marble head*); no pedestals are mentioned.

The *North Bedchamber*, next to the central room, was the first room in the northward apartment of the West Range. It was hung with four tapestries of the story of Paulus Aemillius; two further pieces from this set hung in the seventh room. None of these is now in the house; two were sent to Snape Castle in 1689 or 1690 with the Moses tapestries, but the other four are untraced. The *Imperial* bedstead was hung with *Scarlett mohaire*,[52] and there were ten walnut chairs upholstered to match. There was an inlaid *Grenoble* table,[53] candlestands and mirror (and a leather cover), and, unusually, a Turkey-work foot-carpet. The sixth room was the dressing room

for the *North Bedchamber* and was hung with crimson damask, with seven chairs to match; it contained a *Right Indian Jappan Cabinet*, probably Japanese lacquer, and some marble sculpture. The seventh room, or *North End Chamber,* was another bedroom; it is the northwest corner room, with the small turret room as its *Clossett*—in fact, probably a dressing room, as it contained a mirror. The bedroom was hung with two tapestries of the Aemillius set and one from an Alexander series, of which seven were later sent to Snape Castle. There was an Imperial bedstead hung with blue damask and eight low-backed chairs to match. There is mention of five marble busts but, as before, no pedestals. The small Closet was hung in yellow thread damask, and there were five chairs to match *with old fframes*, a small table, and a large walnut-framed looking glass. Six pictures hung there.

The North Range clearly was used for public functions when relatively large numbers of visitors were present; these were the State Rooms. The West Range was for the use of overnight visitors and their visitors. The apartments were arranged more or less as were the Exeters' own apartments below them, with the standard seventeenth-century procession of rooms. One gets the impression, particularly when comparing the contents of the State Rooms of the West Range with those of the State Rooms of the North Range, that the West Range was not much used. The arrangement has a temporary feeling about it. No doubt this was due to the curtailed access to the South Range; anyone reaching as far as the *second Roome* would have had to retrace his or her steps back through the West and North Ranges or else take one of the subsidiary staircases at the inner corners that were really for the use of servants. The North Range was clearly the grand area of the house, though the Exeters seem to have considered their own comfort before their desire to make a public show.

The George Rooms

The rooms in the West and North Ranges were those used in August 1688. Work on the South Range was in progress but had barely begun before 1686. The five rooms in the South Range are called the George Rooms,[54] beginning with the First George Room in the southwest angle of the house, which has a closet in the turret called (by 1738) the *Jewel Closet*. The sequence runs to the Fifth George Room, also called the *Heaven Room*, and beyond that to the Hell Staircase, the Great Staircase at the southeast corner of the house. The South Range had originally been a long gallery. The rooms were divided out of this gallery and ran into each other, for there was then no corridor behind them. The rooms were very tall, some twenty-four feet, for they took up the space of two floors; the upper windows in the South Range are false. Only the First George Room is lower (sixteen feet), because above it was the end room of the second floor of the West Range. The design for these rooms may have been that of William Talman,[55] who was paid £200 by the executors in 1704 after the Fifth Earl's death. The first room to be worked on was the First George Room, which was paneled in quarter-cut Norwegian oak. It had a large, elaborately carved cornice and even more elaborate door-cases and overdoors. The cornices seem to have been the work of Young, Mayne, or Davis;[56] some of the work may have been done by Grinling Gibbons, but the evidence is conflicting. The ceilings were coved and were to be painted by Antonio Verrio, who had recently been working at Windsor Castle. Verrio was paid an installment of £50 in 1686 for work on the First George Room and its closet. The other rooms were to cost £200 each, except for the Fifth George Room, which was to cost £500. This was called the *Heaven Room* (fig. 14) for the painting depicting the gods by Verrio covering the walls and ceiling (it was not paneled). Verrio finished the ceiling of the Great Staircase, depicting Hell, in 1697.[57] From his contract Verrio had to pay not only for his materials, but also for his assistants, René Cousin, the gilder, Alexandre Souville, the architectural painter,[58] and possibly others. His own speciality, abundantly evident, was the human figure.

Before Verrio could begin, the cornices had to be made. By the time he had reached the Fourth George Room, the carvers were behind in their

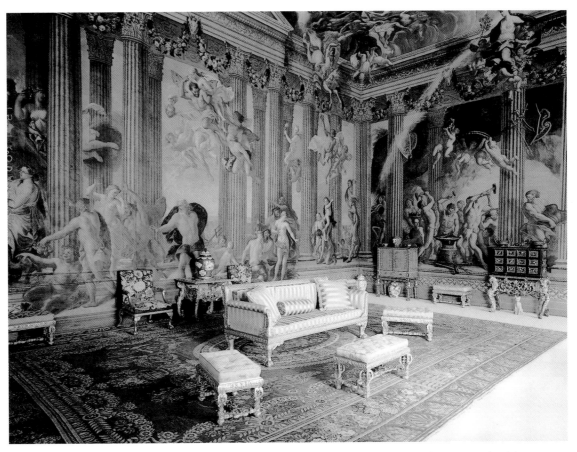

Figure 14. The Heaven Room (the Fifth George Room), so called on account of the frescoes by Antonio Verrio that cover the walls and ceiling, depicting the gods, in a classical architectural setting. In the room today are the second pietra dure cabinet and the suite of gilt-wood furniture, of which two pieces are exhibited here (see cat. no. 92). (Burghley House)

work, and the cornice there is less well finished than it is in the other rooms. It should be said that the paneling and carving were far more expensive than the work of the painter. The paneling itself was not completed when the Fifth Earl died in 1700, though some of the door-cases and overdoors were. The First George Room has a parquet floor, and it is likely that this room was finished before the Earl's death. The other rooms, still unpaneled, also lacked completed floors, which may explain why poor Verrio had to work from a sort of suspended wicker cradle (called a craik) rather than from a movable platform such as the one he used at Chatsworth.

As the Fifth Earl died deep in debt, work stopped in 1700. It was begun again by the Ninth Earl after 1754. Astonishingly, the Ninth Earl followed the same scheme for the George Rooms as his great-grandfather and continued the work on the paneling in oak, by then definitely out of fashion. In all probability, some of the fireplaces in the more important rooms, including three of the George Rooms, were changed at this time. They were placed symmetrically in the center of a wall rather

than across a corner, involving considerable building work. In fact, the George Rooms were not completed on the death of the Ninth Earl in 1793 but were finished by the Tenth Earl (the First Marquess) by 1796.

The sequence of the George Rooms is, of course, reversed by the numbering. A visitor would have ascended the Hell Staircase to reach the saloon, the *Heaven Room*. From there on was the sequence of rooms whose purposes were proclaimed by the subject matter of Verrio's ceiling paintings. The Fourth George Room, the central room of the South Range, has a ceiling depicting the Feast of the Gods; clearly this was to be a dining room. Beyond the Third George Room was the *Withdrawing Room*, according to the 1738 inventory (when the George Rooms were still unfinished), but as the ceiling depicts Cupid and Psyche one wonders whether this room was originally planned in the seventeenth century to be the bedchamber and only became the *Withdrawing Room* on completion in the eighteenth century. Beyond it was the bedchamber, possibly originally intended as a Withdrawing

Room, as the ceiling depicts Mars presenting Romulus to Jupiter for deification; perhaps this is a not-so-subtle allusion to the builder of the house. The First George Room was the *Dressing Room* with its *Closet*; here the ceiling depicts Morning chasing Night from the Heavens, the four Elements, and the four Seasons. Though the paintings were finished in 1697, the rooms would not be completed and useable for almost a hundred years.

THE DEVONSHIRE SCHEDULE OF 1690

When the Fifth Countess's mother, Elizabeth, Countess of Devonshire, died in 1689 (for a portrait miniature of her, see cat. no. 11), she left in her will the entire contents of her apartment at Chatsworth to her daughter, with the strict proviso that they were "For [her] peculiar use and benefit and at [her] disposall. . .with which the. . . Earl of Exeter should not intermedle and nor should the same in any sort be lyable to his debts Arts or Disposition"; in other words, that they were to belong to her absolutely. This was rare in those days, when a man usually owned his wife's possessions. The gift was enormous; it was as if the entire apartments of the Countess of Exeter, described above, were to be removed—pictures, tapestries, furniture, curtains, the lot—and given away. The contents of the Countess of Devonshire's apartment were particularly rich, more so than that of her daughter at Burghley, and this was a huge inheritance. It is all meticulously described in a long list, the Conveyance and Schedule of Gift, dated April 18, 1690, referred to here as the Devonshire Schedule.[59] Several miniature paintings and many pieces of porcelain from this gift are included in this exhibition, but two examples will serve: *A picture of the late Countess of Devonshire by Cooper in White*, her portrait (cat. no. 11), and one of the Japanese porcelain *pair of Boxes of three pieces Each painted in Colours garnisht with philigrin Top Bottoms Hinges and Clasps* (cat. no. 73). The former is classified under *Water colour pictures*, the latter under *Lesser China garnisht with silver guilt*.

More important than these examples, perhaps, are the sixteenth- and seventeenth-century jewels,[60] semiprecious stone vessels beautifully worked and embellished, and other enameled and gem-studded artifacts, the extraordinary survival of a collection unparalleled in Britain today (cat. nos. 19–35). This is the remainder of a treasury, or a *Schatzkammer*, a collection of rare and precious materials catering to the taste for the exotic. Some pieces came from India or other Eastern countries; most were made in Italy or Germany, where the taste for such things was strongest. The Countess's mother was herself a Cecil from Hatfield House; whether she collected these herself or inherited them is not known. She may have ordered some of the English pieces.

EXCURSUS: THE TRAVELS OF THE FIFTH EARL The Fifth Earl traveled to the continent four times (not always with the Countess). This was more than the usual Grand Tour and, indeed, was somewhat early for the type of Grand Tour that was to be developed later. Certainly they purchased and ordered works of art of all sorts, just as did other Grand Tourists. Perhaps because English milords were still infrequent travelers in Italy, on his second trip Lord Exeter seems to have established himself at the court of the Archduke Cosimo III in Florence, where he spent the winter of 1683–1684, and he received from the Archduke as a gift the magnificent ebony, marquetry, and *pietra dure* cabinet that is exhibited here (cat. no. 93). Apparently by way of a return gift, when the Earl returned to England, he ordered from his coach-builder in London a *Charryot*, costing £70, *for Florence*.

The later journeys, of 1693 and 1699–1700, may have been taken partly for political expediency. The Earl was no Jacobite, but he must have been an old-fashioned Tory,[61] for he would not swear allegiance to King William III after the Glorious Revolution of 1688. The Earls of Exeter were hereditary Grand Almoners, and the Fifth Earl had acted as such at the coronation of King James II on April 23, 1685. Two dishes, one of which is exhibited here (cat. no. 104), were sent to him as his perquisites on May 13, 1685. But he refused to act for the coronation of

William III. It might also be suggested that the Exeters were anxious to escape from the chaos at home resulting from the endless renovations and improvements to both the house and the grounds at Burghley.

The first journey through France to Italy was made from 1679 to 1681, by which time work on the house was well under way. The Earl took his steward Culpepper Tanner with him, leaving Thomas Stretch as house steward and upholsterer at Burghley;[62] Roger Davis was in charge of the woodworking part of the redecoration. Both corresponded with Tanner throughout the journey, giving exact measurements of some of the rooms so that the correct amount of the very expensive textiles the Countess required could be ordered. Even the head gardener demanded decisions; he complained about the ruin of the garden and asked for extra help. Results suggest that he got it.

In a time when it was not the fashion to travel light, the Exeters were unusually well equipped. In 1679 the Earl and Countess took with them their two sons, two gentlemen soldiers (John Willoughby and John James Gaeles), their chaplain (Edward Child), the steward (Tanner), five women servants, fourteen menservants, thirty horses, a mule, two dogs (one was called Towser), a carriage, a wagon, and a litter for the Countess. They also carried a number of blunderbusses, a huge tent complete with its furniture, and a vast number of cooking utensils. By the time of the second voyage, in 1683–1684, Lord Exeter had learned better and traveled lighter.

On the first journey, in Paris, the Earl ordered the two sets of tapestries from Jan Jans at the Gobelins, the *Fables* of la Fontaine and the *Metamorphoses* of Ovid. These had to be paid for in installments, for the weaver refused to dye the wool until he had a deposit. Presumably, he also bought the set of marquetry furniture by Pierre Gole (see fig. 12), who then had his workshop at the Gobelins. This furniture bears the royal fleur de lis and was presumably available to the Earl as surplus to Louis XIV's requirements.

From 1680 to 1681 they were in Genoa, Leghorn, Padua, Venice, Florence, and Rome, buying pictures and other works of art, which all had to be sent home. However, it was not until the second voyage (on which the Countess did not accompany him) that Lord Exeter began to buy and commission pictures in quantity. No Englishman, it has been said, ever commissioned contemporary Italian painting on such a scale.[63] He seems to have bought in every large town he visited. The huge number and good quality of the seventeenth-century Italian paintings still at Burghley testify to his eclectic taste and voracious appetite. He also spent much time generally enjoying himself. Tanner (who was also on this second trip) records the purchase of the ivory figure of Apollo and Daphne for 60 crowns (which was in Lady Exeter's *Clossett* in 1688; cat. no. 55); the previous entry in Tanner's list is for brandy, also for 60 crowns. In 1684, he went as far south as Naples with Tanner and his two soldier companions, Captain Hyde and Captain Fitzwilliam, where they saw the sights (Pompeii had not yet been discovered) and spent considerable sums on *handy capping*, an indoor game, and on *flasques of snow*, cherries, and *fresco* drinks. While in Naples he ordered the great flower pieces by Giuseppe Recco (see fig. 8) that he would hang in his *Dressing Roome* and other paintings still in the house. Presumably he also ordered or bought the glazed tiles for his *Tile Roome*. Back in Rome he commissioned and bought paintings by Carlo Maratta, David de Koninck, Daniel Seiter, and many others;[64] many of these pictures remain in the house.

On their last journey, in 1699, Lord and Lady Exeter visited the studio of Pierre-Etienne Monnot,[65] a French sculptor working in Rome, where they sat for their portraits in marble (cat. no. 4). The busts portray the Earl and Countess in Roman dress, which reflected their love of Rome and of antiquity. They also bought lesser sculptures and ordered more for Burghley, including the *Andromeda chained*, which at first stood in the *Marble Saloon Roome*. None had arrived at Burghley before the death of the Earl on the return

Figure 15. The marble tomb of the Fifth Earl and his Countess in St. Martin's Church, Stamford, ordered from Pierre-Etienne Monnot in 1700 in Paris and installed in 1707. The figures are in Roman dress and recline in the Etruscan manner. (Burghley House)

journey in 1700. The widowed Countess ordered from Monnot the great marble tomb sculpture (fig. 15), today in St Martin's Church, Stamford, that portrays the two, again in Roman dress, reclining in a pose clearly intended to evoke that so frequently found on Etruscan tomb figures. In Paris shortly before his death, the Earl had ordered a set of four tapestries from Jan Jans at the Gobelins, which were never delivered. However, the trustees of the Sixth Earl must have had to cope with crates of pictures and other objects arriving from the continent for some years after his inheritance, even after his mother's death in 1703 (the tomb sculpture arrived in 1707).

As Daniel Defoe wrote in 1724:

The late Earl of Excester, Father of his present Lordship, had a great Genius for Painting and Architecture. . . . It would be endless to give a Detail of the fine Pieces his Lordship brought from Italy, *all Originals, and by the best Masters; 'tis enough to say, they infinitely exceed all that can be seen in* England, *and are of more Value than the House itself, and all the Park belonging to it.*[66]

LATER CHANGES AND PURCHASES OF THE FIFTH EARL

There is no probate inventory of either the Fifth Earl, who died in 1700, or of his Countess, who died in 1703. We can, however, deduce a considerable amount about the last decade of the century from purchases still in the house, from the bills settled by the executors, from remarks by Celia Fiennes, who visited the house in 1697, and from the inventory taken in 1738 under Brownlow, the Eighth Earl.

The rooms on the ground floor that were un-finished in August 1688 may not have been finished by the Fifth Earl, for they are barely described in the 1738 inventory; little had been done in the inter-vening years. These rooms were the *Hall*, the center of the North Range, and the rooms on either side. The room on the west is called in 1738 the *Billiard Room*, for it held a billiard table, and the room on the east is not even mentioned. There were neither furniture nor pictures in the *North Hall*.

In the 1690s, three further sets of tapestries were ordered, two from Vanderbank, the other from Jan

Jans at the Gobelins. The Vanderbank tapestries were the *Story of Venus and Cupid* and the two *Grotesques*. In 1738 the *Venus and Cupid* was in the *Chints Bedchamber* (the *North Bed Chamber* of 1688), replacing the Aemillius tapestries that had gone to Snape Castle. The *Grotesques* replaced the *Bacchanals* in the *Green Mohair Bedchamber* (*The Bedd Chamber next ye Gallery Roomes* of 1688), today the Black and Yellow Bedroom, where they still hang. The *Bacchanals* had been moved to the *blue Velvet Bedchamber*. A set of three *Elements* by Vanderbank—ordered in about 1685 and clearly intended for the Second George Room, where they hang today (see fig. 25)—were still in the Wardrobe in 1688. A fourth tapestry, "Earth," was probably never ordered, for there was no room for another tapestry in the Second George Room, where the three fit exactly. On the other hand, no place seems to have been envisaged for the set of four Mortlake *Acts of the Apostles*, made after cartoons by Raphael, probably between 1670 and 1678. These, too, were in the wardrobe in 1688. The order placed with Jan Jans in 1700 was for a set of four from a "Tenture des Indes" series for the considerable sum of 7,950 livres; 3237 livres were paid, and one tapestry was duly delivered to Lord Exeter's agent. Three were not finished when the Fifth Earl died, and the executors apparently never took delivery of any of them. (Nor did they pay the balance; Jans was still petitioning the Sixth Earl in 1716.)

Celia Fiennes, the independent-minded traveler and diarist, visited Burghley in 1697. She gives a slightly confusing account of her entry, as she seems to have entered first through the North Courtyard. Yet she certainly entered through the West Door, as she praises the Tijou gates (see fig. 6): "the door you enter is of iron carv'd the finest I ever saw, all sorts of leaves flowers figures birds beast wheate in the Carving." She continued through the Inner Court and through the East Porch in the East Range into "the hall [which] is a noble roome painted finely, the walls with armory and battles." This room was the *Salloon*, the central room of the East Range, which had been painted by Verrio, according

to the 1738 inventory, *all round, the Ceiling represented to be supported by 10 Marble Pillars & Marble Cornish, upon the ceiling a large garland of fruit supported at the 4 Corners wth Stone Work: in the Middle, Bacchus and Ariadne. . . ; this painted in colours*. Unfortunately, this decoration was later removed by the Ninth Earl.

Celia Fiennes describes the house in some detail; she went into the private rooms (where she was shocked by the pictures) as well as into the State Rooms. She relates that "My Ladyes Closet is very fine the wanscote of the best Jappan"; this is the only hint we have that the closet was wainscoted in lacquer, almost certainly from dismembered Chinese Coromandel screens. In all probability the closet was the work of Gerreit Jensen, who also worked at Chatsworth, where in 1692 he submitted a bill "ffor frameing, moulding & cutting of the Japan for the Closet, & joyning it into pannells and finishing it" and "ffor japanning the Closet & mending the Japan."[67] According to Celia Fiennes, the Chatsworth closet was also wainscoted in "hollow burnt Japan." Fiennes also comments on the contents of Lady Exeter's closet, where

> there is a great deale of fine worke under glasses and a Glass-case full of all sorts of Curiosityes of amber stone, curral and a world of fine things. My Lord Excetter in his travells was for all sorts of Curious things if it cost him never so much, and a great many of my Ladyes fine things were given her by her Mother the Countess of Devonshire.

This lacquer room was presumably dismantled before 1738, when the room was called the *Shell Closet*.[68] (The room at Chatsworth was dismantled in 1700.)

Fiennes was able to walk through the George Rooms, even though in "some the floores [were] not laid others not finish'd." Verrio had finished the ceilings that year, and she remarks upon some rooms as "very large and lofty and most delicately painted on the top, each roome differing," though she says there were "at least twenty," which there never were. She does not discuss the *North Dining Room*, which is a pity; either she could have told us

Figure 16. Plan of the Park and Garden at Burghley House drawn by John Haynes in 1755 for the Ninth Earl, as it was laid out by the Fifth Earl. The plan remained virtually unchanged until the drastic remodeling of the park by Capability Brown for the Ninth Earl in the 1770s. (Collection Centre Canadien d'Architecture/Canadian Centre for Architecture, Montreal)

how it looked before it was painted by Laguerre, or she might have commented on his work, which began in 1697. Nor does she remark upon the family, implying that she did not meet them and was presumably taken around by an upper servant, the normal practice of the day for those who arrived well horsed or well dressed.[69]

> The great variety of the roomes and fine works tooke me up 2 full hours to go from on roome to another over the house. . . . it is esteemed the finest house and scituation that is in England and will be very compleate when finish'd.

The Garden

If the Earl and Countess were determined to make the house a showpiece, they were equally determined to create a worthy setting for the house in the garden and in the park. Lord Burghley had had a formal garden with raised terraces and formal walks within a park, but not much is known of its detail. Between

1678, when the Fifth Earl inherited, and 1685, he had spent some £450 on the purchase of specified trees, representing probably at least 5,000 plants.[70] In 1683 the landscape gardeners London and Cooke were engaged to draw up further plans.[71] An estate map of 1755 (fig. 16) shows the garden and park much as it was at the end of the seventeenth century. The formal areas were closer to the house, mainly centered on the South Front, and radiating avenues led from the house in the typical *patte d'oie* arrangement. There were, of course, ponds, mostly formally shaped and, according to Celia Fiennes, a great fountain: "the Gardens very fine within one another with lower and higher walls with Statues and fine Grass walks, dwarfs and all sorts of green trees and curious things, very fine fountains, there is one in the middle of the house, that is of an exceeding great size." This means that it, too, was centered on the axis of the South Front.

The final part of the garden of this plan was the mile-long Queen Anne's Avenue, aligned on the

Figure 17. Weighing more than 230 pounds, the silver wine cooler bought by the Eighth Earl from Philip Rollos in 1724 must be one of the largest in existence. The handles are modeled as the lion supporters of the Cecil coat of arms. (Burghley House)

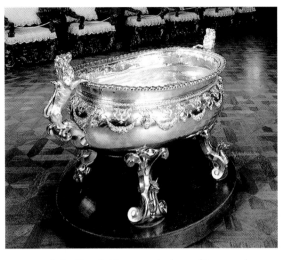

center of the South Front and planted in 1702 by George London, whose last payment (£254) was made in 1704. Most of London's work, except for the avenue, was to be removed by the Ninth Earl after 1755.

THE HOUSE IN THE EIGHTEENTH CENTURY
The Early Years

John, the Sixth Earl (1674–1721), inherited an estate administered by trustees laboring under the enormous debts accumulated by his father and, it must be said, by his mother. London's contract for the park was finished in 1704, but little else. No work was done on the George Rooms and apparently not much on the unfinished rooms on the ground floor of the North Range, even after the accession of the Eighth Earl in 1721. The *North Hall* was empty, and only the *Billiard Room*, adjacent to the west, had been made usable. The room that was called the *Guilt Leather Dining Roome* in 1688 was called *the Old Billiard Room* in the 1738 inventory, so it, at least, had changed function, probably since the death of the Fifth Earl. The Sixth Earl acted as Chief Butler (not, curiously, as Grand Almoner) at the coronation of Queen Anne in 1702, and the silver-gilt dish in this exhibition (cat. no. 108) may have been given to him then. The Seventh Earl (1674–1721) had died within a year of inheriting and was succeeded by his brother Brownlow, aged twenty.

The Eighth Earl (1701–1754), like his grandfather, married an heiress. To celebrate his marriage in 1724 to Sophia, daughter and co-heir of Thomas

Chambers, he bought from Phillip Rollos[72] the celebrated wine cistern (fig. 17), which has handles modeled as the lions that are the supporters of the Cecil arms; the interior is engraved with the Cecil arms, with Chambers in pretence. This massive piece of silver, weighing some 3,690 troy ounces, is probably the largest and heaviest in England. As if this was not enough, in 1728 the Eighth Earl also ordered the silver wine cistern and fountain (cat. nos. 110A&B) from Thomas Farren, to be used in the *Red Velvet Dining Room*. The wine cistern can be seen in place in the engraving done by Lady Sophia Cecil in 1815 (see Nelson essay, fig. 9).[73] As Grand Almoner at the coronation of King George II in 1727, the Eighth Earl probably received the silver-gilt ewer shown here (cat. no. 109) as his official perquisite. Bills survive for many other things, including furniture and pictures. We know that he continued to buy works of art, for in the inventory of 1738, taken seventeen years after he had succeeded, a picture is listed *that was bought last Winter*.

The 1738 Inventory

A comparison of the 1738 inventory and the 1688 inventory reveals some curious changes and an even more curious lack of changes. The person who took the 1738 inventory measured each room and described the fixtures, such as the paneling and window ledges, whereas Tanner had ignored all fittings. On the other hand, the 1738 inventory is perfunctory, to say the least, about furnishings and furniture. No doubt the two inventories were taken for different purposes.

We shall follow the rooms exactly as we did for the 1688 inventory, but because we have less information, we will only remark on certain rooms (plan 5, p. 72). The first surprise is the exchange of the Earl's and the Countess's apartments. The Countess now had the north part of the West Range, though she had no anteroom; Lord Exeter had that for his dressing room (it had been his grandfather's anteroom). Lady Exeter now had the former Lord Exeter's bedroom, still hung with the three *3 pieces of Blue and Gold Hangings by Vanderbanc* (which

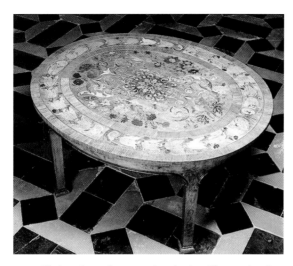

Figure 18. Marquetry table, the center of which was almost certainly part of the Floor Walnut-tree finely inlaid with Natural Flowers in Lady Exeter's Clossett in 1688. Probably this was done to the order of the Ninth Earl, who frequently reused earlier materials. (Burghley House, Bob Laughton)

Figure 19. Detail of the shell border of the Mortlake tapestry of Ovid's Metamorphoses in Queen Elizabeth's Bedroom. The border was most appropriate in 1738 when the closet next door became the Shell Closet and housed a collection of seashells. (Burghley House, Bob Laughton)

are still there); perhaps curiously, it still contained the same three paintings that had so shocked Celia Fiennes. Her bed was described as *a wrough Bed lined with blue satin. Lady Exeter's Dressing Room* and *Closet* followed; the former still contained the huge Recco flower-pieces (see fig. 8), here described as *done by Eques Reeves*. The oddity of this exchange of apartments is all the more striking when it is recalled that the *Clossett*, now Lady Exeter's, led into the Library wing. The *Tile Roome* in the North Range was now *Lady Exeter's outward Dressing Room*; the floor must have been changed, for had it been tiled, it would have been remarked upon. She had two walnut bookcases with glass doors, a Japan cabinet, a walnut chest of drawers, and *an handsome Buroe with Glass-Doors*; the latter may well have been the *Bookcase and Chest & Glass Doors* supplied by Phineas Evans for 10 guineas in 1727.[74] Lady Exeter must have used this well-furnished room as a private sitting room. Apart from the overdoors, the pictures had been changed.

South of the *Arch* (the Gothic Hall in the West Range), Lord Exeter's *Anti-Chamber* still had the painting of *Daphne and Apollo* over the chimney as well as some of the other former pictures. The *Desk inlaid* just might have been the Gerreit Jensen table (cat. no. 91). The bedroom was called the *Red Velvet Bed Chamber* and was hung with *Tapestry, Esop's Fables, wove in France by Mons.r Jant*. It had a mirror and chest *inlaid with Flowers*. The *Dressing room* was still hung with crimson damask and Indian flowered silk and contained most of the original

pictures, including three paintings by Liberi, one of David and Bathsheba by Giordano, and a *Woman taken in adultery*, which had hardly been suitable when it was Lady Exeter's dressing room. The closet that Celia Fiennes had described as paneled with "Jappan" was now called the *Shell Closet*. We have already seen that the Countess of the Fifth Earl had insisted on the best, so it is worth noticing the configuration of this small but extremely important room, so well described here:

> *A square of 10 feet, the Ceiling Fretwork* [that is, one of the finest of the ceilings carved by Edward Martin], *the Floor Walnut-tree finely inlaid with Natural Flowers, hung with green Velvet, a case lined with the same; upon ledges lies a fine Collection of Shells, Glass-Doors round 'em carved and gilt in the same Manner as all the Cornishes, Door-Cases, & Picture Frames.*

The two glass-fronted cabinets, most unusual at this date, are built-in rectangular niches, and they contained the fine *Collection of Shells*, which gives the closet its name. Shell collecting was a fashionable and expensive pursuit;[75] some of the shells may have been as expensive as the pictures. The inlaid floor—clearly the only one in the house—was later removed and the central oval used for a tabletop (fig. 18), now in the West Hall.

It is difficult to judge how much the room had changed since 1688; the pictures seem to have been as before, including those by Carlo Dolci.[76] The room was still hung in green velvet, but Tanner had not mentioned the wall-cases, nor had he mentioned objects suitable for shelves, except for the china over the chimney. They must have been installed since 1688, for in 1697 Celia Fiennes called this room the Japan Closet when it was wainscoted in "the best Jappan" (presumably below the green velvet). She continues, "there is a great deale of fine worke under glasses and a Glass-case full of all sorts of Curiosityes. . . ." The cases have a slightly odd appearance, as if they might have been made up of spare pieces of the correct woodcarvings. The table *inlaid as the floor* was still there, and upon it *a fine set of white China, figured and scqalloped*, but no other

porcelain is mentioned, nor is the figure of Apollo and Daphne (cat. no. 55). The last item on the short list of contents, other than the pictures, is *the Lock silver carved* (cat. no. 102), which presumably had been fitted for the wife of the Fifth Earl after she inherited it in 1690, and hence after the 1688 inventory was taken.

Coming into the South Range, the previous *Best Bedd Chamber* was now *the Turenne Room*[77] and was still hung with the *Metamorphoses* tapestries (see fig. 9); their borders, woven with shells (fig. 19), make a nice reference to the closet. The bed had *gold Tissue ground, velvet flowers with green Sattin all embroidered*, not the earlier crimson velvet, which may be that in Lord Exeter's bedroom. It had a *fine old Japan Screen above 9 Feet high*, which must have been Chinese Coromandel lacquer. The *Drawing Roome* next door was now the *blue velvet Drawing Room* (it was hung with blue velvet before 1688). The room still held the large pictures by Giordano, but the Florentine cabinet was no longer present. Between the four windows were *three Sconces gilt Frames at the Top the Crest and Coronet. Underneath, three gilt Tables with the Crest in the Middle.* These were the tables and sconces sup-

plied by Phineas Evans to the Eighth Earl in 1729, presumably ordered expressly for this room. Evans's bill (fig. 20) lists *Three Sconces carved and Guilt in Gold with A Trebble Branch to each at £14.14.0 per sconce Total £44.2.0* and *for three Tables carved and Guilt in Gold at £9.9.0.* Note the comparative prices; it was mirror-glass that was expensive. One of these sconces is exhibited here (cat. no. 94); the tables are lost.

In the *Marble Saloon*, the portraits of the Fifth Earl and his Countess by Lely (cat. nos. 3A&B) were still high up on the wall. The basins and the *Andromeda chained* by Monnot, delivered after the death of the Fifth Earl, were also here. The *Red Velvet Dining Room* retained the crimson figured velvet of the 1688 inventory. The pictures remained much the same. The *Tea Room*, too, retained most of its original pictures. The area under the great staircase was now called the *Alsatia*.[78] The *Guilt Leather Dining Roome* was now the *Old Billiard Room*; no mention is made of the leather wall hangings. Tanner had not discussed the *Saloon*, the center hall of the East Range; the present inventory carefully describes Verrio's wall and ceiling paintings, now lost. The *Smoaking Roome* retained the same name. We have already seen that the 1738 inventory barely discusses the ground floor rooms in the North Range, though the room to the east of the main hall was now called the *Bethlehem* room, after the Order of New Bedlam, the revival of the Fifth Earl's drinking club.

Upstairs (plan 6, p. 73), the *Chapel* now contained nine religious pictures; Tanner had mentioned no pictures. The *Plaster Dining Roome* was now the *Brown Dining Room*; the *North Dining Roome* was now the *Bow Room*, named after the great bow window. The paintings by Laguerre (his name is not mentioned) are described as the stories of Mark Antony and Cleopatra and of Scipio. On the *Marble Mantle Piece* still stood *very fine old china*; notice the lack of description. There is no hint of a possible use for this room. The *North Drawing Room* was still hung with tapestry, possibly the story of Psyche that was there in 1688, though this is not specified. There was a *large Looking Glass in a wrought Silver Frame: underneath, stands a Tea Table of the same* and there

were *upon the Hangings. . .large Silver carved Sconces for Candles* (possibly cat. nos. 103A&B). The next room was now called the *Green Mohair Bed Chamber* and was hung with tapestries *upon a brown ground*, meaning the Vanderbank *Grotesques* that had replaced the *Bacchanals* in 1689 or 1690. The bed was hung in green mohair *Insid & Out ye Same*, and there was a *large Sconce in a gilt Frame, the Crest and Coronet atop*. The corner room, the *North Dressing Room*, was that for the *Green Mohair Bed Chamber*.

The central room of the West Range, today's Pagoda Room, was called a *Dressing Room* in 1738. The range appears no longer to have been laid out as two apartments, but as sets of bedroom and dressing room. It is difficult to see quite how this layout worked in practice, as there is one too many dressing room. The central room, however, was furnished as a saloon. It had the same pictures as before, including those by de Koninck, but also an ebony cabinet with painted drawers. It was paneled in oak, unlike the other rooms in this wing, which had painted or marbled softwood paneling. It seems probable that this room had been paneled with the sixteenth-century paneling refitted, for the two closets in the tower turrets now contain fine-quality paneling of that date. If so, then the Pagoda Room was in all probability renovated with the present paneling by the Second Marquess for the visit of Queen Victoria in 1844. If we read this room as a saloon, ignoring the name in the 1738 inventory, then the apartments run as before: the *Chints Bedchamber* and its Dressing Room to the north and the *blue Velvet Bed Chamber* and its Dressing Room to the south. The southwest corner room, the First George Room, would have been the dressing room for the bedchamber in the Second George Room had that been functioning.

The *blue Velvet Bed Chamber* (the *South Bed Chamber* of 1688) was hung with three pieces of *Bacchanalian* tapestry, probably three of the set of four *Bacchanalian* or *Naked Boyes* tapestries that replaced the *Moses* tapestries that had gone to Snape. These Mortlake tapestries probably had been bought before 1678. One of them remained in the *Wardrobe* and has rarely been shown, hence its

brilliant and almost original coloring (cat. no 99). The Wissing portrait and the overdoors were no longer the only pictures. The japanned chairs may have been the ones formerly in the *Best Bedd Chamber*. The *blue velvet Dressing Room* was hung with yellow damask; the marbles were still there. More important, the inlaid cabinet and its candlestands by Pierre Gole (see fig. 12), bought by the Fifth Earl in Paris in 1679 and formerly in the *North Drawing Roome*, stood here.

The *Chints Bedchamber* was named after *The Bed Chints lined with white Indian Silk*. The room was no longer hung with the tapestries of the story of Paulus Aemillius, for they had gone to Snape, but with the *Story Cupid*, probably those ordered by the Fifth Earl from Vanderbank after 1688. The *Dressing Room* was still hung with crimson damask. There were many more pictures than before, two green-and-gold settees, and a carved silver table and looking glass, probably similar to those in the *North Drawing Room*. In the *Closet*, perhaps surprisingly, was the grand Florentine cabinet (cat. no. 93) given to the Fifth Earl by the Archduke Cosimo. Now upon a stand of six marble statues, it had been in the *Drawing Roome*. In a small room off the *Closet* was a door that opened onto the roof-leads of the northward wing, later to be removed by the Ninth Earl, which then held the Library.

The First George Room, called a *Dressing Room*, and its closet, now the *Jewel Closet*, were described as *finished for a Model for the rest*. Uniquely, *the floor is inlaid with squares with walnut-tree*. The room was now full of pictures and hung with red damask with olive-green flowers. There were two *fine old Japan Tables* and a *fine Japan Cabinet. . .on a gilt Frame carved. . .fine old China upon it, and underneath the Frame*. This reflects the convention of placing blue and white Chinese and Japanese porcelain on and under lacquer cabinets, the practice that had been so decried by Daniel Defoe.[79] The *Jewel Closet* contained many miniatures, including several shown in this exhibition. No furnishings are mentioned in any of the other George rooms.

The Ninth Earl

Brownlow, the Ninth Earl of Exeter (1725–1793) inherited from his father, who died in 1754, an estate that was solvent and prosperous. He apparently had considerable admiration for his great-grandfather, and he followed his footsteps traveling to Italy, where he bought a huge number of paintings and other works of art. It is ironic that the Lord Treasurer had left a book *of Precepts…left by William Lord Burghley, to his Sonne, at his death*,[80] which includes the sound advice, "Suffer not your Sonnes to passe the *Alpes*: for they shall exchange for their forraine travell… but others vices for their own vertues…." It was perhaps for reasons of this admiration for his great-grandfather that when the Ninth Earl had his portrait painted by Thomas Hudson in 1747 (cat. no. 5), he was depicted wearing seventeenth-century dress.[81]

Most importantly, the Ninth Earl again took up the work of refashioning Burghley, continuing the refitting of the George Rooms and purchasing furniture from the best cabinetmakers. The George Rooms were done with exceptional tact. Unlike most contemporaries of his rank, the Ninth Earl did not have the work done in the latest fashion, but contin-ued the wainscoting in oak, carved to the same high standards that his great-grandfather had demanded. Outside, he employed Lancelot "Capability" Brown

as architect and landscape gardener.[82] He allowed Brown little freedom in the house, keeping rigid control over any alterations that might affect the interiors, but he allowed him to sweep away the formal gardens and create the park as it is today, an amazing contrast with what had been there but fully in keeping with the ideas of the time. Following William Kent, all nature was seen as a garden.[83] There can scarcely have been any element of economy in this—even though a landscape park is far less expensive to keep up than a great formal garden—for the outlay was enormous.

Almost as soon as he inherited, the Ninth Earl had architectural drawings and plans made of his inheritance by John Haynes.[84] Thus we have a 1755 plan (see fig. 16) and several drawings of the formal gardens created by London and Wise for the Fifth Earl and completed in 1704. Comparison with the park today shows the vast extent of Brown's work, covering more than six hundred acres, and explains the great salary of £1000 per year that was paid to him from 1755 to 1779.

Brown pulled down all the outbuildings that stood to the west of the northwest wing of the house (see fig. 1). By 1780 he had also pulled down that wing, which had contained the Library. This change opened up the north courtyard on the west side; Celia Fiennes had described the court as enclosed with a

Figure 21. Burghley seen from the southwest through the arches of the Lion Bridge, built for the Ninth Earl to Capability Brown's designs as part of his remodeling of the garden and park into a landscape. (English Life Ltd.)

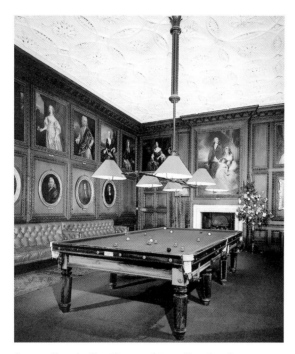

low wall and tall railings. This wall and railing were extended to meet the house at the west end of the North Range. Thus the whole northwestern approach to Burghley—the approach that we originally made to the house—was opened up. To compensate for the lost outbuildings, Brown built new stables and other essential offices on the east side of the house. He also built the present Orangery on the southeast. The charming Banqueting House north of the lake, in a mixture of the neoclassical and the neo-Tudor, was designed by Brown but not built until 1787, after Brown had left Burghley. There were also a boathouse and various grottoes.

Brown swept away the formal ponds, dammed the stream to make an artificial lake of irregular outline, and used the spoil to create a small hill to the southeast of the house. Before work on the lake commenced, Brown designed the Lion Bridge (fig. 21), which was built between 1773 and 1775. Four Coade-stone lions[85] were supplied by Mrs. Eleanor Coade in 1778 (for £114), but the Second Marquess thought they were not sufficiently dignified and removed them in 1844, in time for larger stone lions by Henry Gilbert[86] to be substituted for the occasion of Queen Victoria's visit. The lake was full enough for stocking with fish in 1784. In fact, the lake followed a contour and was not all that wide; it was called by the household the New River. At first it

covered less than eleven acres; it was widened in 1795 (at vast expense) by the First Marquess and again in 1885 to the present size of twenty-six acres.

On the house itself, Brown was particularly active on the facade of the South Range. By raising the height of the two sections between the center and the end bays by the addition of a seven-foot-tall blank wall, he realigned the roofline to be almost straight, adding the connecting balustrade. The upper windows in this wing are, of course, false and were heightened by Brown.

Within the house, it was almost certainly Brown who added the ceiling to the *Plaster Dining Roome* of 1688, the present Billiard Room (fig. 22), to a design derived from engravings of recently discovered ruins at Palmyra.[87] When Brown was dismissed in 1779, the Grand Staircase (later called the Hell Staircase) had not been rebuilt. This was done soon after, probably in the 1780s, to designs by Thomas Lumby,[88] adapted from a presentation drawing by Robert Adam, dated 1779,[89] by John and Robert Hames.[90] At the same time, the *Tea Room* was incorporated into the *South Dining Room*, with a screen of two pillars, very much in the style of Adam and, again, probably from an idea by him.

The most important work to the interior was the near-completion of the George Rooms, the first floor of the South Range (they were not quite finished when the Ninth Earl died). These rooms had ceilings painted by Verrio (see fig. 14 and Nelson essay, p. 19, fig. 6), and the cornices and possibly some of the doorcases were carved by Mayne and Young. However, the paneling was not installed, nor were the floors laid. Only the First George Room had been completed before 1738. The firm employed for most of the work in the George Rooms was that of James Newton.[91] Among many of their surviving bills is one of March 14, 1790, *for wainscoting, carving and gilding one of the George Rooms at Burghley £890.17s.6d.* We have remarked earlier upon the great tact used by the Ninth Earl in the completion of the George Rooms. Today, if one walks through them from the first to the fourth, one sees only slight concessions to recent fashion; the

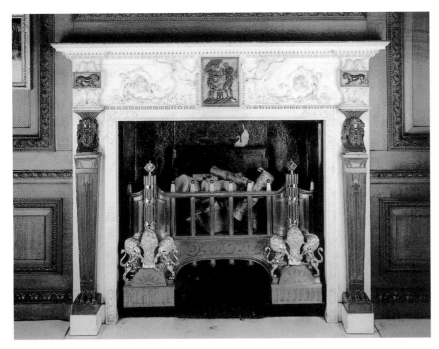

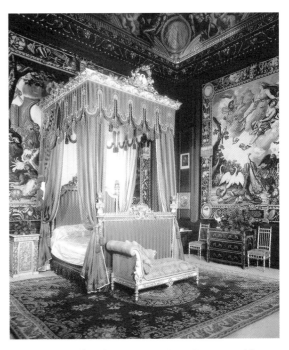

Figure 23 (left). The marble and porphyry fireplace made by Giovanni Battista Piranesi, partly from antique components, in the Second George Room. This fireplace was bought by the Ninth Earl in Italy. (Burghley House)

Figure 24 (right). The State Bed supplied by Newton and Fell in 1791 in the Second George Room. The tapestries depict the Elements and were woven by Vanderbank for the Fifth Earl. In the borders, vignettes show each of the Earl's many houses. (English Life Ltd.)

carving has an increasing hint of the neoclassical as one progresses. The work is all in oak, following the earlier precedent. All the fireplaces are central, except for the corner one in the First George Room, and the chimneypieces are neoclassical in taste. The chimneypiece in the Second George Room, of white marble and porphyry (fig. 23), was made by Piranesi and purchased by the Ninth Earl in Italy.[92] This room was fitted to take the Vanderbank tapestries of the *Elements* that in 1688 were still unused in the Wardrobe; there must be a presumption that they had always been intended for this room. The tapestries are particularly remarkable in that the borders contain cartouches depicting the Fifth Earl's various houses. The Third George Room was hung with damask above dado-level wainscot, and the Fourth George Room was paneled. The Fifth George Room is the *Heaven Room* (see fig. 14).

As we have seen, the staircase in the staircase hall was rebuilt in the 1780s. The Ninth Earl also refurbished the North Hall. He added pillars of scagliola by Bartoli;[93] a memorandum from the Earl to his sister Lady Betty Chaplin from abroad in 1768 includes item 49: *If the pillars in my North Hall have done sweating before my return, Lady Betty will order Bartoli down to repair and polish them.* Bartoli's former partner, Richter, replaced these pillars in

1801–1802 with columns imitating Sienna marble, in a greatly improved technique.

Naturally, the Ninth Earl needed much new furniture. He was careful to employ the celebrated cabinetmakers Mayhew & Ince,[94] while at the same time using the less well-known James Newton (whose company was renovating the George Rooms). Mayhew & Ince supplied, among many other pieces, *4 tripods for the Hall, very richly carv'd and gilt with lamps to ditto gilt and varnish'd* at £120, in April 1768 (for one, see cat. no. 95), the grand commode (cat. no. 98), the pair of medal cabinets (for one, see cat. no. 96), both recognizably in the style of Mayhew & Ince,[95] and the chairs for the *Chapel* (for one, see cat. no. 97). No bill survives for the chairs, but the Ninth Earl's memorandum to Lady Betty Chaplin of 1768 includes a request *to hasten Mr Mayhew in the furniture which I have ordered him to make for the chapel at Burghley*. They also supplied the magnificent bed for the Blue and Silver Room. Newton provided the very grand State Bed (fig. 24) for the State Bed Chamber (the Second George Room) and furniture for the private apartments in 1791 for a total cost of some 3,000 guineas. He had already supplied three looking glasses and their pier tables for the Red Drawing Room; a similar set, of one only, for the Blue Drawing Room; a matching overmantel mirror for

Figure 25 (left). The Blue
Drawing Room, with
Newton's overmantel mirror.
The pier-glasses and tables
en suite are not visible in the
picture. Over the mirror hangs
the portrait by Angelica
Kauffman of the Marchioness
of Townshend and her son as
Venus and Cupid. (Burghley
House, Bob Laughton)

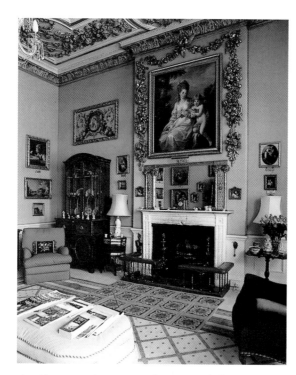

Figure 26 (right). One of
the set of commodes and corner
cupboards made up of old
pieces of marquetry by Mayhew
& Ince for the Ninth Earl in
1767. (Burghley House)

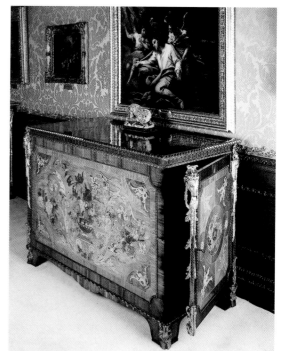

the Blue Drawing Room (fig. 25); and also a cabinet;
all are still in place.

Curiously, the Ninth Earl tended to reuse older
material, probably for antiquarian reasons rather
than parsimony; both Mayhew & Ince and James
Newton were required to use older materials for
certain pieces of furniture. On August 27, 1767,
Mayhew & Ince submitted a bill for *Entirely new
working, some old inlaid work, making good the
defficiencys, and making up the same, into 2 commodes*
(fig. 26), *one with sliding shelves, lined, the other with
drawers, both with brass mouldings, and other very rich
ornaments, finely gilded and lacquer'd Two corners
ditto, to match them complete* at £237.15s.0d.[96] They
are describing the magnificent but decidedly
eccentric pair of commodes and pair of corner
cupboards now in the Third George Room. The
origin of the marquetry panels is unknown. It is
possible that it was Mayhew & Ince who turned
part of the marquetry floor of the Countess's closet
into the tabletop to be seen today in the West Hall
(see fig. 18). Newton, too, had to incorporate two
sections from a walnut secretaire into two cabinets.
In all probability this was the *walnutt Tree Cabinett
or Scritto* that had stood in the *Chapel Chamber* next
to the Fifth Earl's upstairs closet. These cabinets
are still in the house.

The 1770s Inventory

The Ninth Earl was a compulsive list maker. The
archives at Burghley contain his commonplace
journal in which are many of his lists, recipes, and
supposed cures for all ills. He made various
incomplete lists of pictures and other items in the
house, but he seems not to have kept records of his
travels in Italy, which one might have expected him
to do. There is an undated partial inventory, which
can be dated to after 1767 by its inclusion of the
Mayhew & Ince made-up commodes and corner
cupboards that were supplied in 1767. Entitled
*Inventory of the plate, pictures, china, linnen, and
house-hold furniture at Burghley, -taken by me,
Exeter*,[97] much of it is in Lord Exeter's hand, but it
has been annotated extensively in another hand.

The Gothic Hall on the ground floor of the West
Range (plan 7, p. 74) was called in this inventory the
passuage. The patterns of Lord and Lady Exeter's
apartments have been reversed again, so that Lord
Exeter had the north apartment and Lady Exeter the
south, as it was in 1688. Lord Exeter's *dressing room*
contained a *settee bed* (fig. 27), which must be the
one supplied by Robert Tymperon in 1750 (the
invoice reads *Wall sofia bed. . .£8.8.0*).[98] It is still in
the house. His *bed chamber* kept the Vanderbank
blue and gold tapestries and thirteen pieces of blue

and white china; the bed had been supplied in 1768 by Mayhew & Ince, at great expense. Alas, we are not told whether the pictures that Celia Fiennes had found "immodest" had been changed. South of the *passuage* was the *outer dressing room* which held *a double Chest of Mahogany Drawers* and, again, thirteen pieces of china. In *Lady Exeters dressing room* were *the four senses (Dresden china)* (cat. nos. 64A–64D) and *Two small enamell'd china jars & covers* (cat. nos. 63A&B). The Closet was no longer the *Shell Closet*, but the *Japan Closet*. Presumably, though we are not told so, the built-in cupboards held the collection of Japanese and other small lacquer boxes and other objects that would be described in this room in 1804. The shells had been moved to the northwest turret closet.

In the South Range, the *Best Bedd Chamber* of 1688 was now the *picture room*, which suggests that the great bed had been taken upstairs, which in turn suggests that the George Rooms were in the process of being furnished, even though unfinished. If so, then this inventory dates to before 1791, when James Newton supplied the State Bed (see fig. 24) specifically for the Second George Room. If the rooms were completely furnished, the Ninth Earl would have described them in the inventory, but he does not. In this room, today the Blue Drawing Room (see fig. 25), were two sets of chairs and *one marble table between the windows, guilt and carv'd* and *One glass between the windows in a carv'd and guilt*

Figure 27. The settee bed by Robert Tymperon, supplied in 1750. It folds out into a bed and may well have been used by the manservant of a visitor sleeping within call of his master. (Burghley House, Bob Laughton)

frame. These are the set supplied by Newton, date unknown, which are still in the room. The *drawing room* had *three Girandoles for candles* (cat. no. 94), supplied by Evans in 1729 (see fig. 20), which must have been between the windows. There is no mention of the tables, nor is there mention of the three sets of pier glasses and tables to be supplied by Newton for this room to replace those of Evans; presumably they had not yet been delivered. The rococo overmantel was installed by Mayhew & Ince in 1767. There were three pictures by Giordano, *one carpet work'd in a mosaic pattern for summer;* [and] *one Turkey carpet for winter*. Carpets appear in some numbers in this inventory, in contrast with that of 1738; it is interesting that they might be changed according to the season.

On the other side of the *marble hall* was the *dining room*, which had two sideboards and sixteen chairs, all of mahogany, and a *Turkey carpet*. On the chimney stood *two horses in brass* (surely cat. nos. 50, 51) and *four figures carv'd in box-wood*; four figures from the same set are shown here (cat. nos. 54A–54D). On the North Range, the *Bethlehem Room* of 1738 was now the *North Dining room*, which contained *a Horse Shoe Table mahogany*, fifteen chairs, and a mahogany organ. The *North Hall* was now called the *Egyptn Hall* and seems to have been used as a storeroom. The *Billiard Room* of 1738 was now the *Library*; it contained desks, chairs, a carpet, and 3,191 books. Presumably Capability Brown had by then pulled down the north-extending wing that held the old Library. In the *Breakfast room* next door (it had been *Lady Exeter's outward Dressing Room* in 1738), there was also a *Turkey Carpet*. There were bookshelves on the east side of the room; later, shelves were added on the south and west sides.

Upstairs (plan 8, p. 75), the *brown dining room* retained its function and contained the portrait of the Ninth Earl by Thomas Hudson (cat. no. 5). There were now three dining rooms and a breakfast room. The *Bow Room* was now the *bow window room*; the contents give no clues as to its use, but on the chimney was some porcelain, including *two elephants in china*, one of which is shown here

(cat. no. 76). Next door in the *North drawing room* were *eighteen wallnut-tree chairs* (now a bit out of date) and a *six leav'd indented japan screen*, which may have been a Coromandel screen.[99] The Japanese porcelain *two china boys wrestling* (cat. no. 77) and some pieces of *blanc de Chine* stood on the chimneypiece. The *Green Mohair Bed Chamber* was now the *black bed-chamber*. The corner room, the *West Dressing room*, now held the *curious Florence cabinet on a guilt frame* which is likely to have been the one shown here (cat. no. 93), not the less imposing one now in the Heaven Room. There was also a silver-gilt toilet service, not the one represented here (cat. nos. 106A–106F), but another still in the house. Included with it were the *two cocoa nut cups silver gilt* that were in Lady Exeter's *Dressing Roome* in 1688. The *Chints Bed-Chamber* was now the *West Bed Chamber*. The Pagoda Room was now *Queen Elizabeths room*, which contained the Gobelins marquetry cabinet (see fig. 12) and its stands by Pierre Gole and *A large oval table curiously inlaid*, which may be the table made from the floor of Lady Exeter's *Clossett* of 1688 (see fig. 18). Among the china were *two row waggons* (cat. nos. 85A&B). Next door was the *Green Bed-Chamber*, formerly the *blue Velvet Bed Chamber*, with the Bacchanalian tapestries. The First George Room was called *The dressing room to the George rooms*, and the *Jewel closet* retained its name.

The George Rooms are not described in the Ninth Earl's hand but in another, later hand, possibly that of the First Marquess, at an unknown date but certainly around 1795. The Second George Room was *the bedchamber*, though it apparently held no bed, and here hung the Elements tapestries. The two corner cupboards made by Mayhew & Ince stood in this room. The commodes (see fig. 26) were next door in the *drawing room*. Among the decorations were the *2 Old painted Dishes in Black Frames*, two of the majolica dishes bought by the Ninth Earl in Naples (cat. no. 76), the other four boxwood figures (see cat. nos. 54A–54D), and *2 Figr. ivory blck pedestal Daphne Folld by Apollo is changed into a Laurel* (cat. no. 55), bought by the Fifth Earl,

that was in *My Ladyes Clossett* in 1688. The Third George Room was the *drawing room*, where the Joseph Nollekens[100] marble head of *Medusa* (cat. no. 58), bought by the Ninth Earl in Rome in 1764, stood on the chimneypiece. There was also *Livia from Dr Meads collection 1755 upon ye table* (cat. no. 47).[101] The *dining room* contained the *Child sleeping by Pietro Monot of Besancon white marble*, the marble busts of the Fifth Earl (cat. no. 4) and his Countess by Monnot, and *1 mahogany fluted stand Boy Hercules Black. By Algardi* (cat. no. 49).[102] This inventory provides the first indication of the use of the George Rooms, partly furnished even though they were not completely decorated.

Second Excursus: The Travels of the Ninth Earl
The Ninth Earl made two trips to Italy, in 1763–1764 and 1768–1769. Curiously, although he was a maker of lists, he left very few clues as to his itineraries; there is no travel diary and no lists of purchases. Annotated copies of contemporary books such as Orlandi's *Abecedario Pittorico* of 1704[103] remark upon his purchases but rarely give dates. However, we know that in common with most Grand Tourists, he went as far south as Naples, possibly tempted by reports of the finds at Pompeii, which had been "discovered" in 1748. In fact he stayed there a considerable time, befriending Sir William Hamilton[104] and patronizing Angelica Kauffmann,[105] who painted his portrait and other pictures (see fig. 25) for him. The actor David Garrick[106] tells us that he met Lord Exeter frequently in Naples, often with Lord and Lady Spencer, Lord Palmerston, and Lady Orford. At the same time the Ninth Earl was buying other things; several of the majolica dishes (cat. no. 59) have frames upon which is written in the Earl's hand, *Naples 1763*.

He was certainly in Rome in June 1764, for the historian Edward Gibbon tells us so.[107] There he met Thomas Jenkins,[108] the reputable dealer in antiquities, and the perhaps less reputable James Byres,[109] who sold him Poussin's *Assumption of the Virgin*, ca. 1626, and a so-called "Raphael." He also certainly visited Florence, Bologna, and Venice. His

picture buying seems to have been erratic: on the one hand, good pictures by Veronese, Bassano, Claude, and Poussin,[110] and on the other, many copies and fakes of old masters.

Having sat to Angelica Kauffmann, he apparently felt no need to sit to either Pompeo Batoni or Anton Raffael Mengs,[111] the most popular portraitists for Grand Tourists. He patronized several other artists, however, and collected books and prints. Presumably from his last visit to Rome came the two vitreous cameos by Reiffenstein (cat. nos. 46A&B)[112] and the fantastic chimneypiece by Giovanni Battista Piranesi (see fig. 23), of white marble incorporating (according to Piranesi) ancient porphyry carvings, which was to be installed in the Second George Room. On his return to England, he kept up a correspondence with Jenkins, who acted for him in various transactions, such as the commissioning of the mosaic picture of the pair to the Colosseum (cat. no. 45A), which the Earl had presumably bought in Rome.

THE HOUSE IN THE EARLY NINETEENTH CENTURY

The Inventory of 1804

The Ninth Earl died childless in 1793. Perhaps foreseeing this, in spite of his two marriages,[113] he had adopted and brought up his nephew Henry (1754–1804), son of his ne'er-do-well younger brother Thomas. Henry, the Tenth Earl (he was created first Marquess of Exeter in 1801) married three times; his first marriage was unsuccessful, and eventually she ran away with a consumptive curate. Disguising himself (partly, no doubt, to escape from his creditors), he stayed in a village in Shropshire where he lodged with the local cow doctor and fell in love with his daughter Sarah. They were married in 1791, and he took her back to his uncle at Burghley; it must have been somewhat of a surprise. That they adored each other is clear from the charming painting of them and their daughter Sophia by Sir Thomas Lawrence (see fig. 22). Sarah was often referred to as the Cottage Countess; she died in 1797 before her husband was created Marquess.

Henry finished the work on the George Rooms within three years of inheriting; the last bill from James Newton in 1797 was for £1,856.15s.9d. No inventory taken at the death of the Ninth Earl has been found, but there is one of 1804, upon the death of the Tenth Earl (First Marquess), in which there are some important changes. The ground floor of the West Range (plan 9, p. 76) remained bedrooms and dressing rooms, as before, though there is no affirmation as to which apartment was the Earl's and which was the Countess's. In the Gothic Hall there was now a water closet. The *Blue Bed Chamber* (Lord Exeter's bedchamber in 1688), today the Blue and Silver Bedroom (see fig. 7), contained a cabinet that may have been the one presented by the Archduke Cosimo, suggesting it was the Earl's bedroom. But the perfunctory 1804 description could also apply to another cabinet in the house, the one in the *Billiard Room*. The turret at the southwest angle was now called the *Japan Closet*, and in the two glass cases were sixty-three pieces of *curious Japan* and *34 pieces Curious Japann as Boxes Cabinets*, small pieces of (mostly) Japanese lacquer, which confirms our belief in its use in the 1770s.

The changes in the South Range are important. The completion of the George Rooms had allowed them to be furnished, and furnished in the grandest manner as State Rooms. Thus, some of the downstairs rooms were freed for family use. The *Turenne Room* now became the *Blue Drawing Room*, which was largely furnished by Newton; the floor was covered in a Wilton carpet, and there were *3 rose wood and gold Bookcases statuary tops* and *A mahogany and gold sofa in blue damask/ 4 Elbow Chairs to match*. The *blue velvet Drawing Room* became the *Red Drawing Room*, whose furnishings by Newton included the three pier glasses and their tables. The *Marble Hall* may have been used as a games room, for it contained two pianos, a card table, and a small billiard table. The *South Dining Room* seems not to have been used as such, for it contained such things as *boxes of ivory counters*. It was certainly used again as a dining room by 1815, when Lady Sophia Cecil depicted it (see Nelson essay, p. 22, fig. 9), showing a

mass of plate on the sideboard. On the chimneypiece were *2 metal horses gilt*, surely the bronzes by Fanelli (cat. nos. 50, 51).[114] The *Old Hall* (see fig. 2) was now hung with *4 large pieces Tapestry (the Cartoons)*, presumably the Mortlake *Acts of the Apostles*, and the four Mortlake *Bacchanal* tapestries (see cat. no. 99). The one shown here is presumably not one of the three that had been in the *blue Velvet Bed Chamber* in 1738. Also in the *Old Hall* were the *Andromeda chained* (removed from the *Marble Hall*) and *85 Glass front Cases with Stuffed Birds*.

In the North Range, the *New Bethlehem Room* became the *Stone Dining Room*, and the Hall was now called the *Scagliola Hall* after the columns added by the Ninth Earl. The *Billiard Room* became the *Library* (the billiard table had gone upstairs to the former *Brown Dining Room*), and the *Breakfast Room* became the *Ante Library*. At this time, libraries held not only books but also such things as curiosities and scientific instruments. The Tenth Earl had a considerable collection of working scientific instruments, most of which were kept in these two rooms. But the library was quite comfortable, for it also held one *Easy*, five *Elbow*, and two *Bergier* chairs and *a Mahogany Gouty wheel chair*. The *Scagliola Hall* was very sparsely furnished.

Upstairs (plan 10, p. 77), the *Brown Dining Room* had become the *Billiard Room*. There was a *Brussell Carpet round the table*, an ebony cabinet, and among *Ornamental China*, the Japanese porcelain *2 Chinese figures wrestling* (cat. no. 77). Next door, the *Ballroom* (the room decorated by Laguerre) had, with some (presumably) *blanc-de-Chine*, two other Japanese porcelains, the *2 elephants* that had been in Lord Exeter's *Dressing Roome* in 1688 (see no. 76). The *Brown Drawing Room* and the *Black Bedroom* each contained Turkey carpets; the latter had also *a Needle work Bed round Carpet*, and both rooms had either drugget or green baize around the carpets. Carpets were to be found in many rooms at this time, more than in the 1770s. The *North Dressing Room* contained *an inlaid french Writing Table*, which may have been the Gerreit Jensen table (cat. no. 91).[115] These three rooms were probably a suite for a guest.

In the West Range, the *Queen Elizth Room or Pagoda Room*,[116] called a dressing room in 1738 but probably a saloon, seems also to have been one in 1804. In it were *4 Delph Dishes painted in black frames*, which must be the majolica dishes bought by the Ninth Earl in Naples (see cat. no. 59). And, of course, there was the Chinese *Large Pearl Pagoda in a plate Glass Case*. The bedroom to the north, in 1738 called the *Chints bedchamber*, was now *Queen Elizabeths Room*. It contained the grand bed (see fig. 13) that may have been Lord Exeter's bed in 1688 and the chairs that have been ascribed to Daniel Cookman that were, in 1688, in the *Bedd Chamber next ye Gallery Roomes*. South of this room was the *Purple Bed Chamber*, where among *Ornamental China* stood the *2 Colour'd Chinese Cocks* (cat. no. 79). The corner turret was still called the *Jewel Closet* and then contained *A pietra dura Crucifix on a bracket* (cat. no. 38).

The George Rooms were the grandest State Rooms and were furnished suitably. The Second George Room was the *State Bedroom* and contained the great bed (see fig. 24) supplied by Newton in 1791; what must have been the Mayhew & Ince commode (cat. no. 98); the carving of Apollo and Daphne (cat. no. 55); and four of the boxwood figures (see cat. nos. 54A–54D). As the room was hung with the Vanderbank *Elements* tapestries, this was a very grand bedroom. The Third George Room had the made-up Mayhew & Ince commodes (see fig. 26) and corner cupboards and *3 carved & gilt candlebras* [sic] *3 light each*. These were probably the Mayhew & Ince torchères (cat. no. 95). On the chimneypiece was the marble head of Medusa by Nollekens (cat. no. 58).

Some Comments on an Inventory of 1854
An inventory of 1854 is chiefly concerned with ceramics and with the collection of small lacquer objects in the *Japan closet*. A few points are worth discussing here. The first mention was made of the London Delft *Large round dish with Burghley House. Blue and white*, dated 1745 (cat. no. 65); it was in the *Brown Drawing Room*. In the *North Room* of the

West Range was *A pair of spotted dogs both broken in one foot*, the Japanese porcelain dogs, one of which is in this exhibition (cat. no. 78). In the *China Closet* (third shelf) were *two essence pots with covers metal mounted one small vase much broken and repaired the above painted with festoons & angels were made at the manufactury patronised by the Duke of Buckingham, time of Charles the ii* (cat. nos. 63A&B). In the *Pagoda Room*, under the table, was *A dark blue enamelled vase with handles, delft,* which is likely to have been the Nevers jardinière (cat. no. 62). In the *Red Drawing Room* was *A Malachite & embossed silver chest, mounted in silver under a glass shade,* surely the Augsburg cabinet (cat. no. 36) and *A box of oriental agates mounted in silver gilt under a glass shade, bought in 1822.* This latter (cat. no. 37) had belonged to William Beckford,[117] is illustrated in Rutter's book on Fonthill Abbey,[118] and was bought by the Second Marquess in 1822 or 1823.[119] In the *Blue Drawing Room* was a *silver buhl table,* probably the Gerreit Jensen table (cat. no. 91).[120] There were also two figures: *A silver gilt figure of St John the Baptist under a glass shade given to Lord Exeter by the Rt. Honble Henry Pierrepont* (cat. no. 53) on the chimneypiece[121] and *A figure of Charles V of embossed silver, under a glass shade, two pieces broken off the crown* (cat. no. 52) on a bookcase between the windows (the pier table by Newton).

The Courtyard Corridors

In 1828, the architect J. P. Gandy[122] was commissioned to build corridors at the ground-floor and first-floor levels around the interior walls of the house within the Inner Court (see fig. 3). Only the west side had had corridors before. This, of course, greatly altered the look of the courtyard, but the intention was purely practical. It fundamentally altered the way in which rooms could be used, for now they were no longer interconnecting. Much more privacy was possible, for anyone could go directly to a room without passing through others. It also meant that servants were less obtrusive; in some houses extra corridors were built so that the housekeeping staff might never be seen by the family.

Burghley House:

The Chinese and Japanese Porcelain

The collection or, rather, the accumulation of Chinese and Japanese porcelain at Burghley House is most remarkable. Not only is it extraordinary in its documentation and in the light it throws upon the distribution of imported and exotic porcelain in the seventeenth and eighteenth centuries, but it famously contains the earliest documented pieces of Japanese export porcelain in the Western world.[123]

It would be a mistake to consider Chinese or Japanese porcelain anomalous in a great British house. On the contrary, it was an almost essential part of the decoration.[124] It was present in varying quantity in almost all the great houses of Europe. Some houses had rooms devoted to the display of porcelain; in other houses porcelain was displayed as a valuable and decorative adjunct to other materials, such as silver or silver-gilt vessels.

Porcelain, made of a substance unknown in Europe until the eighteenth century, was exported from China to the Near East from the eighth century and filtered slowly into Europe in small quantities. In the fifteenth century both porcelain decorated in underglaze blue and the heavy green stoneware now called celadon can be seen in European paintings and found in European inventories, but porcelain was still not at all well known in Northern Europe until the middle of the sixteenth century.[125]

In England porcelain was very uncommon until this time. One of the earliest extant examples is the small silver-gilt-mounted celadon bowl given to New College, Oxford, by Archbishop Warham, almost certainly in 1532.[126] In his will, made in 1597, Sir Walter Raleigh, the explorer of North America, left to "my Right Honourable Good frinde Sir Robert Cecill. . .one suite of Porcellane sett in silver and gylt."[127] It is possible that this "suite" came to Burghley from Theobalds and corresponds to the three (possibly four) Wanli (1573–1619) pieces with fine European silver-gilt mounts that were sold from Burghley House in 1888 and that are now in the Metropolitan Museum of Art, New York.[128] Even then, some porcelain was actually used, rather than being merely decorative. In 1629 at Hatfield House[129] there were "in the Chamber over the Porters Lodge. . . . XXVI [twenty-six] China dishes to sett out a banquet."[130]

Dutch intervention in the Eastern trade in the early seventeenth century made Chinese porcelain much more easily available in northern Europe, and most great houses began to accumulate considerable quantities. Most of this porcelain was blue and white or the plain white called *blanc-de-Chine*, but occasionally brown stoneware (Yixing), monochrome-glazed porcelain, and, more rarely, enameled porcelain appear in contemporary inventories. Only in the mid-seventeenth century did the Japanese begin to export porcelain;[131] much of this was colored with overglaze enamels, and brightly colored porcelain appeared in quantity for the first time.

Much of the Chinese porcelain exhibited here is not merely export porcelain of the best-known types; the earliest is the so-called Walsingham Bowl (cat. no. 67), of the late sixteenth century, mounted, as so often, in silver-gilt mounts both to enhance and to protect it. Such

mounting was practiced well into the eighteenth century, and many pieces in this exhibition are so mounted. Equally unusual are two early-seventeenth-century pieces: the small mounted bowl, originally blue and white but covered (in China) with a transparent green lead glaze and then mounted in Europe, perhaps about 1650 (cat. no. 66) and the blue-glazed mug, of an obvious European shape (cat. no. 71), both of which are listed in the Devonshire Schedule of 1690. The large dish (cat. no. 68) is of the type known as *kraak porselein*, from its supposed shipment on Portuguese carracks, and is typical of the Wanli export type of the end of the sixteenth century. It must be of about the same date as the bottle (cat. no. 69), which also came from the Countess of Devonshire and is listed in the schedule. The charming square teapot (cat. nos. 70A&B) shows a change of style, that of the mid-seventeenth century; it is described in the Devonshire schedule as *A Large ffour square Tea pott and a little square Top, Garnisht on the Neck handle and spout End with a Chaine to it*. There is a considerable quantity of Chinese porcelain listed in the Devonshire Schedule; much blue and white and much *blanc-de-Chine*, a smaller quantity of monochromes and a few oddities.

Much later, from the mid-eighteenth century, is the large Chinese punch bowl (cat. no. 72) with the Cecil coat of arms and a picture of the South Front of Burghley House copied after an engraving.[132] In the eighteenth century it became the fashion for armorial porcelain to be ordered through the Honourable East India Company. Sending a copy of his bookplate or a suitable engraving, the buyer could have his coat of arms or cipher or a particular picture painted in China on whole dinner services, or on tea services or punch bowls.

The Japanese porcelain is remarkable not only for its intrinsic beauty and its rarity, but also for what we can read from its presence in the house. Several pieces in the exhibition are listed in the 1688 inventory, which was taken only a few years after the pieces were made. It is thus extremely important documentary evidence of the date of these porcelains, for Japanese porcelain was first exported to Europe in quantity only in 1659.[133] The earliest of these are the ones with the darker style of enamels, and we can see more than one group; the earliest is certainly the figure on a tortoise (cat. no. 74), which may well date from 1665.[134] Probably slightly later is the cockerel (cat. no. 79). Neither of these objects recognizably appears in the 1688 inventory. The earliest of the listed pieces are the *2 painted relev'd brown Juggs with handle Guilt rimms*, which were then in *The Drawing Roome* (cat. nos. 75A&B), over the chimney, and the *2 figures with Juggs at their backs*, which were in Lord Exeter's *Dressing Roome*.[135] The enamels on the *2 large Ellephants* (cat. no. 76) in Lord Exeter's *Bedd Chamber* and on the *2 China boyes Wrestling* (cat. no. 77), then in the *Wardrobe or Clock Chamber*, are more translucent and brighter, and they may well have been very recently imported, as they had probably been made only just before the inventory was taken. The spotted dogs (cat. no. 78) do not appear with certainty in the inventory (they may possibly be *2 Doggs* in Lord Exeter's *Dressing Roome*), though they are of that date. They are first unequivocally present in a mid-nineteenth-century undated inventory as *A pair of spotted dogs both broken in one foot* in the *North Dressing Room*. There are other pieces in the house that can be recognized in the 1688 inventory; the only Japanese porcelain we can be sure of in the Devonshire

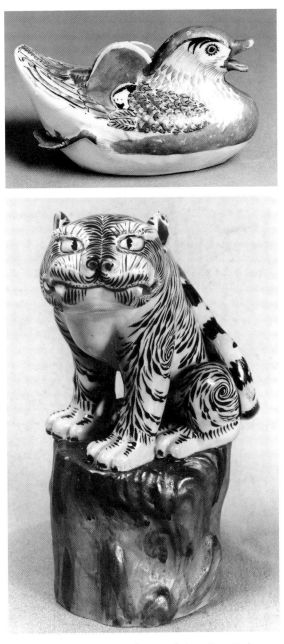

and therefore probably acquired after 1688 by the Fifth Earl, thus not appearing in Tanner's inventory. Some of these are pieces that Tanner would surely have recognized; for instance, lot 203, "A PAIR OF FIGURES OF DUCKS, with coloured plumage" (fig. 28) were probably a well-known type of Japanese figure of mandarin ducks, certainly made before 1688. Clearly Tanner would have recognized a figure of a duck, even such an exotic as a mandarin, and would have listed it had it been there. Lot 204, the "PAIR OF FIGURES OF TIGERS, on pedestals painted with plants," similar to a pair formerly at Drayton House (fig. 29),[138] were probably made after 1688, offering further evidence of continued purchasing by the Fifth Earl. In the house today there are many other export porcelains from both China and Japan that testify to continual acquisition in the eighteenth century. These cannot be identified from the somewhat laconic descriptions given in inventories. Some are of the type we call Kakiemon (see cat. nos. 76, 78, 79), others are Imari, and some are straightforward export blue and white (see, for instance, cat. nos. 85, 87).

There is also at Burghley a group of outstanding small blue and white wares that is paralleled in Britain only in the collections formerly at Drayton House and at Welbeck Abbey.[139] These pieces were not made for export, but for Japanese demand in Japanese taste in the 1650s and 1660s, a time coincident with the beginning of the export trade. One at least (cat. no. 81) was made before the export period, in the late 1640s or early 1650s.[140] Quite how or when they were exported is not known, but it must certainly have been a number of years after they were made. This suggests that someone in the Dutch East India Company was buying old Japanese porcelain in Japan especially to cater to a European demand for exotic porcelain not normally seen on the market. It is known that Lady Betty Germain of Drayton and Margaret, the second Duchess of Portland of Welbeck, were both keen collectors in the eighteenth century.[141] Unfortunately, no document has been found at Burghley that throws any light on which of the Cecils might have shared this passion. It must be presumed that all three houses bought from the same dealer, a "China-man" or "Indian Merchant" who specialized in such rarities, but we do not know his identity.

Chinese and Japanese porcelain has never been out of fashion. It has not, however, always been seen as an integral part of the gradual accumulation of the contents of a great house, and many such houses have lost their porcelain to the auction houses. Burghley lost much in 1888, but the collection in the house today is still one of the most important in the West.

Schedule of 1690 is *A pair of Boxes of three pieces Each painted in colours garnisht with Philgrin Tops Bottoms Hinges and Clasps* (cat. no. 73).

Porcelain, as did other decorative objects, stood symmetrically in rows or tiers of rows, usually over the chimneypiece; thus, in Lord Exeter's *Dressing Roome* as *China over ye Chimney* were *2 Doggs, 2 Lyons, 2 Staggs, 2 blue & wt Birds/1 heathen Godd with many Armes/2 figures with Juggs at their backs.* The central figure would have been the *heathen Godd* (probably *blanc-de-Chine*), and the others, significantly all pairs, would have been ranged symmetrically on either side. Symmetry became the fashion in all great houses as the shapes of the rooms demanded it.[136] Porcelain, especially blue and white, was frequently thought to be appropriately placed upon Japanese lacquer cabinets, as we saw in the *Jewel Closet* in 1738.

Much porcelain was bought after 1688. Not only is there a quantity of later material still in the house, but when much was sold from the house in 1888, the auction catalogue[137] reveals pieces that were certainly late seventeenth century

APPENDIX 2

The Staff at Burghley House

Included here, for interest, are some details of surviving
accounts and records of payments to staff and an attempt at
ascertaining the number of indoor and outdoor servants at
any one time.

1703 Wages were paid to 15 men and 14 women.

1704 Wages were paid to 8 men and 7 women; this great
discrepancy is difficult to account for.

1707 In the half year, £163.13s.2d. was paid to staff,
including officers' salaries, servants' wages and deer
and keepers' wages.

1737 Wages were paid to 24 men and 8 women.

1738 Wages were paid to 31 staff, including £2.10s.0d
to William Botts for *a years Mole Catching*.

1752 Wages were paid to 21 men and 13 women.

1761 Wages were paid to 19 men and 7 women, ranging
from £25 to £2.10s.0d. per half year.

1770 Wages were paid to 22 men and 11 women.

1793 Wages were paid to 20 men and 12 women; the
highest paid were the butler and the gardener,
marginally more than the cook (a woman). The head
keeper, the baker, and the whitesmith[136] were paid the
same as the housekeeper (a woman).

1795 One hundred thirteen dozen and one bottles of wine
and 94 hogsheads of ale were drunk in the year.

1798 Seventy-five dozen bottles of wine, 23 butts of ale,
and 20 butts of small beer were drunk in the year

1798/9 Thirty-seven oxen, 92 sheep, 5 lambs, and 22 *porkers*
were killed.

1804 Wages were paid to 15 indoor menservants and 19
indoor women servants. The steward was paid £100
p.a., and his assistant £60; the butler and the groom
of the chambers £40 each (the gardener had £60);
the valet £36.15s.0d. and the cook (a woman) £30.
There were 13 outdoor employees, including keepers.

1805 Wages were paid to 11 men and 7 women; presumably
this was because the Second Marquess, who inherited
that year, was only nine years old and did not require
a large staff. Curiously, no cook is listed.

1832 Wages were paid to 21 men and 18 women; apart
from the agent, the best paid was the cook, Monsieur
Dalleux at £126 (the first notice we have of a French
chef!). The butler was next at £84, and the groom
was paid more than the valet. The porter's,
coachman's and footmen's wages included extra for
hair powder.

1866 Wages were paid to 22 men and 16 women. The cook
(sex unspecified) was paid £100 and so was the
studgroom (the Second Marquess took his horses
seriously; see cat. nos. 114, 115, 116). The gardener had
dropped (comparatively) to £80, the same as the butler.

1926 Wages were paid to 6 indoor menservants and 17
women; there were 10 outdoor employees.

NOTES

1. Thomas Jenkins (1722–1798), English painter, active in
Rome after 1752, who took up dealing in antiquities and
the organization of excavations.

2. For a catalogue of the paintings, see Hugh Brigstocke
and John Somerville, *Italian Paintings from Burghley
House*, exh. cat., Art Services International (Alexandria,
Va., 1995).

3. These are listed in the *Conveyance and Schedule of Gift,
18th April 1690* (hereafter the Devonshire Schedule),
Exeter Manuscripts 41/82, Burghley House, Stamford,
Lincolnshire (hereafter Exeter MSS).

4. For a life of Lord Burghley, see B. W.Beckinsale,
Burghley: Tudor Statesman 1520–1598 (London, 1967).

5. For an account of the building of the sixteenth-century
house and a discussion of the motives for its building
and the iconography used, see Mark Girouard,
"Burghley House, Lincolnshire," parts 1 and 2, *Country
Life* 186, nos. 17 and 18 (April 23 and April 30, 1992):
56–59 and 58–61.

6. Celia Fiennes, *The Journeys of Celia Fiennes*, ed.
Christopher Morris (London, 1919), 68–70. Further
quotations from Fiennes are from this edition.

7. Plans drawn up by John Thorpe, ca. 1565–1655, English
surveyor.

8. In the inventories, as is normal in Britain, the ground
floor is called that. The first floor is above it, in effect the
second floor in American usage, while the English
second floor would be the American third floor.

9. For a discussion of the Roman staircase, see Girouard,
"Burghley House," part 2, note 5, who comments on its
resemblance to the demolished but recorded staircase of
the Hôtel de Ville in Paris, built about 1550.

10. Many of the chimney columns are paired or in
multiples. They have at the top, joining them, what
looks like part of an entablature, as if on a ruin (and also
castle-shaped chimney pots, which referred to a heraldic
badge of the Cecils). At that time, two buildings in the
Forum Romanum were clearly visible in that state, and
the Earl may well have obtained the idea from there.
Possibly he also studied Vitruvius' *On Architecture*; he
could probably read Italian, but if he could not, he
could have read the French translation of 1547.

11. Sir Edward Astley, letter to his wife, July 29, 1643, now
at Melton Constable, Norfolk.

12. It has been suggested to me that as Cromwell's troops
occupied the house for some months, and as the Earl
was but a boy of fourteen, there may well have been a
considerable amount of looting. The house might,
indeed, have been nearly emptied.

13. Daniel Defoe, *A Tour thro' the whole Island of Great
Britain* (London, 1724–1727), edited by G.D.H.Cole
(London, 1927), vol. 2, 506–507.

14. For an excellent explanation and discussion of this, see
Mark Girouard, *Life in the English Country House: A
Social and Architectural History* (New Haven, 1978).

15. Culpepper Tanner, *"An Inventory of the Goods in Burghley House belonging to the Right Honble John Earl of Exeter and Ann Countess of Exeter Taken August 21th 1688"* (no Exeter muniment number).

16. Jean Tijou (fl. 1689–1712), French (Huguenot) metalworker working in England from 1689. Also worked at Chatsworth, Hampton Court, and under Sir Christopher Wren at St. Paul's Cathedral between 1695 and 1707. The Burghley gates are illustrated in his *New Booke of Drawings*, 1693, for which his son-in-law, Louis Laguerre (see n. 42) drew the frontispiece. He was paid £150 on June 8, 1704 (Child's Bank ledgers, One Fleet Street, London).

17. René Cousin (fl. late seventeenth century), gilder, submitted his bill (for £12) for gilding the gates in May 1694 (Exeter MSS 51/15).

18. All quotations from documents at Burghley, including the names of rooms as written in documents or when they vary from those in use today, are *in italics*.

19. It is not clear if *right Japann* means that Tanner thought that the objects were made of oriental lacquer. In some cases the term is used where the object is definitely not oriental; for example, the "jappanned" chairs were certainly English, as Tanner must surely have known.

20. John Vanderbank (d. 1717), tapestry weaver of Soho, London. He was paid £30 in 1696, £40 in 1698, £96.0s 4d in 1704 (Child's Bank ledgers), and probably more.

21. What the term *Imperial* means in this context is not clear; possibly it means a tester bed, that is, one with posts and a canopy.

22. For Mayhew & Ince, cabinetmakers, see note 94. The bed was supplied, with its hangings, in 1768 (Exeter MSS 90/51); see Helena Hayward and Eric Till, "A Furniture Discovery at Burghley," *Country Life* 154 (June 7, 1973), 1604–7.

23. Gerreit Jensen (fl. ca. 1680–1715), English cabinetmaker; appears in the bills as Garrett Johnson or Jerret Janson. He was paid a total of £534 between 1682 and 1704 (Child's Bank ledgers).

24. Giuseppe Recco (1634–1695), Neapolitan painter. The paintings measured 256 by 210 cm (100 by 79 in.) each.

25. Jan Jans (fl. 1662–1716), Flemish tapestry weaver working at the Gobelins, the Royal Manufactury set up by Jean-Baptiste Colbert for Louis XIV, king of France. He had not been paid for these tapestries in 1681, when he complained to Lord Exeter (Exeter MSS 51/8/14).

26. A cabinet of curiosities, or *Wunderkammer*, was present in almost all great houses in the seventeenth century and typically would have contained both natural and "artificial" (manmade) objects. See Oliver Impey and Arthur MacGregor, eds., *The Origins of Museums; The Cabinet of Curiosities in Sixteenth- and Seventeenth-Century Europe* (Oxford, 1985).

27. Edward Martin (fl. 1648–1704), English plasterer. Payments for work at Burghley are recorded in 1682–1683, the £150 probably representing only a small part of his bill, and in 1704 for £40 (Child's Bank ledgers).

28. For the George Rooms, see note 54.

29. Grinling Gibbons (1648–1721), Huguenot sculptor working in England after 1668, specialized in high-relief woodcarving in great detail; he was much admired and much imitated. He was paid £100 in 1683–1685 for unidentified work. His contemporaries Thomas Young (dates unknown) and Jonathan Mayne (fl. 1680–1709), who also worked at Chatsworth, appear to have done most of the carving at Burghley; recorded payments to them amount to £730 and are certainly incomplete (Child's Bank ledgers).

30. Roger Davis (or Davies), often resident at Burghley, 1679–1687, was a wainscot joiner and furniture maker. He was paid some £420 between 1683 and 1687 (Exeter MSS 51/8/1).

31. Archduke Cosimo III of Tuscany (1642–1723).

32. Luca Giordano (1634–1705), Neapolitan painter who moved to Florence in 1682.

33. Giles Balle (dates unknown), a shipping agent and banker active in Genoa and Leghorn (Exeter MSS, 51/8/11 and 12).

34. Sir Peter Lely (1618–1680), Dutch painter active in England after ca. 1637.

35. Johann Carl Loth (1632–1698), German painter working in Venice.

36. Spanish leather, stamped, printed, colored, and gilded, was mostly made in the Netherlands (which had been ruled by Spain) and was used for wall hangings, its brilliant color and gilding giving a grand yet somber effect. See John Waterer, *Spanish Leather* (London, 1971).

37. The New Bedlam Society was the *Honourable Order of Little Bedlam* founded by the Fifth Earl in 1684. This was a convivial social club in which each member took the name of an animal. Interestingly, both Sir Godfrey Kneller (Unicorn) and Antonio Verrio (Porcupine) were members. Each member had his portrait painted with his familiar; that of Verrio by Kneller is still among others in the Billiard Room (see fig. 22).

38. Antonio Verrio (1630–1707), Italian painter active in England after ca. 1671. He worked at Burghley on and off from 1685–1697. A colorful character, he lived a scandalous life, drinking and womanizing. His paintings contain hidden caricatures and references to persons he knew. He also worked for the King and at Chatsworth. As he had continual money troubles, payment was always (after problems over payment for the First George Room) by contract; thus he was paid £200 for each of the ceilings of the Second, Third, and Fourth George Rooms, £500 for the Fifth George Room (the Heaven Room), and £200 for the ceiling of the Hell Staircase. Eric Till notes that the latter was painted between October 1696 and September 1697 without assistants and is therefore not gilded (Till, unpublished notes on the 1688 inventory).

39. These cabinets, but not the interiors, are illustrated as figures 9 and 12–3 in Giles Ellwood, "James Newton," *Furniture History* 31 (1995): 129–205. For Newton, see note 90.

40. Jamaica wood could be an early instance of the use of mahogany.

41. The term Turkey-work usually implies an English textile in some sort of imitation or emulation of a Turkish-style carpet. Most textiles were placed on tables or other pieces of furniture. For a brief discussion, see Oliver Impey, "Eastern Trade and the Furnishing of the British Country House," in Gervase Jackson-Stops, ed., *The Fashioning and Functioning of the British Country House*, Studies in the History of Art 25 (Washington D.C., 1989), 177–92.

42. Louis Laguerre (1663–1721), French painter who came to England (1683/4) and worked at first with Verrio. He worked at Burghley from 1697. He was the son-in-law of the metalworker Jean Tijou (see n. 16). The last recorded payment to him was for £29.5s.0d in 1704 (Child's Bank ledgers).

43. It was normal for ladies of the house to embroider or weave textiles for household purposes.

44. A *Wardrobe* room or even a series of rooms was a general storeroom for unused furniture and fittings.

45. Foot-carpets are rarely found in early inventories, though they can be seen in contemporary paintings. In the 1601 inventory of Hardwick Hall, for instance, there are only five foot-carpets among the hundreds of textiles listed. See Lindsay Boynton, "The Hardwick Hall Inventory of 1601," *Furniture History* 7 (1971): 1–40. See also Impey, "Eastern Trade."

46. Pierre Gole (ca. 1620–1684), Dutch cabinetmaker working in France at the Royal Manufactory, the Gobelins, after 1643. Most of his work was undertaken for Royal Palaces, and especially for Vincennes and Versailles.

47. Francis Poyntz (d. 1685), English tapestry weaver in charge of the Mortlake factory after 1668.

48. Daniel Cookman (dates unknown) was paid for furniture between 1678 and 1683.

49. David de Koninck (1636–1699), Flemish painter who worked in Rome after about 1670.

50. Cantoons (or cantoins) were narrow curtains at the corners of the bed to close the gap between the main bedcurtains. See Peter Thornton, *Seventeenth-Century Interior Decoration in England, France, and Holland* (New Haven and London, 1978), 165.

51. William Wissing (1656–1687), Dutch painter working in England after 1676, was the pupil of and assistant to Sir Peter Lely and rival of Sir Godfrey Kneller. He was patronized and befriended by the Fifth Earl; he died and is buried in Stamford.

52. Thornton, *Seventeenth-Century Interior Decoration*, 116, argues that *mohaire* must have been a silk fabric.

53. *Grenoble* almost certainly means open-grained walnut wood, for the best French walnut was said to come from around Grenoble.

54. It is not known why the George Rooms were so called. Eric Till has suggested that it was in emulation of St. George's Hall at Windsor Castle, painted by Verrio in 1684 (Till, unpublished notes on the 1688 inventory).

55. William Talman (1650–1719), English architect specializing in the design of country houses. He worked, for example, at Drayton House and at Chatsworth. The payment of £200 in 1704 (Child's Bank ledgers) was the last of his payments, probably since 1680.

56. See notes 29 and 30.

57. It is not known what decoration was on the walls (they were not painted by Verrio), for they were altered when the staircase was rebuilt (see n. 89). Verrio apparently started some form of decoration, for some *grisaille* work can be seen on the window splays. The present wall paintings are the work of Thomas Stothard (1755–1834), English painter and illustrator, much admired in his day. Burghley was his most important commission.

58. For Cousin, see note 17. Alexandre Souville (active ca. 1685–1722), French painter specializing in architectural scenes.

59. Devonshire Schedule.

60. Anna Somers Cocks, *The Countess's Gems* (Burghley House Preservation Trust, 1985).

61. Because King James II was Roman Catholic, as was his brother the Duke of York (his heir), a movement started to exclude York from inheriting the throne. Those who proposed this movement were called Whigs, while those who opposed it as unlawful were called Tories. It was the Whigs who invited William of Orange, who was married to Mary, daughter of James II, to take the throne and depose James II. This event, called the Glorious Revolution, took place in 1688. Many Tories must have continued to feel that this was illegal or improper.

62. Thomas Stretch (dates unknown) acted as steward while Tanner was (twice) in Italy. He was a tradesman-upholsterer who worked at Burghley at least from 1679 to 1693 and possibly later. See Exeter MSS 51/8/25.

63. Francis Haskell, *Patrons and Painters: Art and Society in Baroque Italy* (New Haven and London, 1980), 197.

64. Carlo Maratta (1625–1713), Italian painter working in Rome; for Koninck, see note 49; Daniel Seiter (1649–1705), Austrian painter who worked in Venice from 1670 and in Rome from 1682.

65. Pierre-Etienne Monnot (1657–1733), French sculptor active in Rome after ca. 1687.

66. Defoe, *Travels*.

67. Gerreit Jensen at Chatsworth, quoted in Francis Thompson, *History of Chatsworth* (London, 1949), 157. From Chatsworth building accounts, ii.97e. See also Impey, "Eastern Trade."

68. For shell collecting, see S. Peter Dance, *Shell Collecting: An Illustrated History* (London, 1966).

69. It was a common practice in the seventeenth and eighteenth centuries to visit country houses whether or not the family were there; such houses were usually open to gentry visitors.

70. E. C. Till, "The Development of the Park and Gardens at Burghley," *Garden History* 19, no. 2. (Autumn 1991): 128–45.

71. London and Cooke, after 1688 London and Wise. George London (d. 1717), nursery gardener and designer of formal gardens, in partnership with Henry Wise (1653–1738).

72. Phillip Rollos (ca. 1660–after 1715), English goldsmith, probably of Huguenot descent.

73. Lady Sophia Cecil (1792–1823), daughter of Henry the Tenth Earl and Sarah (the "Cottage Countess"), married Henry Manvers Pierrepont. Their daughter married the second son of the First Duke of Wellington, and two of their grandsons succeeded as Third and Fourth Dukes of Wellington. She made a series of drawings of interiors at Burghley, which were engraved.

74. Phineas Evans (fl. 1727–1747), London cabinetmaker. There is a bill from him dated October 2, 1727, includes the item *For a Bookcase and chest 2 Glass Doors. . .£10.10s.0d.* (Exeter MSS 51/21/37).

75. For shell collecting, see note 68.

76. Carlo Dolci (1660–1686), Florentine painter.

77. The reason the room was called "Turenne" is uncertain.

78. The name *Alsatia* seems to have been a facetious name given to this area close to the dining room of the *Honourable Order of Little Bedlam,* the Fifth Earl's drinking club, because of its meaning of a sanctuary for transgressors (see also n. 37). We do not know the shape of this area, with its staircase, before the remodeling of the staircase by the Ninth Earl.

79. "The Queen brought in the Custom or Humour, as I may call it, of furnishing Houses with *China*-Ware,which increased to a strange degree afterwards, piling their *China* upon the Tops of Cabinets, Scrutores, and every Chymney-Piece, to the Tops of the Ceilings and even setting up Shelves for their *China*-Ware, where they wanted such Places, till it became a grievance in the Expence of it, and even injurious to their Families and Estates." Defoe, *Tour,* 166.

80. William, Lord Burghley, *Precepts. . .left by William Lord Burghley, to his Sonne, at his death* (London, 1637).

81. Thomas Hudson (1701?–1779), English painter.

82. Lancelot "Capability" Brown (1716–1783), the most celebrated of the English landscape gardeners, much influenced by William Kent (see n. 83). He also worked as an architect. Brown worked at Burghley from 1755 to 1779 at a yearly retainer of £1000, a very large sum.

83. William Kent (1685–1748), English painter, architect, and garden designer; protégé of Lord Burlington. Horace Walpole famously said of him that "He leaped the fence and saw that all nature was a garden." He was the first exponent of the informal garden.

84. John Haynes (fl.1730–1755) of York, draftsman and engraver, who made a series of plans and views of Burghley.

85. Coade-stone was an artificial stoneware. See Alison Kelly, *Mrs. Coade's Stone* (London, 1990).

86. Henry Gilbert (fl. 1812–1837), English sculptor resident in Stamford.

87. Palmyra is the site of an oasis city in Syria. Rediscovered in the late seventeenth century, it was popularized by the publication of James Dawkins and Robert Wood's *The Ruins of Palmyra* (London and Paris, 1753). Plate 19, the south thalamus ceiling of the Temple of Bel, was particularly influential on Robert Adam (see note 89) and other decorators.

88. Thomas Lumby (fl. ca.1761–ca.1781) of Lincoln, architect and master carpenter.

89. Robert Adam (1728–1792), Scottish architect and interior designer active from London after 1758. He made a presentation drawing for the Hell Staircase dated March 6, 1779, more elaborate than the staircase as built. See Margaret Richardson, "A 'Fair' Drawing: A Little-Known Adam Design for Burghley," *Apollo Magazine* 136, no. 366 (August 1992): 87–88.

90. John and Robert Hames were local masons; their bill for £246.3s.0d. for the alterations to the South Dining Room was submitted in December 1788, and for £118.8s.0d. for *stonework and putting up at the New Staircase Burghley in full* in July 1790.

91. James Newton (1760–1829), English cabinetmaker. The firm became, successively, Turton and Fell, Lawrence Fell & Co., Newton & Fell, Fell & Newton, James Newton, and Robert & James Newton. See Ellwood, "James Newton."

92. Giovanni Battista Piranesi (1720–1778), Italian etcher, engraver, designer, architect, archaeologist, and restorer of and dealer in antiquities. Active in Rome after 1740. In the 1760s he began to manufacture chimney-pieces incorporating classical fragments. Some, including the Burghley example, are illustrated in his *Diverse maniere d'adornare i cammini. . .* (Rome, 1769).

93. Domenico Bartoli (fl. 1764–1813), Italian specialist in scagliola, working in England. He was also employed at Stowe and Kedleston.

94. John Mayhew (1736–1811) and William Ince (d. 1804), English cabinetmakers and "upholders," published, as Ince and Mayhew, *The Universal System of Household Furniture* (London, 1759–1762) in a series of booklets of designs for fashionable furniture. For Newton, see note 91.

95. Mayhew & Ince account; Exeter MSS 90/1/51.

96. *Ibid.*

97. *Inventory of the plate, pictures, china, linnen, and household furniture at Burghley, - taken by me, Exeter,* after 1767, Burghley House.

98. Robert Tymperon (1728?–1796), cabinetmaker of Stamford. He worked at Burghley at least from 1750 to 1771 and was paid an annuity of £20 from 1796 to 1798, suggesting that he had also worked at Burghley in the intervening years (Exeter MSS 45/28 and Day Books).

99. This screen may possibly have been in the *Turenne Room* in 1735 and may be the other half of the screen dismembered to make the *Japan Closet* (now in the Exhibition Room).

100. Joseph Nollekens (1737–1823), English sculptor active in Rome, 1762–1770, and in London after 1770.

101. For Dr. Richard Mead (1673–1754), who had owned the *Livia* and the *Hercules*, and his collection, see Mary Webster, "The Taste of an Augustan Collector: The Collection of Dr. Richard Mead," parts 1 and 2, *Country Life* 147 and 148 (January 29 and September 24, 1970): 249–51 and 765–67.

102. Allessandro Algardi (1598–1654), Italian sculptor, architect and draftsman, active in Rome after 1725.

103. There is an annotated copy of Pellegino Antonio Orlandi, *Abecedario Pittorico* (Bologna, 1704), in the Ninth Earl's library.

104. Sir William Hamilton (1730–1803), English diplomat, connoisseur, and collector, Plenipotentiary in Naples, 1764–1800.

105. Angelica Kauffmann (1741–1807), Swiss painter and etcher active in Rome, 1763–1765, and in Naples and London, 1766–1781.

106. David Garrick (1717–1779), English actor-manager, patron, and collector, in Italy in 1763.

107. Edward Gibbon (1737–1794), English historian, author of *The History of the Decline and Fall of the Roman Empire* (London, 1776–1788), in Italy in 1764–1765.

108. For Jenkins, see note 1.

109. James Byres (1734–1817), Scottish antiquarian, active in Rome, 1758–1790. His most notable purchase for the Ninth Earl was Poussin's *Assumption of the Virgin*, ca. 1626, now in the National Gallery of Art, Washington.

110. Paolo Caliari, called Veronese (1528–1588), Venetian painter; Jacopo da Ponte, called Bassano (1710/1518–1592), Venetian painter; Claude Gellée, called Claude Lorrain (1600–1682), French painter working in Rome from 1613; Nicolas Poussin (1594–1665), French painter working in Rome after 1624.

111. Pompeo Batoni (1708–1787), Italian painter active in Rome after 1727; Anton Raphael Mengs (1728–1778), Bohemian (Czech) painter active in Rome and Naples, 1756–1761, and later in Madrid.

112. Johann Friedrich Reiffenstein (1719–1793), German painter and wax modeler active in Rome after 1762.

113. There is more than one line of evidence, including his compulsive list making, to suggest that the Ninth Earl had psychomotor epilepsy. Perhaps it was for this reason that he had no children, or chose to have no children, and therefore was anxious to adopt his nephew.

114. Francesco Fanelli (fl. 1608–?1661), Italian sculptor active in England after ca. 1627.

115. It is quite likely that Jensen's inlaid table would have been mistaken for the style named after André-Charles Boulle, the French cabinetmaker, who used a similar style employing brass and tortoiseshell.

116. Queen Elizabeth actually never slept in the house, as Exeter's daughter Ann was suffering from smallpox at the time of her only recorded visit in 1565. Of course, the George Rooms had not even been created at that time.

117. William Beckford (1759–1844), English collector, patron, and writer, sold his vast house Fonthill Abbey in 1822.

118. W. Hughes, after T. Higham, *A group of the rarest articles of virtu*, woodcut, in J. Rutter, *Delineations of Fonthill and Its Abbey* (London, 1823), 7.

119. John Farquar (1751–1826), an eccentric millionaire, bought Fonthill Abbey and most of its contents from William Beckford in 1822. Much of the contents were then bought back by Beckford, who sold it in a series of sales. There is a problem here in that this casket is probably that sold in the 1823 sale, lot 1294 (bought by Lewis). See Michael Snodin and Malcolm Baker, "William Beckford's Silver," parts 1 and 2, *Burlington Magazine* 122, nos. 932 and 933 (November and December 1980), 735–48 and 820–34. Possibly the *1822* of the document is a mistake for 1823.

120. *Buhl* was an alternative spelling of Boulle (see n. 115).

121. Henry Manvers Pierrepont, second son of Charles, First Earl Manvers, privy councillor and envoy to the Court of Denmark, married Lady Sophia Cecil (see n. 73) in 1818.

122. J. P. Gandy (1787–1850), later, by deed-poll, Gandy-Deering, English architect.

123. *The Burghley Porcelains: An Exhibition from the Burghley House Collection and based on the 1688 Inventory and 1690 Devonshire Schedule*, exh. cat., Japan Society (New York, 1986).

124. See Oliver Impey, "Porcelain for Palaces," in John Ayers, Oliver Impey, and J.V.G. Mallett, *Porcelain for Palaces: The Fashion for Japan in Europe, 1650–1750* (London, 1990), 56–69.

125. At that time, the Portuguese, who had a virtual monopoly of the Eastern trade, established a base in China at Macao and were able to order porcelain to be made to their required shapes and sizes, objects usable in a European context.

126. John Ayers, "The Early China Trade," in Impey and MacGregor, *Origins of Museums*, 259–66.

127. Sir Walter Raleigh was executed in 1618.

128. Oliver Impey, "Collecting Oriental Porcelain in Britain in the Seventeenth and Eighteenth Centuries," in *The Burghley Porcelains*, 36–43; C. Louise Avery, "Chinese Porcelain in English Mounts," *Metropolitan Museum of Art Bulletin* 2 (May 1944): 266–72.

129. Sir Robert Cecil exchanged Theobalds for Hatfield House with King James I in 1607.

130. Inventory of Hatfield House, 1629. Hatfield House.

131. See Oliver Impey, "The Trade in Japanese Porcelain," in Ayers, Impey, and Mallett *Porcelain for Palaces*, 15–24.

132. David Sanctuary Howard, *Chinese Armorial Porcelain* (London, 1974).

133. Oliver Impey, *The Early Porcelain Kilns of Japan: Arita in the First Half of the Seventeenth Century* (Oxford, 1996).

134. T. Volker, "Porcelain and the Dutch East India Company...," *Mededelingenblad van het Rijksmuseum voor Volkenkunde, Leiden* 11 (1954): 152.

135. *The Burghley Porcelains*, pl. 89.

136. Th. H. Lunsingh Scheurleer, "Documents on the Furnishing of Kensington House," *Walpole Society* 38 (1962): 15–58; see also Linda Shulsky, "Queen Mary's Collection of Porcelain and Delft and Its Display at Kensington Palace Based upon an Analysis of the Inventory Taken in 1679," *American Ceramic Circle Journal* 7 (Spring 1990): 51–74.

137. *Catalogue of Old Oriental Porcelain and Objects of Art and Ancient and Modern Plate the property of the Marquis of Exeter from Burghley House*, auction catalogue, Christie, Manson, and Woods, June 7–8, 1888 (London, 1888).

138. Mark Hinton and Oliver Impey, *Kakiemon Porcelain from the English Country House: Flowers of Fire* (London, 1989).

139. *Ibid.*

140. See Impey, *Early Porcelain Kilns of Japan*.

141. See Soame Jenyns, *Japanese Porcelain* (London, 1965), 7 and pl. 8.

142. A whitesmith worked with the metals, tin, zinc, and possibly pewter, whereas a blacksmith worked with iron.

AUTHOR'S NOTE

I am deeply grateful to Lady Victoria Leatham for asking me to undertake the work for this catalogue; with her support and that of Simon Leatham it has been more than a voyage of discovery, but a great pleasure. Of course, I never could have thought of doing it without being able to draw upon the immense labors of Dr. Eric Till, in his lifetime study of the house and its contents, his unfailing generosity with his work, and his infectious enthusiasm, nor without the great help and the wide knowledge of Jon and Sarah Culverhouse and their team, especially Charlotte Rawlinson, and their patience with my endless inquiries.

Many others like myself have enjoyed the rejuvenation of the house under the stewardship of Lady Victoria and Simon and have participated in the work on Burghley and its archives. I have had free access to their work, published or unpublished, and am deeply indebted to Hugh Brigstocke, Giles Ellwood, Mark Girouard, George Hughes Hartman, Wendy Hefford, Gordon Lang, Anna Somers-Cocks, John Somerville, Gerard Turner, Roberto Valeriani, John Webster, and no doubt many others.

Outside this group, I am also indebted to Peter Day at Chatsworth, Robin Harcourt Williams at Hatfield, Judy Rudoe at the British Museum, Jon and Linda Whiteley, Tim Wilson and Michael Vickers at the Ashmolean Museum, Clare le Corbeiller at the Metropolitan Museum of Art, and Joanna Marschner at Kensington Palace.

Christina Nelson has offered careful and valuable criticism and, to my great satisfaction, written a much-needed introductory essay; she has been ably assisted by Nancy Miller-Franitza. Lynn Rogerson and her team at Art Services International have done everything possible to make things run smoothly. Finally, I thank my family, who have put up with my immersion in the affairs of the Fifth Earl or the Ninth Earl with amusement and tolerance.

Burghley House, 1623

GROUND FLOOR

N

PLAN 1

Plans of Burghley House in 1623, drawn up by John Thorpe, English surveyor, show the undivided state of the rooms before the time of the Fifth Earl's remodeling. Note particularly the open arcade in the South Range and the presence of three long galleries. The rooms are not named here because there is no inventory of the house from that period.

FIRST FLOOR

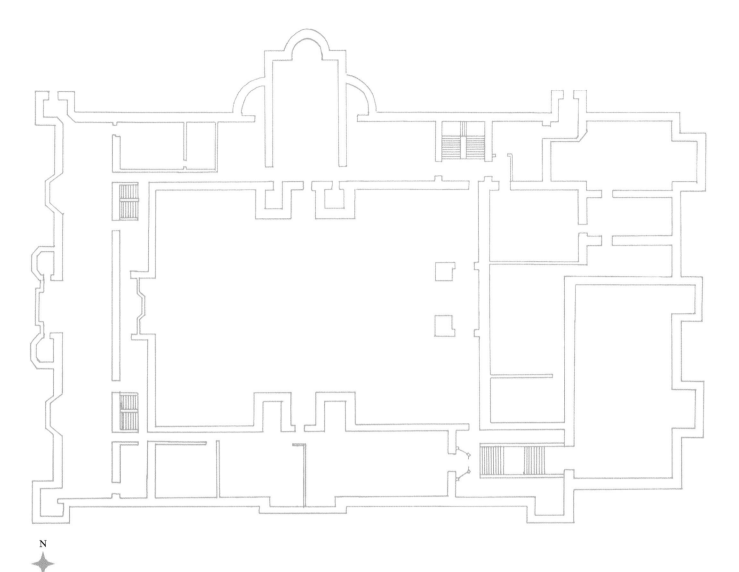

N

PLAN 2

1688

GROUND FLOOR

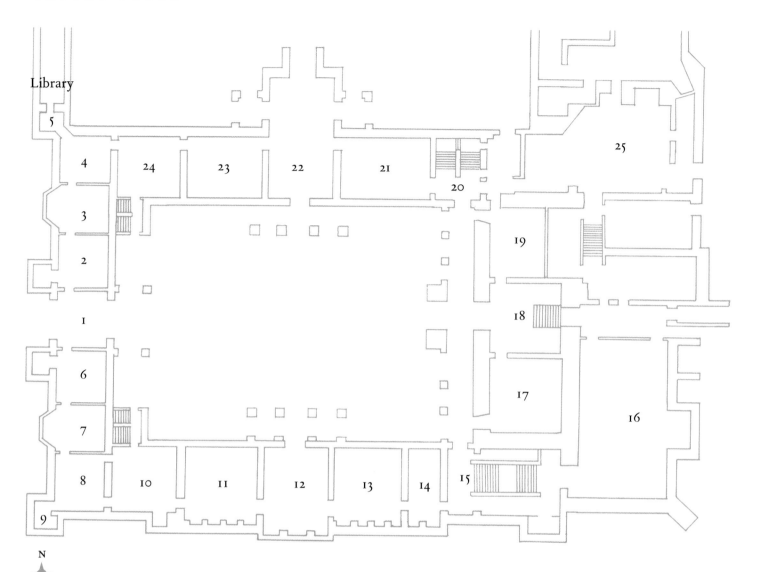

Library

N

PLAN 3

1 Gothic Hall
2 My Lords Anty Room
3 My Lords Bedd Chamber
4 My Lords Dressing Roome
5 My Lords Clossett
6 My Ladyes Anty Roome
7 My Ladyes Bed Chamber
8 My Ladyes Dressing Roome
9 My Ladyes Clossett
10 Best Bedd Chamber
11 Drawing Roome
12 Marble Salloon Roome
13 Dining Roome
14 Tea Roome
15 ye Great Staires
16 Great Hall
17 Guilt Leather Dining Roome
18 Passage by ye Hall Staires
19 Smoking Roome
20 Roman Staircase
24 Tile Roome
25 Old Kitchen

FIRST FLOOR

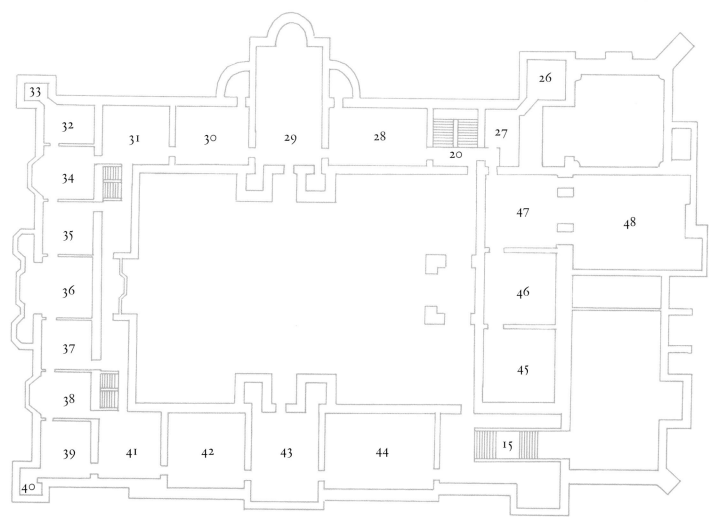

N

PLAN 4

26 My Lords Clossett
27 Chappell Chamber
28 Plaster Dining Roome
29 North Dining Roome
30 North Drawing Roome
31 Bedd Chamber next ye Gallery Roomes
32 North End Chamber
33 Clossett
34 6th Roome
35 North Bedchamber
36 Midle or 4th Roome
37 South Bedchamber
38 2nd Roome Next the South
40 Clossett
46 My Lords Dark Bed Chamber
48 Chappell

1738

GROUND FLOOR

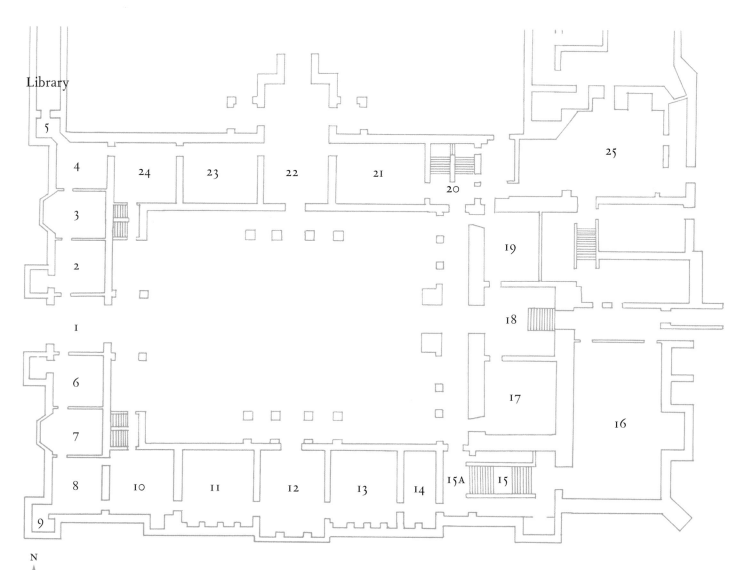

Library

PLAN 5

N

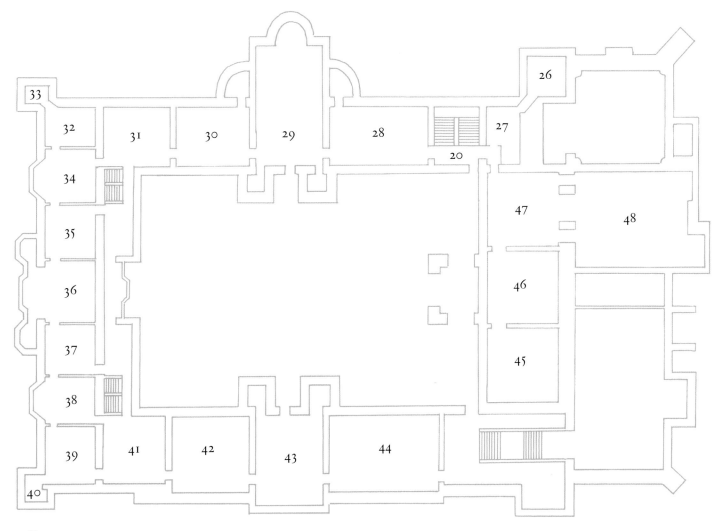

N

PLAN 6

28 Brown Dining Room
29 Bow Room
30 North Drawing Room
31 Green Mohair Bed Chamber
32 North Dressing-Room
33 Closet
34 Dressing Room
35 Chints Bed Chamber
36 Dressing Room
37 blue Velvet Bed Chamber
38 blue Velvet Dressing Room
39 Dressing Room
40 Jewel Closet
41 Bed Chamber
42 3d Room or Drawing Room
43 Second Room
44 Anti-Room
47 Anti-Chapel Room
48 Chapel

1770S

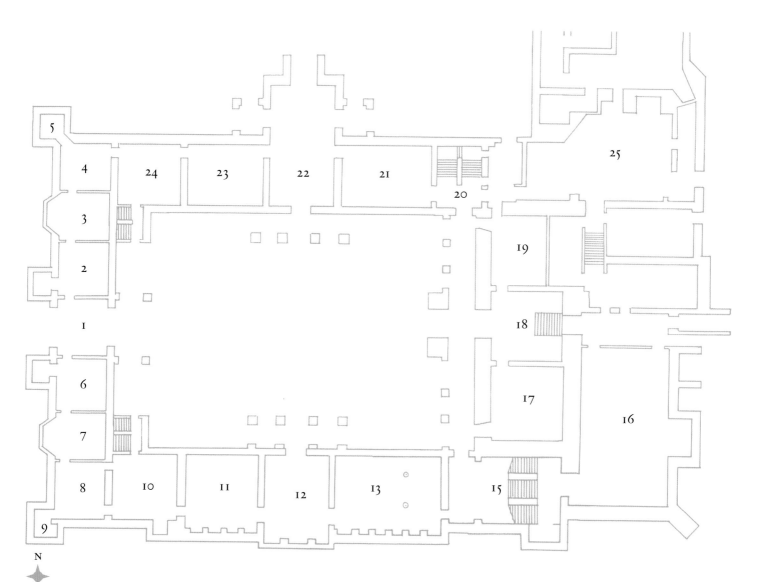

N

PLAN 7

1 Passuage
2 Lord Exeter's Dressing Room
3 Bed Chamber
4 Dressing Room
5 Shell Closet
6 Outer Dressing Room
7 Bed Chamber
8 Lady Exeter's Dressing Room
9 Japan Closet
10 Picture Room
11 Drawing Room
12 Marble Hall
13 Dining Room
21 North Dining Room
22 Egyptian Hall
23 Library
24 Breakfast Room

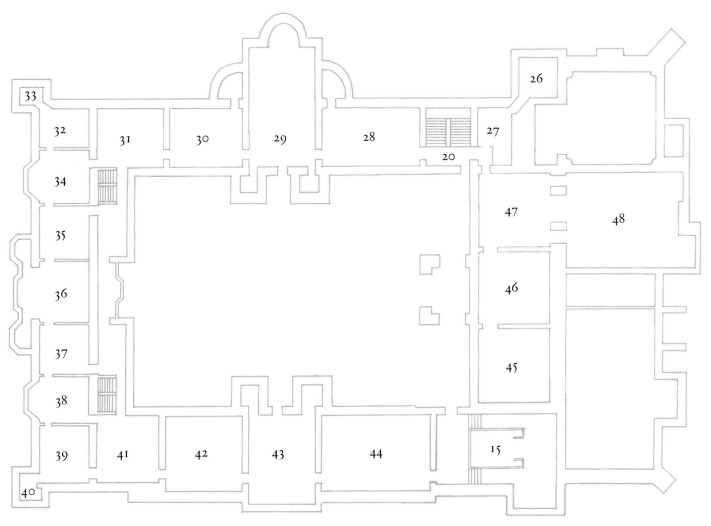

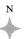

N

PLAN 8

28 Brown Dining Room
29 Bow Window Room
30 North Drawing Room
31 Black Bed-Chamber
32 West Dressing Room
33 Closet
34 North Dressing Room
35 West Bed Chamber
36 Queen Elizabeths room
37 Green Bed-Chamber
38 Dressing Room
39 Dressing Room to the George Rooms
40 Jewel Closet
41 Bed Chamber (Second George)
42 Drawing Room (Third George)
43 Dining Room (Fourth George)
44 Vestibule (Fifth George; Heaven Room)

1804

GROUND FLOOR

N

PLAN 9

1 West Entrance
2 South Dressing Room
3 Blue Bed Chamber
4 North Dressing Room
5 Closet
6 Dressing Room
7 Crimson Velvet Bedroom
8 Green Dressing Room
9 Japan Closet
10 Blue Drawing Room
11 Red Drawing Room
12 Marble Hall
13 South Dining Room
15 Alsatia
19 Waiting Room
21 Stone Dining Room
22 Scagliola Hall
23 Library
24 Ante Library

FIRST FLOOR

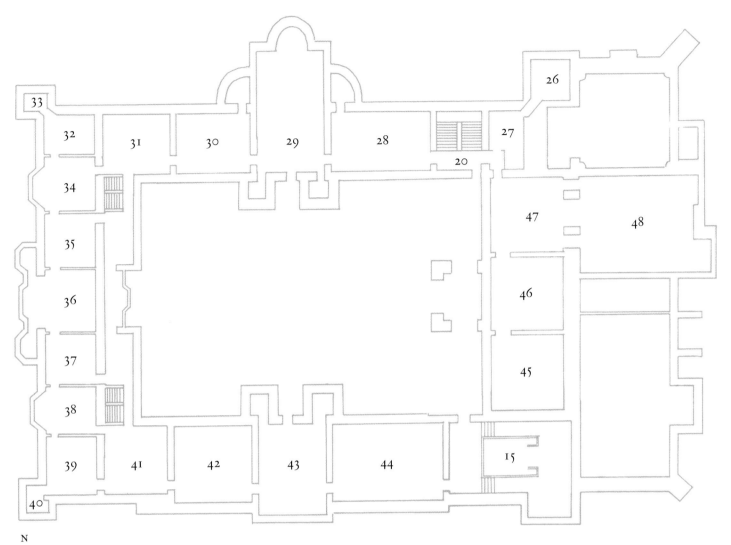

N

PLAN 10

26 Chapel Dressing Room
27 Chapel Bedroom
28 Billiard Room
29 Ballroom
30 Brown Drawing Room
31 Black Bedroom
32 North Dressing Room
33 China Closet
34 West Dressing Room
35 Queen Elizabeth's Bed Chamber
36 Queen Eliz*th* or Pagoda Room
37 Purple Bed Chamber
38 Blue Dressing Room to Purple Bed Room
39 State Dressing Room (First George Room)
40 Jewell Closet
41 State Bedroom (Second George Room)
42 Third George Room
43 Fourth George Room
44 Fifth George Room
47 First Part of Chapel
48 Chapel

Burghley House Today

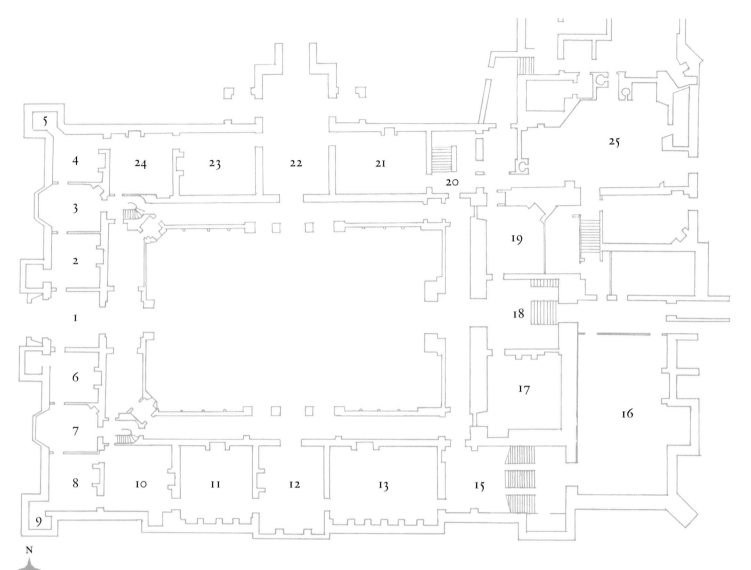

N

PLAN 11

1 West Hall
2 Business Room
3 Blue and Silver Bedroom
4 Blue and Silver Dressing Room
5 Bathroom
6 Dressing Room
7 Bedroom
8 Dressing Room
9 Bathroom
10 Blue Drawing Room
11 Red Drawing Room
12 Marble Hall
13 South Dining Room
15 Hell Stairwell
16 Great Hall
17 Butler's Pantry
18 Saloon
19 Kitchen
21 Dining Room
22 North Hall
23 Library
24 Ante Library Plan

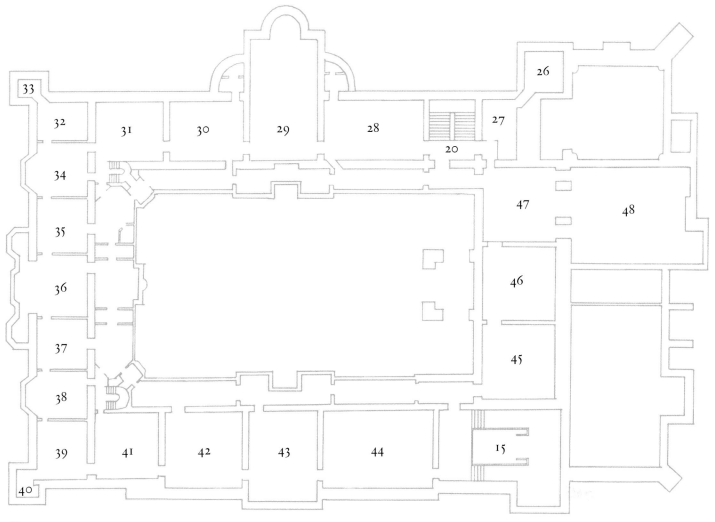

N

PLAN 12

26&27 Bedroom
28 Billiard Room
29 Bow Room
30 Brown Drawing Room
31 Black and Yellow Bedroom
32 Green Damask Bedroom
33 Bathroom
34 Marquetry Room
35 Queen Elizabeth's Bedroom
36 Pagoda Room
37 Blue Silk Bedroom
38 Blue Silk Dressing Room
39 First George Room
40 Jewel Closet
41 Second George Room
42 Third George Room
43 Fourth George Room
44 Heaven Room
47 Ante Chapel
48 Chapel

CATALOGUE

William Cecil, Lord Burghley

Attributed to Marcus Gheeraerts the Younger

*England
ca. 1585*

Oil on canvas
h. 122.5, w. 97.5 cm
(h. 39¼, w. 38⅜ in.)
Leatham Collection

Three-quarter length, standing, wearing robes and the insignia of the Order of the Garter, his staff of office in his right hand, with the sitter's coat of arms and motto.

This portrait is a copy after the original at Burghley House, which in the 1688 inventory is listed as *Ld. Treasurer Burghley's picture in a frame* in the *North Dining Roome*.

William Cecil (1520–1598), Lord Treasurer of England, the original builder of Burghley House, was created Lord Burghley in 1571 (see cat. no. 2). He was a faithful servant of Queen Elizabeth and the most powerful statesman of the time.

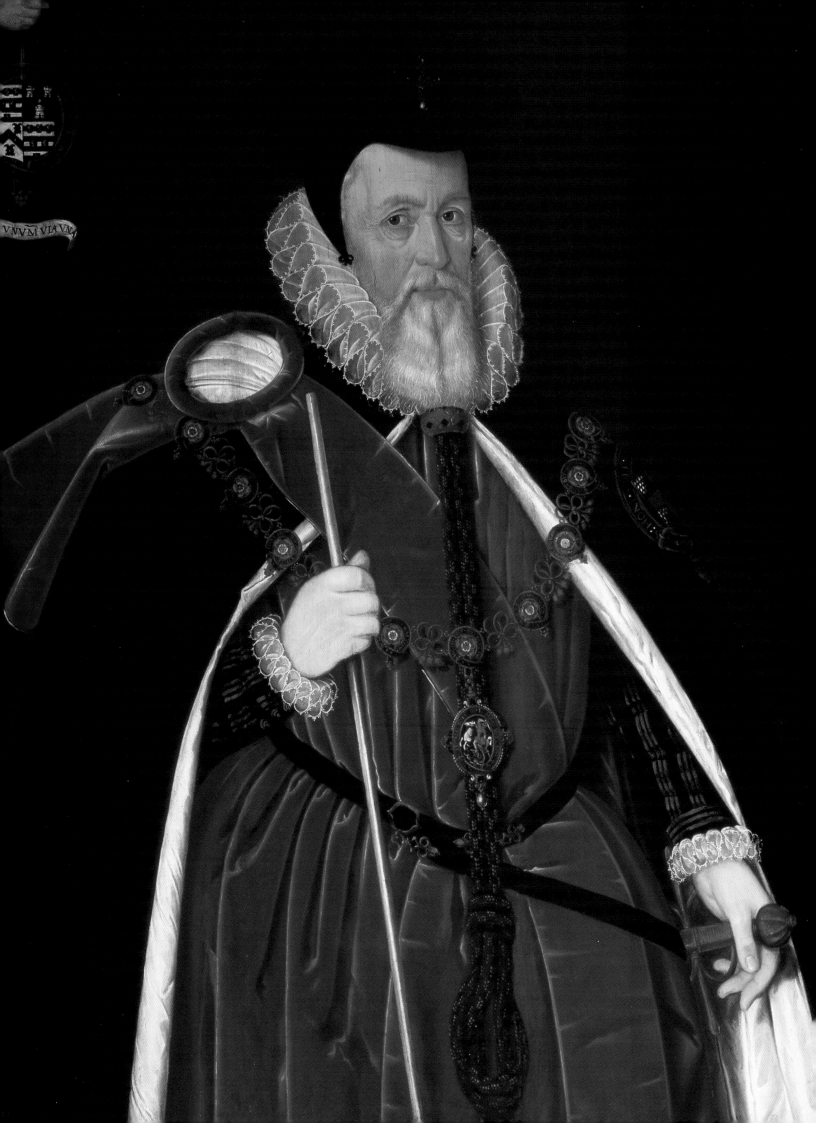

Royal Letters Patent

February 25, 1571

Oil on canvas, ink, and watercolor on vellum
MUN18518

The illuminated Royal Letters Patent, with fine colored initial letter portrait, elevating William Cecil to the peerage as Lord Burghley.

Sir William Cecil was created Lord Burghley on February 25, 1571, the day this grant was issued. In the words of the *Dictionary of National Biography*: "To follow his career from this point to its close would be to write the history of England; for by him, more than by any other single man during the last thirty years of his life, was the history of England written." He was made a Knight of the Garter and created Lord High Treasurer the following year but received no further honors, a fact acknowledged by his contemporaries:

*If thou wouldst know
 the virtues of mankind,
Read here in one, what
 thou in all canst find,
And go no farther: let this
 circle be
Thy universe, though his
 epitome.
Cecil the grave, the wise,
 the great, the good,
What is there more that
 can ennoble blood?
The orphan's pillar, the
 true subject's field,
The only faithful
 watchman for the realm,
That in all tempests never
 quit the helm,
But stood unshaken in his
 deeds and name,
And laboured in the work;
 not with the fame:
That still was good for
 goodness' sake, nor
 thought
Upon reward, till the
 reward him sought.
Whose offices and
 honours did surprise,
Rather than meet him:
 and, before his eyes
Closed to their peace, he
 saw his branches shoot,
And in the noblest
 families took root
Of all the land, who now
 at such a rate,
Of divine blessing,
 would not serve a state?*

—BEN JONSON, *"An
 Epigram on William,
 Lord Burl[eigh]...,"
in* Ben Jonson: The
 Complete Poems,
*edited by George Parfitt
 (Middlesex, 1975).*

He himself wrote to a correspondent that he was, "if you list to write truly, the poorest lord in England."

The Great Seal attached to this document has been smashed and sewn into a rough hessian bag, which has been inscribed in Burghley's distinctive handwriting: "25 febr. 13. EI" (February 25 in the thirteenth year of Elizabeth I's reign, the normal way such documents were dated). The seal was therefore either broken by the time Burghley received the document, or it was broken while in his care; possibly he dropped it himself. It has only recently come to light, rolled up in a cupboard at Burghley House.

Exhibited: From King Arthur to the First Queen Elizabeth, *1993.*

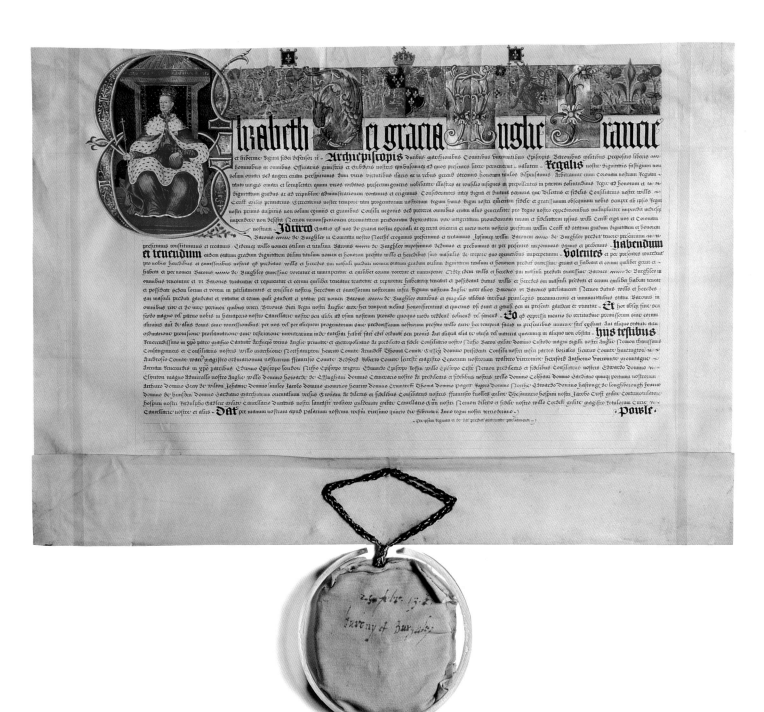

John, Fifth Earl of Exeter

Sir Peter Lely
England
ca. 1664–1688

Oil on canvas
h. 120.6, w. 94 cm
(h. 47½, w. 37 in.)
PIC391

Three-quarter length,
seated with his dog,
wearing brown robes.
Inscribed with identity
of sitter.

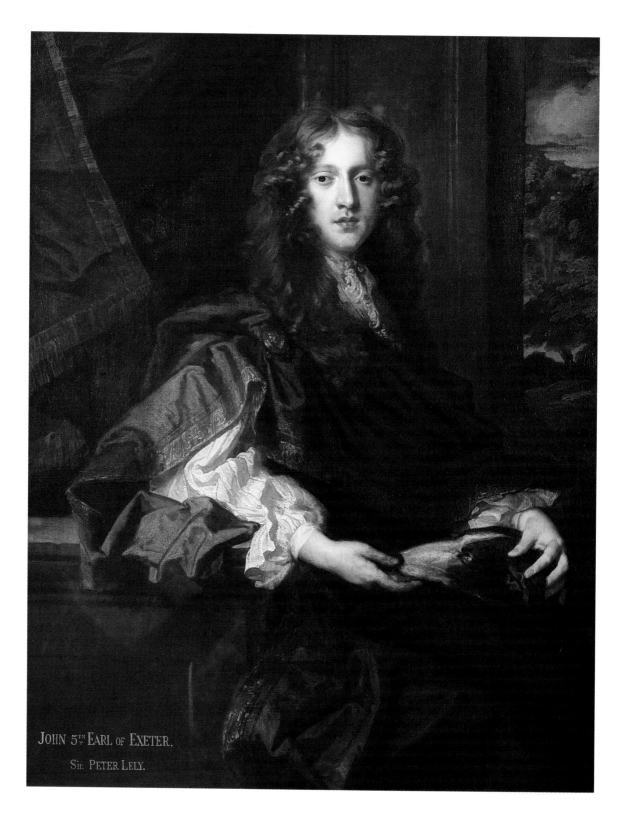

JOHN 5ᵀᴴ EARL OF EXETER.

Sir. PETER LELY.

3B

Anne, Countess of Exeter

Sir Peter Lely
England
ca. 1664–1688

Oil on canvas
h. 120.7, w. 94 cm
(h. 47 ½, w. 37 in.)
PIC390

Three-quarter length, seated, wearing a brown dress and holding a garland of flowers.

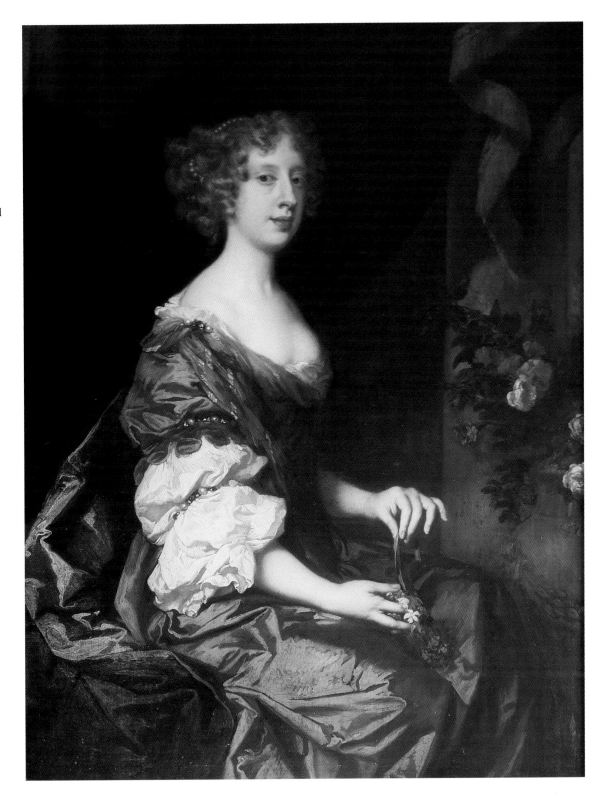

John Cecil (1648–1700) inherited the earldom in 1678. Eight years earlier he had married Anne Cavendish, daughter of the Third Earl of Devonshire, who was then the widow of Lord Rich. The Fifth Earl and his Countess modernized Burghley, their major works transforming the Elizabethan house with its vast rooms into a more up-to-date house in conformity with seventeenth-century taste. They are major figures in the development of Burghley, and they have left a mark on the house not only in itself, but also in the contents acquired both in England and on their several voyages to the Continent. Many of their acquisitions are featured in this exhibition.

These two portraits have always hung in the Marble Hall, where they fit the paneling. Early in this century the moldings were cut so that they could be removed, acting as movable frames for the portraits.

4

John, Fifth Earl of Exeter

Pierre-Etienne Monnot
Italy, Rome
1701

White marble
h. 62.2, w. 65, d. approx.
32 cm (h. 24½, w. 25⅝,
d. approx. 12⅝ in.)

Signed: P.S. Monnot.f.
Rom.1701
EWA08604

Lord and Lady Exeter visited the studio of Pierre-Etienne Monnot in Rome in 1699 on their fourth tour to the Continent. They both sat for their portraits in the Roman manner; only that of the Earl is exhibited here. These and some other sculptures commissioned from Monnot were delivered to Burghley only after the death of the Fifth Earl.

In the eighteenth century the busts stood in the Fourth George Room. Today they stand at the base of the Hell Staircase.

Exhibited: Treasure Houses of Britain, *1985, no. 217.*

Literature: Gunnis 1969, 261; Whinney 1988, 254.

5

Brownlow, Ninth Earl of Exeter

Thomas Hudson
England
1747

Oil on canvas
h. 124.5, w. 100.3 cm
(h. 49, w. 39½ in.)

Signed lower right:
Tho: Hudson Pinxit/1747
PIC083

Three-quarter length, standing, wearing black Van Dyck costume.

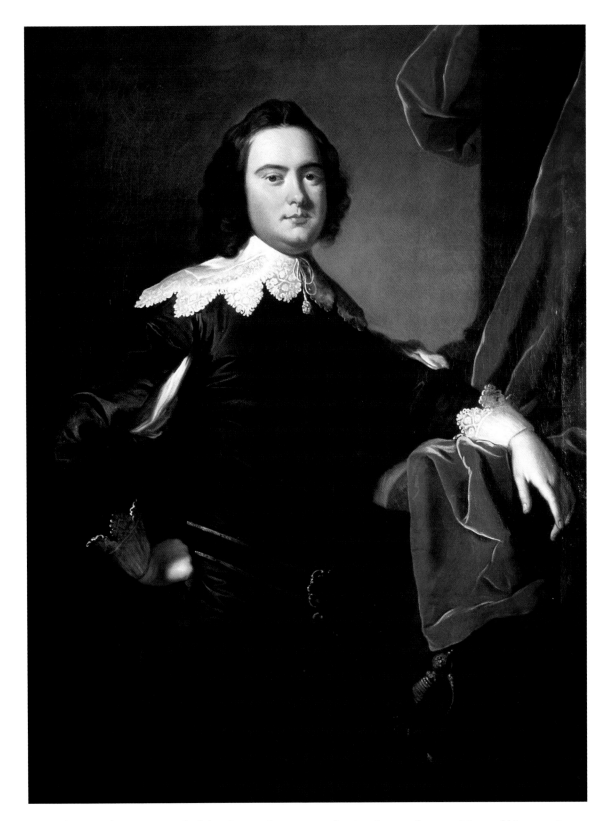

Brownlow Cecil (1725–1793), great-grandson of the Fifth Earl, was the second major figure in the transformation of Burghley. His respect for the Fifth Earl, possibly indicated by the antique costume in which he chose to be portrayed, is also apparent in the house, where he continued the renovation of the George rooms in the style, by then out of date, begun by his great-grandfather. The Ninth Earl, too, traveled to the Continent, where he purchased and ordered pictures and objects for Burghley. Having a liking for the reworking of old materials, he commissioned several of the finest English cabinet-makers and carvers. Many of his commissions and acquisitions can be seen in this exhibition.

In the eighteenth century, this portrait hung in the *Brown Dining Room*. Today it remains in the same room, now the Billiard Room.

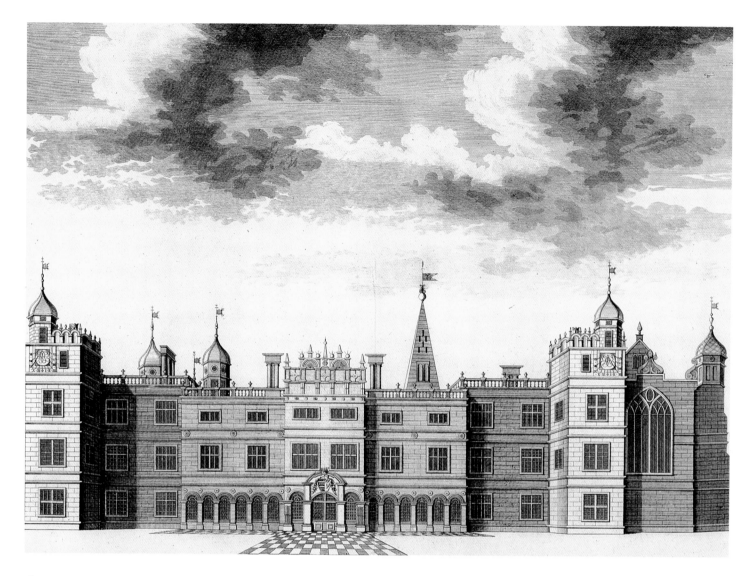

6

**Burleigh House.
The Earl of Exeters**

*England
ca. 1740*

Engraving on paper
h. 35, w. 43 cm
(h. 13¾, w. 16⅞ in.)

This engraving is a
recent purchase and has
no history in the house.
The design on the
English "Delftware"
dish (cat. no. 65) closely
resembles this print and
may be taken from it.
The house is shown
as it stood before
"Capability" Brown
altered the skyline
(see cat. nos. 8, 9).

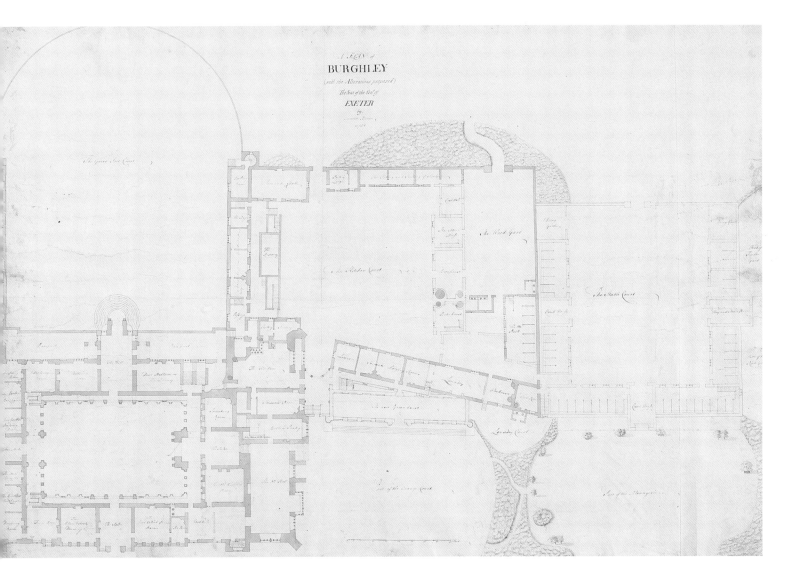

A PLAN of
BURGHLEY
(with the Alterations proposed)
The Seat of the Earl of
EXETER
by

7

A Plan of Burghley
(with the Alterations
proposed)

*Lancelot "Capability" Brown
England
1756*

Pen and black ink and gray
wash on laid paper
h. 103, w. 160 cm
(h. 40½, w. 63 in.)

Inscribed with title
and signed u.c.:...*by/
Lancelot Brown /1756*
PIC13548

This is Brown's first
plan, of 1756, and many
of his ideas were not
carried out, while other
changes were made that
do not appear on the
plan. Not executed were
the planned corridors in
the Inner Court along
the North and South
Ranges (they were to be
added in the nineteenth
century), useful though
these would have been.

The fireplace in the
Great Hall was not
transferred to the west
side. The new Green-
house and the Stable
Court were built as
planned, but Brown had
not yet envisaged the
demolition of the west
wing (the Library Wing)
that projected from the
North Range, though he
was to do so before 1770.

*Literature: Till 1975, 983,
fig. 5.*

8

The North Front of Burghley, the seat of the Earl of Exeter, with the intended alterations

Lancelot "Capability" Brown
England
ca. 1756

Pen and black ink and gray wash on laid paper
h. 35, w. 52 cm
(h. 14, w. 20⅝ in.)

Signed lower right:
L: Brown and inscribed with title beneath
PIC13547

Brown's drawing shows at the extreme right the junction with the west wing that he was later to demolish. His main proposals were for a more regular arrangement of the fenestration and for the central feature, where the windows of the ground floor were to be arched. The North Range was much more visible after the removal of the west wing, and consequently more important.

Literature: Till 1975, 983, fig. 1.

The South Front of Burghley, the seat of the Earl of Exeter, with the intended alterations

Lancelot "Capability" Brown
England
ca. 1756

Pen and black ink and gray wash on laid paper
h. 35, w. 52 cm (h. 13¾, w. 20½ in.)

Signed lower right:
L: Brown and inscribed with title beneath
PIC13550

The South Front had been damaged in the Cromwellian bombardment of 1643, and the Fifth Earl had already altered its original appearance before this drawing was made. Comparison of Brown's drawing with the engraving of ca. 1740 (cat. no. 6) shows that the most important of his proposals was the leveling out of the skyline by raising false walls above the bays flanking the central feature and the regulation of the fenestration.

It should be remembered that all the upper windows of this range are false, as the State Rooms with Antonio Verrio's high ceilings are behind them. Brown gives alternate proposals for either a battlemented or a balustraded skyline; the balustraded was preferred. The central Elizabethan cresting, retained in Brown's drawing, does not survive and may have been removed at that time.

Literature: Till 1975, fig. 7.

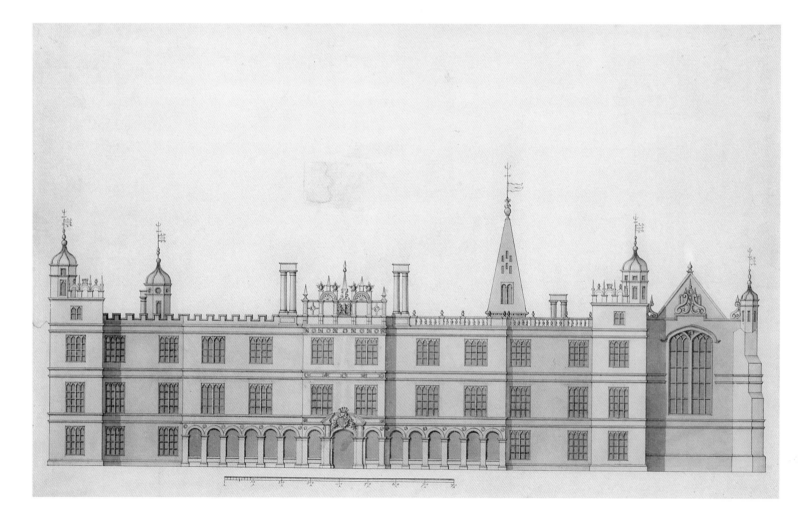

Robert Cecil, First Earl of Salisbury

Isaac Oliver
England
ca. 1600

Miniature on vellum
Oval, 5 cm (2 in.);
rectangular frame,
h. 8.7, w. 7.1 cm
(h. 3⁷⁄₁₆, w. 2¹³⁄₁₆ in.)
MIN0008

With gray backswept hair
and a chestnut-colored half-
beard and mustache,
wearing a black doublet
with a white ruff and the
ribbon of the Order
of the Garter, blue
background, gold border.

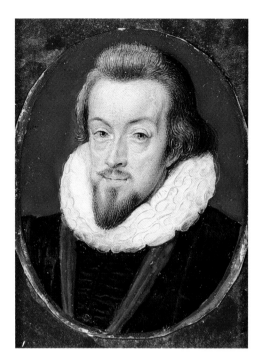

Robert was the younger
son of William Cecil,
Lord Burghley, Lord
Treasurer, and his
second wife Mildred
Cooke. In 1589 he
married Elizabeth, sister
of Henry Brooke, Lord
Cobham.

Lady Elizabeth Cecil
(ca. 1620–1689), second
daughter of William,
Second Earl of
Salisbury, married
in 1638/1639 William,
Third Earl of Devon-
shire (1617–1684). In
her will she bequeathed
a number of miniatures
to her daughter Anne,
who had married John,
Fifth Earl of Exeter,
in 1670. This group
provides the nucleus
of the Burghley House
collection.

Isaac Oliver (ca.
1565–1617) was a pupil
of Nicholas Hilliard,
the foremost miniature
painter of the Eliza-
bethan age. Oliver,
of French extraction,
concentrated more
on continental models,
taking the "limning"
style into a more
modern idiom. He was
appointed Limner to
the Queen, Anne of
Denmark, in 1605.

Provenance: Elizabeth,
Countess of Devonshire, née
Cecil, her will, proved 13th
November 1690, listed as
A picture of the Treasurer
Salisbury by Oliver, *by*
whom given to her daughter,
Anne, Countess of Exeter.

Elizabeth, Countess of Devonshire, née Cecil

Samuel Cooper
England
1642

Miniature on vellum
h. 15.5, d. 11.7 cm
(h. 6⅛, w. 4⅞ in.)
Signed and dated: 1642
MIN0014

Three-quarter length with crossed arms, her hair dressed in ringlets and adorned with pearls, wearing a pale cream-colored gown with pink bows down the front and a white chemise, pearl necklace and double drop earrings, gold brocade and window background, rectangular dark-stained fruitwood veneer frame.

This miniature is the earliest recorded signed and dated miniature by Samuel Cooper (?1608–1672). It reveals an already established master hand, which has drawn from the paintings of Van Dyck a psychological subtlety and compositional sophistication.

Samuel Cooper and his brother Alexander were nephews, wards, and pupils of John Hoskins (see cat. no. 12). As well known on the Continent as in Britain, Cooper painted Oliver Cromwell and two of the regicides, but nevertheless was working for King Charles II within days of the Restoration and was appointed the King's Limner in 1663.

Provenance: Elizabeth, Countess of Devonshire, née Cecil, her will, proved 13th November 1690, listed as A picture of the late Countess of Devonshire by Cooper in white, by whom given to her daughter, Anne, Countess of Exeter.

Exhibited: Age of Charles II, 1960, no. 593; Age of Charles I, 1972, no. 216; Samuel Cooper and His Contemporaries, 1973, no. 12; Treasure Houses of Britain, 1985, no. 78.

Literature: Williamson 1926, pl. 35; Long 1929, 91; Foskett 1972, pl. 51, no. 155; Foskett 1973, 71, 108, fig. 7.

William Cavendish, Fourth Earl and First Duke of Devonshire (1640/1–1707), as a Young Boy

John Hoskins
England
1644

Miniature on vellum
Oval, 8.5 cm (3⅜ in.);
rectangular frame,
h. 8.5, w. 8.0, d. 1.5 cm
(h. 3⅜, w. 3¹/₁₆, d. ⁹/₁₆ in.)

Signed with initials
and dated: 1644
MIN0043

Half-length holding
a puppy, with red hair,
wearing a lace cap and
a blue gown with white
facings, a plinth to dexter
with landscape and distant
castle beyond.

William Cavendish
was the son of William,
Third Earl of Devon-
shire and his wife,
Elizabeth, née Cecil (see
cat. no. 14, another
miniature by Hoskins
painted in the same
year). In 1662 he
married Mary, second
daughter of James
Butler, First Duke of
Ormonde. In 1694 he
was created Marquess
of Hartington and
Duke of Devonshire.
 John Hoskins (ca.
1650–1665) was a pupil
of Nicholas Hilliard and
uncle, guardian, and
teacher of Samuel
Cooper (see cat. nos. 11,
13). In his later life his
work was overshadowed
by that of Cooper
and shows that Hoskins
was influenced by his
immensely successful
former pupil.

Provenance: Elizabeth,
Countess of Devonshire, née
Cecil, her will, proved 13th
November 1690, listed as
A picture of the present
Earle of Devonshire when
a Child by Hoskins, *by*
whom given to her daughter,
Anne, Countess of Exeter.

Exhibited: Age of Charles
II, *1960, no. 663;* Age of
Charles I, *1971, no. 199;*
Samuel Cooper and His
Contemporaries, *1974,*
no. 150; Treasure Houses
of Britain, *1985, no. 79.*

Elizabeth, Countess of Northumberland, née Howard

Samuel Cooper
England
ca. 1645

Miniature on vellum
Oval, 7 cm (2¾ in.);
rectangular frame,
h. 7, w. 5.8 cm
(h. 2¾, w. 2⁵/₁₆ in.)
MIN003

Three-quarters dexter, with chestnut-colored hair falling in coils to her shoulders, wearing a low-cut rose-colored dress edged with a white band, and a pearl necklace, sky background.

Lady Elizabeth Howard (ca. 1622–1704/5), second daughter of Theophilus, Second Earl of Suffolk, married in 1642, as his second wife, Elizabeth Howard, daughter of Algernon, Tenth Earl of Northumberland. He had previously been married to Lady Anne Cecil (1612–1637), elder sister of Elizabeth, Countess of Devonshire, whose will cites this miniature (see cat. no. 11).

Provenance: Elizabeth, Countess of Devonshire, née Cecil, her will, proved 13th November 1690, listed as A picture of the Earle of Northumberlands second wife by Cooper, *by whom given to her daughter, Anne, Countess of Exeter.*

Exhibited: Age of Charles II, 1960, *no. 614;* Samuel Cooper and His Contemporaries, *1974, no. 34.*

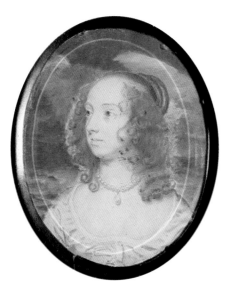

A Lady, Possibly Lady Anne Rich, née Cavendish and Later Countess of Exeter, with Her Brother and a Black Page

Nicholas Dixon
England
1668

Miniature on vellum
h. 16, w. 19.7 cm
(h. 6�5⁄16, w. 7¾ in.)

Signed with monogram
and dated: 1668
MIN0018

The young lady on the right gesturing to center, with light brown hair bound with ribbon and pearls, wearing a rose dress and a white chemise with a striped fichu and spangled drape, the youth on the left, his left hand resting on the richly attired black page, a spear in his right hand, wearing Arcadian hunting clothes of blue and white, landscape background

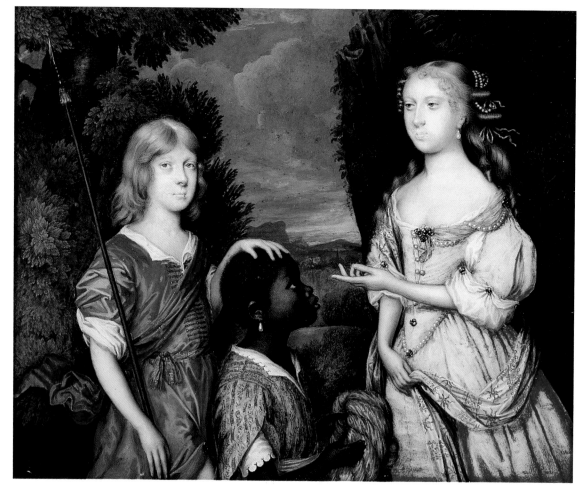

The sitters traditionally have been identified as Lady Anne Cavendish (1648–1703) and her brother William, Lord Cavendish, later First Duke of Devonshire (1640/1–1707). Considering that the miniature is dated 1668, it is likely that the female sitter is Lady Anne, although it is curious that there is no allusion to her widowed state (she was briefly married to Lord Rich). However, it is unacceptable to identify the youth as her elder brother William, who was twenty-eight years old at the time.

William Cavendish, Third Earl of Devonshire (1617–1684), had three children: William (1640–1707), who became First Duke in 1694; Anne (1649–1703), who married Charles, Lord Rich, and after his death in 1664 John Cecil, later Fifth Earl of Exeter; and Charles (?–1670), who was unmarried. Thus, in 1668, William was twenty-eight, Anne was nineteen, and Charles could not have been more than seventeen (and was probably much younger). The brother depicted must surely be Charles.

Nicholas Dixon (fl. ca. 1660–1665, d. ca. 1707) succeeded Samuel Cooper (see cat. nos. 11, 13) as Limner to King Charles II in 1673. The present miniature is perhaps the first example of his work (see also cat. no. 16).

Provenance: Elizabeth, Countess of Devonshire, née Cecil, her will, proved 13th November 1690, A picture of the present Countess of Exeter to the knees, with her brother and a blackamoor boy by Dixon, by whom given to her daughter, Anne, Countess of Exeter.

Exhibited: Age of Charles II, 1960, *no. 667;* Samuel Cooper and His Contemporaries, *1974, no. 216.*

15

Brownlow, Ninth Earl of Exeter

Christian Friedrich Zincke
England
ca. 1732

Enamel on porcelain
Oval, 4.5 cm (1¾ in.)
MIN0045

With flowing brown hair, wearing a maroon coat and a lace jabot, sky background with a tree, the reverse engraved with cipher and inscription.

Brownlow, Ninth Earl of Exeter, was six and a half years old at the time this miniature was painted. An inscription on the reverse reads: *Was born September ye 4th 1727. His age 6 years and a half.*

Christian Friedrich Zincke (1683/5–1767) was a German painter active in England after 1706. Having studied painting in Dresden, he came to England to work in enamels with Charles Boit. His work was immensely popular, and he was appointed Cabinet Painter to Frederick, Prince of Wales, in 1732.

16

The Adoration of the Magi

Nicholas Dixon,
after Peter Paul Rubens
England
ca. 1680

Miniature on vellum
h. 41, w. 31.5 cm
(h. 16⅛, w. 12⁷⁄₁₆ in.)
MIN0087

The three kings kneeling before the Christ child held out by a blue-habited Virgin, in a barn with other onlookers. The composition is based upon Rubens' *Adoration of the Magi,* painted in 1624 for the high altar of the church of St. Michael, Antwerp, now in the Antwerp Museum.

Miniature copies of famous paintings, as well as original history paintings, had been a considerable part of the miniaturists' oeuvre since the work of Samuel Cooper and his brother Alexander.

Provenance: Elizabeth, Countess of Devonshire, née Cecil, her will, proved 13th November 1690, listed as A picture of the Nativity of our Saviour Ten figures by Dixon, *by whom given to her daughter, Anne, Countess of Exeter.*

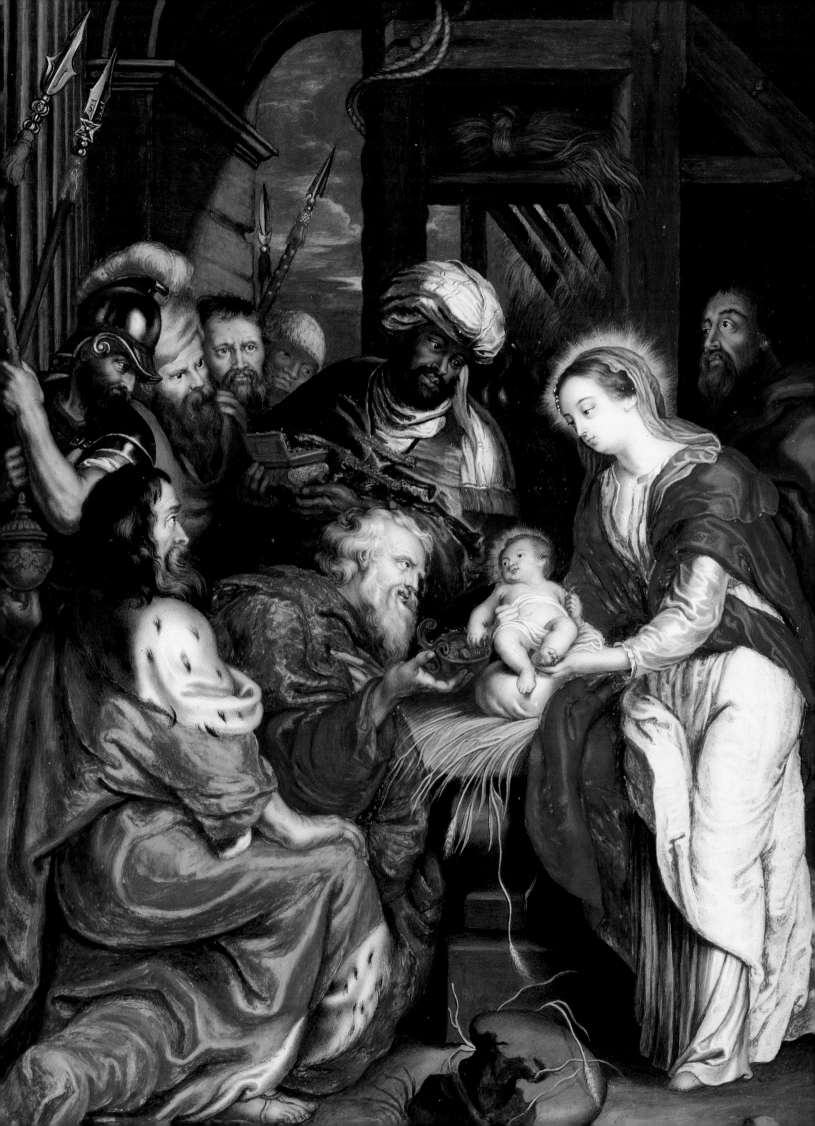

The Education of Cupid

*John Hoskins, after Correggio
England
ca. 1640*

Miniature on vellum
h. 24, w. 16 cm
(h. 9⁷⁄₁₆, w. 6⁵⁄₁₆ in.)
MIN0002

Mercury seated holding
a script which the young
Cupid reads, Venus
standing beside them, wood
and rock background.

Correggio's *Education
of Cupid*, painted by
ca. 1528, entered the
collection of King
Charles I in 1628
when he acquired the
celebrated Gonzaga
collection from Mantua.
It is now in the National
Gallery, London.

*Provenance: Elizabeth,
Countess of Devonshire, née
Cecil, her will, proved 13th
November 1690, listed as*
A Picture of Venus and
Mercury with a Cupid by
Hoskins, *by whom given to
her daughter, Anne, Countess
of Exeter.*

*Literature: Foskett 1972,
vol. 1, pl. 8 (color).*

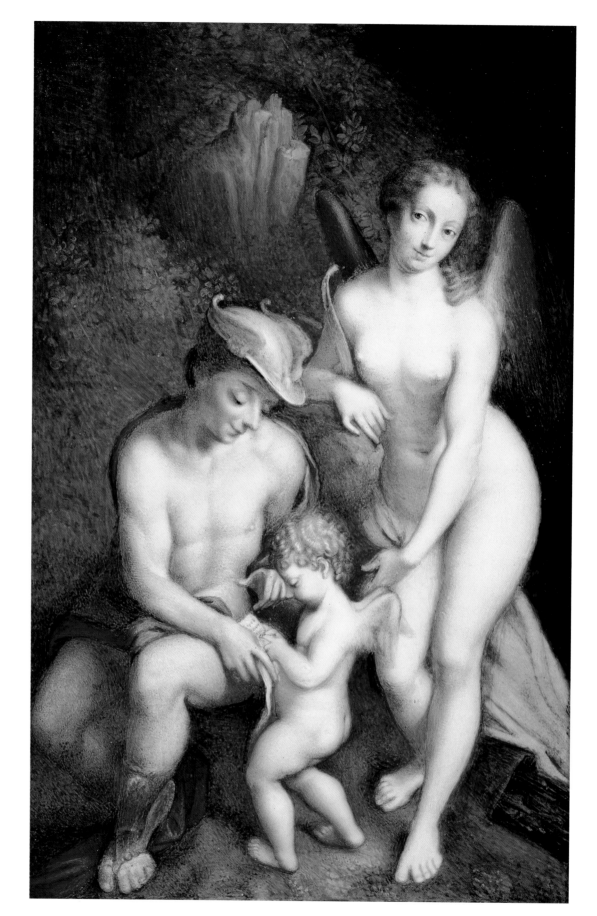

18

Self-Portrait

Luca Giordano
Italy, probably Naples
ca. 1680

Oil on paper
Oval, 7.4 cm (2¹⁵⁄₁₆ in.);
rectangular frame, h. 7.5,
w. 6 cm (h. 2⅚₆, w. 2⅜ in.)

Reverse label inscribed by
Brownlow, Ninth Earl of
Exeter: *L Jordanus painted*
by himself on a card
MIN0027

Wearing black spectacles,
with long brown hair,
wearing an embroidered
brown gown with a white
jabot and a red bow, a
medallion upon a chain
about his neck, blue
background.

This self-portrait was
presumably purchased
by John, Fifth Earl of
Exeter, either on one of
his trips to Italy or
through the agent Gilles
Balle. Luca Giordano
(1634–1705) was one of
the artists patronized by
the Fifth Earl of Exeter
during his time in Italy.
The Earl bought a
number of paintings
from him, including
such major works as
The Death of Seneca
and *The Rape of*
Europa.

Literature: Ferrari and
Scavizzi 1966, 122.

Ewer

*Italy, Miseroni workshop
ca. 1600
Mounts, handle, and possibly
the foot, England, ca. 1660*

Rock crystal, gold, precious
stones, and enamel
h. 18, w. 8, d. 17.5 cm
(h. 7⅛, w. 3³⁄₁₆, d. 6⅞ in.)
EWA08509

Mounted in enameled gold
set with rubies, spinels,
a garnet, and diamonds,
helmet-shaped bowl
engraved with leafy scrolls,
fruit, and swags, with
handle of angular section,
the mount to the handle,
front of the bowl, and foot
pierced and enriched with
white, blue, and black
enamel and set with stones.

The goldsmith's work
is of superior quality
and includes the only
known cameo carved
on a precious stone
of Queen Elizabeth.
Family tradition calls
this "Queen Elizabeth's
Goblet," though there
is no mention of this
in the 1690 schedule.

According to Celia
Fiennes (1697), all
the jewels and semi-
precious stone artifacts
bequeathed to Anne,
Countess of Exeter,
by her mother in 1690
were kept in *Lady
Exeter's Closet*.

*Provenance: Elizabeth,
Countess of Devonshire, née
Cecil, her will, proved 13th
November 1690, listed as* A
Christall ewer Garnisht
with Diamonds and Rubies
one of the Rubies being
Queen Elizabeths head, *by
whom given to her daughter
Anne, Countess of Exeter.*

*Literature: Somers-Cocks
1985, no. 1.*

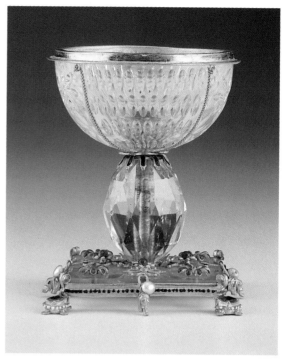

21

Standing bowl or salt

*Western Europe
Early 17th century*

Rock crystal with gold
and cloisonné enamel
h. 7, w. 5.5, d. 5.5 cm
(h. 2¾, w. 2³⁄₁₆, d. 2³⁄₁₆ in.)
EWA08514

Hemispherical rock crystal
bowl carved with ovals, the
interior of the bowl with
red petaled cinquefoil with
green leaves fixing the
faceted ovoid stem, the
square foot applied with
gold brackets decorated
with black cloisonné enamel
and red and white rosettes,
cast elephant feet in gold
interspersed with table-cut
emeralds in shaped collets.

It has not proved
possible firmly to
attribute this crystal
to a country or
workshop of origin.

*Provenance: Elizabeth,
Countess of Devonshire, née
Cecil, her will, proved 13th
November 1690, listed as* A
wrought Round Christall
Cupp on a Square ffoote
with a Cover Garnisht with
Gold pearles Emrods
Rubies and Enamel, *by
whom given to her daughter,
Anne, Countess of Exeter.*

*Literature: Somers-Cocks
1985, no. 6.*

20

Standing bowl

*Italy, Milan
ca. 1600*

Rock crystal, enamel,
gold-mounted
h. 10.8, w. 31, d. 7.5 cm
(h. 4¼, w. 12³⁄₁₆, d. 2¹⁵⁄₁₆ in.)
EWA08512

Octolobate rock crystal
body carved with scroll
work, beading, and stylized
flowers, urn-shaped stem
and circular foot.

*Provenance: Elizabeth,
Countess of Devonshire, née
Cecil, her will, proved 13th
November 1690, listed as* A
wrought Ribd Christall
ovall Cupp upon an Ovall
ffoot sett together in Two
plates with Gold & Black
enamel, *by whom given to her
daughter, Anne, Countess of
Exeter.*

*Literature: Somers-Cocks
1985, no. 4.*

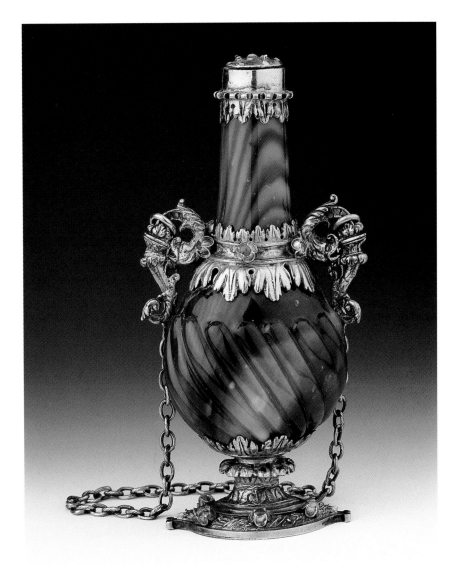

22

Casting bottle

*Perhaps England
ca. 1535–1540*

Agate with silver-gilt
mounting and rubies
h. 13, w. 7, d. 4 cm
(h. 5⅛, w. 2¾, d. 1 ⁹⁄₁₆ in.)
EWA08516

The agate body carved
with spiraling gadroons,
almond-shaped foot of
silver-gilt cast with a leaf
pattern, the handles in the
form of stylized dolphins,
the neck and rim mount
with acanthus decoration
enriched with rubies in
quatrefoil collets, the whole
in the form of a pilgrim
bottle with chains, formerly
one of a pair, the lid
missing.

Anna Somers-Cocks
attributes this casting
bottle to England,
commenting that "it
increases the number
of surviving English
mounted hardstone
vessels from the early
Renaissance to three."
Casting bottles held
aromatic substances that
could be sprinkled onto
textiles.

*Provenance: Elizabeth,
Countess of Devonshire, née
Cecil, her will, proved 13th
November 1690, listed as
A pair of Large Agat
Bottles with Chaines set
with Turquoises and Rubies
Garnisht with Silver-Gilt,
by whom given to her
daughter, Anne, Countess
of Exeter. The pair is now
missing.*

*Literature: Somers-Cocks
1985, no. 9.*

23

Standing bowl

Italy
Late 16th century

Agate, gold, enamel, pearls,
diamonds, and rubies
h. 8.9, w. 5.5, d. 4 cm
(h. 3½, w. 3³⁄₁₆, d. 1⁹⁄₁₆ in.)
EWA08520

The oval agate bowl
gadrooned together with
the urn-shaped stem and
domed foot, the enamel
mounts decorated with
strapwork and arabesques
in white, black, red, and
blue, the whole enriched
with pearls and table-cut
diamonds and rubies in
collets, the cover missing.

Provenance: Elizabeth,
Countess of Devonshire, née
Cecil, her will, proved 13th
November 1690, listed as
An Agat wrought Cupp
and Cover upon a high ffoot
sett with Diamonds, Rubies
and pearles, *by whom given*
to her daughter, Anne,
Countess of Exeter.

Literature: Somers-Cocks
1985, no. 13.

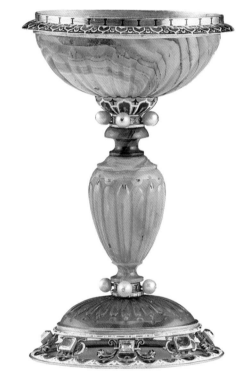

24

Bust of a Moor

Enamel, gold, and gem-set
agate

*Italy, Milan, probably
Miseroni workshop
Bust ca. 1600,
on late-18th-century base*

Agate with gold set with
rubies, diamonds, and white,
black, and green enamel
h. excluding aigrette 3.2,
w. 4, d. 3 cm (h. 1¼, w. 1⁹⁄₁₆,
d. 1³⁄₁₆ in.)
EWA08521

The agate head and turban
set at a later date with
a diamond-set aigrette,
wearing a frogged coat
decorated in white, black,
and green enamel, the frog-
ging of translucent blue.
Bust itself included in the
1690 inventory and set at a
later date on a gold pedestal
decorated with trellis work
enriched with spinels.

*Provenance: Elizabeth,
Countess of Devonshire, née
Cecil, her will, proved 13th
November 1690, listed as* A
Moores Head Cutt out of
an olive stone sett with
pearle Rubies and
Diamonds upon a Gold and
Jett ped-stall with a large
Turquoise stone plate of
Eight Squares, *by whom
given to her daughter Anne,
Countess of Exeter.*

*Literature: Somers-Cocks
1985, no. 14.*

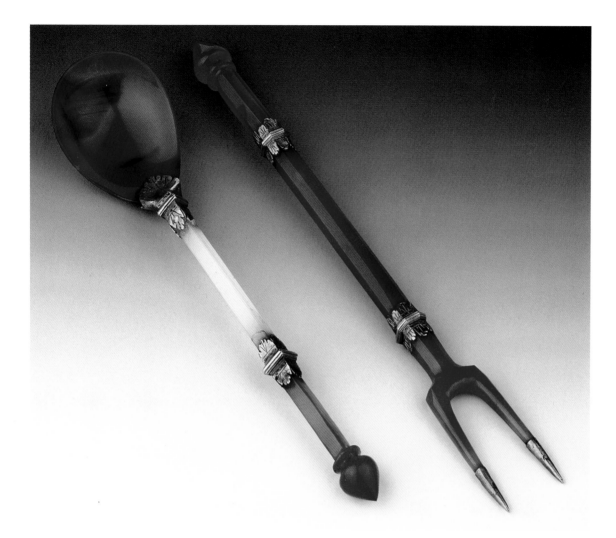

25

Spoon and fork

Germany
17th century

Carnelian and white
chalcedony, mounted
in gold
Spoon, l. 14.3 cm (5⅝ in.);
fork, l. 16.2 cm (6⅜ in.)
EWA08523

This exotic cutlery was
not for use, but served
as examples of fine
workmanship and
precious material. As
such, they are typically
contents of a Cabinet of
Curiosities.

*Provenance: Elizabeth,
Countess of Devonshire, née
Cecil, her will, proved 13th
November 1690, listed as* A
Cornelian Spoone and
fforke sett in Gold, the
Middle part of the spoon
White, *by whom given to her
daughter Anne, Countess of
Exeter.*

*Literature: Somers-Cocks
1985, no. 17.*

Covered salt

Indo-Portuguese
17th century

Rock crystal with gold,
rubies, and sapphires
h. 11.4, w. 6.5, d. 6.5 cm
(h. 4½, w. 2⁹⁄₁₆, d. 2⁹⁄₁₆ in.)
EWA08530

The whole of triangular
section, lidded, raised on
scrolling feet with double
pyramidal finial, set at each
angle with cabochon rubies
and sapphires.

Salts are not part of
the repertoire of Indian
goldsmiths, and the
form was introduced
by the Portuguese into
Goa, where this was
probably made. The
1690 description quotes
emeralds, but there are
none here and have
never been any present;
this is probably a slip
of the pen.

Provenance: Elizabeth,
Countess of Devonshire, née
Cecil, her will, proved 13th
November 1690, listed as
A Christall Salt & Cover
Garnisht with Gold, Rubies
and Emrods and with a
painted Saphir on the Top
of the Cover, *by whom given*
to her daughter, Anne,
Countess of Exeter.

Literature: Somers-Cocks
1985, no. 26.

27

Scent bottle

India, Mughal
17th century

Rock crystal with gold,
rubies, and emeralds
h. 7.7, w. 4.5, d. 3.5 cm
(h. 3¹⁄₁₆, w. 1¾, d. 1⅜ in.)
EWA08531

The leaf-shaped body laid
with gold scroll work set
with rubies and emeralds,
the neck a gold band,
and the stopper similarly
mounted.

The technique of the
attachment of precious
stones to a crystal or
jade body by means of
gold bands is typical of
the Mughal workshops.

Provenance: Elizabeth,
Countess of Devonshire, née
Cecil, her will, proved 13th
November 1690, listed as A
Christall Indian Bottle like a
Beane Garnisht with Gold,
Emrods and Rubies, *by*
whom given to her daughter,
Anne, Countess of Exeter.

Literature: Somers-Cocks
1985, no. 27.

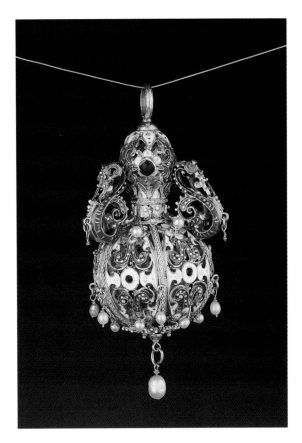

28

Roundel

Germany
ca. 1570

Enameled gold
diam. 3.5 cm (1⅜ in.)
EWA08551

Perhaps the reverse of
a jewel, naturalistically
enameled with the story
of Diana and Acteon.

This roundel depicts
the story from Ovid's
Metamorphoses in which
the huntsman Acteon,
having stumbled upon
the virgin goddess and
her attendants bathing,
is punished by being
turned into a stag.
This image is close
to a woodcut in G. S.
Florentin, *Illustrés
Observations Antiques*
(Lyons de Tournes,
1558).

*Provenance: Elizabeth,
Countess of Devonshire, née
Cecil, her will, proved 13th
November 1690, listed as* A
Round openwork plate of
Gold Enamel'd in little the
story of Acteon, *by whom
given to her daughter, Anne,
Countess of Exeter.*

*Literature: Somers-Cocks
1985, no. 50.*

29

Pomander

Germany
ca. 1600

Gold and green, white, and
mid-blue cloisonné enamel
with pearls and rubies
h. 8, diam. 4 cm
(h. 3³⁄₁₆, diam. 1⁹⁄₁₆ in.)
EWA08553

Decorated in cloisonné
enamel in colors of white,
green, turquoise, and mid-
blue, in the form of a globe
with applied scroll work,
pendant ring enriched with
numerous pendant pearls,
perhaps formerly attached
to a girdle.

*Provenance: Elizabeth,
Countess of Devonshire, née
Cecil, her will, proved 13th
November 1690, where it is
probably listed as one of
Two Gold casting Bottles
for Incens Enamel'd
Openworke sett full with
pearle, by whom given to her
daughter, Anne, Countess
of Exeter.*

*Literature: Somers-Cocks
1985, no. 52.*

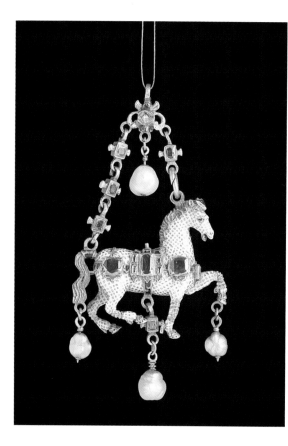

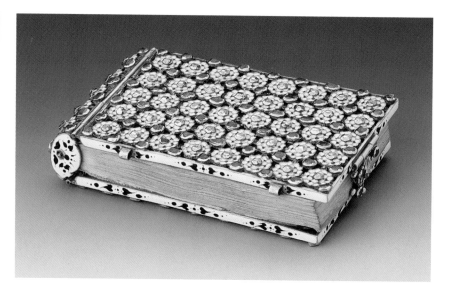

30

Pendant

Spain
ca. 1600

Gold and enamel
with rubies, diamonds,
emeralds, and pearls
h. 8.3, w. 4.2 cm
(h. 3¼, w. 1¹¹⁄₁₆ in.)
EWA08555

Now missing a Cupid, the
white horse saddled and set
on one side with diamonds,
the other with rubies,
emeralds, and diamonds
and hung with pearls, the
raised leg hinged.

Of the seventy-one
items listed in the
Devonshire Schedule in
the category "Jewels,"
only two survive: this
incomplete pendant and
the jeweled *fly* (cat. no.
32). Presumably, the
individual stones were
taken from the old
settings by later genera-
tions of Cecils and
reused in up-to-date
settings.

Provenance: Elizabeth,
Countess of Devonshire, née
Cecil, her will, proved 13th
November 1690, listed as
A Cupid on horseback in
Gold with a gold Chaine
sett with rubies & diamonds
and three pendant pearls, by
whom given to her daughter,
Anne, Countess, of Exeter.

Literature: Somers-Cocks
1985, no. 54.

31 A&B

Book cover
and book

Possibly England
ca. 1620–1630

Gold with white enamel set
with rubies and diamonds
h. 4.4, w. 6.8, d. 1.4 cm
(h. 1¾, w. 2¹¹⁄₁₆, d. ½ in.)
EWA08556

Traditionally called "Queen
Elizabeth's Pocket Book,"
decorated with rosettes
of white enamel centered
by rubies and diamonds,
the sides with stylized
leaves around hinged
clasp en suite. An empty
notebook, probably
contemporary, is inside.

This was made to be
hung on a cord or chain,
as there are two suspen-
sion rings for this pur-
pose. The name *Table
Booke* meant a tablet or
a memorandum book.

Provenance: Elizabeth,
Countess of Devonshire, née
Cecil, her will, proved 13th
November 1690, listed as
One Table Booke Enamel'd
sett with Diamonds and
Rubies in Roses, by whom
given to her daughter Anne,
Countess of Exeter.

Literature: Somers-Cocks
1985, no. 55.

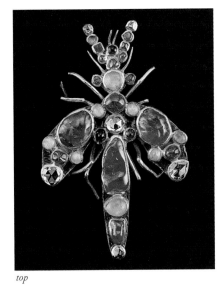

top

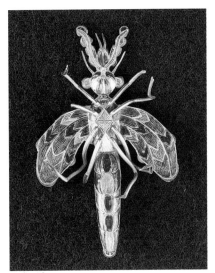

underside

32

Fly

*Probably England
Early 17th century*

Gold, enamel, rubies, opals,
sapphires, and diamonds
h. 6, d. 3.7 cm
(h. 2⅜, d. 1⁷⁄₁₆ in.)
EWA08558

Enameled naturalistically
in royal blue and green
and set with rubies, opals,
sapphires, and diamonds
in deep collets.

The Devonshire
Schedule lists three
other insect jewels
in the same section:
*A Beetle ffly of Gold
Enamell the Tayle a
Garnett the wings Green
and blue; A Large
Dragon ffly sett with
Garnetts, Opalls &
Diamonds. . .; and A ffly
of Gold A Large
Emerald the Tayle, a
Saphire the body, Two
Diamonds on the wings,
a Ruby the head with
other Diamond sparkes.*

*Provenance: Elizabeth,
Countess of Devonshire, née
Cecil, her will, proved 13th
November 1690, listed as*
A lesser ffly sett with
diamonds, Rubys Opalls
and Catts Eys, *by whom
given to her daughter Anne,
Countess of Exeter.*

*Literature: Somers-Cocks
1985, no. 57.*

Goa stone case and stand

*Probably England and Goa, India
17th century*

Silver-gilt with goa stone
h. 7, diam. 5 cm
(h. 2¾, diam. 2 in.)
EWA08563

Together with a Goa stone, the globular case pierced with scrolling foliage raised on three scrolling feet.

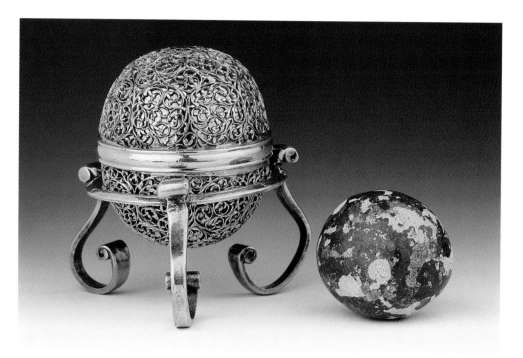

Goa stones were made from bezoar stones (accretions from the stomachs of ruminants), mixed with ambergris, musk, and ground precious stones and pearls. Invented by a Florentine lay-brother in Goa in the seventeenth century, they were supposed to have prophylactic and medicinal properties.

Provenance: Elizabeth, Countess of Devonshire, née Cecil, her will, proved 13th November 1690, by whom given to her daughter Anne, Countess of Exeter.

Literature: Somers-Cocks 1985, no. 62.

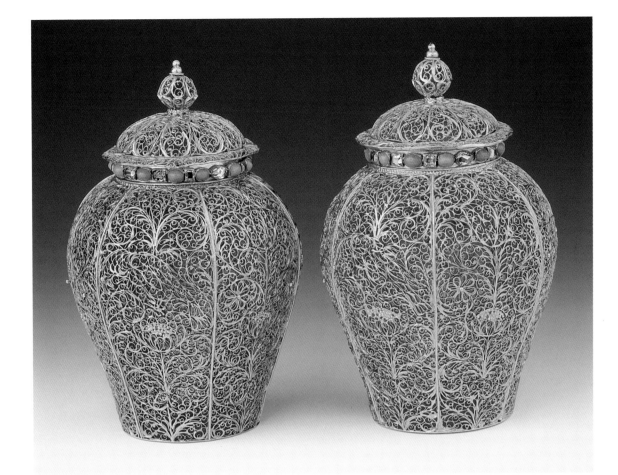

34 A & B

Pair of baluster vases with covers

England
Late 17th century

Gold filigree with diamond and turquoise
h. 10.5, diam. 7.0 cm
(h. 4⅛, diam. 2¾ in.)
SIL04548

The jars are paneled vertically, and concealed in the decoration are daisy flowers surmounted alternately by a tulip and a bird.

There are several examples of filigree work at Burghley, with typical scroll work and leaf motifs. The outstanding item is a large toilet service, only part of which is Elizabethan in date, demonstrating the continued use of the technique (see Webster, 1984, no. 19). These, however, are of particular importance precisely because they can be accurately dated.

Provenance: Elizabeth, Countess of Devonshire, née Cecil, her will, proved 13th November 1690, listed as Two Gold jarrs philligrin with Covers sett round the necks with Turquoise and Diamonds, *by whom given to her daughter, Anne, Countess of Exeter.*

Literature: Somers-Cocks 1985, no. 63.

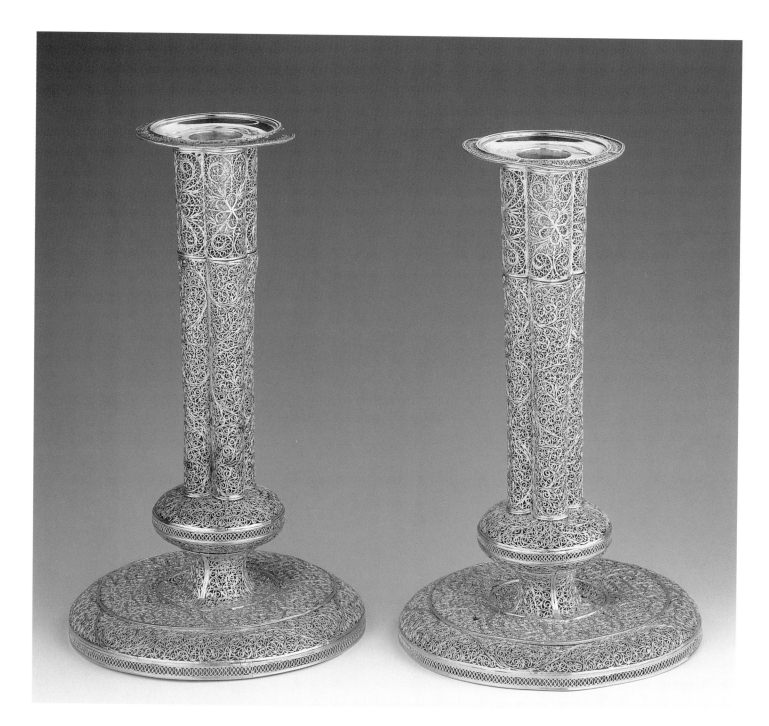

35A&B

Pair of candlesticks

England
Late 17th century

Silver-gilt filigree
h. 22.9, diam. 14 cm
(h. 9, diam. 5½ in.)
SIL04547

With circular bases and
quatrefoil stems. The upper
parts differ from the rest
of the body, suggesting that
the candlesticks were made
taller at a slightly later date.

Provenance: Elizabeth,
Countess of Devonshire, née
Cecil, her will, proved 13th
November 1690, by whom
given to her daughter, Anne,
Countess of Exeter.

Literature: Somers-Cocks
1985, no. 65.

Casket

Augsburg
Late 17th century

Tortoiseshell, ivory,
and silver foil
h. 29, w. 44.5, d. 36 cm
(h. 11⁷⁄₁₆, w. 17½, d. 14¼ in.)
EWA08673

Applied with further
pierced silver scroll work
and enriched with green
stained ivory columns, the
sides set with oval reliefs
of mythological and biblical
subjects.

In the 1804 inventory
this casket is listed in the
Red Drawing Room as
a tortoiseshell & silver
Cabinet on a Black stand
in a Glass case. In 1854 it
was in the same room as
a malachite & embossed
silver chest, mounted
in silver under a glass
shade.

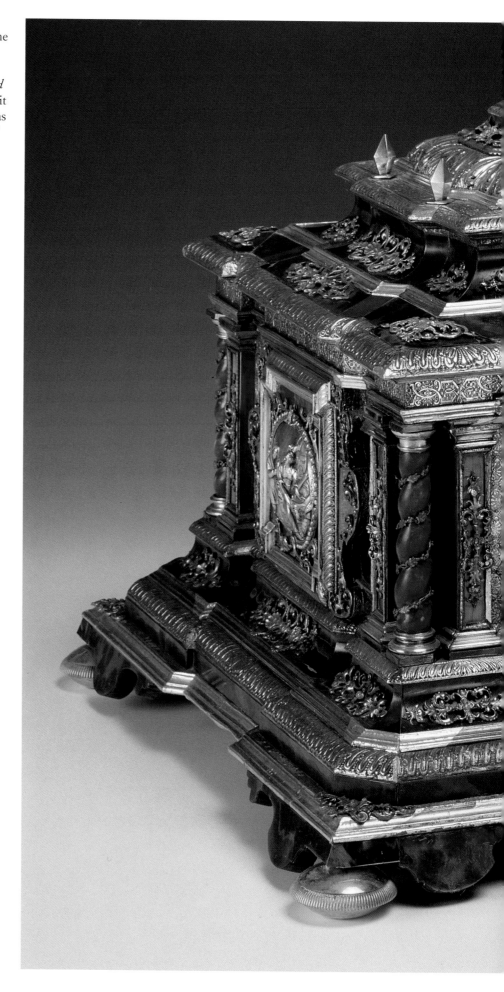

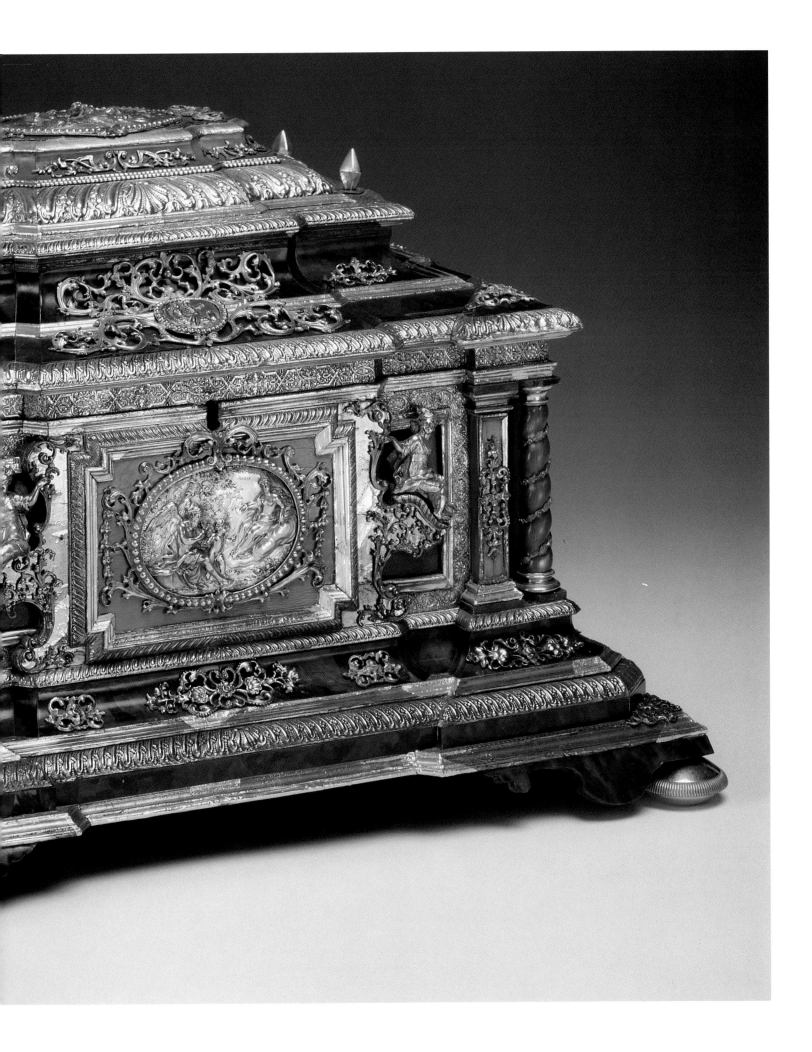

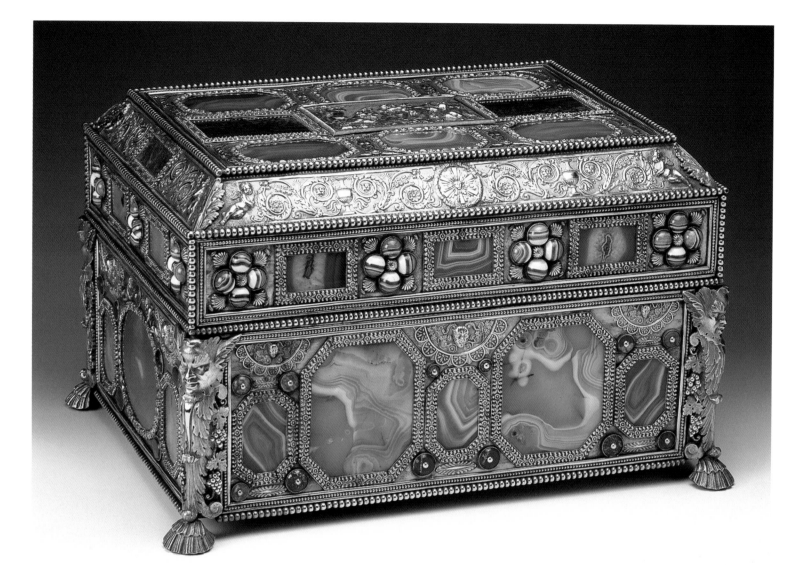

37

Casket

Italy
ca. 1800

Silver gilt, set with panels
of semiprecious stones
h. 21.5, w. 37, d. 28 cm
(h. 8½, w. 14⅝, d. 11¹/₁₆ in.)
EWA08666

Decorated with panels of
agate, heliotrope, and lapis
lazuli, the sides with
chiseled urns and scrolling
acanthus supported by
cherubim, the corners with
grotesque masks and shell
feet, the lid with a
rectangular gilt silver relief
of putti teasing a goat, after
Duquesnoy, a shield with
monogram on the back.
Probably designed for a
christening robe.

In the 1854 inventory
this casket was in the
Red Drawing Room,
listed as *a box of oriental
agates mounted in silver
gilt under a glass shade
bought in 1822.*

William Beckford
(1759–1844) was an
English writer, patron,
and art collector who
inherited in 1770 what
was said to be the
greatest fortune in
England, enabling him
to travel extensively in
continental Europe,
collecting books and
objects of art. His
extravagantly rebuilt
house, Fonthill Abbey,

was one of the archi-
tectural wonders (and
follies) of the age.

This casket is illus-
trated in a woodcut in J.
Rutter's *Delineations of
Fonthill and its Abbey*
(London, 1823), written
at the time of the great
auction sale of Beck-
ford's collections. The
sale has a complicated
history as much was
sold beforehand to, and
some was bought back
from, the almost equally
eccentric John Farquar
(1751–1826). The casket
is illustrated among a
group of varied objects
(including the famous

Fonthill vase) entitled
"A groupe of the rarest
objects of virtu." In the
sale of 1823, it is listed
as lot 1294, described
as "A Magnificent silver
gilt casket, paneled with
36 of the most beautiful
specimens of Oriental
& moss agates, jaspers,
bloodstones, &c. the
friezes elaborately
chased in arabesque
devices from the
Vatican." Quite how
this was sold in 1823,
when it is listed in
Burghley as bought
in 1822, is difficult to
explain. (See Snodin
and Baker 1980.)

Altar cross

Italy, Florence
ca. 1680

Ebony with hardstone,
lapis, and agate, gilt bronze
h. 110.2, w. 46.5, d. 21.5 cm
(h. 43⅜, w. 18¼, d. 8½ in.)
EWA08639

Set with panels of hardstone
including lapis and agate,
the cross applied with a gilt
bronze figure of Christ after
Giambologna, the pedestal
base set with a gold *verre fixe*
panel of St. Francis, flanked
by bronze figures of St.
Peter and St. Paul.

In the 1804 inventory
this cross was in the
Jewel Closet, described
as a *Pietra Dura Crucifix*
on a bracket.

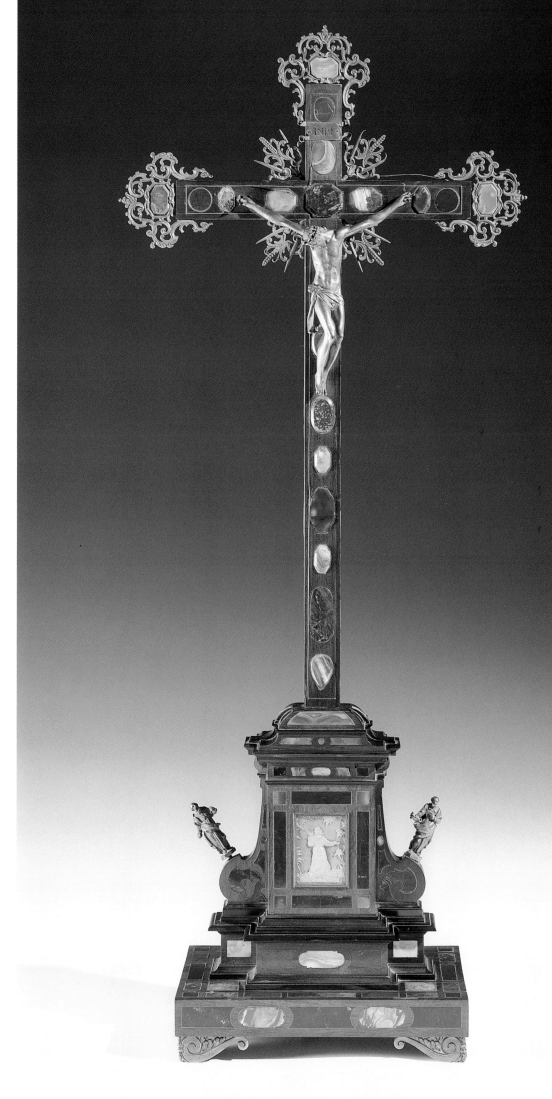

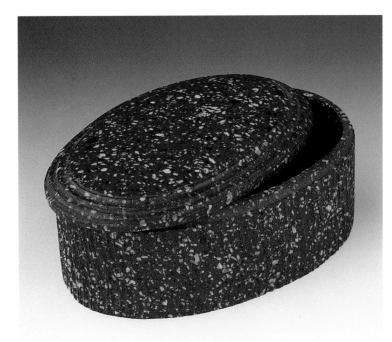

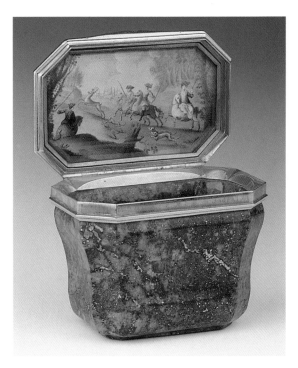

39

Snuff box

Italy, Florence
ca. 1760

Porphyry
h. 3.5, w. 8, d. 5.5 cm
(h. 1⅜, w. 3³⁄₁₆, d. 2³⁄₁₆ in.)
VER12023

With wavy fluted sides and
bevel-edged lid. The box is
unmounted and has no
hinge.

The quarries where
porphyry was found
were worked out in
antiquity, and all
Renaissance and later
worked porphyry
originated in reused
classical fragments.

40

Snuff box

Probably Charles Cordier
Paris
ca. 1722–1726

Lapis lazuli with gold
mounts and oil on canvas,
en grisaille
h. 4, w. 5.5, d. 3.7 cm
(h. 1⁹⁄₁₆, w. 2³⁄₁₆, d. 1⁷⁄₁₆ in.)
VER12009

Of upright rectangular
form with cut corners and
shaped sides, reeded gold
mounts, the interior of the
lid with a hunting miniature
painted *en grisaille*. Signed
with an illegible monogram,
rubbed discharge mark,
apparently that of Charles
Cordier, Paris, 1722–1726.

The use of a single
piece of hardstone for a
snuff box was in fashion
in Germany toward the
end of the seventeenth
century before it
reached France.

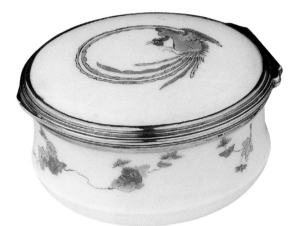

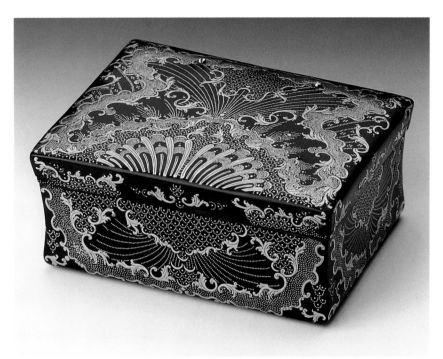

41

Circular box and cover

Meissen Kakiemon
Germany, Dresden
ca. 1730–1740

Porcelain,
overglaze-decorated
h. 4, diam. 7.5 cm
(h. 1⁹⁄₁₆, diam. 2¹⁵⁄₁₆ in.)
CER07492

Painted in colored enamels
with a phoenix and
chrysanthemum trails, the
interior with a moth. In
contemporary marked silver
mounts (French). Blue
enamel crossed swords
mark.

Literature: Lang 1983,
no. 248.

42

Snuff box

Italy, Naples
Mid-18th century

Tortoiseshell and gold piqué
h. 4, w. 8.5, d. 6.5 cm
(h. 1⁹⁄₁₆, w. 3⅜, d. 2⁹⁄₁₆ in.)
VER12020

Of rectangular form with
waisted sides, decorated
overall in gold piqué pose
foliate scroll work and flutes
with fan and scale motifs in
piquéd point and clous,
shaped, pierced gold hinge.

The technique of gold
inlay into and addition
to tortoiseshell seems
to have originated
in Naples.

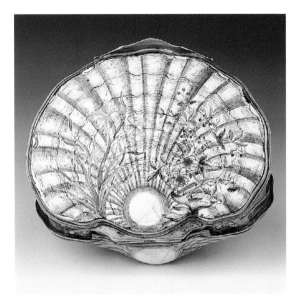

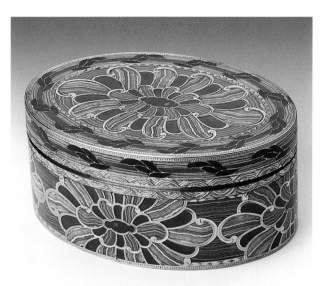

43

Snuff box

China, Canton
Mid-18th century

Enamel with painted
decorations and silver-gilt
mounts
h. 2.5, w. 7.5, d. 6 cm
(h. 1, w. 2¹⁵⁄₁₆, d. 2⅜ in.)
VERI2016

Painted with flowers against
the naturalistically painted
shell, the interior with
further fruit and flowers.
Reeded silver-gilt mounts
with raised thumbpiece.

44

Snuff box

Johann Christian Neuber
Germany, Dresden
ca. 1780

Gold and hardstone with
agate and carnelian
h. 4, w. 8.5, d. 6 cm
(h. 1⁹⁄₁₆, w. 3⅜, d. 2⅜ in.)
VERI2011

Of oval form, the lid, base,
and sides decorated with
swirling rosettes of striated
agate and carnelian within
engraved gold cloisonné,
the borders with a band of
carnelian ribbon entwined
with green laurel, the gold
mounts engraved with
chevron and interlaced
rosette motifs.

Johann Neuber
(1736–1808) specialized
in the use of the local
minerals for which
Dresden was famous.

45A

The Colosseum

Cesare Aguatti
Italy, Rome
1774

Mosaic
h. 42, w. 54.6, in gilt frame
(h. 15⅝, w. 21½ in.)

Signed: Cesare Aguatti
(Aguozzi) Romano, 1774
EWA08660

One of a pair of mosaic pictures, this was purchased by the Ninth Earl in Rome in 1775 through the antiquarian Thomas Jenkins, to be followed by the companion piece, the *Temple of Vesta* (cat no. 45B). Such miniature mosaics were a favorite purchase of Grand Tourists. Frequently they were set into pieces of furniture, such as tabletops.

Aguatti was especially celebrated for this technique. A letter from Rome, dated March 11, 1775, from Thomas Jenkins, the antiquarian who acted for several Grand Tourists, comments that Aguatti "was certainly the best workman that ever was in Mosaick."

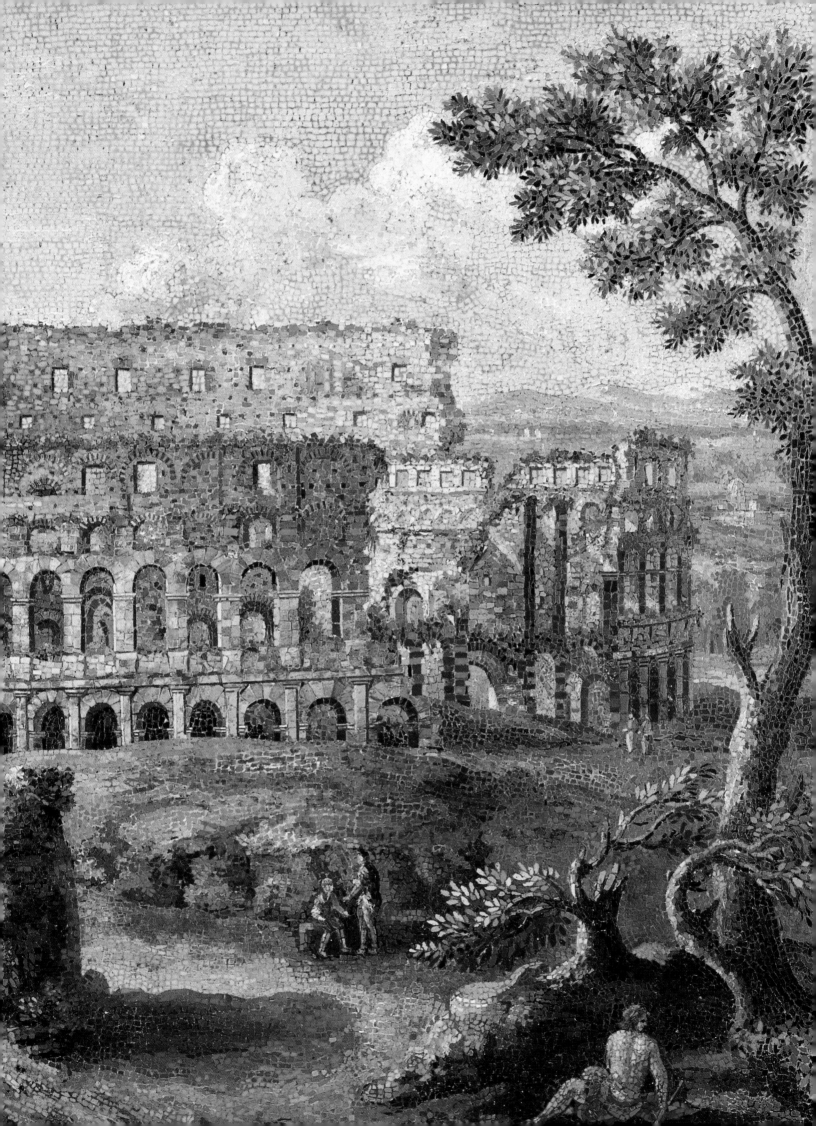

45B

The Temple of Vesta

Cesare Aguatti
Italy, Rome
1774

Mosaic
h. 42, w. 54.6, in gilt frame
(h. 15⅝, w. 21½ in.)

Signed: Cesare Aguatti
(Aguozzi) Romano, 1774
EWA08660

A letter from Thomas
Jenkins (see cat. no. 35A)
describes how Jenkins
ordered this mosaic:
"The Minerva (?)
ordered as a Companion
to Your Lordp. Colloseo
will most assuredly
make an excellent
Mosaick, the Person that
Makes it has by hm one
of the Sibils temple at
Tivoli somewaht larger
than your Picture which
will cost (?) or about
£70, but tis really
wonderfully fine."

Pair of molded glass paste medallions

Endymion, Jupiter and Ganymede

Johann F. Reiffenstein
Italy, Rome
Second half of 18th century

Oval, h. 17, w. 11.5, diam. 6 cm (h. 6¹¹/₁₆, w. 4⁹/₁₆, diam. 2⅜ in.); in original rectangular gilt-wood frames, h. 32, w. 28 cm (h. 12⁹/₁₆, w. 11 in.)

Inscribed: The one inscribed on the reverse in the hand of the Ninth Earl, *Endymion from an ancient Bas Relief in the Villa Albani near Rome. This oval was made in imitation of the Ancient Roman pastes by Mr. Reiffenstein, Councellor to the Landgrav of Hesse Cassel,* the other *Hebe feeding Jupiter.* The Earl (or Mr. Reiffenstein) has misidentified Ganymede as Hebe.
EWA08669

Both medallions are copied from famous marble reliefs in Villa Albani, Rome. The *Jupiter and Ganymede* remains in the Villa Albani, while the *Endymion* is now in the Capitoline Museum.

Jupiter and Ganymede

Endymion

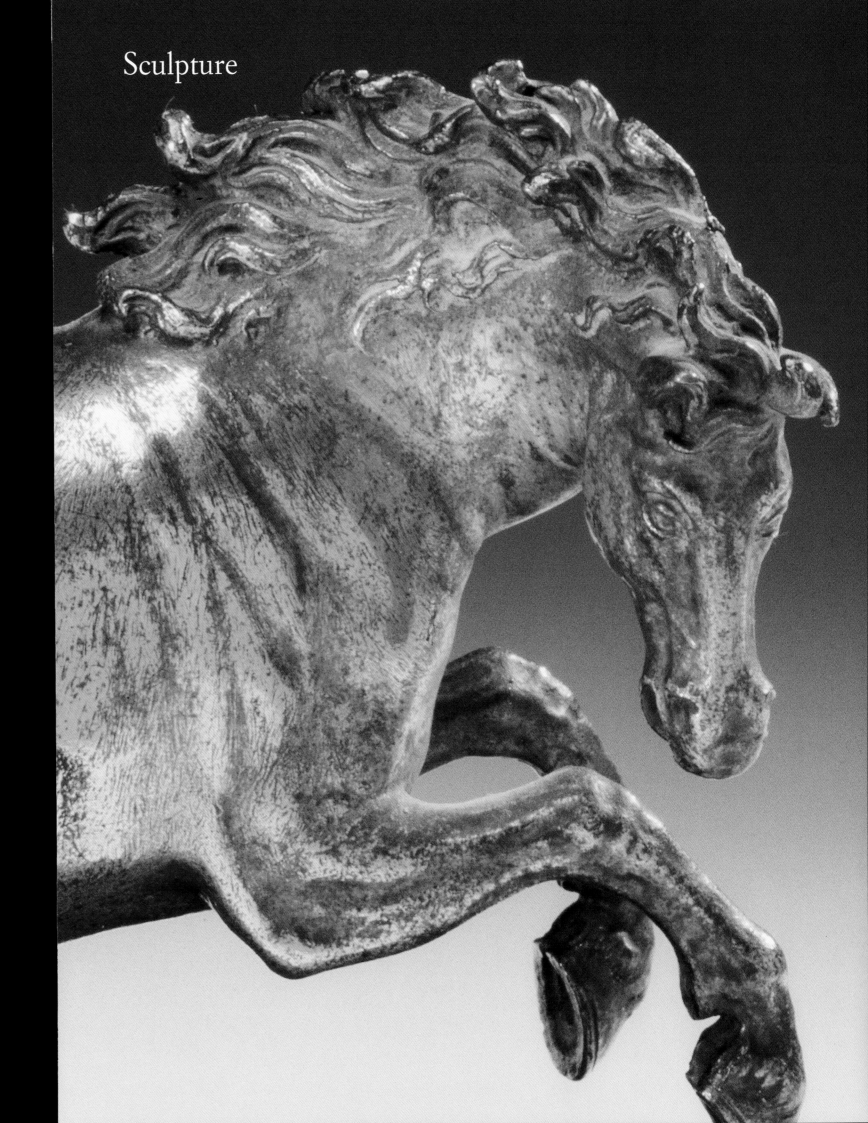

Sculpture

Draped female torso

*Italy, Rome
1st/2nd century, with
17th-century additions*

Alabaster, bronze,
and marble
h. 59.8, w. 32.5, d. 30 cm
(h. 23½, w. 12¹³⁄₁₆,
d. 11¹³⁄₁₆ in.)
EWA08605

Mounted, in the seventeenth
century, with bronze head,
arms, and feet and set
on a red and black marble
throne, holding a writing
horn and sheaf of corn.

The description in the
sale catalogue of 1755
(see cat. no. 49) refers
to the statue as "Livia
Imperatrix, uxor
Augusti, stolata, velata,
et diademate cincta,
sedens; caput, manus
et pedes ex aere habet,
vestes ex alabastrite.
Cererem autem refert;
altera enim manu
cornucopiae, altera
aristas tenet. . ." (The
Empress Livia, wife
of Augustus, dressed
in a stola, veiled and
crowned with a diadem.
She is seated, her head,
hands and feet are made
of bronze and her
clothing of alabaster.
She is representing
Ceres, for in one hand
she holds a cornucopia
and in the other ears
of corn.)

The addition of
bronze or other body
parts or accoutrements
to substitute for those
broken off or missing
was a specialty of
certain workshops
in Rome.

This figure is referred
to in the late-eighteenth-
century inventory in *the
Drawing Room* as *Livia
from Dr. Mead's collection
1755 upon ye table.*

*Provenance: From the sale
of the collection of Dr.
Mead, 1755 (see cat. no. 49).*

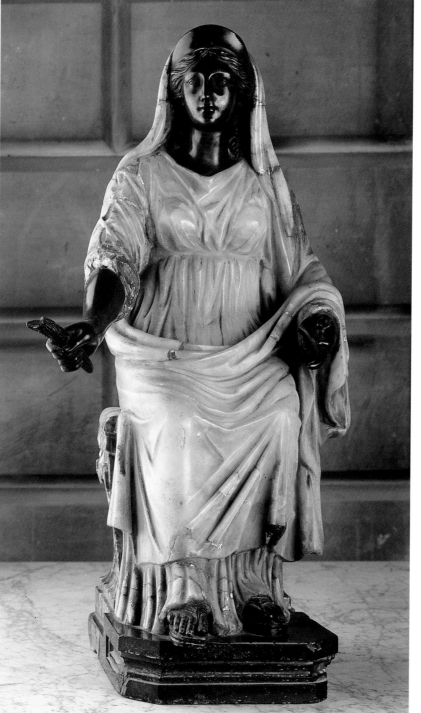

48

Relief of the Pieta

? England
15th century

Alabaster and wood
h. 43.2, w. 28, d. 19 cm
(h. 17, w. 11, d. 7 7/16 in.)
EWA08599

Retaining some original
color.

This may be *the Virgin
Mary with our Saviour
in armes in Allablaster*
in *My Ladyes Anty
Room* in 1688.

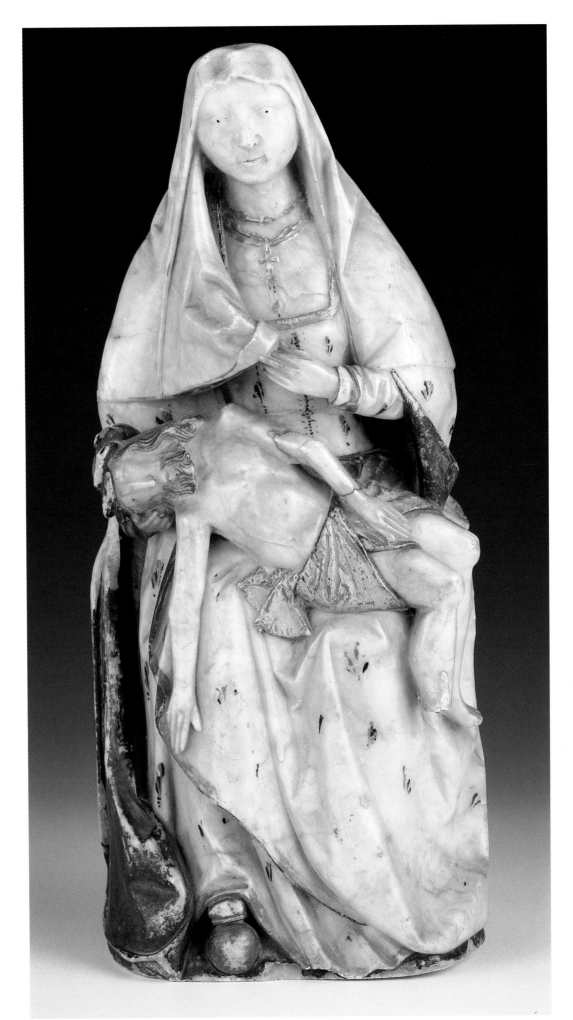

Infant Hercules

*From the workshop
of Alessandro Algardi
Italy, Rome
17th century*

Bronze
h. 34.3, w. 46, d. 21.5 cm
(h. 13½, w. 18⅛, d. 8⁷⁄₁₆ in.)
EWA08675

The young god seated,
struggling with the serpent.

This is a casting of the
famous original by the
sculptor Algardi, who
was among the greatest
exponents of the Italian
Baroque. Other copies
of this bronze are also
known. The prototype
can be dated to approxi-
mately 1650. However,
as Jennifer Montagu has
noted, this casting at
Burghley is among the
most interesting not
only from the point of
view of quality, but also
because of its prove-
nance. It was part of
the collection of the
eminent English
scientist Dr. Richard
Mead (1673–1753), the
physician of George II
and author of a success-
ful book on poisons.
The last edition of
his book includes an

engraving of Hercules
and the Serpent. Mead
had traveled to Italy
between 1695 and 1696,
purchasing modern and
ancient art objects
(Michaelis 1882, 49),
including Roman
pictorial fragments,
coins, and carved
gemstones. He also
purchased a great many
objects in England,
perhaps including this
Hercules, and certainly
a head of Homer, which
he acquired from Lord
Arundel. At the sale of
the Mead collection in
1755 the Earl of Exeter
purchased this Algardi
bronze and the head of
Homer, which he gave
to the newly founded
British Museum.

In the late eighteenth
century this sculpture
was in the Third
George Room.

*Provenance: From the sale
of the collection of Dr.
Richard Mead, 1755. See
Montagu 1985, 406, no. 127.
Transcription of entry in the
1755 sale catalogue:
"Hercules infans decumbens
et serpentem strangulans.
Algardi opus. Ex aere. Alt.
duos pedes cum semisse."*

*Literature: Montagu 1985;
Webster 1970.*

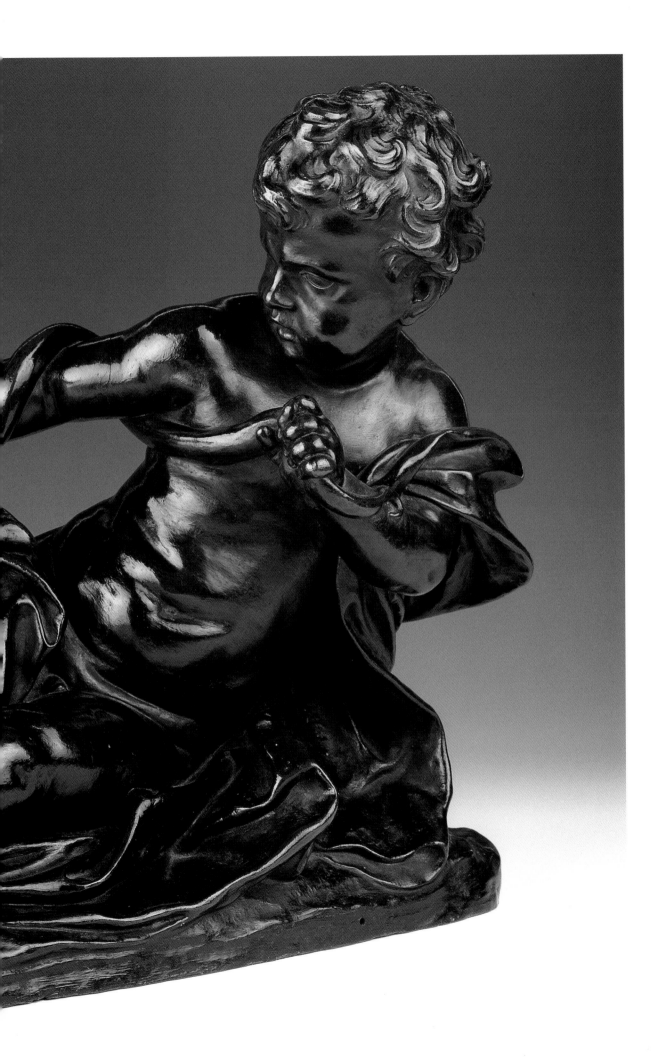

Trotting stallion

*Attributed to Francesco
Fanelli, after Giambologna
England
ca. 1630–1640*

Gilt bronze on ebonized base
h. 16.5, w. 22, d. 8 cm
(h. 6½, w. 8⅝, d. 3⅛ in.)
EWA08591

The standing horse with
right foreleg raised in
movement. The figure is
more or less exactly adapted
from the horse of the
monument to Cosimo I by
Giambologna, dateable to
1587–1593, which stands in
the Piazza della Signoria in
Florence. The same horse
was used as the model for
statuettes of Ferdinando I
de' Medici, cast in 1600,
now in the Ducal Collec-
tions in Liechtenstein, and
of the Emperor Rudolph II,
of about 1600, in the
National Museum, Stock-
holm. On ebonized base.
This and catalogue number
51 have always been treated
as a pair at Burghley.

Francesco Fanelli
(fl. 1608 –?1661) was an
Italian sculptor, origin-
ally from Genoa, who
was active in England
from possibly before
1635 to 1641. A specialist
caster of small-scale
bronzes, he was without
a rival in England in his
time. He described
himself, possibly
truthfully, as Sculptor
to the King of England;
certainly he was given a
pension by Charles I in
1635. His most frequent
subject matter, at least

while he was in
England, was horses,
perhaps a carefully
chosen speciality (see
Pope-Hennessy 1953).
 In 1688, the horses
were in the *Dining
Room* as *2 Brasse horses
on ebony pedistalls*; they
remained in that room,
under its differing
names, in the eighteenth
century and in 1804.

*Literature: Avery 1987,
figs. 164, 169, 170, 313.*

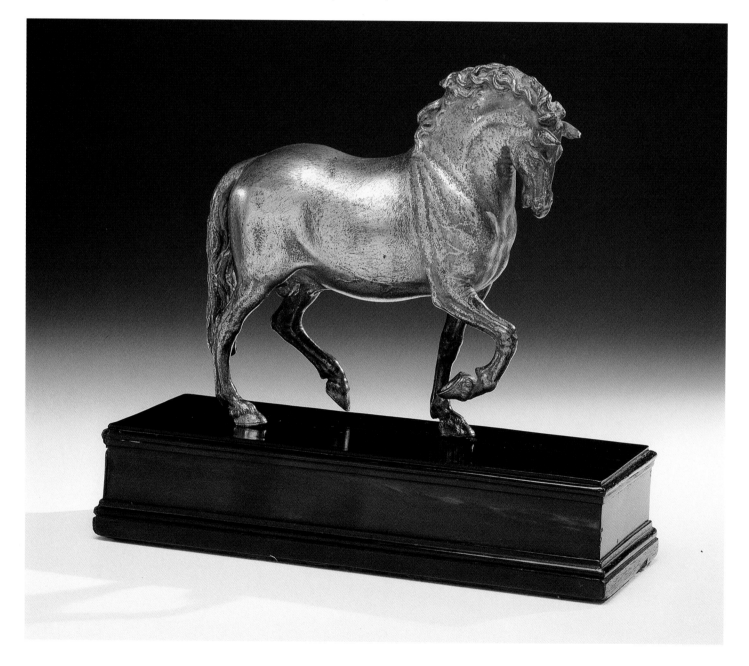

51

Rearing stallion

Attributed to Francesco Fanelli
England
ca. 1630–1640

Gilt bronze on ebonized base
h. 19, w. 22, d. 8 cm
(h. 7⁷⁄₁₆, w. 8⅝, d. 3⅛ in.)
EWA08592

The horse rearing with both
forelegs thrust forward.
On ebony pedestal.

For Francesco Fanelli,
see catalogue number
50. The horse greatly
resembles a figure of
a horse with Cupid
riding, in the Victoria
and Albert Museum
(A37–1952), attributed
to Fanelli (see Pope-
Hennessy 1953).

This figure stood with
its "pair" in the *Dining
Room* in 1688, where it
remained at least until
1804, described as *2
Brasse horses on ebony
pedistalls*.

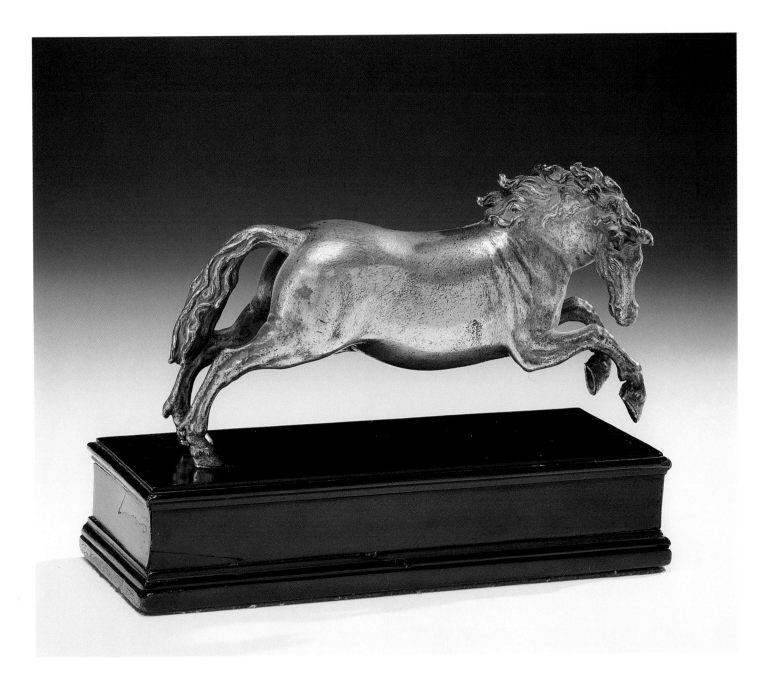

Figure of a king wearing armor

Italy
Second half of 17th century

Silver, parcel-gilt
h. 28.6, diam. 16.5 cm
(h. 11¼, diam. 6½ in.)
SIL05006

Decorated with applied gilt scroll work set with small brilliants and wearing brilliant set crown, with flowing cloak decorated with applied gilt scrolls and flowers, on octagonal plinth with left foot resting on a globe and with a lion at the other side and military trophies.

In all probability this is a figure of King Charles II of Spain, who, being childless, is most remarkable for having left the kingdom to Philip, grandson of Louis XIV of France, thus initiating the War of the Spanish Succession.

In the 1854 inventory this and the figure of St. John the Baptist (cat. no. 53) were in the *Blue Drawing Room*. This figure was referred to as *A figure of Charles V of embossed silver, under a glass shade, two pieces broken off the crown*. Today, the crown shows signs of repair.

Exhibited: Burghley House Silver, *1984, no. 25.*

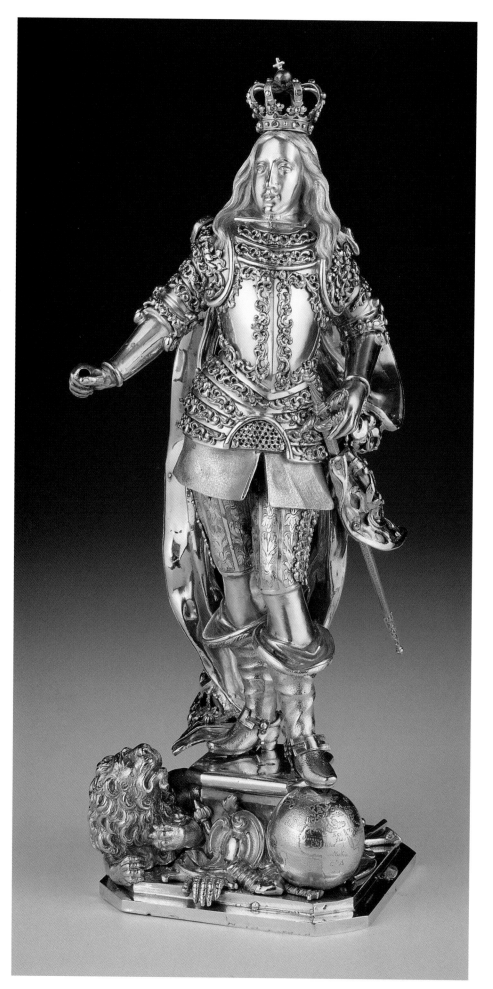

53

Figure of St. John the Baptist

Italy
First half of 17th century

Silver-gilt and filigree
h. 27.9, diam. 13.5 cm
(h. 11, diam. 5⁵⁄₁₆ in.)
SIL05005

Figure unmarked, the later base marked 1819

The Saint with a nimbus, wearing an animal skin and draped in a cloak, holding a staff with banner inscribed "Ecce Agnus Dei," with nimbus and a lamb at his feet, on plain oblong plinth.

Listed in the 1854 inventory in the *Blue Drawing Room* on the chimneypiece as *a silver gilt figure of St. John the Baptist under a glass shade given to Lord Exeter by the Rt. Honble Henry Pierrepont.* Lady Sophia Cecil (1792–1823) married Henry Manvers Pierrepont, second son of Charles, First Earl Manvers, in 1818.

Exhibited: Burghley House Silver, *1984, no. 24.*

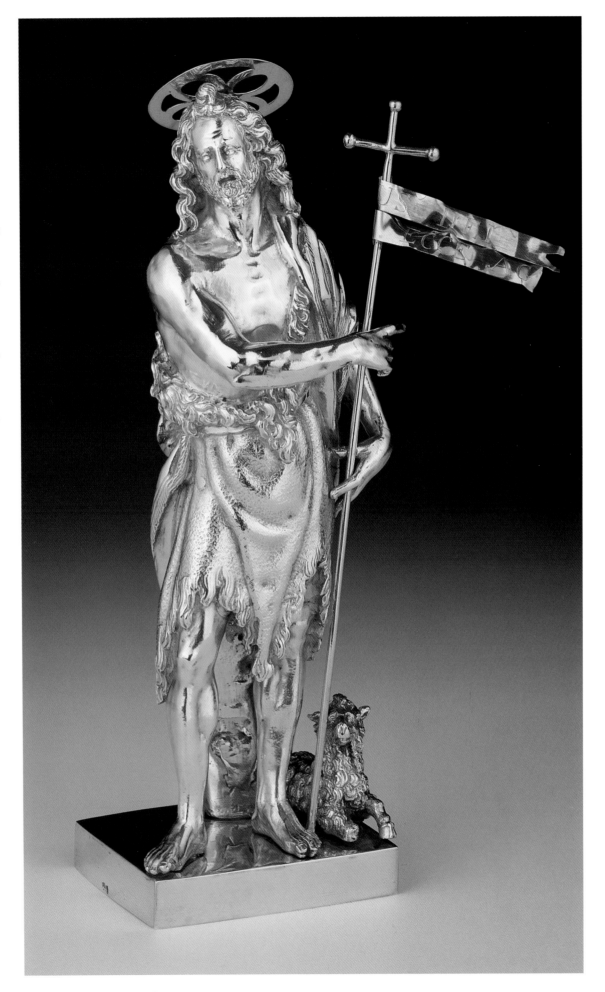

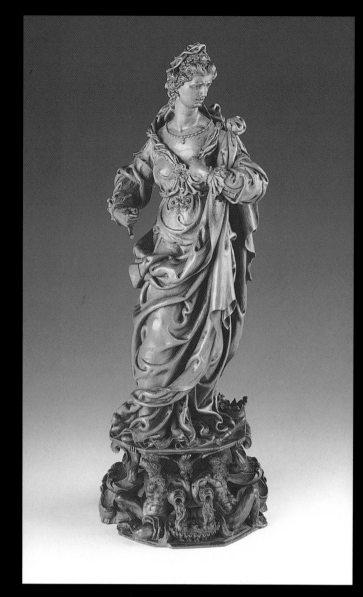

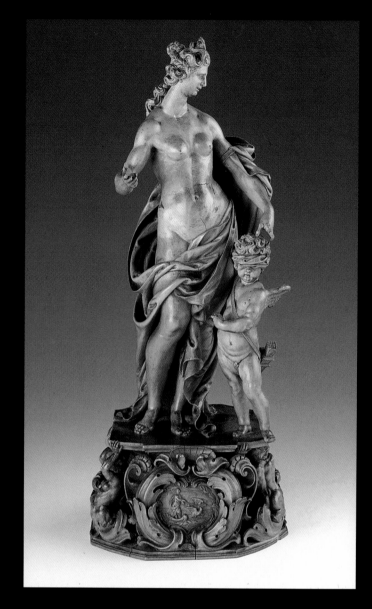

54A

Cleopatra

Italy
Mid-17th century

Boxwood
h. 37, w. 15 cm
(h. 14⅝, w. 5⅞ in.)
EWA08670

Cleopatra with the asp (lacking) to her bosom, the base with two river gods holding upturned vases of water rushing to a bowl containing a crocodile representing the Nile (numbered 3 on the base).

These four figures (cat. nos. 54A–54D) and another four were purchased by the Fifth Earl on one of his travels to Italy between 1679 and 1684. Although the Ninth Earl lists them as coming from Palermo, there is no evidence today to support that attribution; where they were made is a matter of conjecture.

In the 1688 inventory this figure is clearly listed as in Lady Exeter's *Dressing Roome* as one of *2 figures Carv'd in box being a Cleopatra & a Pallace*. In 1738 it and the other figures were either in the *Dressing Room* or in the *Turenne Room*. Later in the eighteenth century they were either in the *Dining Room* or in the Second George Room. In 1804 they were in the Second George Room, and in the engravings by Lady Sophia Cecil of 1817, four appear to be visible in the *State Bed Room*.

54B

Venus

Italy
Mid-17th century

Boxwood
h. 33 to 34.3, w. approx. 15 cm (h. 13 to 13½, w. approx. 5⅞ in.)
EWA08670

Venus with blindfold Cupid, the base with the goddess rising from the waves, supported by a merman and mermaid.

In 1688, this figure was in *My Ladye's Clossett* as one of *2 ffigures in Box, a Venus, a Lucretia*, later, as for catalogue number 54A. Note that this and the Cleopatra, both representing women, stood with *Pallace* (Pallas Athene) and Lucretia in Lady Exeter's rooms, while the male figures stood in a guest room.

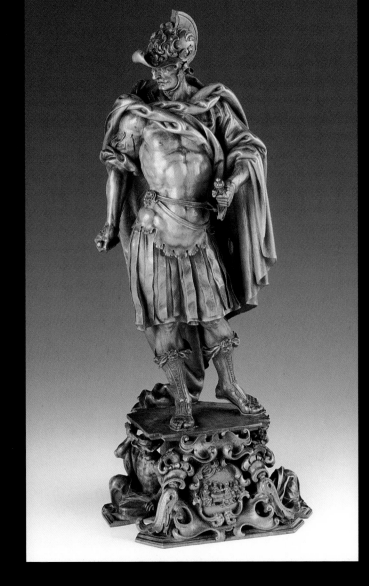

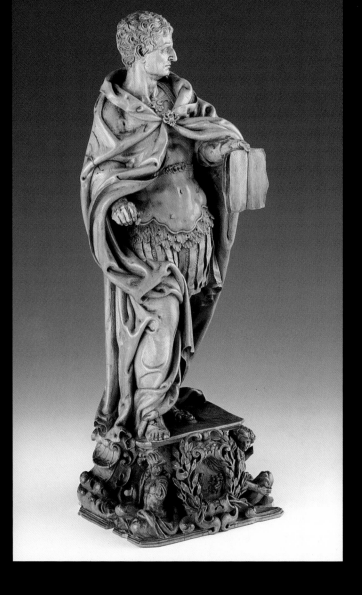

54C

Catalina

Italy
Mid-17th century

Boxwood
h. 33 to 34.3, w. approx.
15 cm (h. 13 to 13½,
w. approx. 5⅞ in.)
EWA08670

Catalina looking to the
right with drawn sword
(broken), the base with
the hero seated at a table
supported by other figures,
possibly plotters.

Catalina was a renegade
patrician who attempted
a coup d'état in 63 B.C.
and was killed at the
head of his rabble of
an army the next year.
 This figure is
probably that listed in
1688 in the *Best Bedd
Chamber* as one of *4
Carv'd figures in Box,
an Alexander, a [] a
[] & a [] done by [].*
For its location after
1688, see catalogue
number 54A.

54D

Cicero

Italy
Mid-17th century

Boxwood
h. 37, w. approx. 15 cm
(h. 14⅝, w. approx. 5⅞ in.)
EWA08670

Cicero holding out an open
book, the base with oratory
scene supported by figures
of Minerva and another
allegorical youth.

See catalogue numbers
54A, 54B, 54C.

Apollo and Daphne

After Bernini
Italy
Late 17th century

Ivory on ebonized base
h. 42, w. 24, d. 11 cm overall
(h. 16½, w. 9⁷⁄₁₆, d. 4⁵⁄₁₆ in.)
EWA08566

An ivory figure of Apollo reaching for Daphne, who is being turned into a laurel tree; on ebonized base with a relief of the river god Peneus, father of Daphne, flanked by swags of fruit.

The purchase is recorded by the Fifth Earl's steward during a journey between Rome and Florence by the Fifth Earl in May 1684, at a cost of 60 crowns. In 1688 this sculpture stood in *My Ladyes Clossett* and was listed as *Daphne & Apollo in Ivory on a pedistall of Ebony & Carved by* _____. In the late eighteenth century it was in the Second George Room.

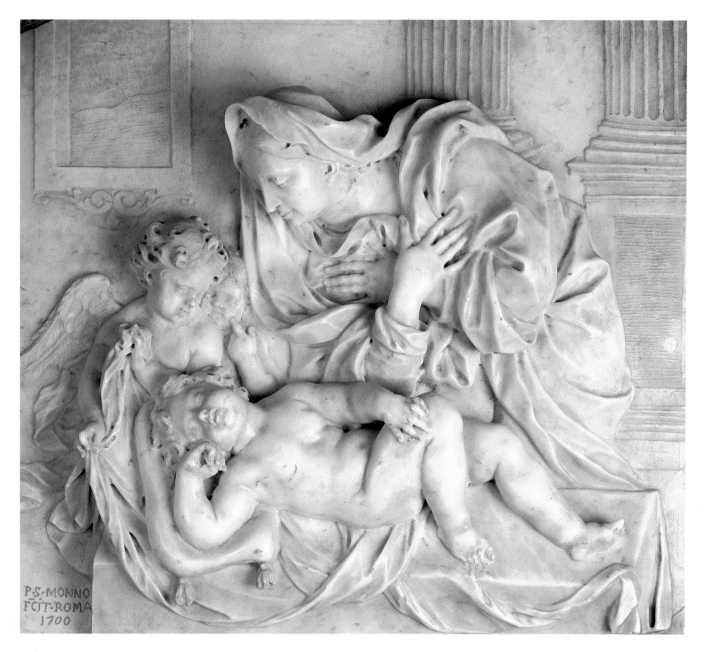

56

Virgin and Child

Pierre Monnot
Italy, Rome
1700

Marble relief
h. 3, w. 49.5, d. 44 cm
(h. 1 3⁄16, w. 19½, d. 17⅜ in.)

Signed and dated: P.S.
Monnot fēit Roma 1700
EWA08617

Roman white marble relief
of the Virgin and Child
with two angels in an
architectural setting.

This relief was among
the sculptures ordered
by the Fifth Earl and
Countess from Monnot
in Rome in 1699. Other
pieces included two
sleeping putti, still in the
house, and a figure of
Andromeda, now in the
Metropolitan Museum
of Art, New York. Their
ultimate commission was
for an elaborate compo-
sition for their own tomb
(see fig. 15, p. 44), which
was erected in 1704
in St. Martin's Church,
Stamford.

Literature: Gunnis 1969, 261.

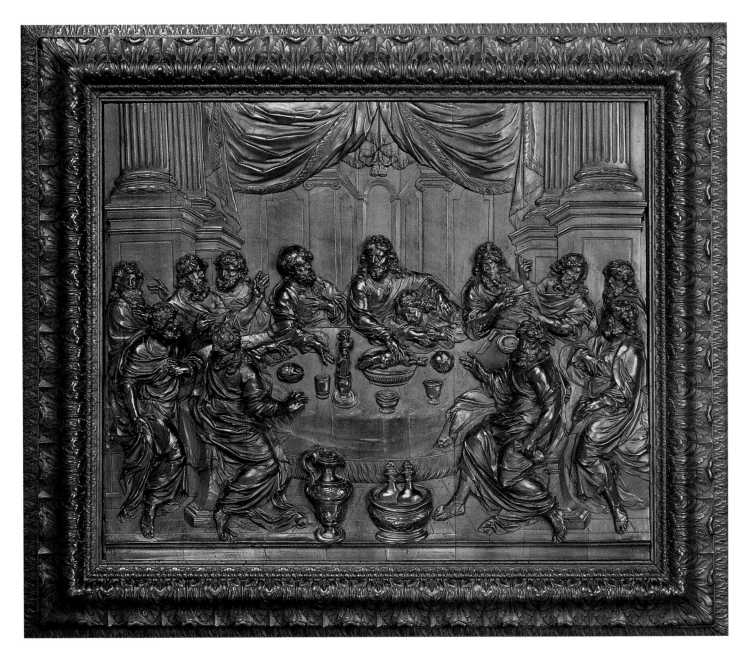

57

Relief of the
Last Supper

Attributed to César Bagard
Franco-Flemish
Late 17th century

Fruitwood
h. 50.5, w. 62.2 cm
(h. 19⅞, w. 24½ in.)
EWA08667

With a temple in the back-
ground, in contemporary
carved wood frame in the
manner of Bagard.

César Bagard
(1620–1707) worked
in both stone and wood.
A native of Nancy, he
may have studied in
Italy. He became
Sculpteur Ordinaire
to Duke Charles IV
of Lorraine in 1669.

Bust of Medusa, after the antique

Joseph Nollekens
Italy, Rome
1764

Marble
h. 54.5, w. 44, d. 18 cm
(h. 21½, w. 17⅜, d. 7¹⁄₁₆ in.)
EWA08671

This bust, purchased by the Ninth Earl in Rome in 1764, is a copy of a famous Roman sculpture known as the Rondanini Medusa, which until the early nineteenth century was one of the prizes in the collection in the Palazzo Rondanini in the Corso. Today it is in the Glyptothek in Munich. The portrait was widely admired because it depicted the features of the Gorgon in a more human form than normal. The hair, for example, is not a mass of snakes; only two serpents protrude from the hair, entwining at the neck in anything but a terrifying manner. By contrast, the purity of the lines is disrupted in the lips, which stand slightly apart, giving us a glimpse of the teeth, rather a menacing detail in a face in the ancient style. Nollekens, an Englishman, met the Ninth Earl in Rome (where the sculptor lived from 1760 to 1770) in 1764, when the Earl was traveling in the company of Lord and Lady Spencer, the actor Garrick, and Lord Palmerston. During those years, Nollekens created portraits for the British aristocracy in the form of busts in the ancient style. He restored Roman statues for shipment to England and made copies of famous original works, such as the sculpture shown here. He produced his own original works as well, as other marble groups still at Burghley attest.

In the late eighteenth century this sculpture is recorded in the *drawing room* (the Third George Room), where it remains; the wall over the chimneypiece has been hollowed out to fit the back of the sculpture.

Literature: Gunnis 1969, 277.

59

"Bella Donna" dish

*Italy, Castel Durante
ca. 1530*

Majolica
h. 10, diam. 23.5 cm
(h. 3⁵⁄₁₆, diam. 9¼ in.)
CERO701

Painted in yellow ochre, blue, and brown, with a bust of a woman, her head inclined to the left, wearing a yellow head scarf and a brown dress with slashed sleeves and a chain necklace. The scroll behind is inscribed *Antonia Bella,* the dish mounted in a turned black painted wood frame, the reverse is inscribed in the handwriting of Brownlow, Ninth Earl of Exeter, with *Naples 1763.*

There are other majolica dishes in the house with similar frames and similar inscriptions by the Ninth Earl. Presumably he had the frames made in England, though no documentation appears to have survived.

In the late eighteenth century there were *2 old painted dishes in black frames* in the *bed chamber,* of which this may be one. In 1804 there were *4 Delph Dishes painted in black frames* in the *Pagoda Room.* After 1854 there were two in the *Black and Yellow Room* and three in the *West Dressing Room.*

Literature: Lang 1991, no. 1.

60

Double-handled vase

Italy, Urbino
ca. 1570

Majolica
h. 50.5, w. 23 cm
(h. 19⅞, w. 9¹/₁₆ in.)
CER0702

Painted with Apollo, quiver in hand in pursuit of Daphne, her upraised arms sprouting branches and roots growing from her feet, a hovering cupid in attendance with strung bow, all in a continuous rocky landscape with buildings and mountains in the distance, the reverse with a different view of the same subject, depicting her father, Peneus, a river god reclining on his urn with one hand resting on his oar, watching a cupid with a quiver. The vase on stepped, flared foot, with twisted, double snake handles emerging from two bearded, grotesque masks and rising to the flared neck, the decoration executed in yellow ochre, blue, green, brown, and yellow.

The scenes on this vase are taken from Ovid's *Metamorphoses*.

Literature: Lang 1991, no. 2.

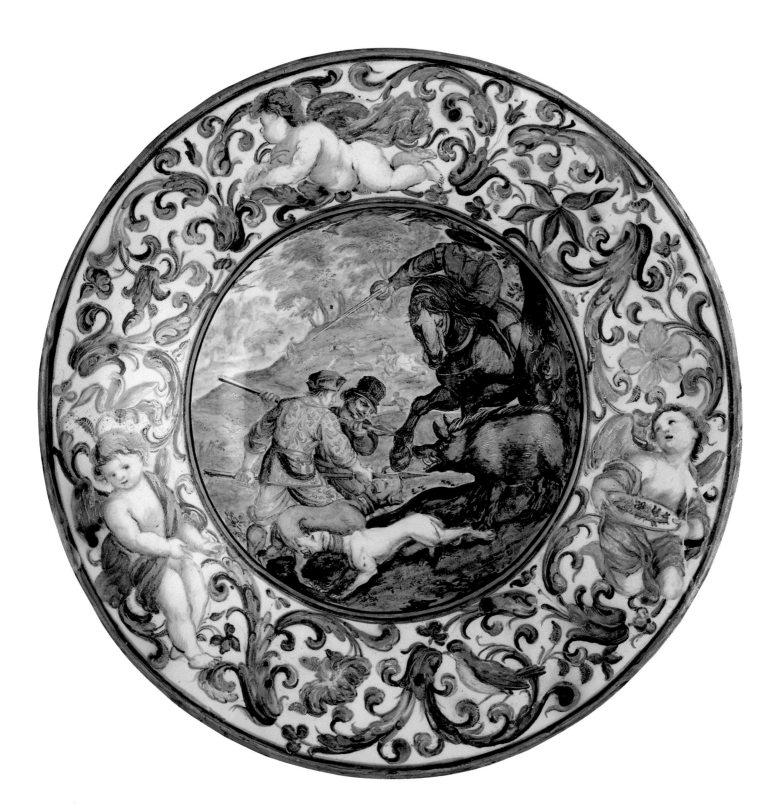

61

Dish

*Possibly painted by Francesco
or Carlo Antonio Gruè
Italy, Castelli
ca. 1680/1700*

Majolica
diam. 33 cm (13 in.)
CER0705

Painted in yellow ochre,
manganese, green, cobalt
blue, and gilding, the well
decorated with a scene of
huntsmen, including one
on horseback and dogs
cornering a wild boar in a
hilly, wooded landscape, the
rim painted with three putti
and a bird amidst scrolling
foliage and flowers.

The scene is taken from
a detail of an engraving
by Antonio Tempesta
(1555–1630).

Literature: Lang 1991, no. 5.

62

Jardiniere

France, Nevers
ca. 1680/1690

Majolica
h. 47.3, w. 61, d. 38 cm
(h. 18⅝, w. 24, d. 15 in.)
CER0717

The heavy campana-shaped body painted in white enamel on a deep blue Persian ground, the upper half with two lobed panels painted in Chinese "Transitional" style with a solitary figure in fantastical landscape with rocks and drifting clouds, the panels reserved on a ground of feathery scrolls. The lower section of the vessel molded with heavy gadroons below a narrow convex rib decorated with disjointed scrolls, the gadroons also embellished with feathery scrolls similar to those on the upper zone, the complex annulated foot decorated with small debased lappets above an X and dash band, amorphous scroll work, and finally, overlapping scales, the sides applied with bold acanthus leaf scroll handles rising from satyr's mask terminals. The footring is unglazed and exposes the warm sandy-brown granular body.

Literature: Lang 1991, no. 17.

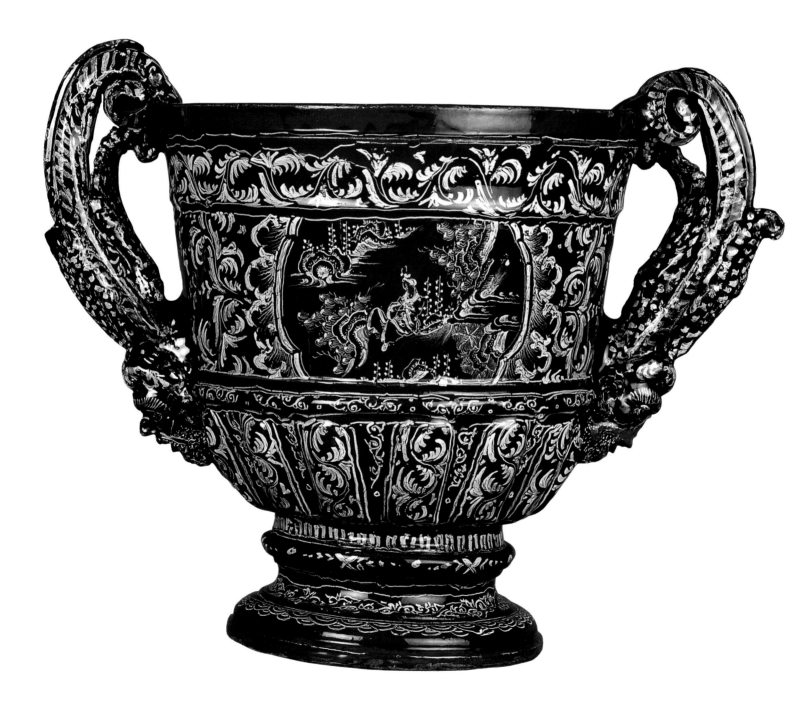

63 A & B

Pair of porcelaneous miniature vases and covers

*European
probably ca. 1660*

Porcelain
Each h. 5.5, diam. 3.1 cm
(h. 2³⁄₁₆, diam. 1¼ in.)
CERO730

Of high-shouldered Chinese *guan* form, painted in iron red, puce, and black on a stippled gilt ground with putti heads, each with a different expression in repose, alert or amused, the short plain neck encircled by a collar of gadroons, the base with a border of stiff leaves.

It is possible that these jars represent very rare examples of the work of the factory set up by George Villiers, second Duke of Buckingham, at Lambeth in 1663. Tests have recently demonstrated that the jars are made of a form of soft paste. Most early attempts to imitate Chinese porcelain were based upon one type or other of soft paste.

In the 1854 inventory these are described in the *China closet* as *two essence pots with covers metal mounted one small vase much broken and repaired the above painted with festoons & angels were made at the manufactury patronised by the Duke of Buckingham, time of Charles the ii.*

Provenance: Elizabeth, Countess of Devonshire, née Cecil, her will, proved 13th November 1690, listed as A pair of little Jarrs and covers guilt and enamel'd with ffestoons and boyes heads, by whom given to her daughter, Anne, Countess of Exeter.

Literature: Lang 1991, no. 32.

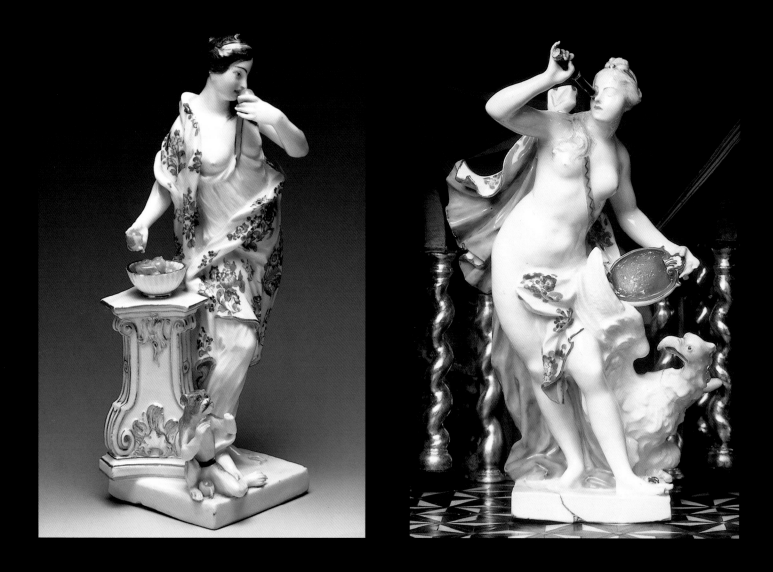

64A

The Senses: Taste

Modeled by J. J. Kaendler
Germany, Meissen
ca. 1740

Porcelain
h. 27.5, w. 16, d. 16 cm
(h. 10¹³⁄₁₆, w. 6⁵⁄₁₆, d. 6⁵⁄₁₆ in.)
CER0647

"Taste" is represented by a figure of a woman scantily clad in classical drapery, the gilt-edged, puce-lined cloak decorated with *indianische Blumen* draped over her back, around her waist, and secured over her shoulder with a turquoise strap, her hair accented with a puce and gilt headband. With her left hand she raises a green apple to her mouth, and with her right she selects another piece of fruit from a fluted bowl, which stands on a triangular pedestal, decorated in gilt-edged C-scrolls. A monkey and a green apple rest by her feet on a plain square base. Crossed swords mark in underglaze blue.

In the late eighteenth century, in *Lady Exeter's dressing room* there stood *on ye chimney ye four senses…dresden china*, confirming that either the fifth sense, *Touch*, had never been purchased, or that it had been lost or broken by then. No entry in the inventory in any other room could apply to the missing figure.

Literature: Lang 1991, no. 52.

64B

The Senses: Sight

Modeled by J. J. Kaendler
Germany, Meissen
ca. 1740

Porcelain
h. 27.5, w. 16, d. 16 cm
(h. 10¹³⁄₁₆, w. 6⁵⁄₁₆, d. 6⁵⁄₁₆ in.)
CER0647

"Sight" is represented by the figure of a woman in an exaggerated posture, scantily clad with a turquoise-lined cloak decorated in *indianische Blumen* and secured over her shoulder with a puce strap, with her right hand she holds to her eye a black and gilt telescope, and in her left is a mirror. Perched at her feet on the plain square base, a large eagle sits preening its wings. Crossed swords mark in underglaze blue.

Literature: Lang 1991, no. 52.

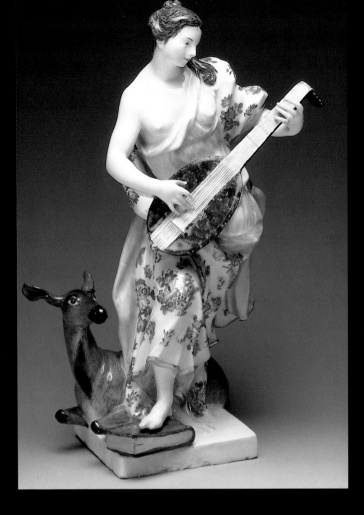

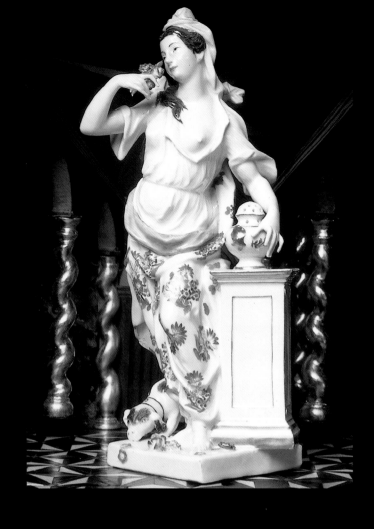

64C

The Senses: Hearing

Modeled by J. J. Kaendler
Germany, Meissen
ca. 1740

Porcelain
h. 27.5, w. 16, d. 16 cm
(h. 10¹³⁄₁₆, w. 6⁵⁄₁₆, d. 6⁵⁄₁₆ in.)
CERO647

"Hearing" is represented by a figure of a woman dressed in classical drapery, her puce-lined cloak painted in *indianische Blumen* and edged in gilding. She plays a small lute with marbled brown surface and gilt detail. Her right foot rests on a closed brown book. Behind her, perched on the plain square base, a young deer, its body decorated in shades of brown, sits with its forelegs tucked and ears cocked, listening attentively. Crossed swords mark in underglaze blue.

Literature: Lang 1991, no. 52.

64D

The Senses: Smell

Modeled by J. J. Kaendler
Germany, Meissen
ca. 1740

Porcelain
h. 27.5, w. 16, d. 16 cm
(h. 10¹³⁄₁₆, w. 6⁵⁄₁₆, d. 6⁵⁄₁₆ in.)
CERO647

"Smell" is personified as a classically draped female wearing a pink-lined robe decorated with sprigs of *indianische Blumen*. She is standing beside a square pedestal on which is set a potpourri jar. She is sniffing a small nosegay, which she holds in her right hand. At her feet a diminutive hound addresses his nose to the ground. The whole assembly is supported on a plain square slab base. The unglazed base bears the cobalt blue crossed-swords mark.

Literature: Lang 1991, no. 52.

65

Delftware dish

England
1745

Earthenware
diam. 43 cm (16⅞ in.)
CER0728

A "Delftware" dish painted in cobalt blue with a view of the south front of Burghley House with deer and trees in the parkland setting.

The view of the house featured on this dish corresponds to that in the engraving (cat. no. 6). In the 1854 inventory it is recorded in the *Brown Drawing Room* as *large round dish with Burghley House. Blue and white.*

Literature: Lang 1991, no. 30.

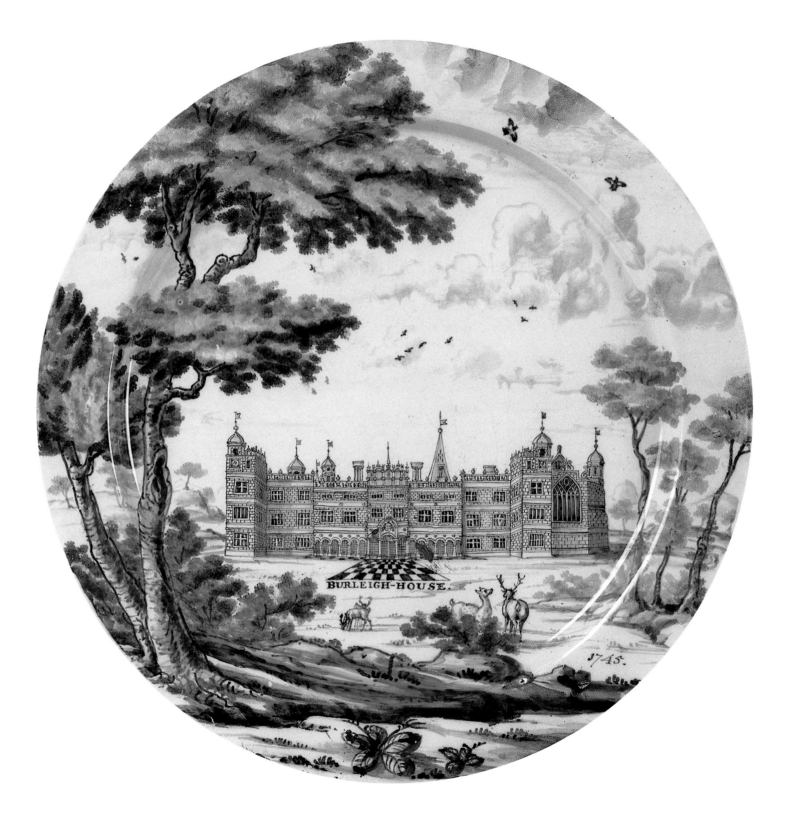

Chinese Ceramics

Blue and white bowl

China
Late Ming dynasty,
mid-17th century

Porcelain with European
silver-gilt mounts formed
as bunches of grapes
diam. 9 cm (3½ in.)
CER0375

With five circular
medallions, each painted
with floral or pastoral
subjects, reserved on a
pierced trellis ground, the
footrim encircled by foliate
panels, the flared rim with
a border of meandering
lingzhih fungus, the whole
dressed in pale green
enamel.

Provenance: Elizabeth,
Countess of Devonshire, née
Cecil, her will, proved 13th
November 1690, listed under
the general heading of
Lesser China garnisht with
Silver guilt as An olive
Color painted Cup with
open work the ffoot and
lineing within with ffive
Bunches of Grapes hanging
on the Top All Garnish, *by*
whom given to her daughter,
Anne, Countess of Exeter.

Literature: Lang 1983,
no. 125.

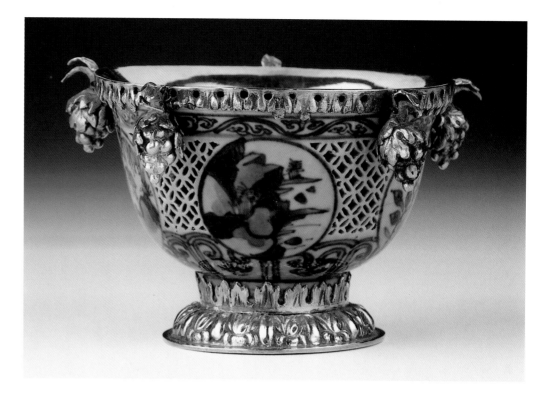

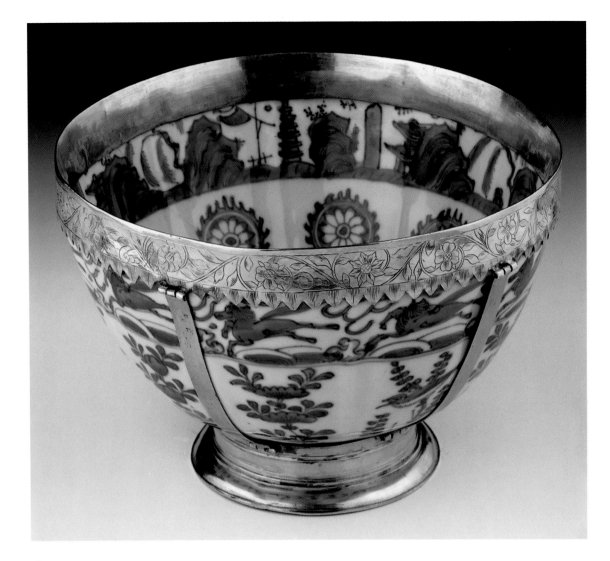

67

The "Walsingham Bowl"

China
ca. 1580–1600

Porcelain with silver-gilt
mounts (European,
ca. 1580–1600)
h. 13, diam. 21.5 cm
(h. 5⅛, diam. 8⁷⁄₁₆ in.)
CER07500

The shallow lobed sides
painted on the exterior with
sprays of fruit and flowers,
below a border with horses
galloping through waves,
the interior painted with
a river scene.

The bowl is traditionally
reputed to have been
presented by Queen
Elizabeth I to her
godchild Walsingham
and given to the Eighth
Earl of Exeter in 1731
as the only male heir
of that family by Lady
Osborne, granddaughter
of Walsingham.

An associated box
bears an inscription that
reads: *The bason inclosed
herein, was given by
Queen Elizabeth, when
she stood, Godmother,
to my great grandfather
Walsingham and was
given to me by my Aunt,
ye Lady Osborne,
(granddaughter to ye said
Walsingham) as being
the only male heir of ye
family left, so that my
children may be*

*christened in it, as all her
family were before 1731.*

It seems likely that the
Walsingham referred to
by Lady Osborne is Sir
Thomas (1568–1630).
It certainly cannot have
been Sir Francis, the
contemporary of
William Cecil, as he
was born in 1530, while
Elizabeth was born
in 1533.

*Literature: Lang 1983,
no. 126.*

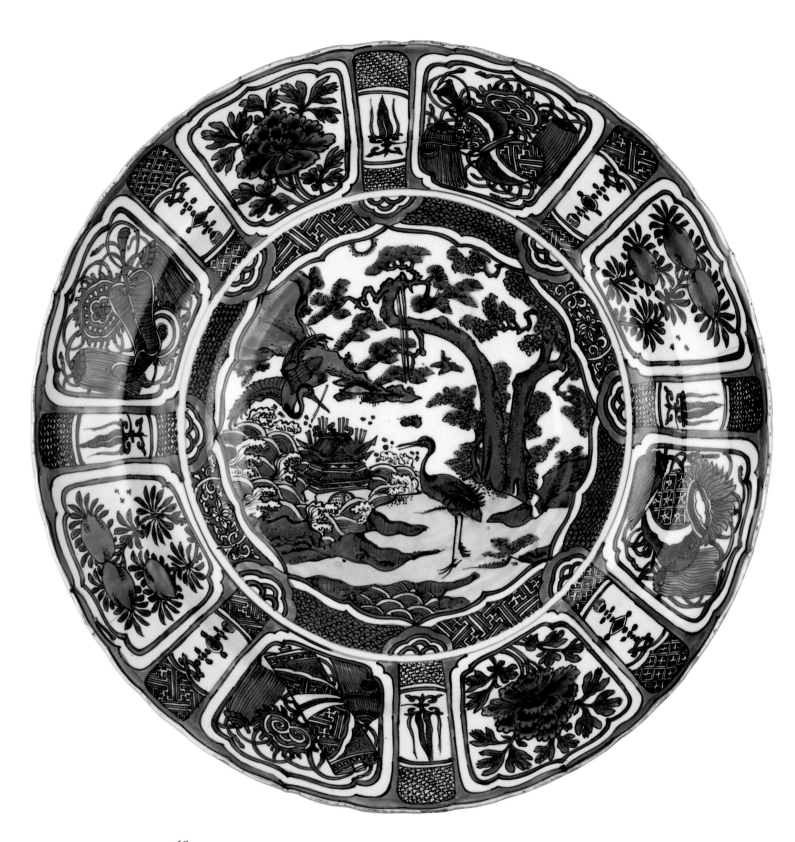

68

Blue and white charger

China
Late Ming dynasty,
late 16th century

Porcelain
diam. 51 cm (20⅛ in.)
CER0309

Of barbed form, the center with a wavy polygonal reserve painted with Taoist subjects, a shrine among waves, a pair of cranes, and pine and maple trees within complex diaper or brocade frame, the cavetto and flanged rim well painted with petalled reserves enclosing Buddhist utensils or flowers separated by rectangular panels of tasseled ornaments and artemisia. The underside with eight casually drawn compartments encircling an unglazed slightly domed base and an undercut foot spattered with kiln grit.

Literature: Lang 1983,
no. 129.

69

Blue and white bottle

*China
Wanli/Tianqi period,
early 17th century*

Porcelain
h. 30.5, diam. 15 cm
(h. 12, diam. 5⅞ in.)
CER0325

The pear-shaped body carved with shallow lobes, each painted with Buddhist emblems or birds and flowers below a collar of trellised gadroons pendant from "eye"-shaped motifs below a section of beaded compartments and a garlic mouth embellished with overlapping lotus petals, the underglaze cobalt blue of irregular tone. The body horizontally luted in three sections, supported on a crudely knife-cut footrim.

Provenance: Probably from Elizabeth, Countess of Devonshire, 1690, but not identifiable in the schedule.

Literature: Lang 1983, no. 137.

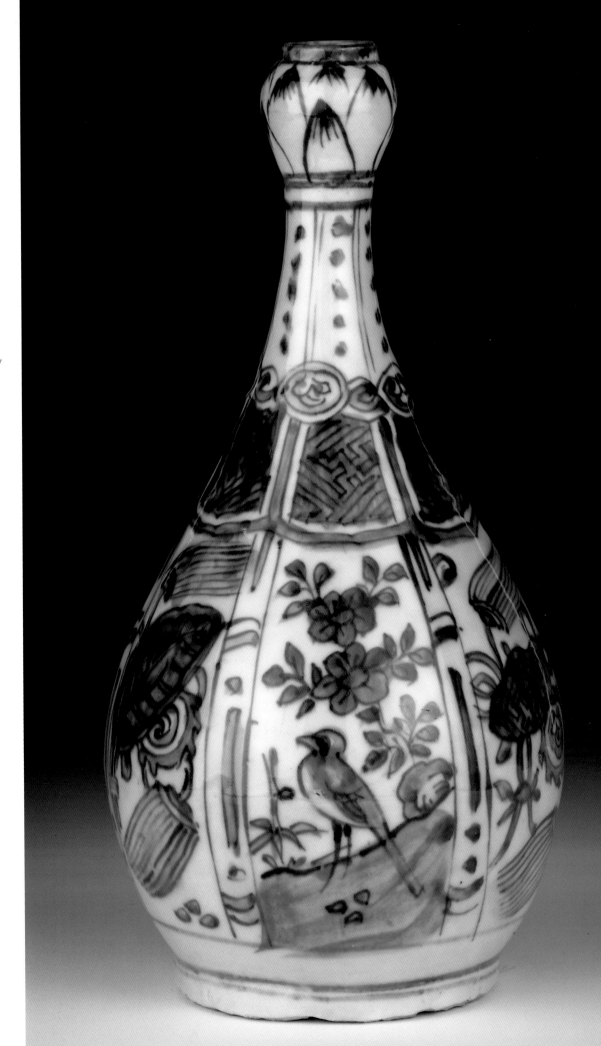

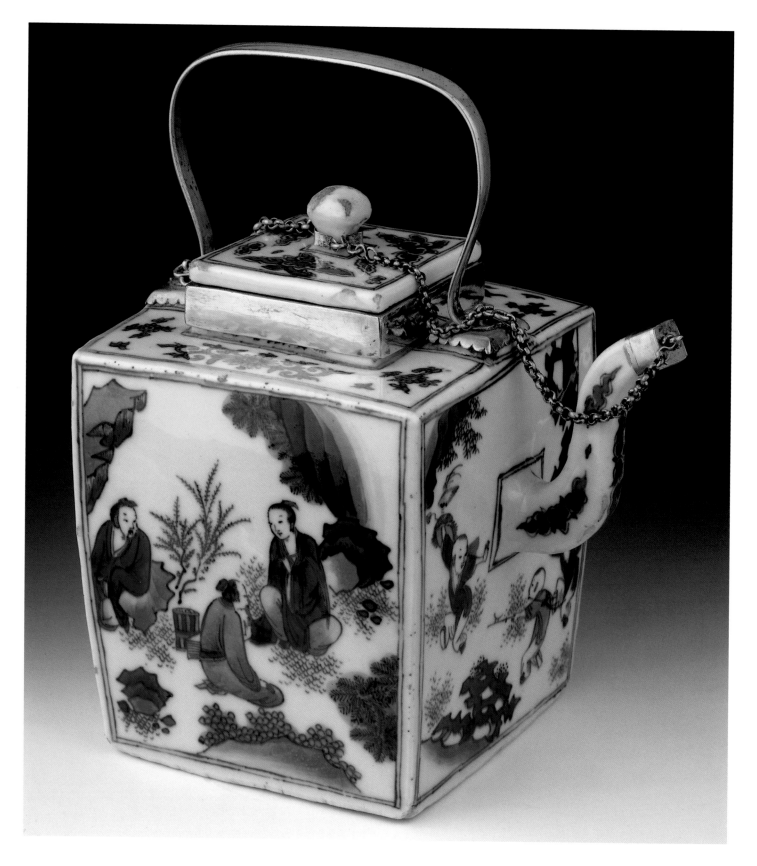

70A&B

Blue and white wine vessel or teapot and cover

*China
ca. 1640–1650
("Transitional")*

Porcelain with silver-gilt mounts (European, late 17th century)
h. 17, w. 18 cm
(h. 6¹¹/₁₆, w. 7¹/₁₆ in.)
CER07499

Of square section, each face painted in "Transitional" style in "outline and wash" within double line borders with figure subjects, the shoulders decorated with sprays of lotus.

Provenance: Elizabeth, Countess of Devonshire, née Cecil, her will, proved 13th November 1690, listed as A Large ffour square Tea pott and a little square Top, Garnisht on the Neck handle and spout End with a Chaine to it, *by whom given to her daughter, Anne, Countess of Exeter.*

Literature: Lang 1983, no. 146.

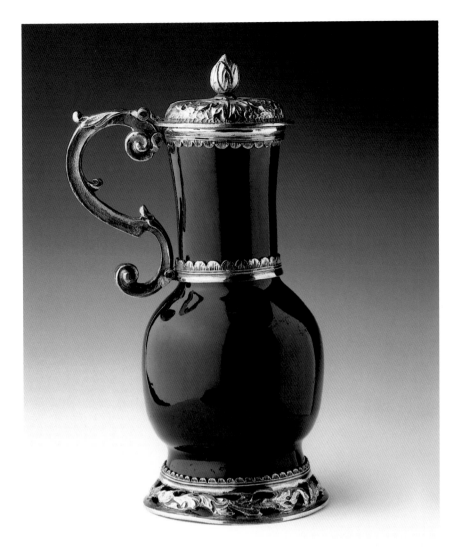

71

Jug

China
Mid-17th-century

Purple glazed porcelain
with silver-gilt mounts
(European, 17th century)
h. 12.5, diam. 7.5,
including handle mount
(h. 4⅝₁₆, diam. 2¹⅝₁₆ in.)
CER0378

The lower half of near
globular form surmounted
by a cylindrical neck everted
slightly toward the rim,
supported on a splayed foot.
Excepting the inner footring
and interior, the vessel is
covered in a rich aubergine
purple lead silicate glaze.

Provenance: Elizabeth,
Countess of Devonshire, née
Cecil, her will, proved 13th
November 1690, listed as A
Purple Cann garnisht Top
Bottom and Middle, *by*
whom given to her daughter,
Anne, Countess of Exeter.

Literature: Lang 1983,
no. 173.

Punch bowl (the "Burghley Bowl")

China
Yongzheng period, ca. 1735

Porcelain
h. 12.5, diam. 29.5 cm
(h. 4¹⁵⁄₁₆, diam. 11⅝ in.)
CER0075

Decorated both in *famille rose* enamels and *en grisaille*, one side of the bowl painted *en grisaille* with a view of the South Front of Burghley House, the reverse with the arms of the Eighth Earl of Exeter and his wife between two sprays of peony and a pair of attendant birds, the rim decorated in iron red and gilding with a band of spearheads. The interior of the bowl painted in the center with an arrangement of objects, including a bronze vase containing flowers, a bowl of auspicious fruit, and utensils for the scholar's table; the rim with a narrow band of honeycomb diaper interrupted by four cartouches enclosing scrolls of *ruyi* scepters.

In the early eighteenth century it became the fashion for aristocratic European families to order dinner services or individual items of Chinese porcelain through the intermediary services of one of the East India Companies. Usually these would bear the family's armorials, frequently copied from a bookplate, and perhaps also another motif copied from an engraving. The exact source of this image of Burghley House has not been identified.

Literature: Lang *1983, no. 220.*

Exhibited: Ceramics and Civilization, *1996.*

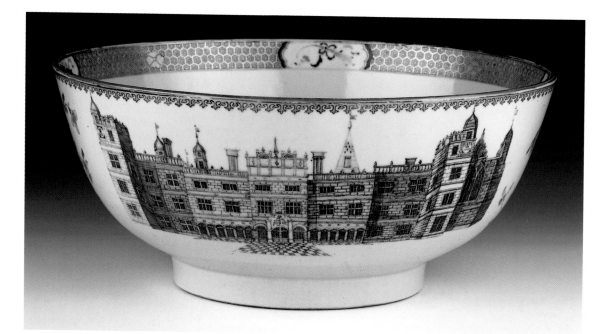

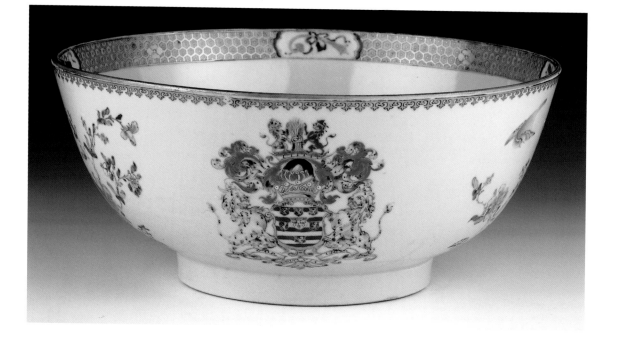

Arita tiered box

Japan
ca. 1660–1680

Porcelain with silver-gilt
mounts (English,
17th century)
h. 4.6, diam. 6.5 cm
(h. 1¹³⁄₁₆, diam. 2⁹⁄₁₆ in.)
CER0490

One of a pair. The
cylindrical vessel potted in
three interlocking sections,
painted in underglaze blue,
iron red, gold, and silver,
on the sides the *shochikubai*
or "The Three Friends of
Winter," prunus, pine, and
bamboo, the flat lid painted
in brocade style divided
into two semicircles, one
half with plum blossom, the
other with a sunburst motif,
the wavy radiating arms
alternately decorated with
basketweave diaper. The
compartments bound
together by means of a
finely wrought silver-gilt
filigree cage.

An identical pair was
in the collection of Sir
Hans Sloane, which
in 1723 became the
foundation collection
of the British Museum
(see Impey 1994).

*Provenance: Elizabeth,
Countess of Devonshire, née
Cecil, her will, proved 13th
November 1690, listed as
A pair of Boxes of three
pieces Each painted in
colors garnisht with
philigrin Top Bottoms
Hinges and Clasps by whom
given to her daughter Anne,
Countess of Exeter.*

Exhibited: Wrestling Boys,
1983, no. 97; Burghley
Porcelains, *1986, no. 70;*
Porcelain for Palaces, *1990,
no. 51.*

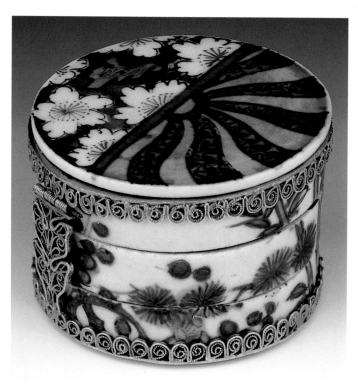

74

Arita figure of an Immortal on a tortoise

Japan
ca. 1660–1680

Porcelain, enameled
h. 18.5, w. 13.5, l. 19 cm
(h. 7⁵⁄₁₆, w. 5⁵⁄₁₆, l. 7⁷⁄₁₆ in.)
CER0076

Shown riding on the back of a "flaming tortoise," its carapace delineated with honeycomb diaper, decorated in overglaze enamels including turquoise, cerulean, iron red, yellow, and black.

The "flaming tortoise," or *minogame*, is actually a terrapin on the carapace of which is a growth of seaweed, indicating its great age.

The documents of the Dutch East India Company record that in 1665, the ship *Nieuwenhoven* carried from Batavia to Holland a cargo including 19,229 pieces of Japanese porcelain, including "295 small statuettes on tortoises" (Volker, *Porcelain and the Dutch East India Company*, 1954).

Exhibited: Wrestling Boys, *1983, no. 93;* Burghley Porcelains, *1986, no. 88;* Porcelain for Palaces, *1990, no. 158.*

Literature: Nelson and Impey 1994, fig 5.

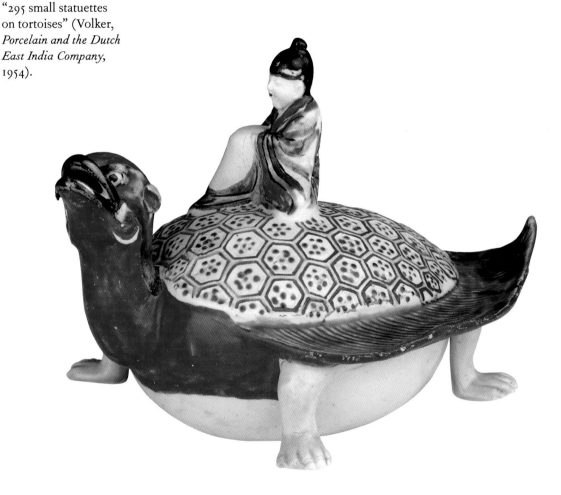

75 A&B

Pair of Arita tankards

Japan
ca. 1660–1680

Porcelain, enameled in early
Kakiemon style
h. 15, diam. 10 cm
(h. 5⅞, diam. 3¹⁵⁄₁₆ in.)
CERO487

Of European silver form,
the lower half globular
carved with four multilobed
panels of alternate dragon
and chrysanthemum in
shallow relief against a pale
iron oxide-washed biscuit
ground with circular seeds,
the cylindrical upper half
carved with sea-birds flying
above waves, the latter
again carved in the biscuit
and dressed in iron oxide,
the glazed handle painted
with *karakusa* scroll. All the
decorative motifs excluding
the ground patterns are
picked out in strong
Kakiemon enamel colors;
the upper handle pierced for
a metal mount, supported
on an unglazed base.

These tankards are
listed in the 1688
inventory as *2 painted
relev'd brown Juggs
with handle Guilt rimms*
in the *Drawing
Roome…China over
the Chimney.*

Exhibited: Wrestling Boys,
1983, no. 83; Burghley
Porcelains, *1986, no. 98;*
Kakiemon Porcelain from
the English Country
House, *1989, no. 3;*
Porcelain for Palaces, *1990,
no. 87;* Ceramics and
Civilization, *1996.*

76

Elephant

Japan
ca. 1670–1685

Porcelain, enameled
in Kakiemon style
h. 28.5, w. 27, d. 12 cm
(h. 11 3/16, w. 10 5/8, d. 4 11/16 in.)
CER0305

One of a pair. Shown
standing four-square with
head raised and turned to
one side, a rectangular
brocade saddlecloth
decorated in Kakiemon
palette enamels with peony
amid scrolling *karakusa*, the
cloth tied with a red tasseled
cinch.

This figure is one of a
pair listed in the 1688
inventory in *My Lord's
Bedd Chamber* as *2 large
Elephants*. In the late
eighteenth century they
stood in the *Ballroom*,
where they remained
throughout the
nineteenth century.

Exhibited: Wrestling Boys,
1983, no. 92; Burghley
Porcelains, *1986, no. 93;*
Kakiemon Porcelain from
the English Country House,
1989, no. 6; Porcelain for
Palaces, *1990, no. 160. One
exhibited*, Ceramics and
Civilization, *1996.*

Group of two wrestlers

Japan
ca. 1670–1685

Porcelain, painted in
Kakiemon style
h. 30.7, d. 21 cm
(h. 12¹⁄₁₆, w. 8¼ in.)
CER0296

Each figure wearing a
loincloth enameled in iron
red, the one plain, the other
with florets and foliate
scrolls in blue and yellow
enamels, the hair in black
enamel and the lips in iron
red.

In the 1688 inventory
2 China boyes wrestling
stood in *the Wardrobe
or Closet Chamber.* In
the eighteenth century
they stood in the *North
Drawing Room,* but
by 1804 they had been
moved to the *Billiard
Room.*

Exhibited: Wrestling Boys,
1983, no. 96; Burghley
Porcelains, *1986, no. 95;*
Porcelain for Palaces, *1990,
no. 163.*

Literature: Impey 1985.

78

Arita puppy

Japan
ca. 1670–1690

Porcelain, enameled
in Imari style
h. 24, w. 14, d. 25 cm
(h. 9⁷⁄₁₆, w. 5½, d. 9¹³⁄₁₆ in.)
CER0303

One of a pair. Standing
with its head turned to the
left, the body dappled in
black, iron red, turquoise
and yellow random
enameled spots. (The left
forefoot has been
incorrectly repaired.)

It is unlikely that these
are the *Dogges* in the
1688 inventory; they
are first unequivocally
mentioned in the 1854
inventory, in the *North
Room* as *a pair of
spotted dogs both broken
in one foot.*

Exhibited: Wrestling Boys,
1983, no. 91; Burghley
Porcelains, *1986, no. 92;*
Porcelain for Palaces, *1990,
no. 175;* Ceramics and
Civilization, *1996.*

79

Arita figure of a rooster

Japan
ca. 1660/80

Porcelain, enameled
in Kakiemon style
h. 28, w. 16.5 cm
(h. 11, w. 6½ in.)
CERO298

Shown modeled in a formalized crowing attitude, with head erect and beak open standing on a rock-work base, its tail feathers meeting the base and forming the third support, the plumage molded and enameled in a strong Kakiemon palette, the base washed in iron oxide.

Also in the Burghley collection are another Japanese figure like this, but unpainted, and a Chinese *blanc de Chine* figure, almost identical, which is listed in the Devonshire Schedule of 1690.

In 1804 this figure stood in the *Purple Bed Chamber*.

Exhibited: Wrestling Boys, *1983, no. 88;* Burghley Porcelains, *1986, no. 90;* Porcelain for Palaces, *1990, no. 169.*

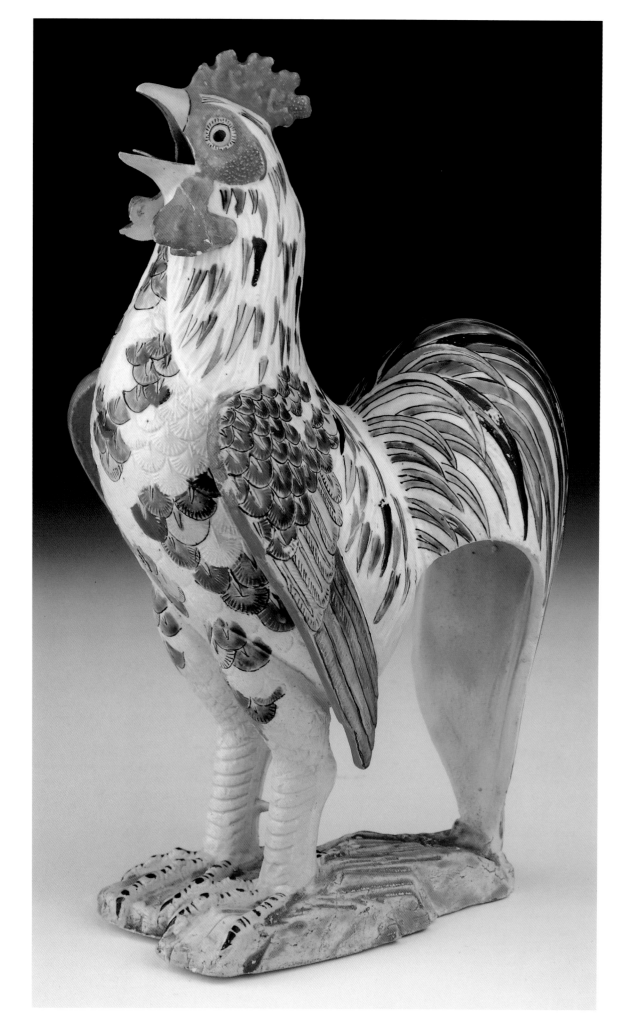

80

Kakiemon octagonal plate

Japan
Late 17th century

Porcelain, enameled
diam. 24.3 cm (9⁹/₁₆ in.)
CER0483

Painted on the milky-white (*nigoshide*) body in Kakiemon enamels with the "Hob-in-the-Well" pattern, depicting the future Chinese statesman Sima Guang rescuing his drowning friend from a massive water jar by smashing it with a rock. To the left Sima Guang is in the act of hurling the rock, and to the right a third figure is pulling their fortunate companion from the now-broken vessel. On the extreme right are lotus and bamboo stalks. The flat rim is decorated with lotus, chrysanthemum, and fern within an iron-brown edge.

Exhibited: Wrestling Boys, *1983, no. 67;* Burghley Porcelains, *1986, no. 100.*

81

Arita blue and white shaped dish

Japan
ca. 1640–1650

Porcelain
l. 15.5, w. 13 cm
(l. 6¹⁄₁₆, w. 5⅛ in.)
CERO455

Formed as an overlapping chrysanthemum leaf and bloom painted in pale grayish underglaze blue on a striped and squared diaper ground within an iron-brown rim, the base with a commendation mark within a double line border.

This is not a piece made for export, being made before the beginning of the export trade to Europe; its presence in this collection, along with several other later blue and white wares not of the export type (see cat. nos. 82, 83, 84) signal the purchase in Japan through some Dutch agent of "antique" porcelain or at least "curious" porcelain for the collectors of seventeenth- and eighteenth-century England.

Exhibited: Wrestling Boys, *1983, no. 13;* Burghley Porcelains, *1986, no. 23.*

Literature: Impey 1996, *fig. 79.*

Arita blue and white shaped dish

Japan
Mid-17th century

Porcelain
l. 11.5, d. 28.6 cm
(l. 4½, w. 11¼ in.)
CERO453

Of rectangular form, composed of two overlapping brocade panels, one with scattered maple leaves, the second with barbed reserves of prunus and bamboo on a honeycomb diaper ground, the square-cut footring embellished with elongated key fret pattern.

These are dishes (*mukozuke*) suitable for use with the Japanese cuisine. They were not made for export, but presumably arrived in Burghley with some other anomalous blue and white dishes (see cat. no. 81). Unfortunately, there are no records of this known.

Similar pieces have been found in other early collections such as that at Drayton House, formed by Sir John and Lady Betty Germain, and at Welbeck Abbey, formed by Margaret, Second Duchess of Portland (see Hinton and Impey 1989).

Exhibited: Wrestling Boys, *1983, no. 11;* Burghley Porcelains, *1986, no. 29.*

Arita blue and white shaped dish

Japan
Mid-17th century

Porcelain
l. 11.5, w. 9 cm
(l. 4⁹⁄₁₆, w. 3½ in.)
CER0388

Molded and crisply carved in the form of a flying crane, the tail feathers forming a serrated edge, the underside and undercut footring decorated with sparse umbelliferous flowers.

See catalogue number 81.

Exhibited: Wrestling Boys, *1983, no. 16;* Burghley Porcelains, *1986, no. 26.*

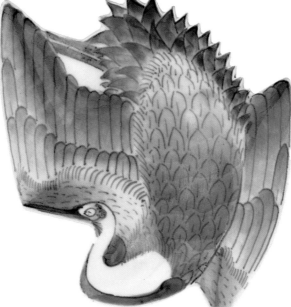

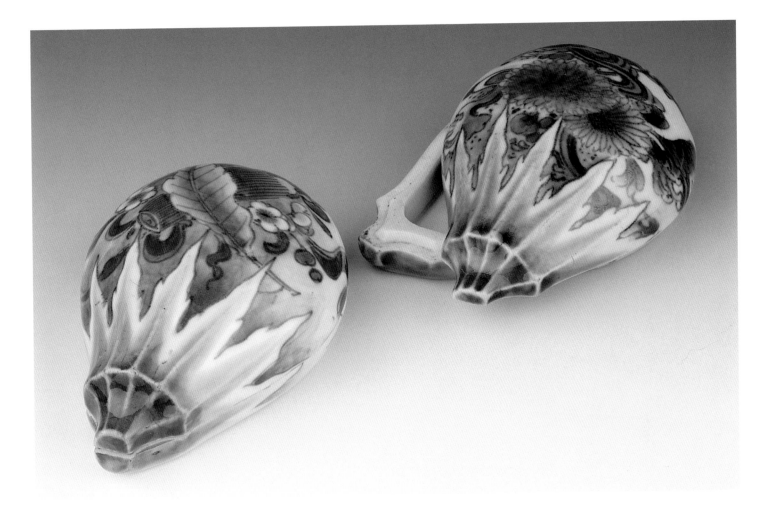

84 A&B

Pair of small Arita blue and white boxes and covers

Japan
Mid- to late 17th century

Porcelain
l. 7.8, w. 5.2, d. 3 cm
(l. 3⅛, w. 2¹⁄₁₆, d. 1³⁄₁₆ in.)
CERO391

Molded in the form of an aubergine, painted in underglaze blue with an artemisia leaf among beribboned sprays of blossom and chrysanthemum.

See catalogue number 81.

Exhibited: Wrestling Boys, *1983, no. 28;* Burghley Porcelains, *1986, no. 66;* Porcelain for Palaces, *1990, no. 63.*

Pair of Arita blue and white sleeve vases, or rolwagons

Japan
ca. 1660–1680

Porcelain
h. 28.5, diam. 11 cm
(h. 11¼, diam. 4⁵⁄₁₆ in.
CER0337

A cylindrical body painted in grayish underglaze blue in the Japanese adaptation of the Chinese "Transitional" style, with a formalized landscape, the neck with lappets and spearheads.

When the Dutch were no longer able to order Chinese porcelain in the shapes they wanted from Jingdezhen, they sent to Japan wooden models of Chinese porcelain that may have been painted by Delft potters. The resulting Japanese export wares may thus present a bizarre third-hand appearance.

The origin of the name *rolwagon* is unclear, but much play was made with the shape in stage performances of Restoration comedies.

In the eighteenth century, several rolwagons were in *Lady Exeter's Closet*, but these may as well have been Chinese or Japanese.

Exhibited: Wrestling Boys, *1983, no. 50;* Burghley Porcelains, *1986, no. 48;* Porcelain for Palaces, *1990, no. 38.*

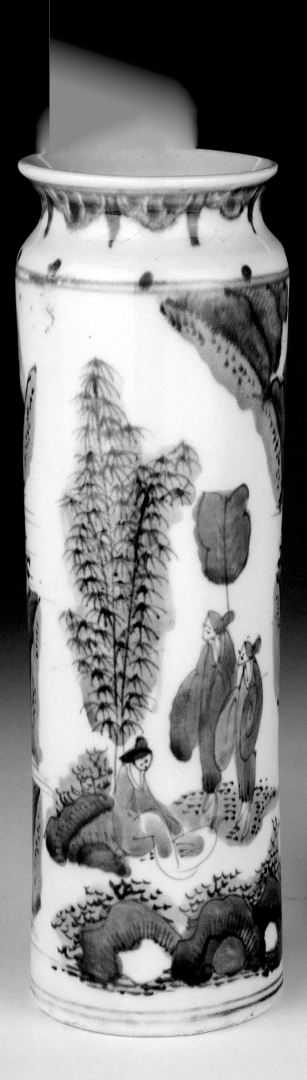
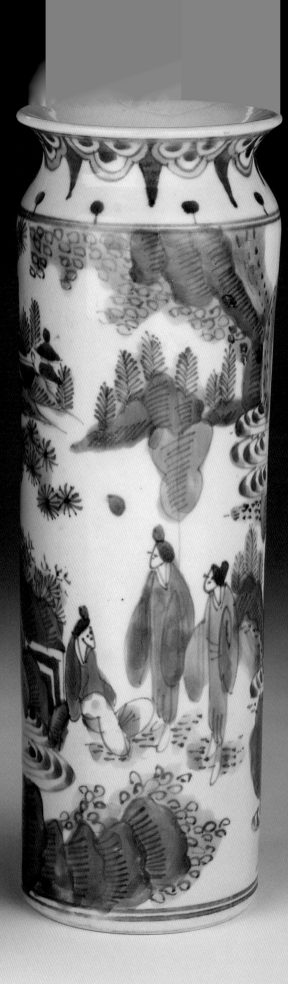

Arita blue and white bucket-shaped flask

Japan
ca. 1660–1680

Porcelain
h. 24.5, diam. 14.5 cm
(h. 11³⁄₁₆, diam. 4⁵⁄₁₆ in.)
CERO427

One of a pair. Modeled after a Japanese wooden original, the slightly tapered sides with two rectangular panels, one a landscape with a small pavilion set beside a waterfall, the second with mallow and reeds growing among rockwork, reserved on a triangular checkered ground between molded borders, the upper border and flanges with scale and wave diaper. The slab-sided handle decorated with *karakusa* scroll, a butterfly on the sunken top which has a single pouring aperture.

This is an unusual shape for an export piece.

Exhibited: Wrestling Boys, *1983, no. 47;* Burghley Porcelains, *1986, no. 50;* Ceramics and Civilization, *1996.*

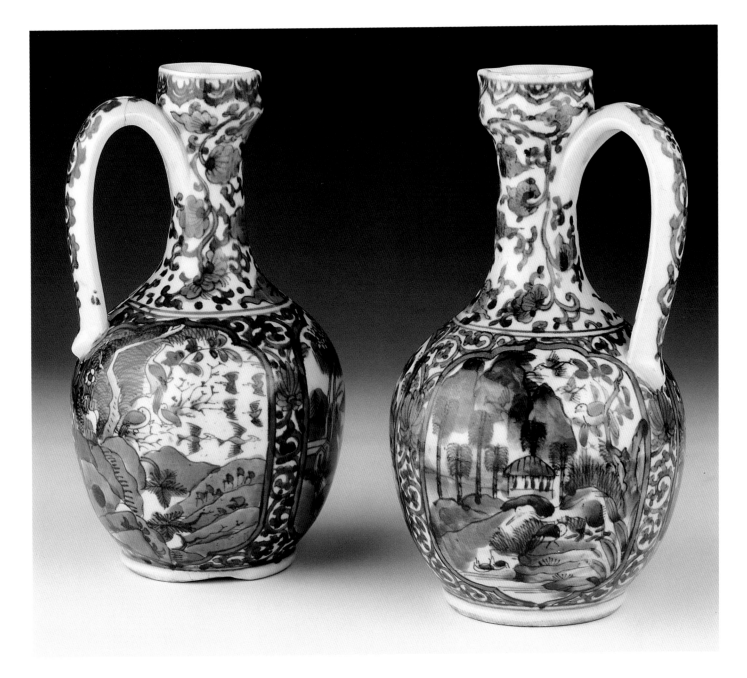

87A&B

Pair of Arita blue and white jugs

Japan
ca. 1660–1680

Porcelain
h. 24.5 cm., diam. 14.5 cm
(h. 9⅝, diam. 5¹¹⁄₁₆ in.)
CER0478

The almost globular body boldly painted in a runny underglaze cobalt, with three different landscape panels, one with two figures carrying parasols, another with a crane near an anchorage or pavilion, the third with a flight of birds passing over a mountainous terrain, the panels within borders of scrolling lotus all below a waisted neck decorated with trailing mallow rising to a galleried mouth painted with a frieze of barbed lappets, the handle decorated with foliage and pierced at the top for a metal mount.

The piercing at the top of the handle was done by the potters to order, for the affixing in Europe of a silver, silver-gilt, or pewter hinged lid.

Exhibited: Wrestling Boys, *1983, no. 49;* Burghley Porcelains, *1986, no. 45.*

88

Arita blue
and white ewer

Japan
Third quarter 17th century

Porcelain
h. 17.8 cm (7 in.)
CER0387

The flattened baluster body
molded with lotus leaves,
buds, and half-opened
blooms in shallow relief
on wave diaper ground,
surmounted by multilobed
cup-shaped mouth.

Exhibited: Wrestling Boys,
1983, no. 57; Burghley
Porcelains, *1986, no. 53;*
Ceramics and Civilization,
1996.

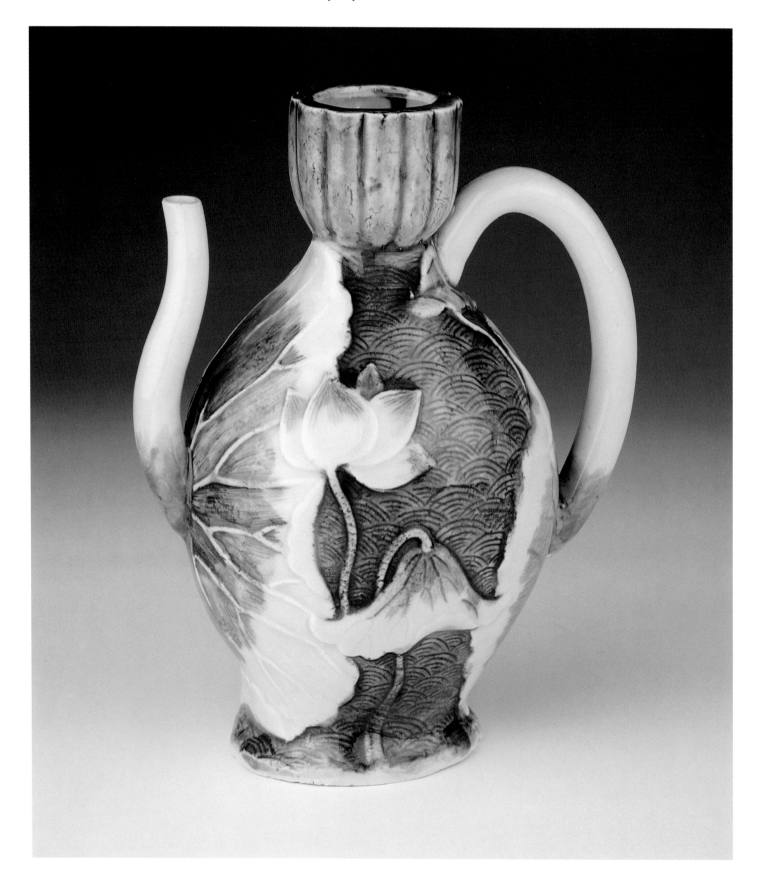

89

Arita blue and white
and molded dish

Japan
Late 17th/early 18th century

Porcelain
diam. 21.5 cm (8⁷⁄₁₆ in.)
CER0463

The center painted in
underglaze blue with a
design of a square sheet of
paper folded at one corner
and painted with a beaker of
prunus blossom on a low
table, the border molded
with stylized characters
enclosed in cartouches. The
base with three spur marks
and a square commendation
mark.

Sherds of the same
pattern have been found
at the Kakiemon kiln
site in Arita.

Exhibited: Wrestling Boys,
1983, no. 22; Burghley
Porcelains, *1986, no. 19.*

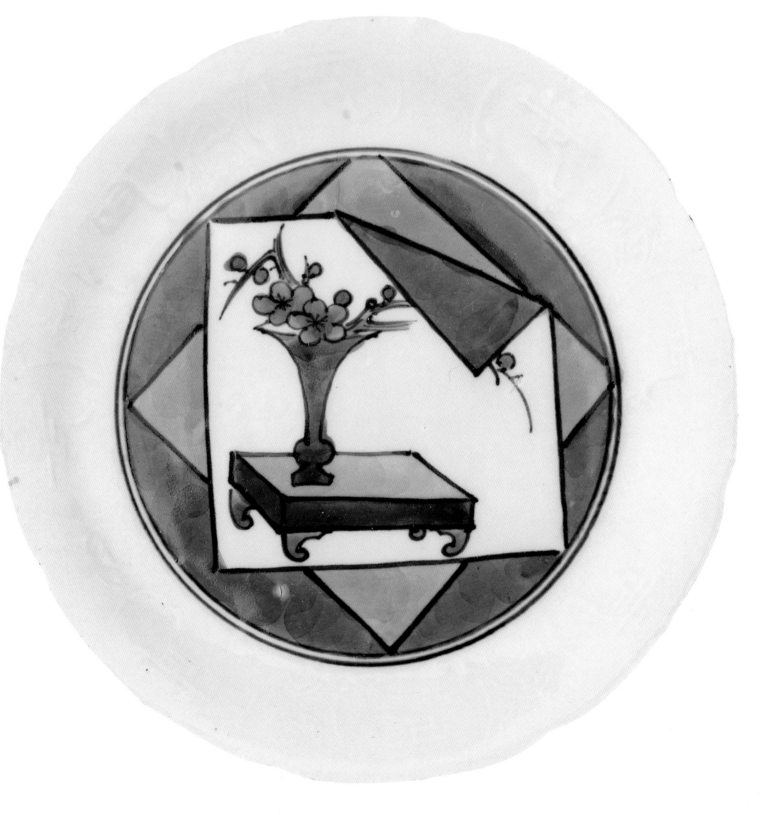

90

Arita blue and white lobed oval dish

Japan
Early 18th century

Porcelain
l. 15.8, w. 12.7 cm
(l. 6³/₁₆, w. 5 in.)
CERO476

Painted in underglaze blue in the manner of van Frytom, with two European square-riggers exchanging broadsides. In the foreground are figures in a long boat, in the distance a fleet of rectilinear vessels, the rim decorated with a continuous band of heart-shaped motifs. The base with four spur marks and a spurious six-character mark of Chenghua.

This dish is one of a series of small dishes of varied shape (there are others at Burghley) that imitate Dutch Delft originals, some of which are marked MB and dated 1684. The Delft originals are painted in a simplified version of the style associated with the painter Frederik van Frytom (1632–1702). It is a matter of conjecture what role van Frytom played in their production; in all probability, he supplied drawings to be copied (see Vecht 1968).

Exhibited: Wrestling Boys, *1983, no. 44;* Burghley Porcelains, *1986, no. 63.*

Furniture and Furnishings

Inlaid side table

Attributed to Gerreit Jensen
England
17th century

Ebony and pewter inlaid
h. 79, w. 100.5,
d. 55.5 cm. (h. 31⅛,
w. 39⅝, d. 21⅞ in.)
FURO324B

The rectangular brass molded top above a frieze drawer raised on square tapered legs with gilt brass capitals and collars and united by a flat stretcher on brass-capped turned and tapered feet, decorated throughout with cut and engraved pewter, brass, and ebony strapwork flowers and scrolls.

In the 1688 inventory this table may be that listed as *1 writing Desk Table, & Drawer Inlaid with metall white* standing in *My Lords Dressing Roome*, and it is likely that it is the *Desk inlaid* in Lord Exeter's *Anti-Chamber* in 1738. In 1804 it was probably in the *North Dressing Room* and in 1854 in the *Blue Drawing Room*.

The Burghley accounts show that between 1682 and 1704 "Jerret Jensen" was paid a total of £534, but itemized accounts have not been traced.

Gerreit Jensen (fl. ca. 1680–1715) was cabinetmaker to the Royal Household from the reign of Charles II to Queen Anne. Of Dutch or Flemish origin, his name is often anglicized to Garret Johnson. He also worked for the first Duke of Devonshire at Chatsworth between 1688 and 1698. Two pieces at Windsor Castle of William III's reign and enriched with "fine" or arabesque marquetry may be attributed to Jensen. He also supplied mirrors and glass panels for Hampton Court, ca. 1699. A former close associate of Pierre Gole (see fig. 12, p. 38), Jensen was the only cabinetmaker working in this technique in England at this date.

Pair of carved gilded footstools

England
Late 17th century

Gilt wood
h. 49, w. 81, d. 45 cm
(h. 19¼, w. 31⅞, d. 17¾ in.)
FUR0498

Two of a suite of fourteen (one illustrated here). With cushion molded seat rails carved with scrolls and leaves and on pierced scrolled square tapering legs with leaf carving and joined by a pierced scrolled flat stretcher and on turned leaf-carved feet.

Almost certainly supplied to the Fifth Earl, these are not unequivocally identifiable in the 1688 inventory and may have been ordered a few years after that time. As they went out of fashion in the eighteenth century, the parts of even such a grand suite as this would probably have been split up and dispersed among the minor bedrooms. This practice is typical for the use of furniture that was no longer fashionable. In fact, at Burghley, the Ninth Earl may well have kept such things longer than would most of his contemporaries. Today these footstools are in the Heaven Room (see fig. 14, p. 41).

Cabinet

*Attributed to Leonardo
van der Vinne
Florence
ca. 1680*

Ebony with bone and
mother-of-pearl marquetry,
marble, gilt-bronze,
on gilt-wood stand
h. 99, w. 175, d. 53 cm
(h. 39, w. 68⅞, d. 20⅞ in.)
FUR0499A

Of architectural form with
an arrangement of drawers
around a central cupboard
enclosing a perspective
interior, set with *pietra dure*
panels of birds, flowers, and
fruit within marquetry
borders incorporating bone
and mother-of-pearl, faced
by six Spanish brocatelle
marble columns
surmounted by six
crouching gilt-bronze
figures, four of them
representing the seasons;
on a contemporary English
gilt-wood stand formed
of leafy scroll work and
incorporating two cherubs.

This cabinet is possibly
the grandest piece of
furniture at Burghley
House. It was given to
the Fifth Earl in the
winter of 1683–1684
by the Archduke
Cosimo III of Tuscany
when the Earl and
Countess were at his
court in Florence. In
1688 it was suitably
placed in the *Drawing
Room*, described as *1
Rich florrence Cabinett
inlaid with stone &
mother of perle with a
carv'd Guilt frame.*

Curiously, in 1738 it
had been moved to the
small northwest *Closet*
off the *North Dressing
Room* where it was
described as *A fine
Cabinet sent by the Great
Duke of Tuscany to this
Lord's Grandfather,
inlaid with precious
Stones in Birds, Flowers,
Fruit and Baskets, the
Drawers Carved, Mother
of Pearl between every
Drawer, a Marble Pillar
& small Brass Images*

*over every Pillar, round
the Top Brass Rails; the
Cabinet stands upon 6
Marble Statues.* Note
that the stand has been
changed.

In 1804 it stood either
in the *Blue Bed Chamber*
or in the *Billiard Room*.
As there is another
Florentine cabinet in the
house (see fig. 14, p. 41),
and as the descriptions
are somewhat per-
functory, it cannot be
placed with confidence,
but it was back on a
gilt-wood stand *(frame)*,
almost certainly its
former, and present-
day, stand.

It was made in the
Galleria dei Lavori of
the Archduke Cosimo
in the Uffizi. The
cabinetmaker's work
can be attributed to
Leonardo van der
Vinne, a Flemish
craftsman, while other
specialist craftsmen
would have made the
pietra dure and other
fittings and decorations.

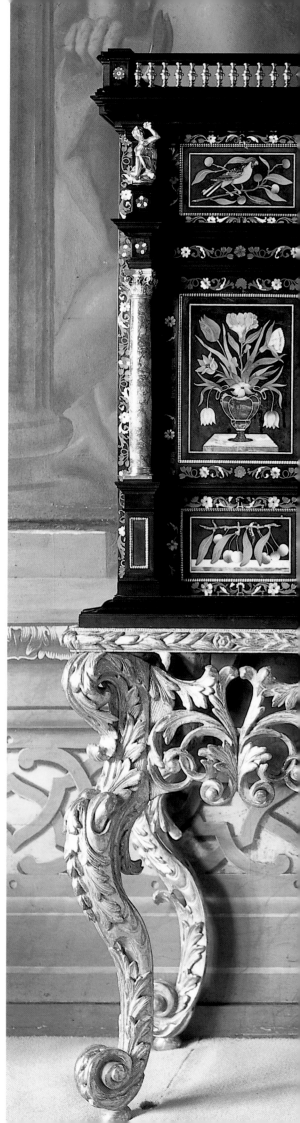

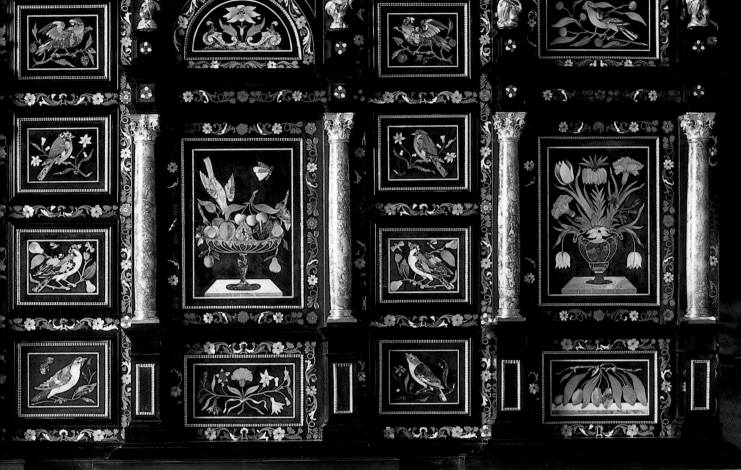
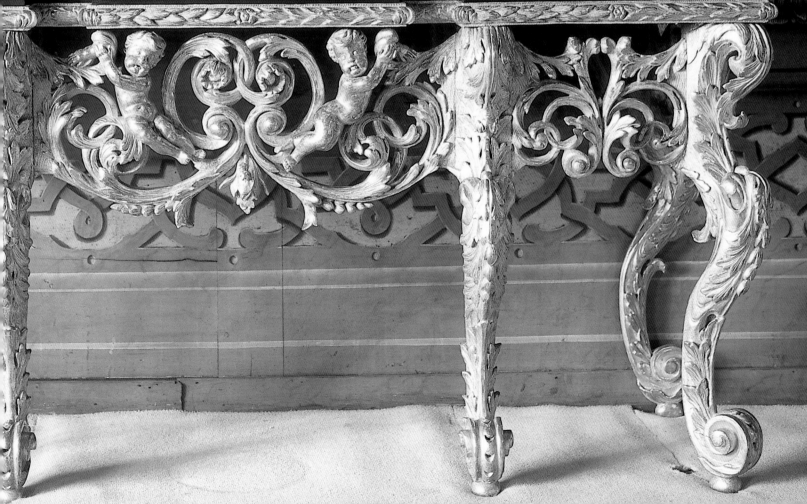

Queen Anne gilt-wood mirror

Phineas Evans
England
1729

Silvered glass, wood,
and gilt-gesso
h. 140, w. 76, d. 28 cm
(h. 55⅛, w. 29⅞, d. 11 in.)
FUR0617

One in a set of three. The
rectangular beveled plates
within a leaf-carved molded
frame, scrolled cresting
centered by a later crest,
with a coronet, shaped
apron scroll carved and
flanked by eagle heads.

The purchase is
recorded in a bill of
1729 from Phineas
Evans (Exeter MSS
51/21/37) *Feb'y 3'd*, for
*Three Sconces carved and
Guilt in Gold with A
Trebble Branch to each
at. . .£14:14:0 per sconce
Total £44:2:0.* The bill
goes on to record *for
Three Tables carved and
Guilt in Gold at £9:9:0.*
This would indicate
three console tables
to match the mirrors.

Clearly these were
ordered for the *blue
Velvet Drawing Room*,
where they stood in
1738, *between 3 Sash-
Windows Sconces, gilt
Frames, at the Top the
Crest and Coronet.
Underneath, 3 gilt
Tables with the Crest in
the Middle.* Actually, the
room has four windows,
between which these
would have stood. The
mirrors are now in the
North Corridor, but the
console tables cannot be
traced.

95

Torchère

Mayhew & Ince
England
1768

Carved gilt wood
h. 188, d. 54 cm
(h. 74, w. 21¼ in.)
FUR0359

One of a set of three. With three naturalistic scrolling branches, fitted with leaf-carved metal candle holders, supported by a cluster column of acanthus leaves carved with pomegranates, grapes, and flowerheads, the open scrolled support carved with husks, leaves, and flowerheads and upon a double scrolled tripod base, with hairy paw feet and acanthus leaf carving.

This torchère is possibly one of the four supplied by Mayhew & Ince in April 1768 and invoiced *Four tripods for the hall, very richly carv'd and gilt with lamps to ditto gilt and varnish'd £120.0.0.*

The 1804 inventory lists *3 carved and gilt candlebras 3 lights each* in the Third George Room. Clearly, by then one had been lost or broken, for there are now three in the house.

Brownlow, the Ninth Earl, employed the celebrated firm of cabinetmakers Mayhew & Ince, spending with them the large sum of £1245.3s.11½d between February 1767 and April 1768 alone. His taste was mainly in the "antique" style, in his case, that of his great-grandfather the Fifth Earl. The bed that Mayhew & Ince supplied for him for the *Blue and Silver Bedroom* was described in the bill as being made in the "antique" style and is, indeed, very much in seventeenth-century style.

Mayhew & Ince also made to the Ninth Earl's order a set of two commodes and two corner cupboards *Entirely new working some old inlaid work, making good the deffciencies* for £237.15.0, which are now in the Third George Room. This was expensive, probably more so than if the furniture had been supplied in the latest fashion. They also supplied several other pieces of furniture, including the collector's cabinets (cat. no. 96), the commode (cat. no. 98), and the chairs for the *Chapel* (cat. no. 97), and they installed curtains and so-on, after April 1768, for payments continued until 1779, to a sum of £382; itemized bills appear not to have survived.

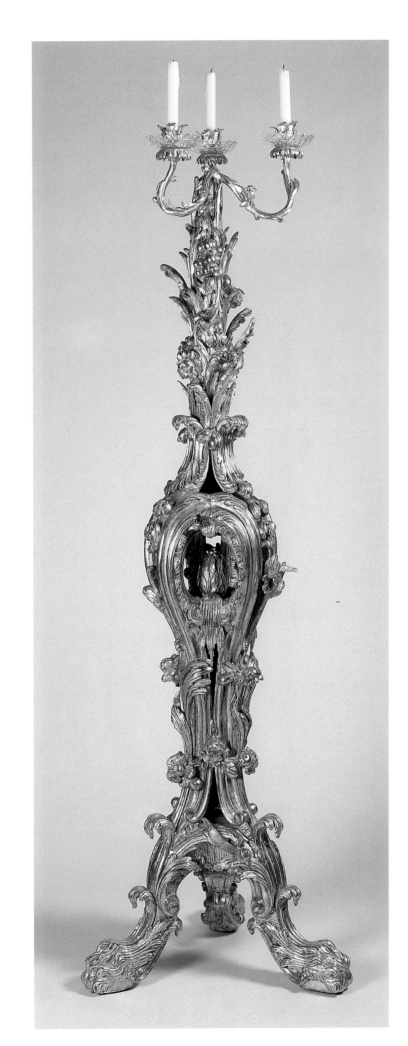

George III collector's cabinet

Attributed to Mayhew & Ince
England
ca. 1770

Mahogany with ivory
and wood inlay
h. 109, w. 46, d. 38 cm
(h. 42⅞, w. 18⅛, d. 15 in.);
d. with front dropped 66 cm
(26 in.)
FUR0052

One of a pair, each with raised molded panels and hinged fronts, enclosing an arrangement of drawers inlaid with ivory letters of the alphabet, above a panel of blind fret carving and a crenellated molding, the downswept chamfered legs with flowerhead and leaf carved column upon a rose and ribbon carved molded plinth.

Typical of Grand Tour souvenirs at the time of the Ninth Earl were collections of plaster moldings of Renaissance and earlier (and, often, later) coins, seals, and medals. These were produced in various places in Italy and were complete with manuscript inventories of the subject matter of the intaglios.

Mayhew & Ince can confidently be identified, on stylistic grounds, as the maker of these two small cabinets on stands.

Chair from a suite of George III chapel furniture

Mayhew & Ince
England
1768

Mahogany
h. 105, w. 64.5, d. 53.3 cm
(h. 41⅜, w. 25⅜, d. 21 in.)
FUR0355

The suite comprising eight armchairs and five chair-back benches, the gothic arched backs centered by a cabochon and carved with acanthus leaves centered by a quatrefoil molded and incorporating a gothic arch centered by an acanthus spray and a trail of husks, the outset scrolled arms filled with a quatrefoil and with blind fret decorated scrolled supports to a molded seat, the seat rail with plain quatrefoils on square-cut legs with blind fret gothic decoration and block feet.

In a memorandum by the Ninth Earl for Lady Elizabeth Chaplin concerning the running of Burghley House while he was abroad during 1768, the following entry refers to the suite of furniture to which this chair belongs: *Item 41… Lady Betty will remember to hasten Mr Mayhew in the furniture which I have ordered him to make for the chapel at Burghley.*

Although the bill for this suite does not survive, this is further confirmation of the employment of Mayhew & Ince at Burghley after the itemized bill of April 1768.

George III commode

Mayhew & Ince
England
ca. 1770

Various woods
with ormolu mounts
h. 90, w. 110, d. 62 cm
(h. 35⅜, w. 43¼, d. 24⅜ in.)
FUR0472

The rectangular top
centered by a circular panel
of burr-yew wood on a
rosewood ground banded in
satinwood and within cast
brass molded border, the
frieze inlaid with brass ovals
on a purpleheart-wood
ground above three long
drawers veneered with
rosewood with burr-yew
wood spandrels banded in
purpleheart, boxwood, and
satinwood and with gilt-
brass chased handles, the
sides, ormolu-mounted
with rams' heads, swags,
leaves, and beads and
on hoof sabots.

Hayward and Till are
surely correct in their
firm attribution of this
grand commode to
Mayhew & Ince, for it
shares the same brass
guilloche ornament
in the frieze as the two
commodes and corner
cupboards made up
from *old inlaid work* by
them (see fig. 26, p. 54).

*Literature: Hayward and Till
1973, 1606.*

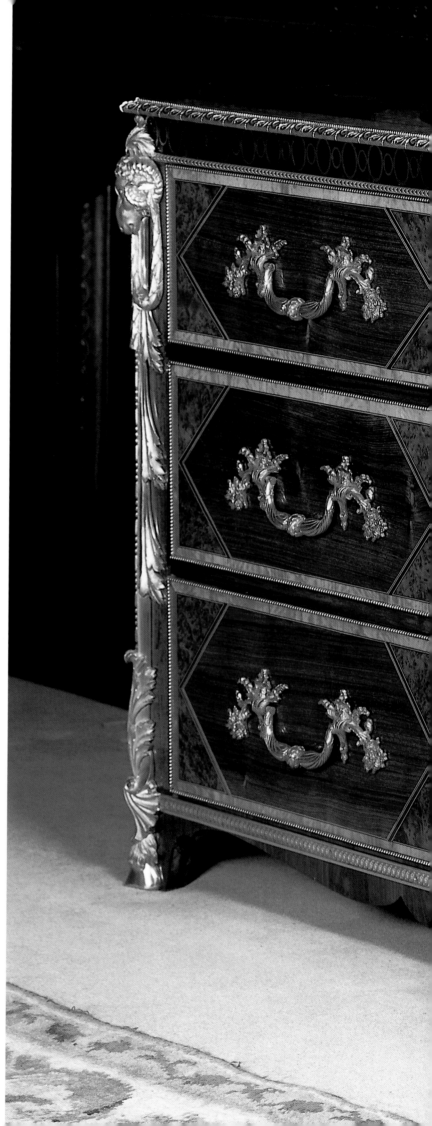

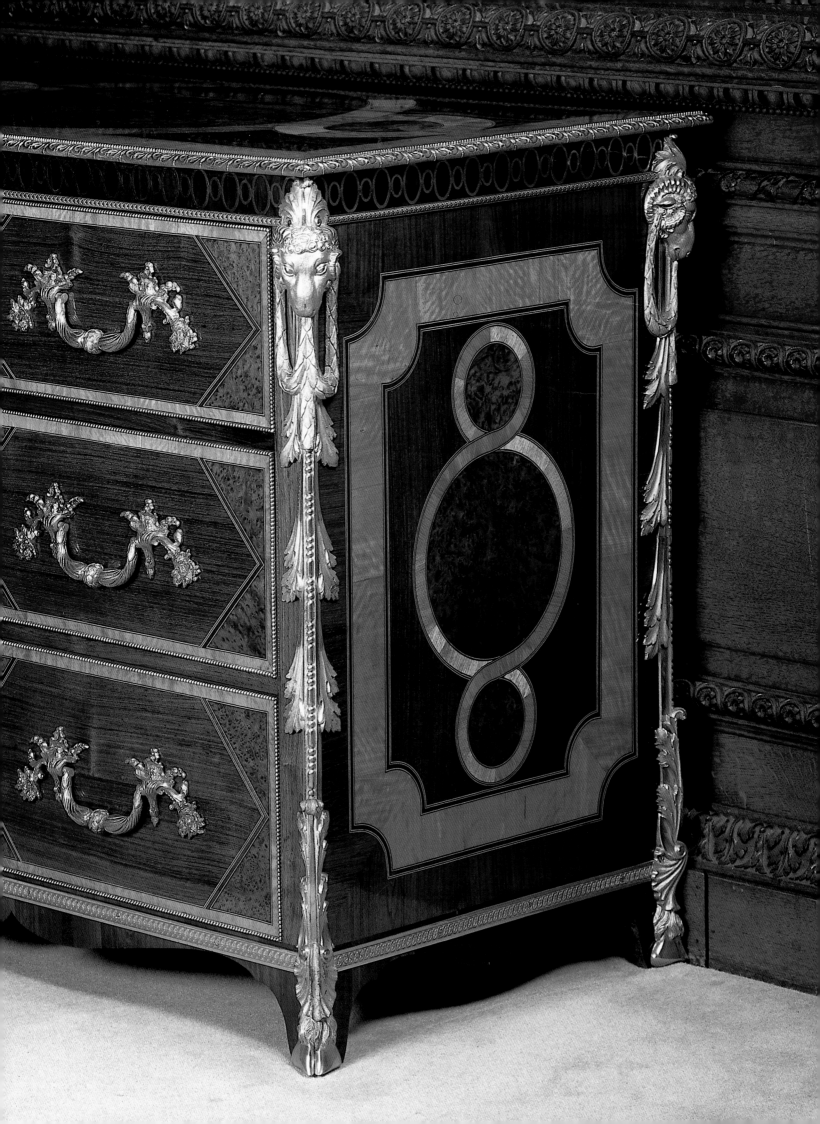

The Grape Harvest (one of the Bacchanals or Naked Boyes tapestries)

Mortlake, after Giulio Romano
Possibly before 1678

Wool tapestry
h. 407, w. 427 cm
(h. 13 ft. 4 in., w. 14 ft.)

Mortlake shield mark
lower right
TAP03026

A vine-clad arbor with a central group of two boys and another crawling between them, other children clambering in the vines above, to the right two kneeling children with a basket of grapes, another carrying a basket on his head, and a fourth with a long-handled fork, two boys by a tree to the left.

Tapestries were always among the most important, and most expensive, decorations of any great house; at Burghley in the 1688 inventory there are listed some twenty-three sets, comprising at least one hundred eight tapestries. Often rooms would be fitted with wainscoting especially for a set, which explains their relative lack of movement from room to room as tastes changed. Fashion in tapestries certainly changed and developed over the years, but even "old-fashioned" sets usually remained in use.

The derivation from Italian tapestries made after designs by Giulio Romano may have come through Brussels imitations, which, as here, omit the wings of the boys. The full Mortlake set may have been of seven tapestries, for included in the sale of the King's Goods in 1651 were seven "hangings of Arras called ye Naked Boyes" valued at the high price of £1377 (see MacGregor 1989).

Henry Baker, the business agent at Mortlake after 1668, supplied the Crown with five pieces of the "Story of the Boyes" between 1670 and 1673 at a cost of £4 the ell (the English ell was 45 inches, or about 114 cm). In November the Fifth Earl paid Mr. Baker the sum of £120, not enough for the 166½ ells of the "Naked Boys" set at Burghley, so it was probably an installment or down payment. (At £4 the ell, the total sum would have been £666.)

In 1688 there were two sets of four tapestries of this subject at Burghley. In the *Bedd Chamber next ye Gallery roomes* there hung *4 pieces of ye Boys tapestry hangings* (no maker mentioned), while in the *Wardrobe*, and hence probably rolled up, were *4 pieces of ye Best Boyes hangings, Mortlake*, almost certainly those represented here. *Best* would have been a quality judgment, and the other set may have been Flemish.

In 1738, three of the Mortlake set hung in the *blue Velvet Bedchamber*, and the fourth was still in the *Wardrobe*. In spite of the fact that all four hung in the *Great Hall* in 1804, the remarkable state of preservation of the exhibited example suggests that it was this one that was in the *Wardrobe* from at least 1688 to about 1800.

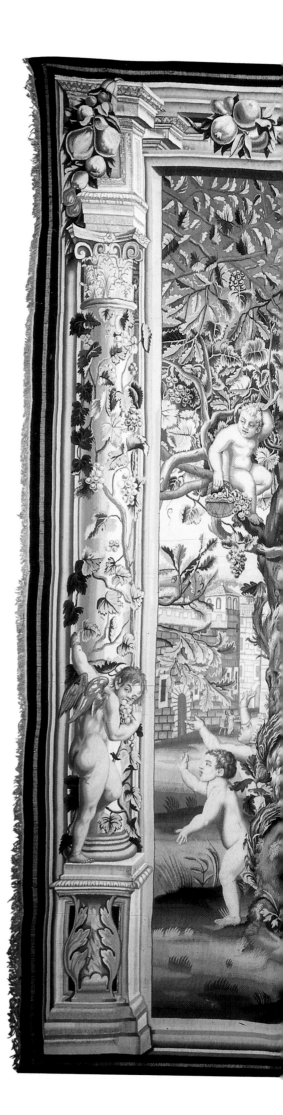

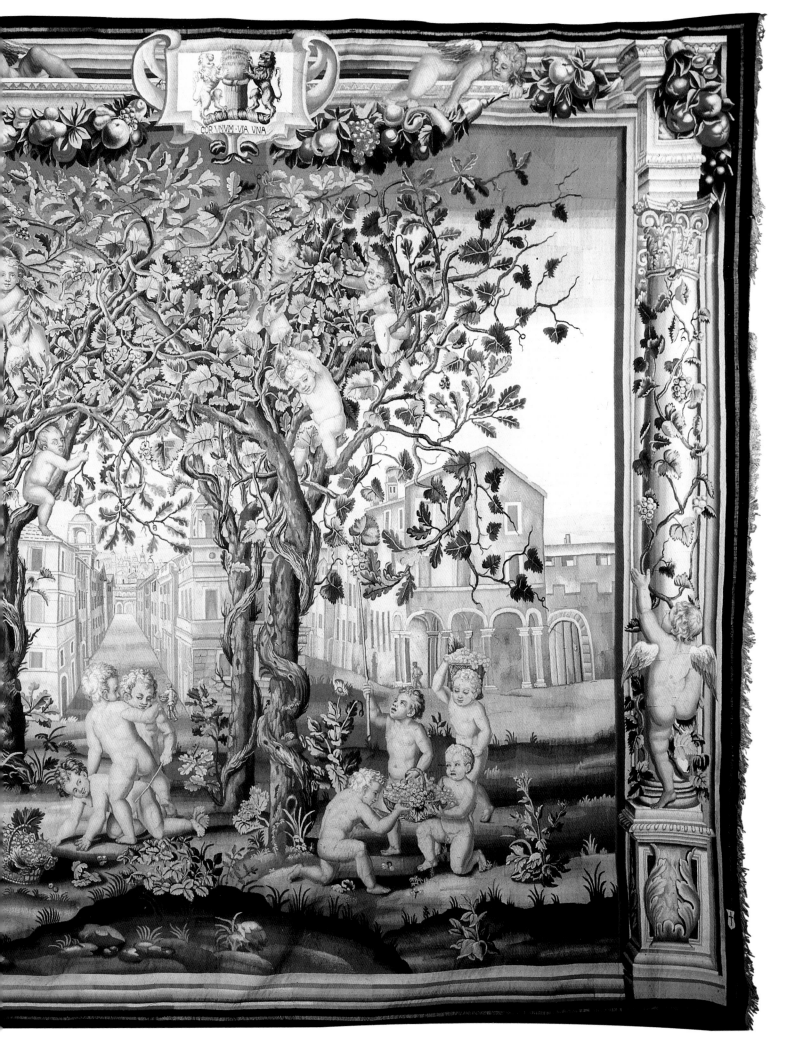

COR·VNVM·VIA·VNA·

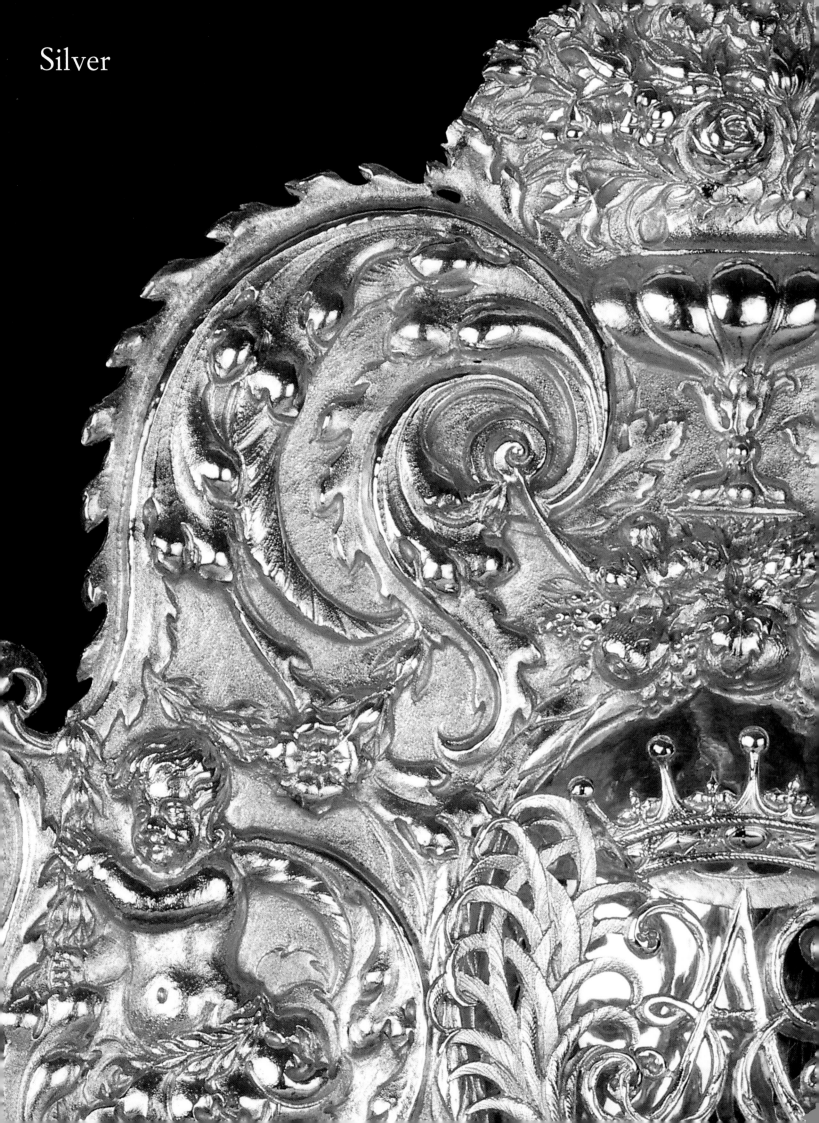

Silver

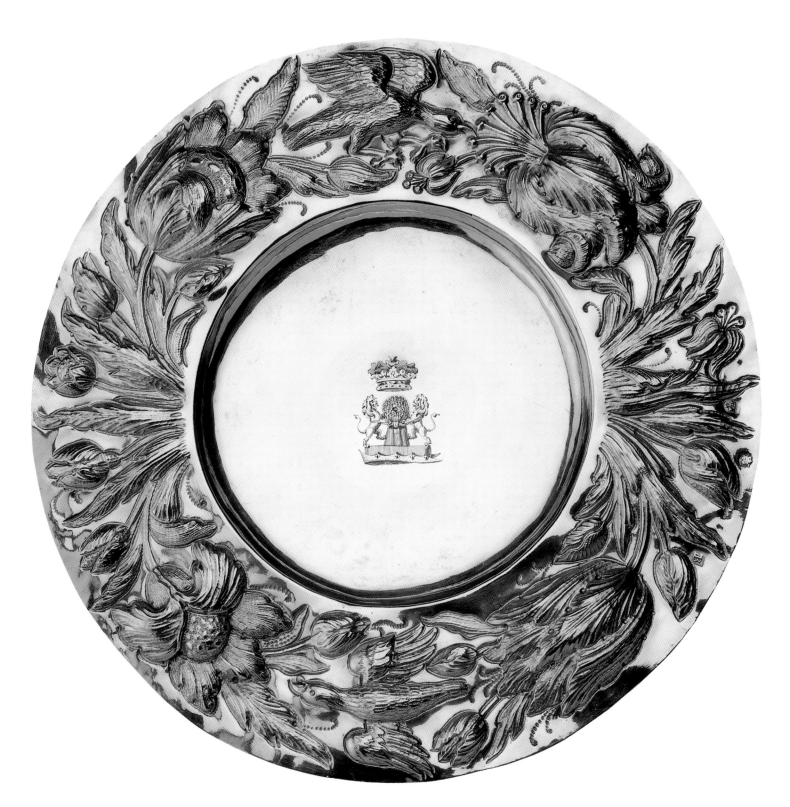

100

Commonwealth circular salver

London
1659

Silver gilt
diam. 27.9 cm (11 in.)

Maker's mark: E.T.,
a crescent below
SIL04681

On central spreading foot,
the broad border repoussé
and chased with large
flowers, foliage, and birds
and the center engraved
with a later Cecil crest
and coronet.

Exhibited: Burghley House
Silver, *1984, no. 9.*

101

Charles II ewer

London
ca. 1670

Silver gilt
h. 25.4, d. 25 cm
(h. 10, d. 9¹³⁄₁₆ in.)

Maker's mark: P. R., mullets
above and below only
SIL04745

Vase-shaped, each on circular foot chased with a border of acanthus foliage, the lower parts of the bodies repoussé and chased with acanthus and palm leaves on matted ground with a chased laurel rib above which extends around the spout. The harp-shaped handles are chased with a leaf with beaded rat-tail below, and the covers are chased with a berry finial, engraved with a coat of arms in plume mantling and crests on the covers.

The arms are those of Cecil impaling Cavendish for John, Fifth Earl of Exeter, who in 1670 married Anne, only daughter of William, Earl of Devonshire.

Exhibited: Burghley House Silver, *1984, no. 15.*

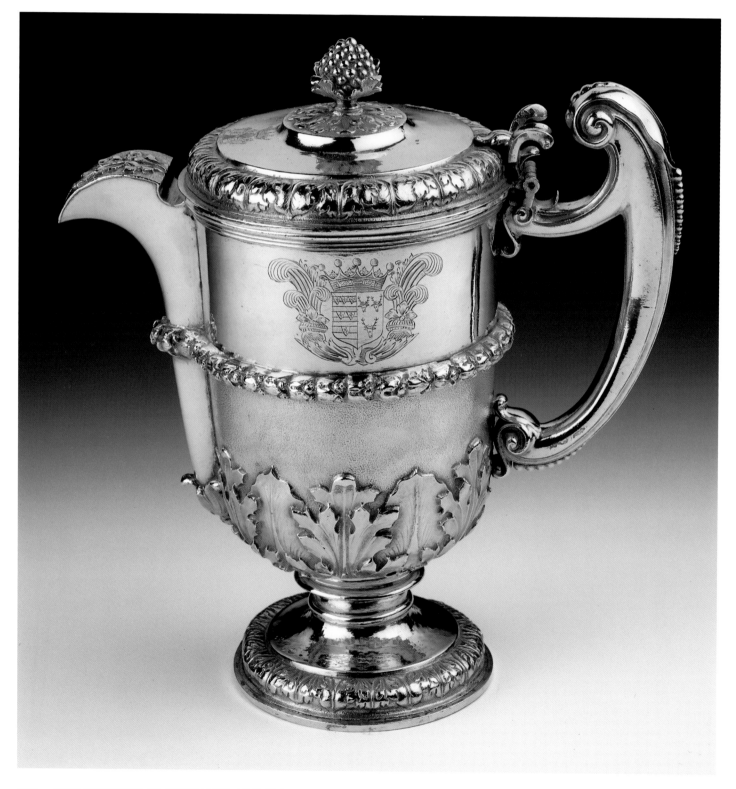

Door lock and handle

*William Partridge
England
ca. 1665*

Silver gilt
l. 13, w. 38, d. 11 cm
(h. 5⅛, w. 15, d. 4⁵⁄₁₆ in.)
SIL04642

Of oblong form, the chased silver depicting a demi-huntsman and two birds among scrolling foliage, wrigglework borders, foliate knop handle and lock. The gilt is now much worn.

The inner workings of the lock are beautifully engraved and signed "William Partridge Fecit." Astonishing care has been given to the inner workings, which would never be seen, perhaps an indication of a craftsman's pride in his work.

The 1738 inventory records *Lady Exeter's Dressing room. . .the Lock silver carved.*

Provenance: Elizabeth, Countess of Devonshire, née Cecil, her will, proved 13th November 1690, listed as a guilt lock and key, *by whom given to her daughter Anne, Countess of Exeter.*

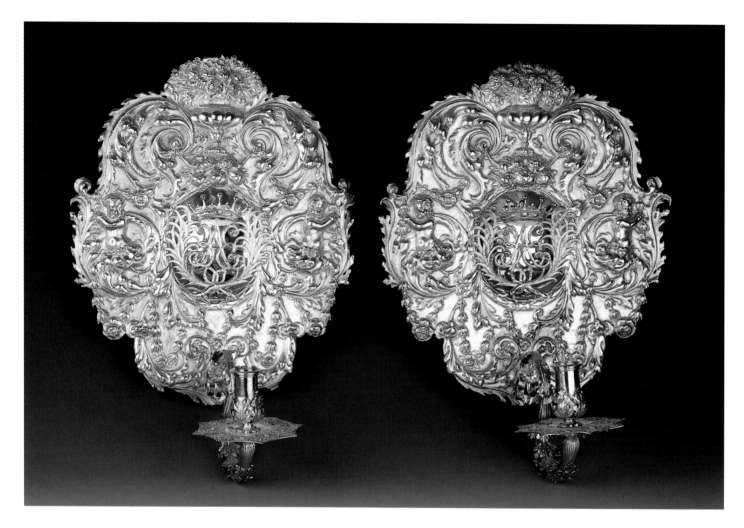

103 A & B

Two Charles II sconces

Unmarked, perhaps Wolfgang Howzer England ca. 1675

Silver
h. 35.6, w. 31, d. 21 cm
(h. 14, w. 12³⁄₁₆, d. 8¼ in.)
SIL04934

From a set of four. Each with single scroll branch decorated with applied acanthus foliage with octagonal wax pans chased with shells and sockets rising from acanthus leaves, the back plates shaped in cartouche form, repoussé and chased with demi-figures of *amorini* at the sides, husks and scrolling foliage on matted ground, and a vase of flowers at the top. The centers have a pierced and applied cipher, *EAE*, and earl's coronet in crossed palms. The monogram is that of Anne, Countess of Exeter, wife of the Fifth Earl.

In 1738 it was probably these sconces that hung *upon the hangings*, that is, over the tapestries, in the *North Drawing Room*.

Wolfgang Howzer (fl.1652–1688) was a Swiss goldsmith active in England after 1657. As Embosser in Ordinary to King Charles II, he was employed directly by the Crown, often working for the Jewel House, but he was also allowed to take private commissions.

Exhibited: Burghley House Silver, *1984, no. 35;* Treasure Houses of Britain, *1985, no. 95.*

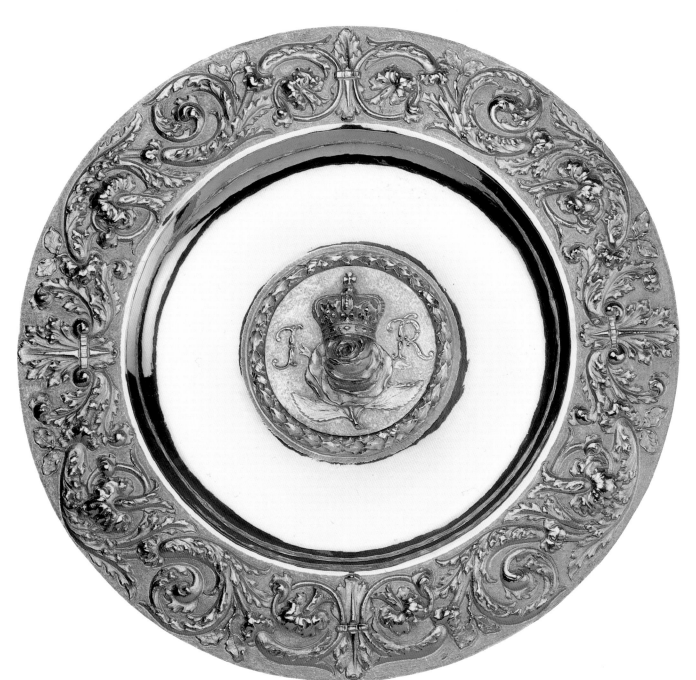

104

Circular sideboard dish

Francis Leake
London
1683

Silver gilt
diam. 58.4 cm (23 in.)

Maker's mark: F. L.,
a bird below
SIL04924

One of a pair, the centers
repoussé and chased with
the royal crown and rose
flanked by the initials *J. R.*
for James II, on matted
ground in laurel wreath
border, the flat rim chased
with scrolling acanthus
foliage and flowers on a
matted ground, the backs
applied with later hanging
loops by R. Garrard, 1874.

The Earls of Exeter are
the hereditary Grand
Almoners of England,
and the house still
contains several pieces
of silver gilt (see, for
example, cat. nos. 108,
109) that were provided
for their use at the
ceremony of the
coronation and were
thereafter their property
as perquisites of the
appointment. In the
Lord Chamberlain's
accounts of 1685, there
occurs the following
reference to these dishes,
which explains the
context: *May ye 13, 1685.*
Deliver'd to ye Earl of
Exeter as Chief Almoner
at his Majs. Coronation
two gilt chas'd basons for
his fees. pair 312.0.0.

James, Duke of York,
succeeded his brother
Charles II in February
1685 and was crowned
on April 23. The dishes
were probably in stock
in the Jewel House, and
only the central bosses
had to be chased and
applied for the
coronation.

The Grand Almoner
was originally the
distributor of the King's
alms. The office was
held by the Earls of
Exeter until the
coronation of
William IV, when the
office was dispensed
with. As Grand
Almoners, they were
entitled to a silver basin
(or two), a fine cloth in
which to wrap the
money to be distributed,
the right to provide (no
doubt at a handsome
profit) textile coverings
for the floors of the
pavements, hall, and
chamber of the King,
and a tun of wine.

Francis Leake was
made free of the
Goldsmiths' Company
in 1655. It has been sug-
gested (Oman 1970, 29)

that Leake may not
have made these dishes,
but may merely have
allowed some "for-
eigner" to use his mark.

Exhibited: Burghley
House Silver, *1984, no. 10;*
Treasure Houses of Britain,
1985, no. 114.

Ornaments of silver flowers in gilt metal vase

Flowers: Italy, 17th century
Vases: England, 18th century

Silver and gilt-metal
h. 45.7, diam. 32 cm
(h. 18, diam. 12⁹⁄₁₆)
SIL05019

A pair of table decorations (one illustrated here), the silver flowers probably Italian, late seventeenth century, the vases English, third quarter eighteenth century, the flowers realistically formed from sheet and wire as roses, poppies, and other blooms.

In 1688, in *Lady Exeter's closet* were *2 silver flower spriggs, from Milan by. . . .*

Exhibited: Blomster fra Sans og Samling, *1990.*

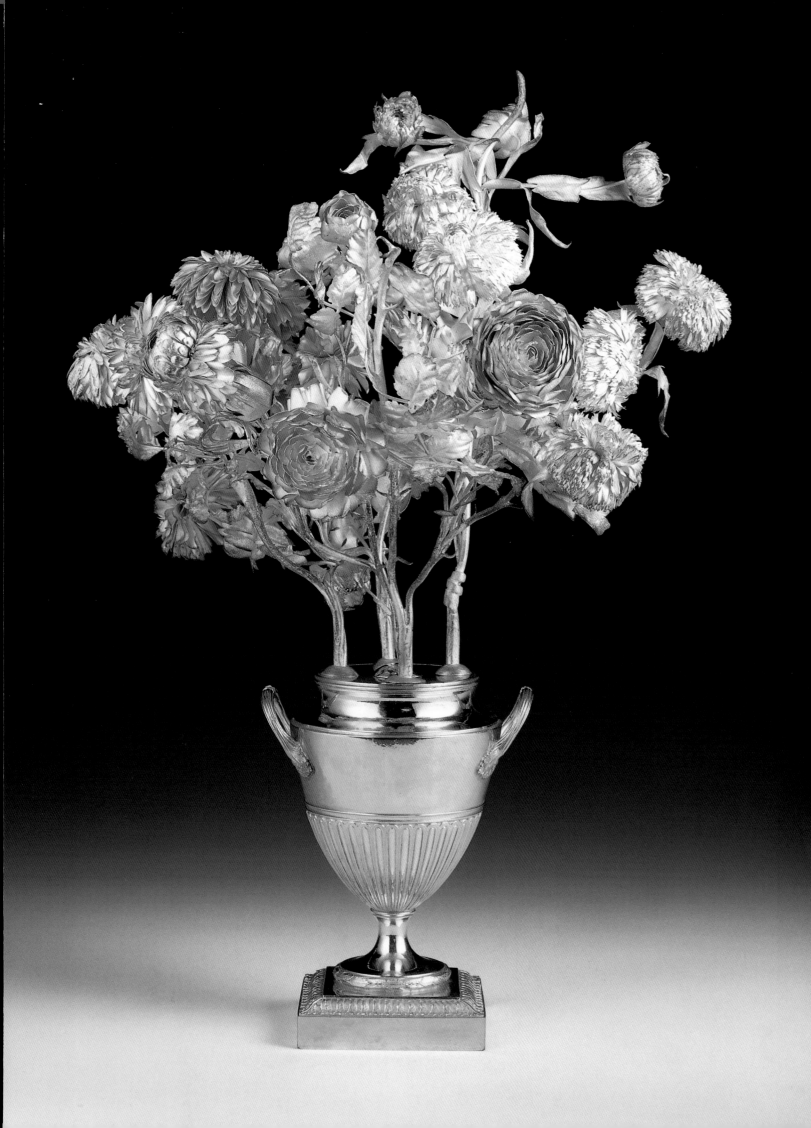

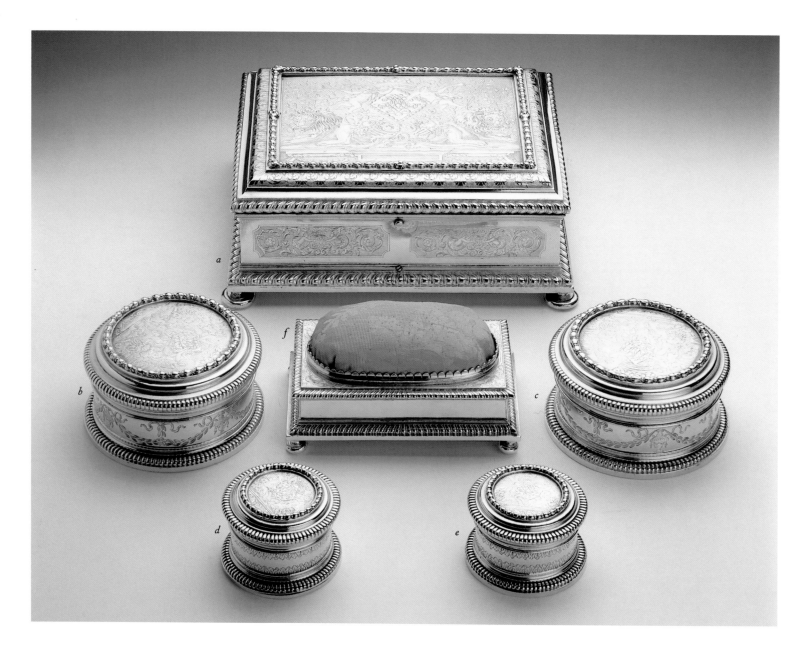

106A

Comb box, from a William III toilet service

Pierre Harache II
London
1695

Silver gilt
h. 10, w. 26.7, d. 21 cm
(h. 3¹⁵⁄₁₆, w. 10½, d. 8¼ in.)
SILO4533

A large oblong comb box on stud feet, the top finely engraved with coroneted cipher supported by trumpeting amorini with two recumbent lions and cornucopiae below, the sides engraved with panels of amorini and amatory trophies on hatched ground.

106B&C

Pair of circular boxes, from a William III toilet service

Pierre Harache II
London
1695

Silver gilt
h. 6.5, diam. 12.7
(h. 2⁹⁄₁₆, diam. 5 in.)
SILO4533

A pair of circular boxes with gadrooned borders, the tops similarly engraved with a group of amorini and lions supporting a cipher and coronet in an applied husk border, the sides engraved with vases and husks.

106D&E

Pair of circular boxes, from a William III toilet service

Pierre Harache II
London
1695

Silver gilt
h. 5, diam. 7.6
(h. 1¹⁵⁄₁₆, diam. 3 in.)
SILO4533

A pair of smaller circular boxes.

106F

Oblong pincushion, from a William III toilet service

Pierre Harache II
London
1695

Silver gilt
h. 7, w. 16.5, d. 8.5 cm
(h. 2¼, w. 6½, d. 3⅜ in.)
SILO4533

An oblong pin cushion on stud feet with gadrooned borders, the spandrels to the oval cushion engraved with scrolling foliage.

It was not unusual for toilet services of this date to comprise thirty or more pieces, and this was certainly true of the present Harache service. Some nineteen pieces from the service were sold by Brownlow, the Fourth Marquess, in a sale at Christie, Manson, and Wood on Thursday, June 7, 1888.

Pierre Harache I (c. 1630–1700) came from a Rouen family of silversmiths. He came to London in 1682, where he was the first Huguenot to be admitted to the Goldsmiths' Company.

Harache was one of the many Huguenot silversmiths of French origin who fled their native land around the time of the revocation of the Edict of Nantes (1685) and the ensuing religious persecutions. The style imported by these artisans is evident in these objects: sober yet majestic neo-classicism, the fashion in vogue at the court of Louis XIV, the Sun King. The focus was on solid architectural forms decorated in the ancient manner, giving less importance to the naturalism of the European Baroque of those years.

This service is here attributed to Pierre Harache II (1653–ca. 1717). He is thought to have been the son of Pierre Harache I, but there is no firm evidence. He became a legal resident in 1698 and was free of the Goldsmiths' Company later that year. This service is stamped with the mark usually attributed to him with the date letter 1695; this presents no problem, for he was already forty-two years old and presumably had been practicing his trade for some years before that date, without observing the letter of the law, a not uncommon practice. At this time the Goldsmiths' Company was having to decide upon the status of many immigrant silversmiths, and upon its own reaction to them. There has been some confusion over the identity of the Harache family, and the work of the two Pierres is not always easily identified.

The engraving on this service is of the finest quality for the Huguenot period, which is renowned for quality engraving and the renaissance of engraved decoration other than that of a heraldic nature on English plate. Recent study by the late Charles Oman has led to the attribution of the engraving to an unknown figure whom Oman christened the "Master of George Vertue." This master was mentioned by Walpole in his notes on George Vertue, recording that the latter (b. ca. 1684) "about the age of thirteen was placed with a master who engraved arms on plate and had the chief business in London, but who being extravagant, broke, and returned to his own country, France, after Vertue had served him between three and four years" (Walpole 1786).

This acknowledgment of the master's dominance of silver engraving in London prior to his departure around 1700, and certain stylistic considerations, make this tentative attribution more credible than the earlier to Gribelin, who as a well-documented post–1700 silver engraver has often had earlier work attributed to him, or to Blaise Gentot (Oman 1978).

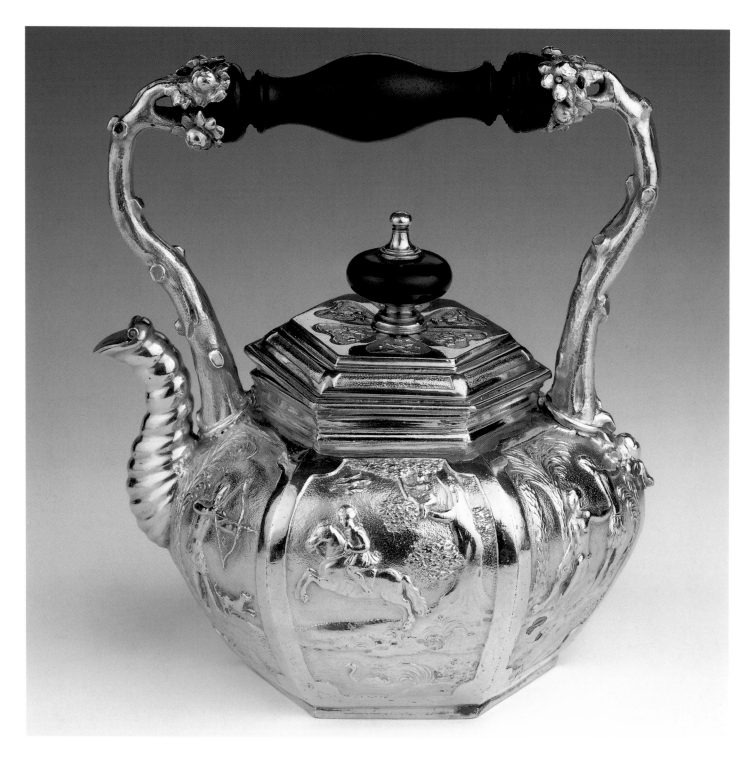

107

William III
hexagonal teapot

Pierre Harache
London
1695

Silver gilt
h. 29, diam. 17.5 cm
(h. 11⅜, diam. 6⅞ in.)
SIL04713

Cast and chased with panels
of American Indians, some
on horseback hunting,
others with bows and
arrows, with ribbed curved
spout with hinged flap and
fixed handle formed as tree
trunks, with a detachable
cover chased with panels
of birds and flowers in the
Chinese taste.

The *chinoiserie* effect,
albeit in detail North
American, is
emphasized by the
dependence of the
shape on Chinese *blanc
de Chine* originals.

Exhibited: Burghley House
Silver, *1984, no. 17;* Courts
and Colonies, *1987.*

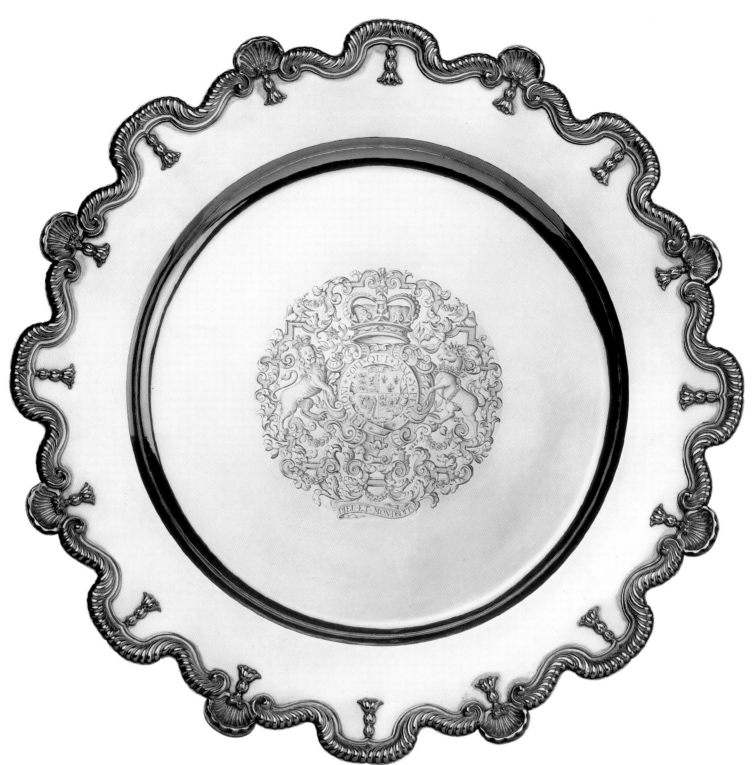

108

Queen Anne circular sideboard dish

*Pierre Harache
London
1702*

Silver gilt
diam. 66 cm (26 in.)
SIL04925

The center finely engraved with the royal arms of George I or II in a baroque cartouche of scrolls and foliage with birds at the top, with boldly scrolling rim chased with gadrooning, shells, and pendant foliage.

The royal arms and date of this piece would at first suggest that it is the Almoner's dish presented to John, Sixth Earl of Exeter, at the coronation of Queen Anne, April 22, 1702. However, the Sixth Earl was Chief Butler and not High Lord Almoner at this Coronation, and the dish itself differs from the other

Almoner's dishes at Burghley in that the relevant royal cipher is absent. The attribution of this dish as the Queen Anne Almoner's dish is further confused by the existence at Burghley of a seventeenth-century silver-gilt dish by George Garthorne, ca. 1690, which is later engraved with the royal arms and cipher *AR*.

This sideboard dish is the same as another made by Harache in 1697 together with a ewer for William, First Duke of Devonshire, and engraved in the center with the Cavendish arms, now in the British Museum.

Exhibited: Burghley House Silver, *1984, no. 14.*

George II
helmet-shaped ewer

Benjamin Pyne
London
1727

Silver gilt
h. 39.3, w. 27.5, diam.
13.5 cm at base (h. 15½,
w. 10¹³⁄₁₆, diam. 5⁵⁄₁₆ in.)
SIL04747

The body applied with a
molded angular girdle part
leaf wrapped and rosette
applied below a shaped rim,
engraved with the royal
arms of George II above
alternate shell, scroll, and
acanthus leaf straps on
matted grounds on the
lower body, the knopped
spreading circular base
featuring further straps and
a band of husk and
flowerhead lattice between
molded borders, with large
leaf-capped flying scroll
handle.

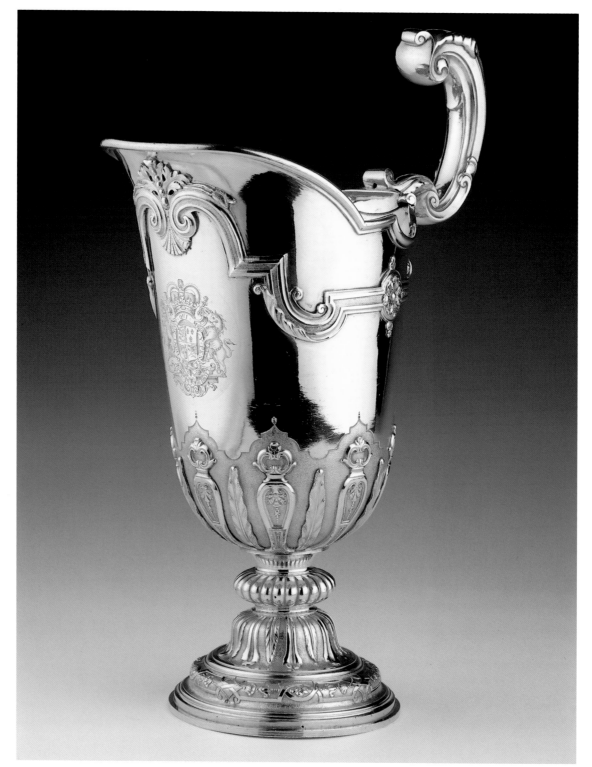

The royal arms and date
of this ewer make it
probable that it was the
Almoner's fee received
by Brownlow, Eighth
Earl of Exeter, who was
Lord High Almoner at
the coronation of
George II, October 11,
1727. The absence of an
Almoner's dish, or any
apparent record of it for
this coronation, would

seem to confirm this
possibility.
 Benjamin Pyne (ca.
1653–1732) was the
leading goldsmith of his
time. He was Prime
Warden of the
Goldsmiths' Company
in 1725 and was
Subordinate Goldsmith
to the King at the time
of the coronation of
King George I in 1714.

Exhibited: Burghley House
Silver, *1984, no. 33;*
Treasure Houses of Britain,
1985, no. 115.

George II wine cistern and fountain

Thomas Farren
London
1728

Silver
cistern without handles:
w. 61 cm (24 in.)
fountain: h. 71.1, diam. 40
cm (h. 28, diam. 15¾ in.)
SIL04997

The cistern on oval foot chased with masks and strapwork panels of trelliswork, the body of bulbous form decorated with applied male masks and shells suspending festoons of flowers with a band of shells and strapwork on matted ground below, the handles formed as demi-lions with front paws resting on bars and the rim decorated with applied masks and shells on matted ground. The fountain of baluster vase form on circular foot similarly chased to that of the cistern, the body decorated with strapwork on the lowest section with baroque cartouches of masks above and festoons of fruit and shells on the upper section with lion's mask and pendant ring handles and incurved neck, the domed cover chased with strapwork and with pineapple finial, the top chased with a dolphin's mask emerging from a larger dolphin, and the spigot with dolphin handle, each engraved with a coat of arms.

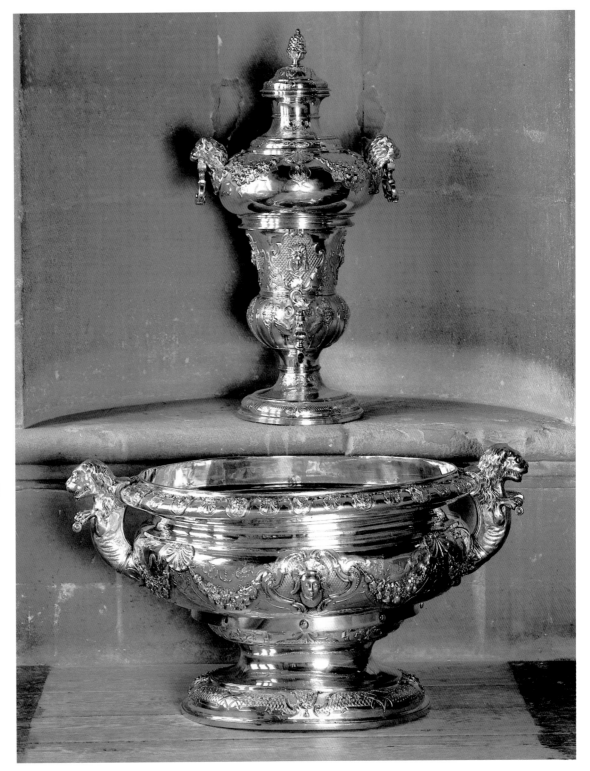

The arms are those of Cecil with Chambers in pretense for Brownlow, Eighth Earl of Exeter, who on July 18, 1724, married Hannah Sophia, daughter and co-heir of Thomas Chambers, a London merchant.

Thomas Farren, otherwise Farrar or Farrer, was apprenticed in 1695 in London. He was appointed Subordinate Goldsmith to the King 1723–1742. The present piece is his best-known work.

This set can clearly be seen in an engraving by Lady Sophia Cecil of 1818 in the South Dining Room (see fig. 9, p. 22).

Exhibited: Loan Exhibition, *1929, nos. 406, 407;* Burghley House Silver, *1984, no. 54;* Treasure Houses of Britain, *1985, no. 119.*

Shaped oblong snuffers or pen tray

Philip Syng Jr.
Philadelphia, Pennsylvania
Mid-18th century

Silver
h. 4.5, w. 19, d. 8 cm
(h. 1¾, w. 7⁷⁄₁₆, d. 3⅛ in.)

Maker's mark: PS struck
twice and an incuse sprig
mark between
SIL04560

The tray of a waisted shape
with a heavy rocaille
border, of shaped oblong
form with plain center
engraved with the crest of
Hamilton, applied border
of cast and chased leafy
scrolls and rocaille motifs,
the flying scroll handle and
four volute feet similarly
decorated. The Hamilton
crest refers to the Dowager
Duchess of Hamilton who
was the third wife of Henry,
First Marquess of Exeter.

Philip Syng Jr. (b.
1703), son of an Irish
silversmith who emi-
grated to America, was
active in Philadelphia
from the 1720s, having
spent nearly a year in
England. He is perhaps
best known as the
maker of the inkstand
used for the signing
of the Declaration
of Independence.

George II two-handled cup and cover

Frederick Kandler
London
1746

Silver gilt
h. 36.2, diam. 14 cm
(h. 14¼, diam. 5½ in.)
SIL04746

On circular molded foot chased with a band of vines, the body decorated with two applied panels of vines, scrolls with rococo cartouches engraved with coats of arms, the scroll handles decorated with vines and with fruit basket finial.

The arms are those of Cecil impaling Townshend for Brownlow, Ninth Earl of Exeter, who in 1749 married Letitia, daughter and heir of the Hon. Horatio Townshend.

Charles Frederick Kandler may have been of German extraction. He was active in London from about 1727 to 1760.

Exhibited: Burghley House Silver, *1984, no. 34.*

George III wine cooler

Joseph Preedy
London
1802

Silver gilt
h. 21, diam. 25.5 cm
(h. 8¼, diam. 10⅛ in.)
SIL04719

One of four, each on circular foot, the lower part of the bodies chased with acanthus foliage on matted ground and with large goats' mask handles and matted borders, engraved with the Cecil crest and coronet.

Joseph Preedy was active in London from 1765 to 1802.

Exhibited: Burghley House Silver, *1984, no. 57.*

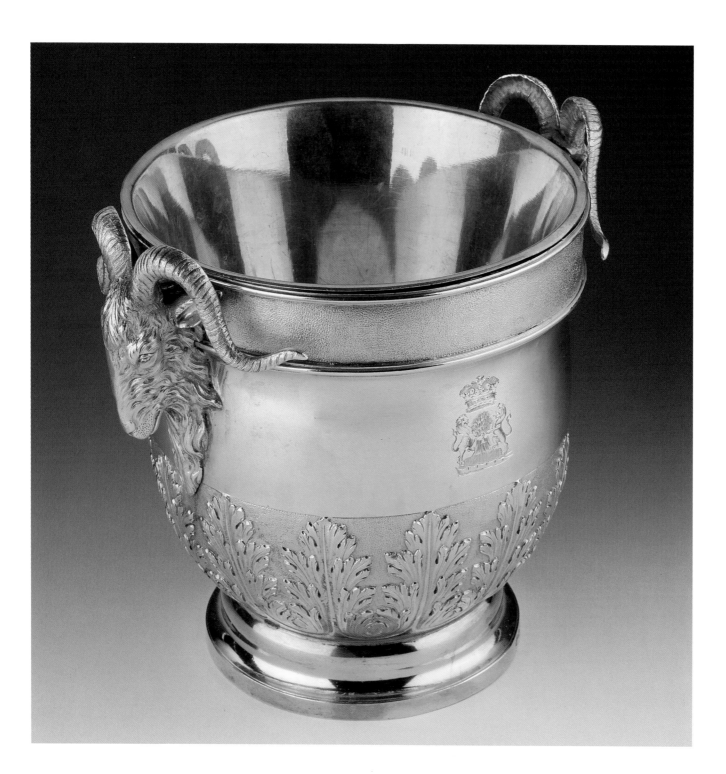

George IV trophy cup

Paul Storr
London
1823

Silver gilt
h. 28.6, diam. 25 cm
(h. 11¼, diam. 9⅞ in.)
SIL04671

Of campana form on circular foot chased with bands of ivy and acanthus leaves, the lower part of the body with applied acanthus leaves and berries and the upper part cast and chased with vines on matted ground and with entwined tendril handles and vine rim, engraved *Stamford Races 1824. . . , Won by Zealot 4 years old*. The Stamford Gold Cup, 1824, valued at 100 guineas, was held June 30.

This and the following two objects (cat. nos. 115, 116) are race trophies dating from the time of Brownlow, Ninth Earl of Exeter. These cups represent a modest selection of the many triumphs brought by his lifelong passion for horse racing, which also entailed enormous expense and the consequent encumbrance of his estates.

Paul Storr (1771–1844) was one of the greatest silversmiths of his age. He was in partnership with Rundell, Bridge, and Rundell from 1807 to 1819. In 1797 he was appointed Goldsmith and Jeweler to the King.

Exhibited: Burghley House Silver, *1984, no. 5.*

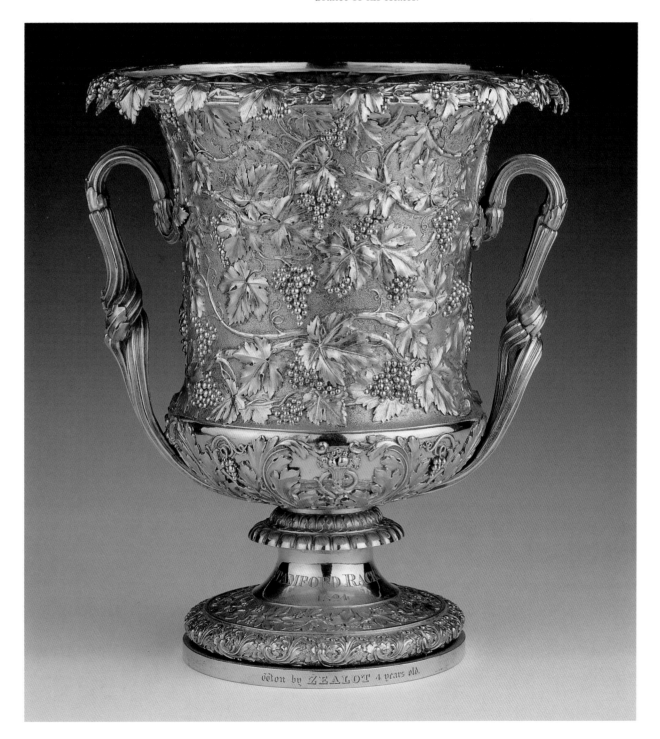

William IV trophy cup

Paul Storr
London
1831

Silver gilt
h. 26.7, diam. 30.5 cm
(h. 10½, diam. 12 in.)
SIL04673

Of Warwick vase form, on square plinth and circular foot decorated with vines, the body with applied horses' heads resting on a band of corn against the matted upper part with vine border, engraved *Brighton, Given by His Majesty 1831, Won by Mahmoud*. The Brighton Gold Cup, 1831, valued at 100 guineas, was held July 28.

Exhibited: Burghley House Silver, *1984, no. 7.*

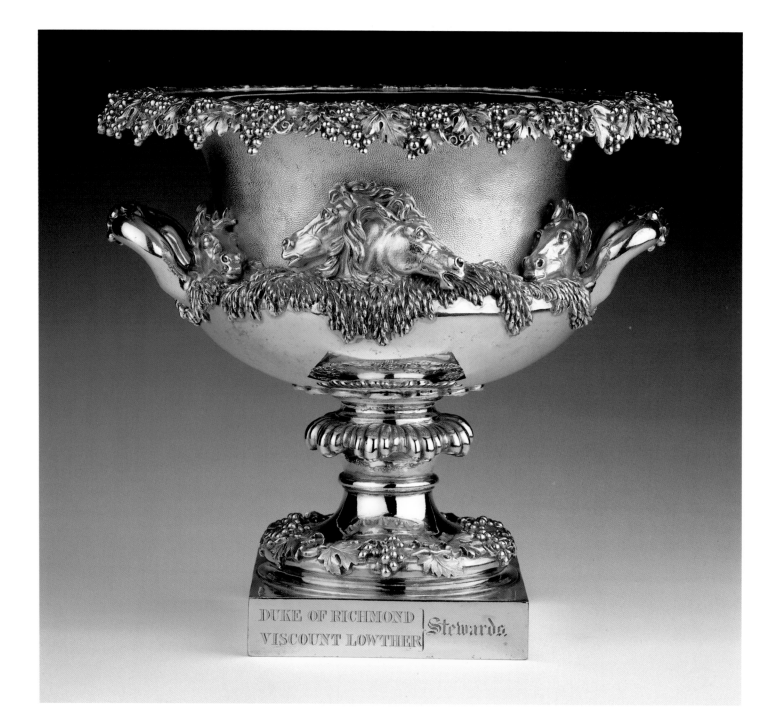

William IV trophy cup

Robert Garrard
London
1832

Silver gilt
h. 45.7, diam. 35.5 cm
(h. 18, diam. 14 in.)
SIL04675

On square plinth, the lower part of the body decorated with applied acanthus foliage and flowers with two groups of racehorses above and scroll foliage handles, on high square pedestal with an applied figure of a racehorse at each side, engraved on the base *R & S Garrard, Fecerunt, Panton Street, London, Ascot Heath Races 1833. . ., Won by the Marquess of Exeter's Galata 4 years old, by Sultan.*" The Ascot Heath, Windsor Forest Stakes, 1833, was held June 21.

The firm of Garrards was appointed Goldsmiths and Jewelers to the King in 1830 and have retained the appointment to the present.

Exhibited: Royal Goldsmiths: The Garrard Heritage, *1991, no. 31;* Burghley House Silver, *1984, no. 6.*

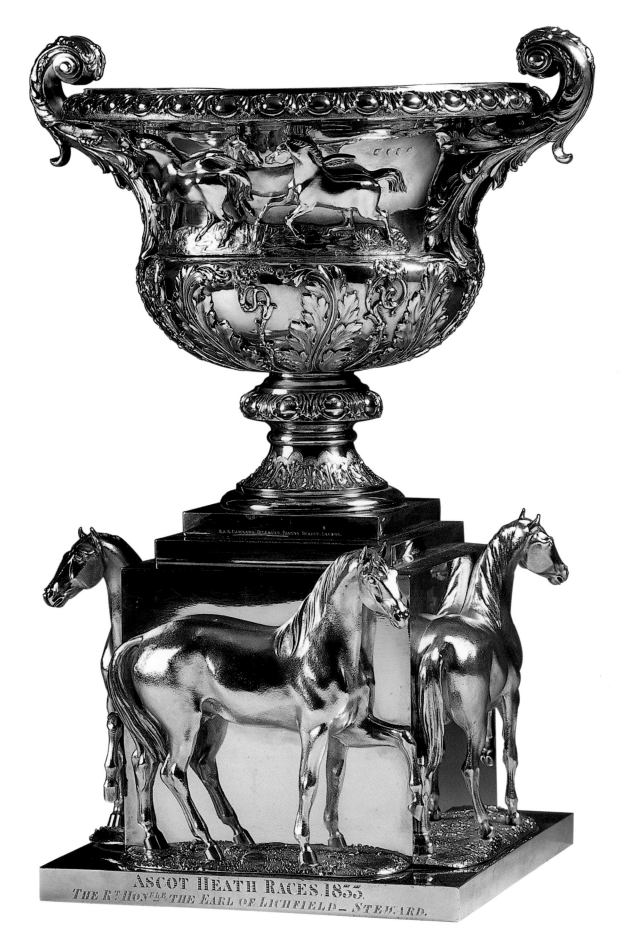

Glossary

anteroom or antechamber. A room through which one passed to a more important room beyond; often an entry room; the most public room in the suite comprising an apartment.

apartment. In a country house, a self-contained suite of rooms occupied by a member of the gentry. Known as lodgings in the sixteenth century, the suite became known as an apartment in the seventeenth century and included a bedchamber and other rooms for private use, such as an antechamber and a closet or cabinet.

barrel vault. The simplest form of vault. It springs from parallel walls and is semicircular in cross-section, uninterrupted by ribs along its length. Thick walls are necessary to support its weight.

Bergier chair. Antiquated spelling of *bergère*; the French name for a type of upholstered armchair. It has a wide seat, and its distinguishing characteristic is a section of upholstery extending from the arm to the seat, thereby enclosing the area under the arms.

Brussell carpet. A Brussels carpet, a type of looped pile carpet manufactured in Brussels, Belgium. They were also woven at Kidderminster, England, where they were made on Jacquard looms.

Buhl. Alternative spelling of *Boulle.* A type of elaborate marquetry made of metal (usually brass) and tortoiseshell or ebony. The technique originated in Italy but was perfected by *ébéniste* André-Charles Boulle (1642–1732). In fabrication, sheets of the two materials are glued together, cut in elaborate designs, and the pieces assembled. A tortoiseshell ground inlaid with brass is called "first part"; brass ground inlaid with tortoiseshell is "counter part." Frequently the brass was engraved. Craftsmen using this technique sometimes used pewter or copper and added inlaid pieces of colored horn, or mother-of-pearl to create a richer effect.

chintz. A type of cotton fabric painted or printed in colorful patterns and usually exhibiting a glazed surface. Chintz was imported from India from the sixteenth century onward, and Europeans made imitations from the late seventeenth century. It was extremely popular as a furnishing and clothing fabric in the eighteenth century. Sometimes imported as a *palampore.*

close stool. A piece of furniture resembling a small cupboard used to enclose a chamber pot.

closet. A small room in an apartment, used for various purposes at different periods and according to the wishes of the owner. It was one of the most private rooms in the house; in the seventeenth century, sometimes valuable objects or those especially esteemed by the owner might be kept there. These small rooms were sometimes called *cabinets* in the French manner, especially if elaborately furnished.

Coade-stone. A type of high-fired stoneware body used to imitate stone and often used for architectural detail or statuary. It was manufactured by Mrs. Eleanor Coade and her successors at Lambeth in London from 1768 to 1843.
commode. A chest of drawers or low cupboard. In English the term often designates a decorated chest of drawers in a French style.

cornice. Decorative molding at the top of a wall where it joins the ceiling.

coromandel lacquer. Name of unknown origin given to a type of Chinese lacquering on a solid wood base, where the colors are filled into depressions cut into the lacquered wood base. In the seventeenth century, it was often referred to as *hollow burnt japan.*

coved. A concave molding in a space above a cornice and below the flat ceiling.

cuivre d'or. Gilt copper alloy.

damask. A durable, lustrous fabric usually of a single color, whose reversible pattern is created in the weaving; usually made from linen, silk, wool, or cotton. Originally used for table linens, the damask weave was later used to make furnishing and clothing fabrics.

Delph. Antiquated spelling of "delft." Tin-glazed earthenware. As great quantities of this type of pottery were made in Delft, Holland, and exported to Britain and America in the late seventeenth and eighteenth centuries, "delft" passed into common parlance as a popular and very general term to identify tin-glazed earthenware regardless of the place of manufacture. Tin-glazed earthenware was produced in Britain and in other European countries as well as in Holland.

double hammer-beam roof. A method of roof construction whereby two sets of superimposed horizontal elements projecting from the wall or upright timbers support vertical elements, even though they do not extend across the entire space to meet the other wall.

dressing room. A small room in an apartment used as a place in which to dress and groom. In grand houses, there was often one for the husband and one for the wife.

drugget. Any hard-wearing fabric used either as a temporary cover for a carpet to prevent wear or as a surround to a carpet.

Easie chair. An easy chair; an upholstered armchair with a high back, a cushion, and sides protruding at right angles to the back, deeper at head height to protect from drafts. Except for the legs, the entire frame is covered with upholstery, including the ample rolled arms and the area between the arms and the seat.

ell. A unit of measurement of length varying in different countries; the English ell is 45 inches.

entailment or entail. Legal restrictions placed on land to assure that estates would pass intact from generation to generation through a specific line and prevent land from being sold, mortgaged, or divided.

foot-carpet. A carpet for the floor as opposed to one placed on a piece of furniture.

garniture. A set of decorative objects for a mantel, often consisting of two to five pottery or porcelain vases; other objects, sometimes in silver, were also used. By the late eighteenth century, a garniture was more commonly composed of a clock with matching candlesticks.

girandole. A candelabrum. The term also sometimes refers to sconces.

Gobelins. This term refers, according to the context, either to the *Manufacture des Gobelins* or specifically to the tapestry factory of that name. The *Manufacture royale des meubles de la Couronne*, commonly called the *Manufacture des Gobelins*, was set up in 1663 by Jean-Baptiste Colbert for Louis XIV of France for the production of all manner of furnishings for the royal palaces. It was disbanded in 1694. The tapestry factory in the suburbs of Paris was originally a scarlet dyeing workshop but became a tapestry workshop by 1607. It was taken over by Colbert for the king in 1662. It also closed in 1694 but reopened in 1699. The tapestry workshop was the most important one in France in the late seventeenth and the eighteenth century.

Gouty wheel chair. A wheelchair for an invalid suffering from gout in which the person's legs can be supported almost horizontally.

Grand Tour. An extended trip taken to the Continent by young Englishmen, ostensibly for educational purposes but also for pleasure. Italy and France were the most popular destinations, but Holland, Germany, and the Low Countries might also be included. The Grand Tour reached the height of popularity in the last half of the eighteenth century.

grotto. An ornamental room or garden building usually made of rough stone or seashells to suggest a cave.

gueridon. A candlestand or a small, often circular, table used to hold a lighting device.

Jacobite. An adherent to the cause of King James II of England after his abdication, or of his son the Young Pretender.

japanning. Imitations of imported oriental lacquer made in Europe or America, using a variety of recipes of varnishes not based on the substance lacquer itself. Perhaps the best known are the varieties made by the Martin brothers of Paris, *vernis martin*.

long gallery. A long room in a country house used for exercise in inclement weather. Evolving from earlier architectural features, the long gallery was characteristic of grand Elizabethan and Jacobean houses. It had a high ceiling and became a place in which to hang portraits.

majolica. Italian tin-glazed earthenware.

malachite. An opulent copper-green stone with black veins; used for decorative objects.

marquetry. Decorative veneer used on furniture and composed of pieces of wood or other appropriate material cut and assembled to form a design. The technique was introduced into France from Germany and the Low Countries in the early seventeenth century and into England slightly later. Geometric patterns are called parquetry.

Mortlake. The most important seventeenth-century tapestry factory in England. Founded in 1619, until the English Civil War (1642–1651), the quality of its tapestries was comparable to that of French and Flemish rival factories. The factory closed in 1703.

orangery. A building or a gallery in a house in which orange or other trees were grown. An orangery had large windows and often faced south for maximum heat and sun.

palampore. A painted or printed cotton fabric bedcover imported from India in the seventeenth and eighteenth centuries. *See also chintz.*

parquet. Floors of polished hardwood assembled in patterns.

patte-d'oie. A pattern of paths in a formal garden or park radiating from one point, thus resembling the foot of a goose.

pietra dure. Hard or semiprecious stones such as lapis lazuli, agate, and chalcedony. Worked with tools similar to those used to cut precious stones, in ancient Rome these materials were used to make small decorative objects. The technique was revived in the Renaissance. Mosaics of *pietra dure* were made from the sixteenth century onward and appear as tabletops or on cabinets or other decorative furniture. These groupings of different types of stone in one object are sometimes incorrectly called *pietra dura* in America and England. Large carved objects such as vases made from single types of stone were often set in elaborate metal mounts.

prodigy house. A term coined by architectural historian Sir John Summerson to describe houses built by subjects of Elizabeth I to receive her on Royal Progresses. Built to impress, these houses are distinctive in their attempt to present a new, fully developed and integrated architectural style.

roll-waggon. Porcelain vase of upright form and slightly constricted neck.

roof leads. Slabs of lead used for the portion of roof exposed to the elements, and hence the surface of an almost flat roof on which it was customary to take private walks.

saloon, salon, or salone. A central, formal room for entertaining guests. In the seventeenth century, this room took over functions of the Great Chamber and was used for dining. The dining function eventually moved into rooms dedicated to that purpose in the early eighteenth century. Although the saloon continued to be used for dining on important occasions, it took on the function of a public reception room. Later in the eighteenth century, the name most commonly was used to designate a less central room for the display of pictures or a room in which to dance.

scagliola. A material used to imitate marble and, later, *pietra dure.* It is composed of crushed selenite (a type of gypsum) set in a gesso ground. It can be colored and highly polished and is often used for interior architectural details such as columns.

Schatzkammer. A treasury in the late sixteenth or seventeenth centuries, not dissimilar to the *Wunderkammer* or cabinet of curiosities, at least in intent, but containing objects made of precious or semiprecious materials. *See also Wunderkammer.*

sconce. A wall light. A candle holder on a bracket attached to a reflective back plate attached to a wall.

secretaire. French term for a piece of furniture at which letters were written and documents stored out of view under lock and key. Often having a fall front that folds down to become a writing surface, the inside usually contains small compartments for storage.

settee bed. A sofa that could be folded out to make a bed.

Soho. A general name for tapestries made in England after the Mortlake factory closed. Only one factory actually in Soho produced tapestries of significance.

Spanish leather. Leather that might be embossed as well as painted or printed in bright, often metallic colors. The technique derived from Moorish Spain. Usually of Netherlandish origin, in the seventeenth century Spanish leather was used as wallcovering or as upholstery on chair seats and backs.

Spanish tables. Tables that were supported on hinged trestle-type legs with center supports that could be unfixed, allowing the trestles to be folded away; hence, folding tables.

table-carpet. A carpet used on a table or other piece of furniture rather than on the floor.

Tenture des Indes. Tapestries depicting oriental or supposedly oriental scenes or subjects.

triad. A set of high-quality furniture consisting of a table, mirror hung above it, and pair of candlestands on either side, forming a roughly triangular composition. Popular in the late seventeenth century, these pieces often were made of or embellished with expensive materials such as silver, lacquer, or marquetry.

toilet service. A set of matching objects used by women for grooming and for storage of cosmetics, jewelry, and small articles of dress such as gloves. Often a wedding gift from a lady's prospective husband, a set might number as many as thirty objects, including small boxes (caskets), a ewer and basin, candlesticks and a snuffer, small bottles, and a mirror. Placed on a toilet table and usually made of silver, sets were often monogrammed and elaborately decorated.

Turkey work. European imitations of Turkish and other Near Eastern carpets. Also a type of pile needlework done on canvas ground and more often used for upholstery in England and colonial America.

wainscot. Wood paneling attached to the lower part of a wall.

wardrobe. A room or series of rooms for the storage and maintenance of clothing and textiles; only later (in the eighteenth century), a piece of furniture for the storage of clothes.

water closet. A flushing lavatory (toilet).

Wilton. A looped pile carpet woven at Wilton and other places in England. It is similar to a Brussels carpet, but the pile loops are cut and the carpet contains more rows of pile per square inch, thus creating a finer product.

wine cistern. A large vessel, often of silver, used mainly for display, but ostensibly for cooling bottles of wine.

withdrawing chamber/room or *drawing room*. In the fifteenth century, a room adjacent to the Great Chamber to which the gentry might withdraw after meals or dine in private. By the end of the fifteenth century, it was often a small room in which a servant slept adjacent to the bedchamber of his master. By Elizabethan times, withdrawing rooms held a more public function for entertaining guests and were often arrayed with valued artworks. They were often still adjacent to bedrooms in the seventeenth and early eighteenth centuries, but by the mid-eighteenth century, drawing rooms were important social spaces almost wholly unattached to bedchambers. They fulfilled some of the same functions as saloons but were often less grand. According to English custom, the ladies retired to the drawing room after dinner, leaving the men in the dining room to drink and smoke.

Wunderkammer. A cabinet of curiosities; a collection of natural and "artificial" (manmade) rarities, much in vogue in the sixteenth and seventeenth centuries. *See also Schatzkammer*.

Select Bibliography

Airs, Malcolm. *The Tudor and Jacobean Country House: A Building History.* Stroud, Gloucestershire, 1995.

Astley, Sir Edward, to his wife, July 19, 1643, Melton Constable, Norfolk.

Avery, Charles. *Giambologna: The Complete Sculpture.* London, 1987.

Avery, C. Louise. "Chinese Porcelain in English Mounts." *Metropolitan Museum of Art Bulletin* 2 (May 1944): 266–72.

Ayers, John. "The Early China Trade." In *The Origins of Museums: The Cabinet of Curiosities in Sixteenth- and Seventeenth-Century Europe*, edited by Oliver Impey and Arthur MacGregor, 259–66. Oxford, 1985.

Baarsen, Reinier. *Courts and Colonies: The William and Mary Style in Holland, England, and America.* Exhibition catalogue, Cooper-Hewitt Museum. New York, 1987.

Beard, Geoffrey. *Craftsmen and Interior Decoration in England 1660-1820.* London, 1981.

Boynton, Lindsay. "The Hardwick Hall Inventory of 1601." *Furniture History* 7 (1971): 1–40.

Brigstocke, Hugh, and John Sommerville. *Italian Paintings from Burghley House.* Exhibition catalogue, Art Services International. Alexandria, Va., 1995.

Burghley House, Stamford. Exhibition catalogue. Stamford, Lincolnshire, 1984.

The Burghley Porcelains: An Exhibition from the Burghley House Collection and based on the 1688 Inventory and 1690 Devonshire Schedule. Exhibition catalogue, Japan Society. New York, 1986.

Burghley, William Lord. *Precepts. . .left by William Lord Burghley, to his Sonne, at his death.* London, 1637. *Catalogue of Old Oriental Porcelain and Objects of Art and Ancient and Modern Plate the property of the Marquis of Exeter from Burghley House 7 and 8 June, 1888.* Auction catalogue, Christie, Manson, and Woods. London, 1888.

Ceramics and Civilization. Exhibition catalogue, Kyushu Ceramic Museum. Arita, Japan, 1996.

Child's Bank ledgers. Child's Bank, 1 Fleet Street, London.

Dance, S. Peter. *Shell Collecting: An Illustrated History.* London, 1966.

Dawkins, James, and Robert Woods. *The Ruins of Palmyra, otherwise Tedmor, in the desart.* London, 1753.

Defoe, Daniel. *A Tour thro' the whole Island of Great Britain.* 1724–1727. Reprint, edited by G.D.H. Cole. London, 1927.

Dictionary of National Biography, 1917. London, 1921–22.

Elizabeth, Countess of Devonshire, née Cecil, her will, proved 13th November 1690.

Ellwood, Giles. "James Newton." *Furniture History* 31 (1995): 129–205.

Evans, Eric J. *The Forging of the Modern State: Early Industrial Britain 1783–1870.* London and New York, 1993.

Exeter Manuscripts. Burghley House, Stamford, Lincolnshire.

Ferrari, Oreste, and G. Scavizzi. *Luca Giordano.* Naples, 1966.

Fiennes, Celia. *The Journeys of Celia Fiennes.* Edited by Christopher Morris. London, 1919.

Ford, Brinsley. "The Englishman in Italy." In *The Treasure Houses of Britain: Five Hundred Years of Private Patronage and Art Collecting*, edited by Gervase Jackson-Stops, 40–49. Exhibition catalogue, National Gallery of Art. Washington, D.C., 1985.

Foskett, Daphne. *Samuel Cooper and His Contemporaries: The National Portrait Gallery.* Exhibition catalogue, National Portrait Gallery. London, 1973.

Foskett, Daphne. *A Dictionary of British Miniature Painters.* London, 1972.

Fowler, John, and John Cornforth. *English Decoration in the 18th Century.* 2nd ed. London, 1978.

From King Arthur to the First Queen Elizabeth: Royal Documents at Burghley House. Exhibition catalogue, Burghley House Preservation Trust. Stamford, Lincolnshire, 1993.

Gibbon, Edward. *The History of the Decline and Fall of the Roman Empire.* London, 1762.

Girouard, Mark. *Life in the English Country House: A Social and Architectural History.* New Haven, 1978; New York, 1980.

Girouard, Mark. "The Power House." In *The Treasure Houses of Britain: Five Hundred Years of Private Patronage and Art Collecting*, edited by Gervase Jackson-Stops, 22–27. Exhibition catalogue, National Gallery of Art. Washington D.C., 1985.

Girouard, Mark. "Burghley House, Lincolnshire," parts 1 and 2. *Country Life* 186, nos. 17 and 18 (April 23 and 30, 1992): 56–59 and 58–61.

Glanville, Philippa. *Silver in England*. New York, 1987.

Gunnis, Rupert. *Dictionary of British Sculptors 1660–1851*. London, 1969.

Harris, John. *The Architect and the British Country House 1620–1920*. Washington D.C., 1985.

Haskell, Francis. *Patrons and Painters: A Study in the Relations between Italian Art and Society in the Age of the Baroque*. New Haven, 1980.

Haskell, Francis. "The British as Collectors." In *The Treasure Houses of Britain: Five Hundred Years of Private Patronage and Art Collecting*, edited by Gervase Jackson-Stops, 50–59. Exhibition catalogue, National Gallery of Art. Washington D.C., 1985.

Hayward, Helena, and Eric Till. "A Furniture Discovery at Burghley." *Country Life* 154 (June 7, 1973): 1604–7.

Hibbert, Christopher. *The English: A Social History 1066–1945*. New York, 1987.

Hinton, Mark, and Oliver Impey. *Kakiemon Porcelain from the English Country House: Flowers of Fire*. Exhibition catalogue, Ashmolean Museum. London, 1989.

Howard, David Sanctuary. *Chinese Armorial Porcelain*. London, 1974.

Impey, Oliver. "Collecting Oriental Porcelain in Britain in the Seventeenth and Eighteenth Centuries." In *The Burghley Porcelains*, 36–43. Exhibition catalogue, Japan Society. New York, 1986.

Impey, Oliver. "Eastern Trade and the Furnishing of the British Country House." In *The Fashioning and Functioning of the British Country House*, edited by Gervase Jackson-Stops et al., 177–92. Studies in the History of Art 25. Washington D.C., 1989.

Impey, Oliver. "Porcelain for Palaces." In John Ayers, Oliver Impey, and J.V.G. Mallett, *Porcelain for Palaces: The Fashion for Japan in Europe, 1650–1750*, 56–69. Exhibition catalogue, British Museum. London, 1990.

Impey, Oliver. "[Sir Hans Sloane as a Collector of] Oriental Antiquities," in *Sir Hans Sloane: Collector, Scientist, Antiquary*, edited by Arthur MacGregor, 222–27. London, 1994.

Impey, Oliver. *The Early Porcelain Kilns of Japan: Arita in the First Half of the Seventeenth Century*. Oxford, 1996.

Impey, Oliver, and Arthur MacGregor, eds. *The Origins of Museums: The Cabinet of Curiosities in Sixteenth- and Seventeenth-Century Europe*. Oxford, 1985.

Impey, Oliver, and Malcolm Fairley. *Treasures of Imperial Japan: Ceramics from the Khalili Collection*. Cardiff, Wales, 1994.

Ince, William, and John Mayhew. *The Universal System of Household Furniture. Consisting of above 300 designs in the most elegant taste, both useful & ornamental. Finely engraved, in which the nature of ornament & perspective, is accurately exemplified. The whole made convenient to the nobility and gentry, in their choice, & comprehensive to the workman, by directions for executing the several designs, with specimens of ornament for young practitioners in drawing*. London, 1762.

Inventory of Hatfield House. 1629. Hatfield House, Hertfordshire.

Jackson-Stops, Gervase. "Temples of the Arts." In *The Treasure Houses of Britain: Five Hundred Years of Private Patronage and Art Collecting*, edited by Gervase Jackson-Stops, 14–21. Exhibition catalogue, National Gallery of Art. Washington D.C., 1985.

Jackson-Stops, Gervase, et al., eds. *The Fashioning and Functioning of the British Country House*. Studies in the History of Art 25. Washington D.C., 1989.

Jenyns, Soame. *Japanese Porcelain*. London, 1965.

Jonson, Ben. "An Epigram on William, Lord Burl[eigh]…," in *Ben Jonson: The Complete Poems*, edited by George Parfitt (Middlesex, 1975).

Kelly, Allison. *Mrs. Coade's Stone*. London, 1990.

Lang, Gordon. *European Ceramics at Burghley House*. Stamford, Lincolnshire, 1991.

Lang, Gordon. *The Wrestling Boys: An Exhibition of Chinese and Japanese Ceramics from the 16th to the 18th Century in the Collection at Burghley House*. Stamford, Lincolnshire, 1983.

Lees-Milne, James. *English Country Houses Baroque 1685–1715*. London, 1970.

Long, B. *British Miniaturists*. London, 1929.

Lunt, W. E. *History of England*. 4th ed. New York, 1957.

MacGregor, Arthur G., ed. *The Late King's Goods; Collections, Possessions and Patronage of Charles I in the Light of the Commonwealth Sale Inventories*. London, 1989.

Millar, Sir Oliver. *The Age of Charles I: Painting in England, 1620–1649*. Exhibition catalogue, Tate Gallery. London, 1972.

Montagu, Jennifer. *Allesandro Algardi*. New Haven, 1985.

Morris, Christopher, ed. *The Illustrated Journeys of Celia Fiennes 1685–c. 1712*. Stroud, Gloucestershire, 1995.

Nelson, Christina, and Oliver Impey. "Oriental Art and French Patronage: The Foundation of the Bourbon-Condé Ceramics Collection." In *International Ceramics Fair and Seminar. London, 1994*, 36–43. Oxford, 1994.

Newman, John. "The Elizabethan and Jacobean Great House: A Review of Recent Research." *Archeological Journal* 145 (1988): 365–73.

Oman, Charles C. *Caroline Silver, 1625–1688*. London, 1970.

Oman, Charles C. *English Engraved Silver, 1150–1900*. London, 1978.

Orlandi, Pellegrino Antonio. *Abecedario Pittorico*. Bologna, 1704.

Piranesi, Giambattista. *Diverse maniere d'adornare i cammini ed ogni altra parte degli edifizi desunte dall'architettura Egizia, Etrusca, Greca e Romana*. Rome, 1769.

Pool, Daniel. *What Jane Austen Ate and Charles Dickens Knew: From Fox Hunting to Whist—The Facts of Daily Life in Nineteenth-Century England*. New York, 1993.

Pope-Hennessy, John. "Some Bronze Sculptures by Franceso Fanelli." *Burlington Magazine* 95, no. 602 (May 1953): 157–62.

Richardson, Margaret. "A 'Fair' Drawing. A Little-Known Adam Design for Burghley." *Apollo Magazine* 136, no. 366 (August 1992): 87–88.

Royal Academy of Arts. *The Age of Charles II*. Exhibition catalogue, Royal Academy of Arts. London, 1960.

Royal Goldsmiths: The Garrard Heritage. Exhibition catalogue, Garrard and Company. London, 1991.

Rutter, John. *Delineations of Fonthill and Its Abbey*. London, 1823.

Scheurleer, Th. H. Lunsingh. "Documents on the Furnishing of Kensington House." *Walpole Society* 38 (1962): 15–58.

Shulsky, Linda. "Queen Mary's Collection of Porcelain and Delft and Its Display at Kensington Palace Based upon an Analysis of the Inventory Taken in 1679." *American Ceramic Circle Journal* 7 (Spring 1990): 51–74.

Smith, Charles Saumarez. *Eighteenth-Century Decoration: Design and the Domestic Interior in England*. London, 1993.

Snodin, Michael, and Malcolm Baker. "William Beckford's Silver," parts 1 and 2. *Burlington Magazine* 122, nos. 932 and 933 (November and December 1980): 735–48 and 820–34.

Somers-Cocks, Anna. *The Countess's Gems: An Exhibition of Sixteenth- and Seventeenth-Century Jewels and Artifacts as Recorded in the Schedule of 1690 from the Collection at Burghley House*. Stamford, Lincolnshire, 1985.

Summerson, John. *Architecture in Britain from 1530–1830*. Baltimore, 1970.

Summerson, Sir John. "The Building of Theobalds, 1564–1585." *Archaeologia*, 2nd ser., 97 (1959): 107–43.
Thompson, Francis. *A History of Chatsworth: Being a Supplement to the Sixth Duke of Devonshire's Handbook*. London, 1949.

Thornton, Peter. *Seventeenth-Century Interior Decoration in England, France, and Holland*. New Haven, 1978.

Thornton, Peter. *Authentic Decor: The Domestic Interior 1620–1920*. London, 1984.

Tijou, Jean. *A New Booke of Drawings Invented and Designed by Jean Tijou*. London, 1693.

Till, Eric C. "Capability Brown at Burghley." *Country Life* 158 (October 16, 1975): 982–85.

Till, Eric C. *A Family Affair: Stamford and the Cecils, 1650–1900*. Rugby, Warwickshire, 1990.

Till, Eric C. "The Development of the Park and Gardens at Burghley." *Garden History* 19, no. 2 (Autumn 1991): 128–45.

Vecht, A. *Frederick van Frytom 1632–1702*. Amsterdam, 1968

Volker, T. *Porcelain and the Dutch East India Company 1602–1682*. Leiden, 1954.

Volker, T. "Porcelain and the Dutch East India Company as Recorded in the *Dagh-registers* of Batavia Castle, Those of Hirado and Deshima and Other Contemporary Papers, 1602–1682." *Mededelingenblad van het Rijksmuseum voor Volkenkunde, Leiden* 11 (1954): 152.

Walpole, Horace. *Anecdotes of Painting in England with some account of the principal artists and incidental notes on other arts; also, A catalogue of engravers who have been born or resided in England*. London, 1862.

Waterer, John. *Spanish Leather: A History of Its Use from 800 to 1800 for Mural Hangings, Screens, Upholstery, Altar Frontals, Ecclesiastical Vestments, Footwear, Gloves, Pouches and Caskets*. London, 1971.

Webster, John. *Catalogue of an Exhibition of Silver in Burghley House*. Stamford, Lincolnshire, 1984.

Webster, Mary. "Taste of an Augustan Collector: The Collection of Dr. Richard Mead," parts 1 and 2. *Country Life* 147 and 148 (January 29 and September 24, 1970): 249–51 and 765–67.

Whinney, Margaret Dickens. *Sculpture in Britain, 1530–1830*. Harmondsworth, 1988.

Williamson, George. C. *The Art of the Miniature Painter*. London, 1926.

Woldbye, Vibeke, ed. *Blomster fra Sans og Samling*. Copenhagen, 1990. Translated by Maria Fabricius Hansen as *Flowers into Art: Floral Motifs in European Painting and Decorative Arts* (The Hague, 1991).

EXHIBITIONS CITED

The Age of Charles II, 1960, London, Royal Academy of Arts

Blomster fra Sans og Samling, 1990, Copenhagen, Kunstindustrimuseum

The Burghley Porcelains, 1986, New York, Japan Society

Ceramics and Civilization, 1996, Arita, Japan, Kyushu Ceramic Museum

Samuel Cooper and His Contemporaries, 1974, London, National Portrait Gallery

Courts and Colonies, 1987, New York, Cooper-Hewitt Museum

From King Arthur to the First Queen Elizabeth: Royal Documents at Burghley House, 1993, Stamford, Lincolnshire, Burghley House

Kaikemon Porcelain from the English Country House, 1989, Oxford, Ashmolean Museum

Loan Exhibition, 1929, London, 25 Park Lane

Porcelain for Palaces, 1990, London, British Museum

Royal Goldsmiths: The Garrard Heritage, 1991, London, Garrard and Company

Burghley House Silver, 1984, Stamford, Lincolnshire, Burghley House

Treasure Houses of Britain, 1985, Washington, D.C., National Gallery of Art

The Wrestling Boys, 1983, Stamford, Lincolnshire, Burghley House

The Cecils of Burghley

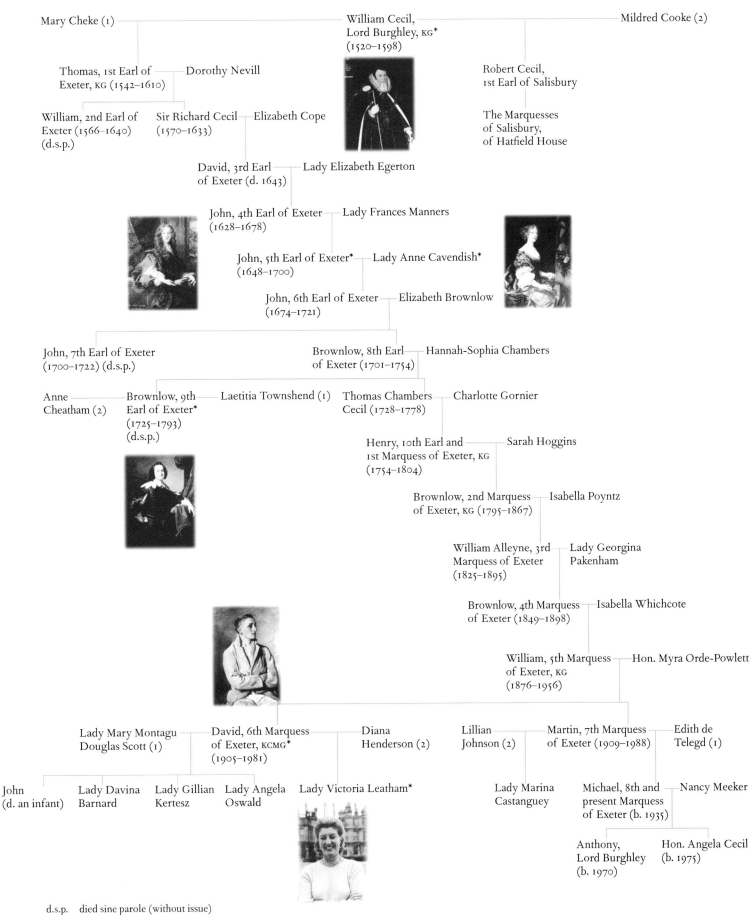

Mary Cheke (1) — William Cecil, Lord Burghley, KG* (1520–1598) — Mildred Cooke (2)

Thomas, 1st Earl of Exeter, KG (1542–1610) — Dorothy Nevill

Robert Cecil, 1st Earl of Salisbury

The Marquesses of Salisbury, of Hatfield House

William, 2nd Earl of Exeter (1566–1640) (d.s.p.)

Sir Richard Cecil (1570–1633) — Elizabeth Cope

David, 3rd Earl of Exeter (d. 1643) — Lady Elizabeth Egerton

John, 4th Earl of Exeter (1628–1678) — Lady Frances Manners

John, 5th Earl of Exeter* (1648–1700) — Lady Anne Cavendish*

John, 6th Earl of Exeter (1674–1721) — Elizabeth Brownlow

John, 7th Earl of Exeter (1700–1722) (d.s.p.)

Brownlow, 8th Earl of Exeter (1701–1754) — Hannah-Sophia Chambers

Anne Cheatham (2) — Brownlow, 9th Earl of Exeter* (1725–1793) (d.s.p.) — Laetitia Townshend (1)

Thomas Chambers Cecil (1728–1778) — Charlotte Gornier

Henry, 10th Earl and 1st Marquess of Exeter, KG (1754–1804) — Sarah Hoggins

Brownlow, 2nd Marquess of Exeter, KG (1795–1867) — Isabella Poyntz

William Alleyne, 3rd Marquess of Exeter (1825–1895) — Lady Georgina Pakenham

Brownlow, 4th Marquess of Exeter (1849–1898) — Isabella Whichcote

William, 5th Marquess of Exeter, KG (1876–1956) — Hon. Myra Orde-Powlett

Lady Mary Montagu Douglas Scott (1) — David, 6th Marquess of Exeter, KCMG* (1905–1981) — Diana Henderson (2)

Lillian Johnson (2) — Martin, 7th Marquess of Exeter (1909–1988) — Edith de Telegd (1)

John (d. an infant)

Lady Davina Barnard

Lady Gillian Kertesz

Lady Angela Oswald

Lady Victoria Leatham*

Lady Marina Castanguey

Michael, 8th and present Marquess of Exeter (b. 1935) — Nancy Meeker

Anthony, Lord Burghley (b. 1970)

Hon. Angela Cecil (b. 1975)

d.s.p. died sine parole (without issue)
KG Knight of the Garter
KCMG Knight Commander of the Order of St. Michael and St. George
* accompanying illustration